MAXFIELD PARRISH

MAXFIELD PARRISH

BY COY LUDWIG

WATSON-GUPTILL PUBLICATIONS/NEW YORK

First published 1973 in New York by Watson-Guptill Publications,
a division of Billboard Publications, Inc.,
One Astor Plaza, New York, N.Y.

Manufactured in Hong Kong

First Printing, 1973
Second Printing, 1974
Third Printing, 1975

Library of Congress Cataloging in Publication Data
Ludwig, Coy, 1935–
 Maxfield Parrish.
 Bibliography: p.
 1. Parrish, Maxfield, 1870–1966.
NC975.5.P37L82 741′.092′4 73-5691
ISBN 0-8230-3897-1

Contents

Color Plates

Chronology

MAXFIELD PARRISH 1870–1966

July 25, 1870. Born in Philadelphia. Named Frederick Parrish. Later he took a family name, Maxfield, as a middle name. Son of Stephen (1846–1938) and Elizabeth Bancroft Parrish, of 324 North Tenth Street, Philadelphia.

1884–1886. Traveled in Europe with parents and studied at Dr. Kornemann's school in Paris. Contracted typhoid in Honfleur, June, 1885. Letters to friends and relatives in the United States, especially those to cousin Henry Bancroft, decorated with many illustrations.

1888–1891. Haverford College, Class of 1892. Member of Phi Kappa Sigma.

Summers, 1892–1893. Painted in Annisquam, Massachusetts, where he shared a seaside studio with his artist father part of each of the two summers.

Ca. 1893. Stephen Parrish built home, "Northcote," at Cornish, New Hampshire. Architect: Wilson Eyre.

1892–1894. Studied at Pennsylvania Academy of Fine Arts under Robert W. Vonnoh and Thomas P. Anschutz. Also attended some classes of Howard Pyle's at the Drexel Institute, Philadelphia, although never officially registering there as a student.

November, 1893. *Moonrise,* painted at Annisquam in August, 1893, exhibited at Philadelphia Art Club. First oil painting he exhibited.

1894. Studio at southeast corner of Thirteenth and Walnut streets, Philadelphia.

Watercolor study, *Old King Cole,* exhibited at Pennsylvania Academy of Fine Arts and purchased for academy's collection.

1894–1896. Studio at 320 South Broad Street, Philadelphia.

1895. First cover design for a national publication, *Harper's Bazar,* Easter number, 1895.

June 1, 1895. Married Lydia Austin (1872–1953) of Woodstown, Salem County, New Jersey. Their first apartment was at Twelfth and Spruce streets, Philadelphia.

June–July, 1895. Traveled to Brussels, Paris and London, shortly after his wedding, to visit the salons and museums.

January, 1897–February, 1898. Studio at 27 South Eleventh Street, Philadelphia.

1897. *The Sandman* exhibited at the Society of American Artists. Parrish honored by being elected to membership in the society.

1898. Construction of house at "The Oaks" was begun in Cornish (Plainfield), New Hampshire, and permanent residence established there.

March, 1898–1966. Studio at "The Oaks," Cornish, New Hampshire (post office: Windsor, Vermont).

November, 1–15, 1899. Exhibition of drawings, among which were many of the illustrations for *The Golden Age,* at the Keppel Gallery, 20 East Sixteenth Street, New York City.

1900. Awarded honorable mention for *The Sandman* at Paris Exposition of 1900.

November, 1900–April, 1901. Convalesced from tuberculosis, while continuing to paint, at Saranac Lake, New York.

1901. Pan-American Exposition, Buffalo, New York. Was awarded silver medal for his drawings.

November, 1901–April, 1902. Traveled to Castle Creek, Hot Springs, Arizona, for the Century Company, where he continued to convalesce and paint. Made stopover visit at Grand Canyon.

November, 1902. Exhibition of paintings and drawings at the Book Shop, 259 Fifth Avenue, New York City.

December, 1902–February, 1903. Second trip to Castle Creek, Hot Springs, Arizona.

March, 1903–June, 1903. Traveled to Italy for the Century Company to make notes and photographs for paintings to illustrate *Italian Villas and Their Gardens.* Also visited France. The Century Company suggested that he consider illustrating a series of chateaux, but he declined.

1904. International Exposition at St. Louis, Missouri. Exhibited *A Venetian Night* and *Saint Patrick. A Venetian Night* purchased by the St. Louis Museum of Art.

Winter, 1904–Spring, 1905. Exhibition of drawings, among which were the colored drawings made for *Italian Villas and Their Gardens* and *Dream Days,* at Williams and Everett Company, 190 Boylston Street, Boston.

December, 1904. Birth of first son, John Dillwyn.

1905. Construction of large studio begun on the grounds of "The Oaks."

1906. Elected to membership in the National Academy of Design.

August, 1906. Birth of second son, Maxfield Parrish, Jr.

1908. Elected to membership in Phi Beta Kappa.

Received the Beck Award, Pennsylvania Academy of Fine Arts, for *Landing of the Brazen Boatman* (award for best picture in the academy's annual exhibition which previously has been reproduced in color).

October, 1909. Birth of third son, Stephen.

June, 1911. Birth of only daughter, Jean.

1912. Elected to honorary membership in the Philadelphia Water Color Club.

1914. Honorary LL.D., Haverford College.

1917. Awarded Medal of Honor in Painting by the Architectural League of New York.

Winter, 1918–1919. Spent the winter painting in New York City at 49 East Sixty-third Street.

September, 1920. Traveled to Colorado Springs, Colorado, to make studies and photographs for a painting of the Broadmoor Hotel.

November–December, 1925. Exhibition of paintings, among which were many illustrations for *The Knave of Hearts* and numerous landscapes, at Scott and Fowles, 667 Fifth Avenue, New York City.

February 10–March 1, 1936. Exhibition, "Maxfield Parrish— New Hampshire Landscapes," at Ferargil Galleries, 63 East Fifty-seventh Street, New York City.

July, 1950. Exhibition of paintings at Saint-Gaudens Memorial, Cornish, New Hampshire.

March 29, 1953. Lydia Austin Parrish died at Saint Simons Island, Georgia.

August, 1953. Exhibition of paintings at Dartmouth College Library.

1954. Honorary Doctor of Fine Arts, University of New Hampshire.

May 4–26, 1964. Exhibition, "Maxfield Parrish, A Second Look," at Bennington College, Bennington, Vermont.

June, 1964. Exhibition of paintings at Gallery of Modern Art, Columbus Circle, New York City.

January 23–March 20, 1966. Exhibition, "Maxfield Parrish— A Retrospect," at George Walter Vincent Smith Art Museum, Springfield, Massachusetts.

March 30, 1966. Maxfield Parrish, age ninety-five, died at "The Oaks."

Foreword

Maxfield Parrish was one of the better known professional artists during the first decades of this century. His many illustrations for children's books and for such publications as *Scribner's Magazine, Century Magazine, Life, Saint Nicholas* and *Collier's* were executed in a wholly personal style that set his work apart from that of his contemporaries and brought him a degree of public recognition seldom achieved by a living artist. In the early 1920s, Parrish turned his creative efforts to making paintings that were reproduced and sold as art prints. His experience in illustrating for the mass media equipped him with a good understanding of public taste, and applying this knowledge to the art-print market, he attained further success. The February 17, 1936, issue of *Time* reported that "as far as the sale of expensive color reproductions is concerned, the three most popular artists in the world are van Gogh, Cézanne, and Maxfield Parrish." In the 1930s, Parrish fulfilled a lifelong dream by making the decision to paint landscapes exclusively. Although his popularity declined somewhat after that, there continued to be a wide audience for the annual color reproductions of his landscapes until he stopped painting early in 1962, at the age of ninety-one.

The letters and other private papers of Maxfield Parrish have provided most of the original material for this study. His many letters to the patrons and advertisers who commissioned paintings from him make it apparent that the artist was an extraordinarily gifted writer. His correspondence, even his business correspondence, reveals much of his personality. Brought up in the nineteenth century, when letter writing was still one of the finer social arts, Maxfield Parrish, even as a boy, began to express his thoughts and describe his impressions quite vividly in his written communications. Throughout his life he continued to be an enthusiastic writer of letters. Even at ninety years of age, when an attack of arthritis temporarily incapacitated his fingers, he maintained an active correspondence, operating his typewriter by holding a pencil in each hand and using the eraser-tipped ends to strike the keys. Indeed, the personal side of the artist as seen in his correspondence leads us to a better understanding of the sources for the romantic imagery of much of his painting. The letters also disclose a great deal about the artist as a businessman.

This study of Maxfield Parrish and his work is not arranged chronologically; that is, it does not trace in successive chapters his development as an artist from the beginning of his career in the mid-1890s through the early 1960s, when he stopped painting. Instead, the separate chapters deal with the various kinds of commissions undertaken by him: book illustrations, magazine illustrations, advertisements and posters, murals, landscapes, etc. Within each chapter, however, the material is arranged more or less chronologically. Although this approach may occasionally require repeating biographical or historical data, it provides a reasonable means of tracing the artist's development and making valid comparisons within the various areas in which he worked. A biographical introduction furnishes the historical background for the succeeding chapters.

Acknowledgments

I wish to acknowledge my indebtedness to Maxfield Parrish, Jr., executor of the Maxfield Parrish estate, for his generosity in making his father's papers and records available for the preparation of this study. I am especially grateful to him for inviting me to Cornish in the autumn of 1966 to see the contents of his father's studio and house at "The Oaks" and to visit "Northcote," the home of Stephen Parrish, before the collections and furnishings were removed from the two estates. Further, I thank him for providing information and personal anecdotes about his father as a man and as an artist, for his delightful stories about life at "The Oaks," for sharing his knowledge of his father's painting technique, for the countless other ways he has facilitated the preparation of this study, and for his friendship.

I also wish to express my gratitude to Helen Parrish (Mrs. Maxfield Parrish, Jr.) for her gracious hospitality during my many visits with her husband; Sharman Oram for her meticulous and untiring assistance with the preparation of the catalog; Frederick Drimmer for his skillful editing of the manuscript; H. Daniel Smith for the preliminary editing of the draft copies; William Fleming for his guiding counsel; my parents for their sustained interest in my research; Lynn Sikora, Sue Lapham and Jane Frost for the careful typing of the manuscript; Diane Casella Hines and Donald Holden at Watson-Guptill for their knowledgeable comments and understanding patience; and the many other individuals and institutions who have given invaluable assistance. Among these are Clair Fry, M. W. Eichers, Dorothy Ryan, Jean M. Weber, Mrs. Harold LaPlante, Edward C. Fricke, John Dryfhout, Robert C. Vose, Jr., Herbert P. Vose, Frank S. Macomber, Allen Burns, Donald Reichert, Sidney L. Manes, Mark Donovan, Austin Purves, Jr., Wilmington Society of Fine Arts, Saint-Gaudens National Historic Site and Haverford College Library.

This study, in a different form, is being given by the author as a doctoral dissertation at Syracuse University.

Throughout the text, illustrations appearing in color are referred to as Color Plates; those appearing in black and white are referred to as Figures.

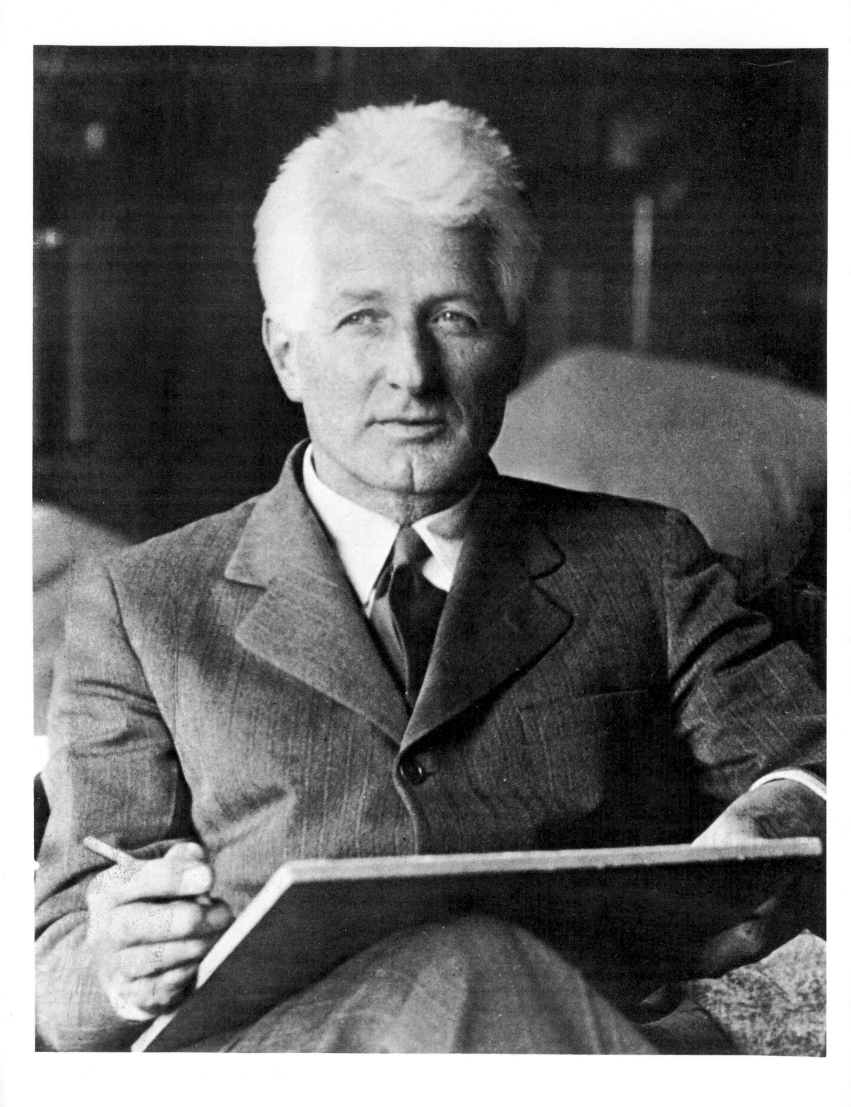

Chapter 1

BIOGRAPHICAL INTRODUCTION

Fred is certainly rebellious and shows even at this early age a decided temper and a determined will. The principal trouble just now is that he will not "work for a living." He enjoys wonderfully taking anything from the bottle or a spoon, but when he is asked to take his meals as nature dictates, which at first requires a little "work," then it is that he fights and kicks and squalls and *won't* work. However, the nurse is all patience and forebearance and says he will soon take kindly to it and then everything will go on nicely and there won't be quite so much rebellion. He has certainly grown notwithstanding.[1]

It was thus in 1870 that Stephen Parrish described his three-day-old son in a letter to his own parents, Dillwyn and Susanna Maxfield Parrish, who were in Atlantic City for a summer holiday. The boy, born in Philadelphia on July 25, 1870, was named simply Frederick Parrish. He later took his paternal grandmother's maiden name of Maxfield as a middle name, and it was by the name "Maxfield Parrish" that he became known professionally. A highly successful art career that spanned more than sixty-five years is sufficient indication that he soon learned to "work for a living." According to Stephen Parrish's description, as a baby Maxfield Parrish already possessed the self-determination and the will that as an adult would enable him to pursue his career in spite of a serious bout with tuberculosis. It was also this self-determination that made him leave the city and seek out the isolation of the beautiful New Hampshire hills, where he could concentrate on his painting without undue interference from visitors or pressure from critics.

Maxfield Parrish was a descendant of Edward Parrish of Yorkshire, England, captain of a trading vessel that traveled between England and Chesapeake Bay. Upon settling in America Captain Parrish received three thousand acres of land where the city of Baltimore now stands and was appointed to the position of surveyor-general of Maryland.[2] Another of Maxfield Parrish's ancestors was the distinguished Quaker author Caleb Pusey, who was closely associated with William Penn in his project for the colonization of Pennsylvania. Maxfield Parrish's great-grandfather was Dr. Joseph Parrish (1779–1840) of Philadelphia. A member of the Society of Friends and a staunch abolitionist, Dr. Parrish gained eminence as a surgeon and humanitarian. As a young man he helped to conduct the country's first evening school for black Americans.[3] Among his patients was the family of the Quaker artist Edward Hicks, perhaps most widely known for his paintings of the *Peaceable Kingdom.* It is believed that another of Hicks' well-known paintings, *Falls of Niagara,* was made about 1835 as a fireboard for the home of Dr. Parrish.[4]

There could hardly have been a more ideal environment in which to bring up a bright, imaginative child than the one in which Maxfield Parrish spent his early years. His cultured parents encouraged the development of his artistic talents by exposing him to fine music, literature and the visual arts from an early age. For his son's third Christmas Stephen Parrish gave him a large sketchbook with "Fred Parrish—Christmas—1873" embossed in a leather panel on the cover. He filled over fifty pages of the book with elaborate and humorous drawings of monkeys and other animals for the amusement and instruction of the young boy. This atmosphere was in striking contrast to that in which Stephen Parrish himself had been raised. Coming from a devout Quaker family who believed painting to be sinful, as a youth he is said to have found it necessary to retreat to the attic in order to draw and paint in secret.

At the time of Maxfield Parrish's birth, his father was owner and operator of a stationery shop in Philadelphia. Always interested in art, he had never quite had the courage to give up his business to become a full-time artist, although he regularly painted for his own pleasure. But Stephen Parrish was determined that his son would have every opportunity to develop his talent. As far as he was able he instructed him in the techniques of drawing, and a number of the earliest extant works of Maxfield Parrish are childhood sketches made on the backs of advertisement fliers received in his father's

Figure 1. Maxfield Parrish.
Photo: Keystone Press Agency.
Courtesy The World Book Encyclopedia.

shop. More important, however, Stephen Parrish helped his son to develop a critical and analytical eye by teaching him how to observe objects in nature. In his early thirties, Stephen sold his business to devote his life to artistic pursuits. Although his paintings were received with favor and were shown regularly in New York and at exhibitions throughout the country, he probably was more widely known for his etchings, especially those of New England coastal scenes.

In the summer of 1884, when he was fourteen, Maxfield sailed with his parents for an extended visit to Europe. For two years he traveled with them throughout England, northern Italy, and France, attending Dr. Kornemann's school in Paris during his first winter there. Young Parrish greeted each new city and the experiences it promised with eager interest. Writing regularly to his grandmother and to his cousin Henry Bancroft in Pennsylvania, he filled his letters with amusing illustrations and long descriptions of his activities. Much of Stephen Parrish's time in Europe was spent at his easel. "We are sitting in our bedroom in Hastings," Maxfield wrote to his grandmother. "Mamma and I are writing and Papa is painting."[5] The family enjoyed the museums, the concerts and the opera in Europe, and perhaps this exposure was partially responsible for instilling in Maxfield Parrish a love of music that equaled his appreciation of the visual arts. Also, the fourteen-year-old traveler especially was interested in the architecture of Europe, and frequently his impressions of buildings, as well as paintings, were included in the accounts of his activities.

Of course thee[6] has heard of Canterbury Cathedral where Thomas à Becket was murdered. Well the first night we were here we went to the Cathedral and it was beautiful. As it was dusk it looked a great deal finer than in the sunlight. Then we went all around the grounds and saw some old remains of Norman and Roman architecture.[7]

Last Friday [he wrote from Paris] we all went to the Opera to see "Faust" played. We enjoyed it immensely, and thee ought to see the house itself. When we went in we entered

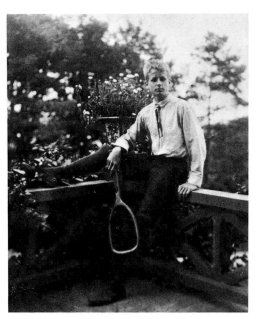

Figure 2. Maxfield Parrish at about seventeen years of age.

into a huge vestibule with carved stone ceiling and waxed floors. Then we waited here a few minutes and then went up the grand staircase . . . It is perfectly magnificent made of polished marble and other different stones.[8]

This morning Papa and I took a walk through the long picture gallery at the Louvre, and I enjoy the pictures more and more each time I see them.[9]

But, as is the case with any young boy on a trip, many of the things that fascinated Maxfield were not to be found in the museums or opera houses. He was intrigued with the mechanical operations of the many ships that he saw, as well as with any technological gadgets that he encountered for the first time in Europe. The equipment in a a Paris dentist's office was the subject of a letter to his cousin.

I have been to the dentist the last two Thursdays, and I don't mind it so much as he is a nice man and don't hurt much. You know when you are with Doctor Pugh, your mouth becomes rather full, after you have had the rubber dam on about half an hour, but this dentist puts a cyphon [*sic*] in your mouth so you don't mind it at all. And then he has the gas light back of a glass globe filled with

water so as to magnify it, and it throws a strong light into your mouth.[10]

Maxfield was in Paris with his family when the great French writer Victor Hugo died in 1885. Crowds of people turned out to pay their respects and to view the funeral procession. "I was fifteen, and climbed a tree on the Champs-Elysées," Parrish later recalled. "The avenue was jammed, but I scattered the crowd when a branch of my tree broke with a noise like a pistol shot. They thought it was the beginning of a nihilist demonstration."[11]

The Parrish family returned to the United States in 1886. Through steady practice Maxfield (Fig. 2) continued to improve his drawing ability, and under his father's tutelage made an etching for an 1887 calendar. In 1888 he entered Haverford College, intent upon becoming an architect. Art was not a part of Parrish's course of study at the Quaker college. "It would be going too far to state that art was in any way forbidden," he wrote in 1942, "yet there was a feeling in the air it was looked upon with suspicion, as maybe related distantly to graven images and the like."[12] Still the room in Barclay Hall occupied by Parrish and his roommate, Christian Brinton,[13] gained campuswide fame for its elaborate wall decorations executed in chalk and crayon by the budding muralist and the antique furniture and rugs the two gleaned from the area's secondhand shops. A member of Phi Kappa Sigma fraternity at Haverford, Parrish in 1908, over fifteen years after leaving the college, was elected to membership in the honorary Phi Beta Kappa Society. Many years later he wrote about the things at Haverford from which he received the greatest inspiration.

I was all for becoming an architect, and once, exploring in some forgotten corner of the library, discovered a number of giant French books of engravings of classic temples; books of wonder, smelling of old mouldy leather and long years of unuse. From the astonished librarian permission was obtained to take them one at a time to my room, where many hours were spent making tracings of capitals and things. . . .

There may have been precious little art

around, but there was surely a wealth of material for making it. For all there was Haverford, and the sheer beauty of the place was an influence and an education hard to equal.

Lying under those copper beeches, when we should have been doing something else, looking into the cathedral windows above did a lot more for us than contemplation of the Roman Colosseum. There were grand trees in those days, and grand trees do something to you. It would be of great interest to know just what it was at college that influenced us most, that helped most to form our futures. Like enough it was not the big things on the front page, but possibly some small affair not mentioned in the catalog. . . .

But then there were big things, and I think the biggest of them all was Dr. [Francis B.] Gummere.[14] His room was like a temple, of music and beauty and all the best that man had written. Through the open window behind his desk were trees again, tall shafts of tulip poplars, and among them the thrushes singing. It would be good to be back there again, listening to the rich music and rhythm of his perfect rendering. . . . Indeed we were in the presence of great art then: it seemed to combine them all, the medium mattered little. Association with his personality and the magic of his teaching seemed to go hand in hand with the beauty of Haverford, a combination never to be forgotten.[15]

Enrolling as a student at the Pennsylvania Academy of the Fine Arts in 1892, Parrish by then was preparing for a career in art rather than architecture. There he studied under Robert Vonnoh and Thomas P. Anschutz. Vonnoh, also one of the teachers of Robert Henri, originally had worked with classic artists in Paris, but eventually came under the influence of the Impressionists before returning to the United States. It is possible that Parrish used as a text at the academy *The Graphic Arts, A Treatise on the Varieties of Drawing, Painting, and Engraving*, Philip Gilbert Hamerton's comprehensive volume published in America in 1889. After he became a professional artist Parrish frequently recommended this book to art students who sought his advice in their educational pursuits.

Throughout his lifetime Parrish preferred to engage in creative work early

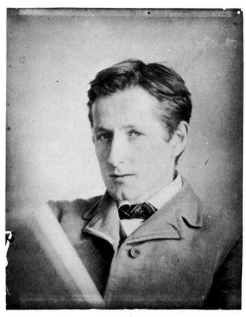

Figure 3. Maxfield Parrish in his early twenties.

in the morning. A letter written to his mother in 1893 reveals that this preference was evident even in his student years. "I am mighty glad to hear that next winter my life class at the Academy comes in the morning, which is a much better time for that kind of work and will enable me to dine with Papa three days of the week, would he so desire."[16]

Parrish credited his father with being his most influential teacher. Not only did Stephen Parrish instruct his son during his boyhood years, but the two men shared a seaside studio at Annisquam, Massachusetts, for two summers in 1892 and 1893. Stephen Parrish spent only a few weeks at Annisquam in 1893, however, as he was busy overseeing the construction of his new home at Cornish, New Hampshire. Maxfield, who remained in Annisquam to paint, apprised his father of his progress in a letter written toward the end of the season.

I trust you will not be disappointed in the little work I have to show—but I have not gone in so much this time for quantity. I've worked as much and more than last year, but have painted over and scraped out—thinking I can gain more by practice and not keeping a lot of useless stuff. If *I* feel encouraged you will know it has not been in vain. You may be glad to know I use up my yellows very fast, which was not the case last year. I suffer from impatience more than anything else.[17]

In subsequent summers Parrish did not regularly make the boat trip from Philadelphia to Annisquam, but instead he often escaped the city's heat at his father's new home, "Northcote," in northern New England (Fig. 4).

The big event of 1893 was the Chicago World's Fair. After leaving Annisquam, Parrish traveled with a friend to the fair in early October to see the exhibitions of painting and sculpture and the architecture that for months had caused much excitement among the artists and students with whom he associated. The experience made a strong impression on him, and the comments written to his mother reflect a keenly developed sense of observation.

Today has been trying to explain why this place is sometimes referred to as the "windy city." It has been blowing a gale, with a little rain and drizzle too. A stunning loose gray sky, just like Normandy, has made a beautiful picture all day long with the white buildings under it. Finer even than yesterday when all was a dazzling white under a clear ultramarine sky. I have not been much in the buildings, though what things I have seen inside are simply marvels of handiwork. What I love to look at most is the conception of the whole thing. Look at it, and realize the possibilities of this effect and that. One often dreams of laying out ideal cities with unlimited means, but such mental recreations have to be remodeled after seeing this. These stupendous architectural groupings could scarcely be surpassed in fairy tales without becoming absurd. And one of the strangest things about it all is that it is almost impossible to imagine such things can ever be done again. It seems more fairy like when one knows it is all to come down in a few months.

The people one never ceases to watch. Such characters and types were never collected before, and in themselves they are a Fair. One has only to come here to find that what is known as caricature is after all a literal rendering of truth. I am enjoying it all in a general way and though horses made of prunes are no doubt very wonderful, yet I prefer to see it as I like best. The Fine Arts building has seen me most. There are few

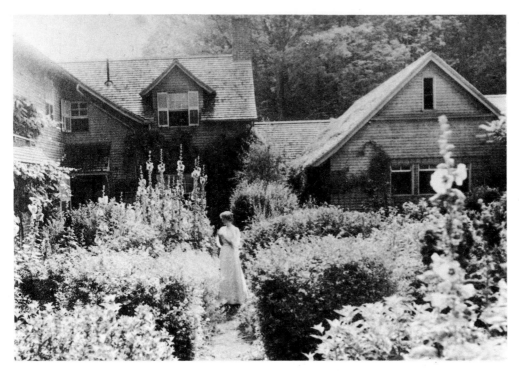

Figure 4. "Northcote," the home of Stephen Parrish, father of Maxfield Parrish, at Cornish, New Hampshire

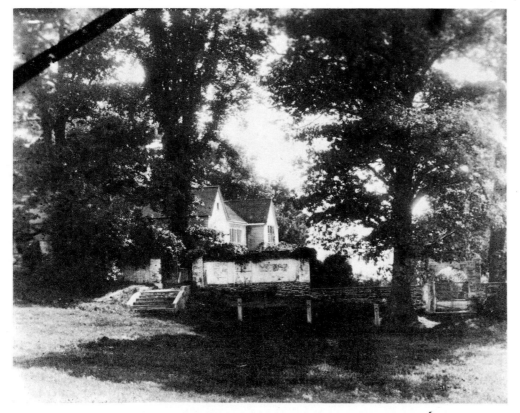

Figure 5. "The Oaks," home of Maxfield Parrish at Plainfield (near Cornish), New Hampshire.

fine, really fine things. That man Zorn from Sweden is certainly a wonder. Tell Papa no pictures are hung in groups. The works of the same artist are scattered all over the place, their only limit being the U.S. section, France section, etc. His etchings are however all together and look very well. The medals were evidently given to a bootblack to confer on the things he liked best—most every other picture has a medal and it seems as much of an honour to be without one as to have one.[18]

Often it has been reported that Maxfield Parrish studied under Howard Pyle at the Drexel Institute of Arts and Sciences; however, the Drexel Institute has no record of Parrish ever having been registered there. According to Maxfield Parrish, Jr., sometime around 1893 his father assembled a portfolio of drawings to show to Pyle, hoping to be accepted as a student of the popular illustrator. When he saw Parrish's work, Pyle told him there was nothing else that he could teach him. He welcomed Parrish to audit his classes, but advised him that as he already had mastered technique he now should begin working toward more fully developing an individual style. Parrish (Fig. 3) attended a few of Pyle's classes but, finding them too elementary for him at that point in his training, he soon stopped going in order to work independently.

Maxfield Parrish's first major commission, undertaken in 1894, just as he was concluding his studies at the Pennsylvania Academy, was for the *Old King Cole* mural and other wall decorations at the Mask and Wig Club of the University of Pennsylvania in Philadelphia. (See Chapter 6.) Wilson Eyre, the architect who a year or so earlier had designed Stephen Parrish's home in Cornish, was in charge of renovating the club's new quarters, and it is likely that he became aware of Maxfield Parrish's abilities as a painter through his association with the artist's father. Parrish established a studio in Philadelphia and worked there making book and magazine illustrations and advertisement designs until 1898, when he moved to New Hampshire.

While auditing one of the classes at

the Drexel Institute Parrish met Lydia Austin, a young painting instructor there. Miss Austin, the daughter of a Quaker family from Woodstown, New Jersey, was an exceptionally attractive woman whose intelligence and enthusiasm impressed those who met her. She and Maxfield Parrish became close friends, and after a courtship of more than a year they were married on Saturday, June 1, 1895, in Philadelphia. Although Parrish had grown up in the Society of Friends, he was not a particularly devout member. In adulthood his own religious beliefs leaned toward agnosticism. Lydia Austin, though a practicing Quaker who attended meetings quite often, was not a member of his meeting and did not care to join. As a result of their marriage, Parrish's membership was terminated with the following notification:

Frederick Maxfield Parrish who had a birthright in the religious Society of Friends married a person not in membership with us, and in the manner of his marriage violated our testimony in favor of the free ministry of the Gospel.

He was visited by a Committee of this Meeting, but having exhibited a want of interest in our religious Society and no design to continue his membership therewith, we no longer consider him a member amongst us. Nevertheless we design that by attention to the Divine Witness he may experience preservation and know the reward of Peace.[19]

As he had not been active in the society, Parrish was not concerned by the termination of his membership. There can be little doubt, however, that the philosophy of humanitarianism and nonviolence that guided his personal life was strongly influenced by the Quaker environment of his childhood in Philadelphia.

Shortly after his wedding Parrish sailed alone for Europe, where he planned to spend the summer visiting the salons and museums. His new bride, after a short stay with her parents, passed the time with friends in Annisquam. The trip was an important one for the artist; it was the first time as an adult that he had had an opportunity to study a wide range of paint-

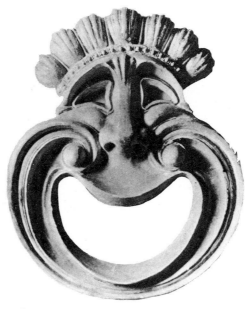

Figure 6. Comic mask. Brass or bronze, 7" x 5"; plaster h. 40". This is probably the only piece of sculpture executed by Maxfield Parrish and reproduced in metal. Four copies exist. Two replicas in plaster ornamented the ends of the curtain in a single performance of A Masque of "Ours" staged in Cornish, New Hampshire, in June, 1905, to honor the sculptor Augustus Saint-Gaudens on the twentieth anniversary of the founding of the Cornish Colony by Augustus and Augusta Saint-Gaudens.

ings by the old masters. Also, it enabled him to observe firsthand the developments taking place in late nineteenth-century painting in France and provided an opportunity for him to meet and talk with many of the American artists studying in Paris. From each city that he visited he wrote to his wife giving her his impressions of what he was seeing.

[Brussels] I have been feasting on glorious pictures in a great gallery. Oh, the masters of the Dutch and Flemish schools knew how to paint! I only wish they showed up better in photos, but their charm is lost. They were a perfect revelation to me—the first time I had a chance to see the old fellows face to face. The van Eyck's, the van Orley's, the Memling's and a host of wonders. Spent last evening in a concert garden under great trees in company with a beautiful string orchestra, where one can sit at one's ease and be very happy and wish with all one's might that someone else were with him.[20]

[Paris] Here I am in Paris at last! And what a Paris it is: there seems a very magic in the name! How often it is that places we have visited in childhood seemed so grand and vast, and when seen again in later years have seemed so contracted and as though something were missing—but not so with Paris. Never has anything appeared to me so vast, so magnificent. When I arrived here at sunset the city burst upon me as nothing ever did. . . . The streets are endless and marvels of beauty: the palace of the Louvre seems simply stupendous, and all is on such a scale of splendor it takes one's breath away. I could not have come upon all this at a time when my appreciation was more keen and my eyes more open to let nothing escape them. I feel that I am seeing so much more than other people here: that they are missing half of it. It takes back all I said of Bruxelles: there is only one Paris, and this is it.

I have been to both the salons and consider it a duty performed. The new salon at the Champs de Mars is very disappointing. I knew there would be lots of bad but I was expecting more good and one or two at least great things. The old salon is simply shocking. Of the Avenues and Avenues of pictures there is not one good thing: not one. The most interesting thing is to see what frightful subjects some have taken, and see which Frenchman had the most original idea of blood. There are many examples worth dwelling upon . . . one . . . is the canvas of a man who has gone straight to the slaughter house for his subject. There before us is a colossal representation of a newly cut-open ox, dripping, swimming, wallowing in crimson, animal blood! . . . I was certainly disappointed with the salons. May be it was too much of a shock coming right out of Bruxelles. However the new salon is not by any means without some mighty good things. Strangely enough it is very, very sane, and it is the old salon which abounds with modern horrors. . . .

I had resolved not to enter the Louvre until I had thoroughly seen the salons; but Sunday as I passed one of the entrances the temptation was too much for me and in I went. As luck would have it the first room I entered was the Salon Carrée. I nearly fainted. If Chapman's Homer was to Keats what that was to me then his Sonnet gives some idea of my sensations. One had but to turn and there were Titians, Rembrandts, Botticellis, Correggios, van Eycks, all together, in one glorious mosaic of richness. What an awe-

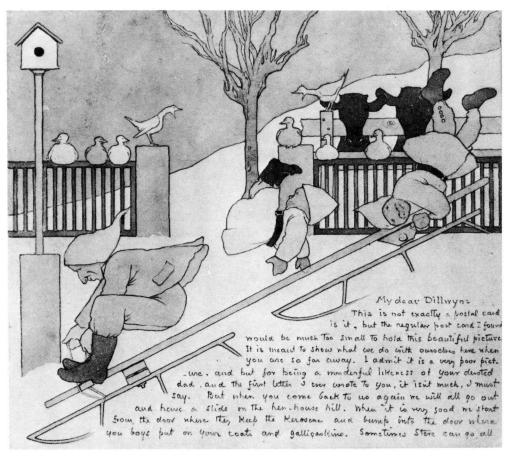

*Figure 7. Letter written by Maxfield Parrish
to his seven-year-old son, Dillwyn.
March 1, 1912. The figures on the sled are
the artist and his two younger sons,
Maxfield, Jr., and Stephen.*

some feeling it is to be in such a presence. I took a hurried walk all through the vast galleries just to see what was in store for me. That great Titian, "La Mise au Tombeau" simply haunts me. I dream about beautiful reds and blues and greens and glorious whites. The color in that picture is pure magic. . . .[21]

[Paris] I am sitting in the Tuileries watching the twilight: a glorious place to be alone in and wish one were not. This evening is simply heavenly—such gray twilights! One does not wonder that the old masters put such beautiful ones behind their madonnas. Took lunch with Henri, Schofield and Glackens and had a fine time. Have laid in a fine stock of photographs, too, but the Velasquez's of Madrid I cannot get. Maybe I can in London.[22]

[London] After breakfast I got on top of a 'bus in the drizzle and rode to morning services in Westminster Abbey. A thick yellow fog was rolling up making all like evening and very fascinating to be out in: and inside Westminster all morning were vast black places to look into, and where there was light it was a beautiful amber. I settled myself away over in the poets' corner, away from people, under Shakespeare and "rare Ben Jonson" and listened to some charming choir boys singing. The rich warm blackness all around was most impressive and like a forest, with nothing above but impenetrable gloom. When it was all over I buttoned up to the teeth and ploughed through the wet across Westminster bridge just as "Big Ben" with a hoarse roar was striking twelve. What is that wonderful fascination about a bell? They are such human things hung up aloft in dark towers, silently waiting until their turn comes. You watch them hanging motionless and they seem possessed of a subtle, quiet power; a being with a voice. And the great domes too, they are like great bells forever silent: they always impressed me as though they were living things but slumbering. Their very names "bell" and "dome" have a ring, and you feel them reverberating when you say them. I shall carry back with me no sweeter, happier recollection than those glad, silvery chimes up in the Cathedral tower at Antwerp; pouring through the air their careless jangle of sweet sound. How fine to be a child and live under them; to look up into the dark tower and wonder what they were doing and saying when they were not ringing: to wonder what made them ring at all, and how fine it would be to be one of them and hang away

up high among the dark rafters, in such happy company, and swing and ring when they did. . . .

Monday evening. I had a grand sleep after my day in the wet; and the rain has left us for awhile. I dined with [Robert] Vonnoh tonight at the Criterion; he is fascinated with London and the pictures . . . I saw one more Annual Exhibition today namely The "New Gallery" on Regent St. It was beastly bad of course, with the exception of John Sargent's portrait of Ada Rehan which was a stunner. My! but you never saw such rot! England is the most hopeless place there is, for her art community surround themselves with a wall, and they are satisfied. In every picture of "the return of the sailor-lad" or mermaid playing with a tiger on the bank and such subjects, is written, satisfaction, we think this is beautiful and so do the people, what more do you want. And when such artists go to the National Gallery, if they go at all, I doubt if they are conscious of any contrast. I firmly believe now that America will in time have modern exhibitions to show that will outclass any on this side of the water; it will take a long time to be sure, but she has not as much to contend against as have England and France, though she has much more to learn. I trust I have deposited my last shilling on modern exhibitions here: I never saw so many at once, but London is a big place.[23]

Filled with ideas about the things he had seen in Europe and anxious to get on again with his own work, Parrish returned to America in mid-August, 1895, and he and his bride settled into their first apartment at Twelfth and Spruce streets in Philadelphia. These were happy times for the young artist. His marriage was good, and his art, which was providing a moderate income for the couple, was beginning to receive attention in the publishing field. One of his early studios in Philadelphia was near Independence Hall, "right on the corner across from what is now the Curtis Publishing Company's building."[24] Reminiscing about his early years as a painter, in 1951 Parrish described this studio. "My quarters were in what was once a swell neighbourhood, the lower stories of the house all white marble, but in my time all run down and neglected, and studios for a song. All that has vanished now and a huge

building towering to the skies in its place. . . ."[25]

In 1896 Parrish painted *The Sandman* (Fig. 10), the work that he later credited with being the most important of his early career. Executed in rich amber tones and striking chiaroscuro, *The Sandman* was included in the 1897 annual exhibition of the Society of American Artists; at that time Parrish was elected to membership in the society. A few years later the same painting was awarded honorable mention at the Paris Exposition of 1900. This recognition for aesthetic quality was important to the young artist, who occasionally was subjected to criticism for earning his living in the more directly commercial areas of art.

Parrish developed a great fondness for Cornish, New Hampshire, when in the early 1890s he first visited that budding summer mecca for artists, writers and others of the well-to-do intelligentsia. The sculptor Augustus Saint-Gaudens about 1885 established a summer residence in Cornish, thereby informally starting what was later referred to as the Cornish colony. Following Saint-Gaudens' lead the artist Thomas W. Dewing built a summer home there, and after him came the architect and landscape gardener Charles A. Platt, who persuaded Stephen Parrish to settle there. Eventually the colony included among its many famous regular summer residents the sculptors Herbert Adams and Paul Manship, artists Kenyon Cox and George de Forest Brush, writers Percy MacKaye, Louis Shipman, Hamlin Garland, Langdon Mitchell, Winston Churchill, Norman Hapgood, Scribner's editor Maxwell Perkins, and the eminent jurist Learned Hand. Many other prominent figures in American culture of the late nineteenth and early twentieth centuries who did not actually establish homes in Cornish frequently leased property there, and passed the summer months working among their friends in the peaceful country atmosphere.

Having purchased a large tract of land on an isolated hillside across the valley from his father's home, Maxfield Parrish and his wife left Philadelphia in the spring of

1898 to begin constructing their new home, which they called "The Oaks" (Fig. 5). The artist not only designed the structure, but he also built it, with the help of George Ruggles, an "entertaining old carpenter, noted for his talkativeness, his Bible learning, his agnosticism, his taste for ice cream and his habit of going barefoot in summer to save shoe leather."[26] Ruggles subsequently worked for Parrish as a handyman at "The Oaks" for more than a quarter of a century, as did Eddie Pierce after Ruggles' death. The artist was extremely fond of both of these old gentlemen and considered them among his close friends. Although "The Oaks" was always said to be in the Cornish colony,[27] it actually was located near the New Hamphsire-Vermont border a few hundred yards from Cornish inside the township of Plainfield, New Hampshire. The post office address, however, was Windsor, Vermont, five miles away.

"The Oaks" began rather modestly with a few rooms in which the artist and his wife lived while he continued to construct the rest of the building as his painting schedule permitted. Within a few years it had become one of the most outstanding residences in the area. Featured in numerous architectural magazines, "The Oaks" was built on a site the artist had selected for its extraordinary view, which he described in a letter to Irénée du Pont.

. . . as you descend some steps from the upper level to the house terrace, through old oak trunks and branches, through them and beyond them, you have a confused sensation that there is something grand going to happen. There is blue distance, infinite distance, seen through this hole and that, a sense of great space and glorious things in store for you, if only you go a little further to grasp it all. It takes your breath away a little, as there seems to be just blue forms ahead and no floor. Then you come upon the lower terrace, and over a level stone wall you see it all: hills and woodlands, high pastures, and beyond them, more and bluer hills, from New Hampshire on one side and from Vermont on the other, come tumbling down into the broad valley of the Connecticut, with one grand mountain over it all.[28]

The house itself was designed to con-

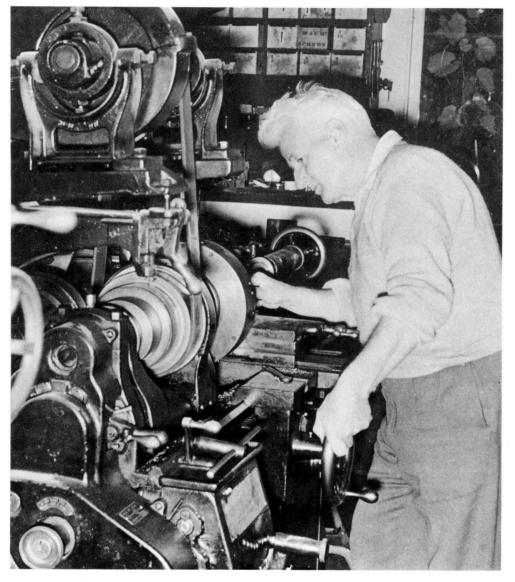

Figure 8. Maxfield Parrish in the machine shop of his studio at "The Oaks," ca.1935.

form to the contour of the terrain, with the first floor or entrance level at the rear extending through the structure to become the second floor at the front, where a grand loggia and numerous windows provided ample opportunity to enjoy the view. The loggia overlooked cascading gardens and a grassy terrace, the central feature of which was a lily pond sixteen feet in diameter. Revealing the artist's abilities in the area of architectural design and decoration, as well as his persistent attention to detail and fine craftsmanship, "The Oaks" was so frequently the subject of magazine articles that Parrish told one writer, "The place has been so photographed that the corners are getting rounded."[29] A 1907 article in

Architectural Record applauded the structure and praised Parrish, who had had no architectural training, for the design.

Mr. Maxfield Parrish has made his reputation as a painter and an illustrator; but his work is not without suggestion that he might perhaps have done quite well as an architect. He seems to be gifted with a sense of form, which is somewhat independent of his vehicle of expression, in which it happens to work, while at the same time he possesses preeminently that feeling for the value of materials and that aptitude for technical process, without which an imaginative gift is artistically sterile he fully appreciates the necessity for the complete composition of a house in relation to its site. . . .

[The music room at "The Oaks" is] about twenty feet wide, twice as long and some fourteen feet high. The walls are paneled for about three-fifths of their height; and the panels, which are of generous size, are painted a dull grey-black in color, which is both luminous and solid. The plaster, immediately above the panels, has been subdued to a white, which is almost grey, and whose tone prevents the room from being split in two by the line of panels. The big panels, which run up to the ceiling on the north wall, and which screen a small stage, also contribute to the same purpose. The floor has been painted a dark red, which has been prevented from counting too strong by the rugs, while the heavy beamed ceiling is lighted by some gold between the beams and some blue on their faces. . . . [It is] in a very real sense a noble room. . . . At once in its dimensions, in its proportions, and in its manner of treatment, it is the work of a man who is mastering the fundamental architectural values; and with all its dignity it is eminently a comfortable and livable room. Interiors of this kind are sufficiently rare in America, and that one should have been designed by an amateur architect is remarkable.[30]

Parrish's major reason for settling in the Cornish area was that it provided the isolation and privacy that he found necessary in order to concentrate on his work. He also was inspired by the natural beauty of the New Hampshire and Vermont scenery and found the fresh country air to be invigorating. Having anticipated the pleasure of living near his parents, the artist was disappointed when only a year later, in the fall of 1899,[31] his mother moved permanently to southern California to participate in a small, informal religious community. His father remained in the East, however, and until his death in 1938 continued to enjoy a close relationship with his son.

It had taken courage for the young artist to leave Philadelphia, where commissions would seem to have been much easier to come by than in New Hampshire. But Parrish never regretted the move. There was a constant demand for his work for as long as he was able to paint, and patrons always could find him working at "The Oaks." He never had to seek work, nor did he ever have an agent, except for a few years

Figure 9. Ethel Barrymore Her Book.
*Bookplate. Ca.1900-1905. Photo: Library
of Congress.*

around 1920, when a lithographing firm in New York City coordinated his advertising commissions.

Two years after he moved to New Hampshire, it was discovered that Maxfield Parrish had contracted tuberculosis. He could not have been stricken at a more inopportune moment in his career. By this time he already had illustrated many magazine features and several books, which had been well received by the public and critics alike. Finishing up a group of magazine commissions, he was just about to begin a series of colored drawings for Kenneth Grahame's *Dream Days.* At his doctor's request Parrish spent the winter of 1900-1901 recuperating at Saranac Lake, New York, where he continued to paint. Still not completely recovered, he was given a commission by the Century Company which enabled him to continue his convalescence in Castle Creek, Hot Springs, Arizona during the winter of 1901-1902.

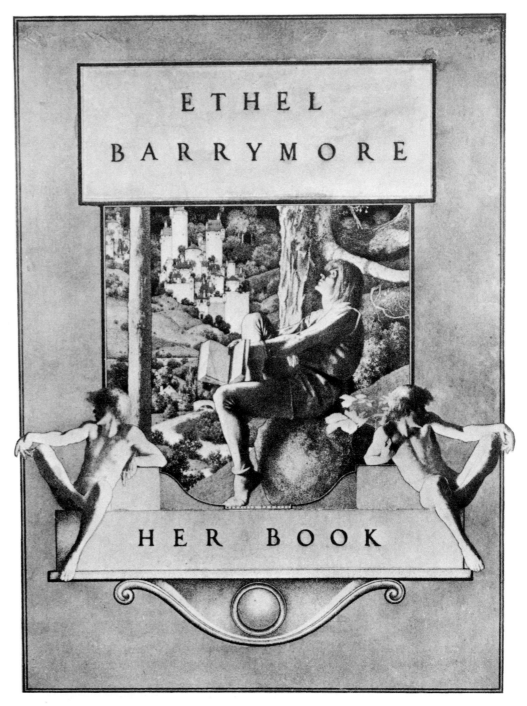

We never expected to find ourselves out here [Parrish wrote to his cousin Henry Bancroft in February, 1902], but here we are and having the time of our lives. Century Co. sent me out to illustrate a series of articles on the region, and though not exactly in my line, there were other inducements which made it hard to resist, and now that we have tried it the art part of it seems to be most enjoyable. . . . And air! You never breathed such stuff in your life: it's right from the keg. We are twenty five miles from a railroad in one of numerous canyons which cut this country in all directions, and wherever we go it is always on desert ponies. We ride to the tops of the mountains, and from there you see nothing but other mountains and not a sign of a human being anywhere. You get a sense of freedom and vastness here that I never imagined existed. . . . Lydia is a regular Annie Oakley, rides the desert horses astride, and is a crack shot with a six shooter. But shooting people is considered bad form here nowadays, so she has to content herself with targets. . . . Christmas day I sat on a Coroner's inquest, a new departure for me in celebrating that day. It was in a little cabin up in a gulch not far from here, and Lord, I wish you could have seen the jury! We pushed back the bottles and sat on the bar, and took the oath while the chickens snuffled around the floor and sad eyed burros looked in at the door. The next day they buried him and put stones on top so the coyotes wouldn't dig him up. And the next day all but two of the jury took to drink and remained in an alcoholic trance for a week. Such is life out here. We shall stay here until April and then up to New Hampshire in time to plant.[32]

A trip to Arizona the following winter lasted but two months, as it was necessary for Parrish to return east to sail for Italy in March, 1903, to make sketches and photographs to aid him in illustrating Edith Wharton's *Italian Villas and Their Gardens.* His health by this time almost completely restored, the artist and his wife regarded the three months' travel in Italy as a working vacation and enjoyed the many new experiences they were sharing. The extraordinarily heavy spring rains they encountered in Italy curtailed their travel

Figure 10. The Sandman. *1896. Oil on canvas fastened to white pine, 22" x 28". Photo: Library of Congress.*

in some regions, but the damp weather and swollen rivers did not prevent Parrish from obtaining photographs and sketches of the villas he was to illustrate for the Century Company. He returned to the United States by way of southern France, where he was able to see once again a number of the places he had visited with his parents as a boy.

Maxfield and Lydia Parrish had four children: John Dillwyn (1904-1969), Maxfield, Jr. (born 1906), Stephen (born 1909), and Jean (born 1911). "The Oaks" seemed really to come alive with the arrival of the children. The woods and pastures were inviting haunts for childhood explorations and the hills provided great sledding in winter. An illustrated letter written in 1912 by Parrish to his eldest son, who was recuperating from a minor childhood ailment, contained a delightful watercolor drawing of the artist and his two younger sons sledding at "The Oaks" (Fig. 7). Parrish often used his mechanical and artistic skills to make toys and games for the children. A Parcheesi board he made for them

was as meticulously painted as any Parrish landscape. As his father had encouraged him, so Maxfield Parrish encouraged his own children to learn to draw and paint, often making cartoons and caricatures in the evenings for their amusement. This encouragement was important to each of the children, but especially to his daughter, who carried the family tradition of painting into the third generation of professional artists. Asserting her own individuality, Jean Parrish adopted a style and a technique quite dissimilar from those of her father. She continues to paint steadily and to gain recognition for her work. The artist's three sons all inherited their father's fascination for machines. John became an expert on railroad history, Maxfield, Jr., made his career in optical engineering and Stephen in the field of airplane instrumentation.

Additions were built to the house at "The Oaks" as they were needed in order to accommodate the growing family. Also, with Parrish's developing interest in mural painting it was necessary to construct a new

large-scale studio for the canvases of mural size. Begun about 1905, and constructed over a period of years, the studio was located a short distance behind the house, providing a place where the artist could work for long periods without interruption. In addition to several large studio or work areas, the studio building also contained a living room, kitchen, two bedrooms, garage and a fully equipped machine shop (Fig. 8), where the artist passed many happy hours making fine hinges, latches and other beautiful utilitarian objects which he incorporated into his house. Experimenting with the machines in his shop was Parrish's way of relaxing after a period of concentrated painting.

Social life at "The Oaks" and at Cornish in general was limited during the winter months, but each year with the arrival of the summer residents the round of parties, dinners and concerts began anew. There were always old friendships to be renewed and new acquaintances to be made, for each summer brought a host of artists, writers and performers as visitors, along with the summer residents of the colony. The 1905 season featured a production of Louis Evan Shipman's *A Masque of "Ours,"* written in celebration of the twentieth anniversary of the founding of the Cornish colony by Augustus and Augusta Saint-Gaudens. The outdoor masque was performed in a pine grove on the Saint-Gaudens' estate by more than seventy costumed neighbors, among whom were about forty artists and writers. Percy MacKaye, who wrote the prologue to the masque, reported on the unusual event in *Scribner's Magazine:*

About twilight, on the longest day of the year, the sculptor, with his family and some hundreds of guests, were seated in front of a green-gray curtain, suspended between two pines, on which hung great gilded masks (executed by Mr. Maxfield Parrish) [Fig. 6]. Close by, secreted artfully behind evergreens, members of the Boston Symphony Orchestra awaited the baton signal of Mr. Arthur Whiting, conductor and composer of the music.[33]

In addition to designing the large masks which ornamented each end of the curtain, Maxfield Parrish also played the role of Chiron, the centaur. The centaur costume,

which he designed and constructed, was made of fabric stretched over barrel-hoop ribs, which attached to the back of the artist at his hips. His legs then became the centaur's front legs. The back legs of the centaur, which were equipped with small wheels, were attached to the artist's feet by small metal rods. Consequently, each time Parrish moved a foot, the corresponding rear leg of the centaur's body moved. The appearance of Chiron was remembered as one of the high moments of *A Masque of "Ours."*

Writing again to his cousin Henry Bancroft, Parrish described the tone of the social activities at the colony in the early part of the following summer:

The summer rush is on and it's pretty gay. We are thinking of going down to New York to rest. The colony has become more or less literary, and a pretty good lot of fellows. Ethel Barrymore is with us for the summer, and all us fossils take a little longer selecting our neckties and brushing what hair we've got as though it made a damn bit of difference. I am hard at work on a big picture [*Old King Cole*] about the size of Texas to go over the bar in the Knickerbocker Hotel in New York.[34]

Parties at "The Oaks" often featured recitals in the music room by well-known musicians, including singers, pianists and string quartets. Since the days of his youth Parrish had been a lover of good music, and as often as possible he drove down from Cornish to hear the Boston Symphony Orchestra perform. "Were I rich," he once wrote to George Eastman in Rochester, New York, "I would found no libraries at all. I would endow music, good music and lots of music. I wish with all my heart it were my medium instead of bad pictures."[35] On at least one occasion the poet Edwin Arlington Robinson gave a reading of his poetry for invited guests in the artist's music room. In 1958, at the age of eighty-eight, Parrish reflected on the social life at "The Oaks" during the first quarter of the century, when guest lists included such names as Philip Littel of the *New Republic,* poet William Vaughn Moody, dramatist Percy MacKaye, actress Ethel Barrymore (Fig. 9), Judge Learned Hand and President Woodrow Wilson.

True, we had some epic parties here long, long ago. Judge Learned Hand to this day likes to talk them over, and to see Walter Lippmann and Felix Frankfurter unbend a bit was a day to remember. But we were all young then, and if we didn't quite understand W. L. we did not bother. Dining then was gay and often too big. Far better were modest lunches on the studio porch of a day in summer. . . .[36]

Although most of Parrish's paintings were made to be reproduced, the originals were eagerly sought by private collectors. No one built a finer collection of his paintings than Austin Purves of Philadelphia (Chestnut Hill), Pennsylvania. When Purves, vice-president of the Pennsylvania Salt Manufacturing Company, became interested in collecting art, his friend, the sculptor Chester Beach, advised him to collect the work of one artist. Another friend of Purves', the author Kenneth Grahame, had been exceedingly pleased with Parrish's illustrations for his books *Golden Age* and *Dream Days,* and when he learned of Purves' intent to begin an art collection, he suggested that he look at some of Parrish's works. At Austin Purves' request the artist sent eleven paintings to Philadelphia in May, 1908, for him to peruse. Mr. Purves purchased three of them—*Jason and the Talking Oak* (Pl. 3), *Winter* and *Dawn*—and over the next few years became the artist's most generous patron. As the collection grew it was necessary to add a new room or gallery to the Purves home to accommodate it. When Austin Purves died in 1915, there were eighty-five paintings and drawings by Maxfield Parrish in his collection. The collection was partially dispersed some forty years later after the death of Mr. Purves' widow.

About 1912 the artist's wife made the first of what were to become her annual winter excursions to Saint Simons Island, a small island off the coast of Georgia. Purchasing a cottage and some land in an area of the island known as Bloody Marsh (named for a famous eighteenth-century battle), Mrs. Parrish became engrossed in researching the songs of the Negroes who inhabited the island. Since many of them had forsaken their own songs, inherited from their slave ancestors, in favor of the more socially accepted Christian hymns, she set out to rekindle their interest in their early traditional music. In an old cabin on her grounds Mrs. Parrish sponsored what she called "plantation sings." The black residents of the island would congregate at the cabin to sing songs and perform dances, many of which were brought over from Africa by their ancestors. These songs and dances had nearly disappeared from the island before Mrs. Parrish arrived and encouraged their preservation. After gaining the confidence of the Negroes, she lived at Saint Simons for more than twenty winters, writing down the songs sung to her by the elderly residents and making notes about the dances which they, with her encouragement, had begun again to teach to the younger generations. Lydia Parrish compiled all her findings in a book, *Slave Songs of the Georgia Sea Islands,* published in 1942 by Creative Age Press[37]

Often the Parrish children accompanied their mother to Georgia for the winter. Later, when they were away at school, or after they were grown, she traveled alone. Each year, as soon as the New Hampshire winter gave way to spring, she hurried back to Cornish to be with her husband and friends and to oversee the gardening and other summer activities at "The Oaks."

Unlike his wife, Maxfield Parrish thrived on the northern winters. Although the winter months were not the best in which to dry paintings, he found them extremely productive as there were few interruptions by visitors. Frequently the only way one could reach the house and his studio (Fig. 11), where he lived in the winter months when he closed the house, was through the use of snowshoes. Sometimes it was necessary for the artist to strap on snowshoes and walk down a steep pasture through deep and blowing snow to pick up mail, milk and other provisions which were left for him at the main road. He appreciated good food any time of the year, and regularly ordered by mail specialties such as teas, Italian chocolates or his favorite watermelon pickles that he could not purchase in Cornish or Windsor.

A diversion that he enjoyed immensely was feeding the winter birds and animals. Each day he put out large quantities of birdseed and peanut butter in an area near his studio window so he could observe the feeding activity while he worked. When the weather was sufficiently calm, ice skating occasionally provided pleasant relaxation. "I could not resist the beautiful ice of Christmas week," he wrote to a business acquaintance. "It was rather exciting to skate up the brook on clear plate glass and have a vanguard of fishes go scooting along ahead of you."[38] With the advent of snow plows, trucks and heavier automobiles, Parrish's home became much more accessible in winter than in the early years, when snowshoes or a sleigh were often required.

In 1913 Parrish was invited to become head of the Art Department at Yale University. He was honored at having received the invitation, but he had no desire to leave the hills of New Hampshire and the life there, which suited him so ideally. "The Oaks" was his home, not just a summer home, but a permanent place that he had built and where he intended to spend the rest of his life. Long after many members of the Cornish colony had stopped coming north for the summer, Parrish remained at "The Oaks," contentedly pursuing his painting interests. Life had changed considerably, however, from the days of the great parties and social gatherings. Parrish's routine, established early in his career, consisted of getting up for breakfast at 5:30 A.M. and being well into the day's work before most people were stirring. While eating breakfast he listened to the early morning world news broadcasts, and then, before dawn, he would tune in the classical music broadcasts from Mt. Washington. As the early morning hours were his most creative, he used them for designing the compositions, drawing the delicate figures and doing other work that required total concentration. Later in the day, when he was more likely to have interruptions, he concentrated on the more routine tasks

of glazing, varnishing, constructing panels, etc. The domestic chores usually were done by his housekeeper and studio assistant, to whom he referred in his letters as "the faithful Susan,"[39] while a handyman often took care of minor repairs.

Nothing pleased the artist more than putting in a good morning's work in his studio, and then having a leisurely summer luncheon on his studio porch with members of his family or one or two close friends. From the porch, while being warmed by the sun, one could enjoy a spectacular view of the Connecticut River valley. "Wish you were here this very day," Parrish wrote to a friend. "It is one of those rare ones that sink in and with waves of wild grape incense sweeping over the place, life isn't bad at all."[40] As he grew older, Parrish looked forward to the few weeks each summer when his children and grandchildren would congregate at "The Oaks." Exercising a grandfather's prerogative, he openly boasted about his beautiful grandchildren, and occasionally remarked that his major regret was that he would not be around to see them when they were grown.

Parrish was a familiar figure in the small towns of Windsor and Plainfield, where he regularly went to shop for supplies and to do his banking. Recognized by his thick white hair and twinkling blue eyes, the artist, despite his fame, was regarded as just another friend by his neighbors, who might occasionally drop in at "The Oaks" to borrow a wrench or to bring some fresh vegetables in season. When he reached eighty years of age on July 25, 1950, Parrish's neighbors gave a surprise birthday celebration in his honor in the nearby town of Claremont, New Hampshire. Although very touched and pleased by the event, the artist was somewhat embarrassed by the attention. He told a representative of Brown and Bigelow, the company which published his landscapes, that he was presented with a "birthday cake about the size of Connecticut, engrossed scroll of parchment setting

forth unbelievable fairy tales and things, and it nearly finished me, congenital shrinking violet that I am."[41]

Mrs. Maxfield Parrish died at Saint Simons Island in the spring of 1953. Her husband remained in remarkably good health for his advanced age, continuing to paint until 1960, when arthritis in the fingers of his right hand made it difficult for him to hold a paintbrush. The following year, after regaining the use of his fingers, he resumed his work. But soon his health began to deteriorate, and in the spring of 1962, at age ninety-one, he put away his paintbrushes forever.

Parrish lived long enough to see the beginning of a major revival of interest in his work among a new generation of Americans. In the early 1960s, the first of several recent major retrospective exhibitions of his paintings was organized at Bennington College. When the exhibition traveled to the Gallery of Modern Art in New York, Parrish asked in an interview in *Time,* "How can these avant-garde people get any fun out of my work? I'm hopelessly commonplace."[42]

Maxfield Parrish died at "The Oaks" on March 30, 1966. He was ninety-five years of age. Many years earlier, in his sixties, he had written some comments on aging to J. H. Chapin at Scribner's, a long-time friend:

Strange what keeps us going, isn't it, or did you ever take time enough out to speculate? Seems as though, for all the yesterdays are very much alike, it is the chronic curiosity of what tomorrow may have to offer. And, as a matter of fact, what more could one ask?

. . . I haven't a gray hair yet, the chief reason being they are all pure white. And yet it is rather interesting to be alive and think of things; to take delight in the trivial qualities of the material world around you, having discovered long ago you don't have to go so far afield to get it. I sometimes think the dawn of a new day, the magic silence of midwinter is about all there is, and however that may perhaps be, it is good to know no better.[43]

Mother Goose in Prose was the first book illustrated by Maxfield Parrish. By coincidence, it was also the first book written by L. Frank Baum, who later rose to fame as the author of *The Wizard of Oz* and other tales of the mythical country of Oz. The volume was not a collaboration in the true sense of the word, for the author and the artist never met. Parrish had not yet moved his studio to Cornish when Mr. Way, one of the partners of the Chicago publishing firm of Way and Williams, called on him in Philadelphia to discuss the possibility of his providing illustrations for Baum's prose versions of famous nursery rhymes. "An unusual individual," Parrish later wrote of Mr. Way. "We had dinner together, and merry talk flowed from him with ease."[1] Apparently the talk was as convincing as it was merry, for the artist agreed to make fourteen black-and-white drawings and a colored cover design (Fig. 12) for *Mother Goose in Prose,* published by Way and Williams in December, 1897.

Imaginative in concept and executed with confidence and originality, the illustrations for *Mother Goose in Prose* brought Parrish immediate recognition as a young book illustrator of ability. An expression of strong individuality, the illustrations portray a bygone era that is the unique domain of the nursery rhyme or fairy tale. The fanciful architecture in the drawings suggests a combination of the Gothic and Dutch styles. But as the artist intended, it simply represents an imaginary past and cannot be identified with a definite historical era. Appropriate to the setting are the goblinlike characters that inhabit the wondrous castled towns and sleepy rural villages.

This series of black-and-white drawings illustrates Parrish's mastery of complicated technique and his ability to combine several media to achieve the desired effect. *Humpty-Dumpty* (Fig. 13) and *The Man in the Moon* (Fig. 14), which at first glance appear to be pen-and-ink drawings, actually combine pen and ink, collage, Rossboard, and, in the latter drawing, lithographic crayon. His technique in making these drawings is revealed in the close examination of *Humpty-Dumpty*. The figure and the ledge on which it sits, as well as the group of castles, were cut from a single piece of heavy drawing paper. The cutout, detailed in India ink, was glued to a Rossboard background. Silhouettes of trees seen growing from behind the castles were then drawn in on the Rossboard in India ink. Parrish used Rossboard of one textured pattern for the sky of *Humpty-Dumpty* and another for the horizontal base below the figure. Rossboard, a commercially prepared board, could be purchased printed with various indented patterns, such as dots, lines, etc. Having the appearance we now associate with the Benday screen, it was extensively used for making shaded surfaces for halftone printing before the invention of the Benday shading machine.[2]

Mother Goose in Prose was printed in several editions. As the first book of both Baum and Parrish, it was not long before the early editions became collector's items. Certainly one of the most unusual editions of *Mother Goose in Prose* was the 1900 edition printed in twelve separate chapters or sections and offered as premiums to the users of Pettijohn's Breakfast Food.

In 1897, at about the same time the fifteen *Mother Goose in Prose* illustrations were being made, Parrish designed the covers for two novels and a frontispiece for *The Whist Reference Book* (Fig. 15). The cover for the first novel, Opie Read's *Bolanyo* (Fig. 16), was finished in February, immediately before the *Mother Goose in Prose* drawings were begun. After finishing that series, Parrish took a short vacation trip to Annisquam, Massachusetts, where the cover design for Emma Rayner's *Free to Serve* (Fig. 17), the second novel commission, was made in September. Both had the direct, eye-catching quality that Parrish believed to be essential in such work. "A book cover certainly should have a poster quality,"[3] he once told a client for whom he was considering making a catalog cover. So posterlike was the cover for *Free to Serve* that an enlargement of the design was used as the poster to advertise the book.

Parrish began a series of drawings in the spring of 1898 to illustrate the well-known book *Knickerbocker's History of New York.* A delightful parody on the history

Figure 12. Mother Goose in Prose. Book cover. July, 1897. 13½" x 11½".

Figure 13. Humpty-Dumpty.
Illustration for Mother Goose in Prose
*by L. Frank Baum. 1897. Ink and collage
on Rossboard, 16¾" x 12½".*

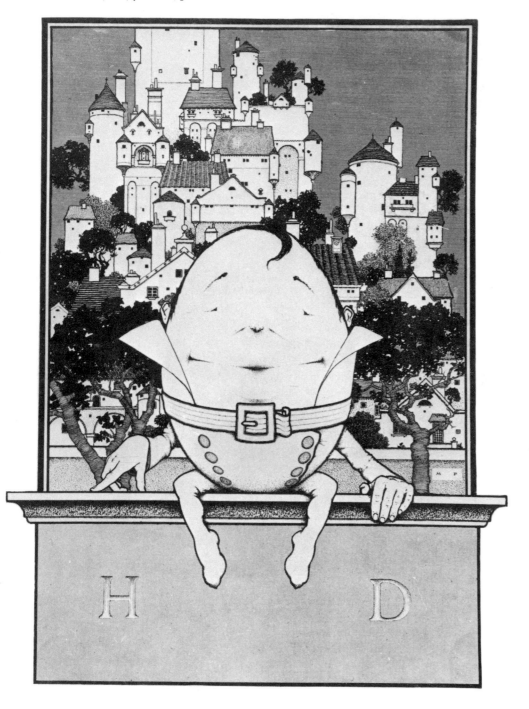

of colonial New York written by Washington Irving in 1809, Diedrich Knickerbocker's history was reprinted with Parrish's drawings in 1900 by R. H. Russell of New York. The artist worked the series into his schedule of commissions for magazine and poster designs, finishing the last of the nine drawings in September, 1899, a year and a half after the first one was begun.

Parrish's visual interpretations of Washington Irving's Knickerbocker characters were as amusing as the text for which they were created. In depicting Oloffe Van Kortlandt's dream of the future New York (Oloffe, by selecting the site for New Amsterdam, became America's first great land speculator), Parrish set him against a turn-of-the-century Manhattan skyline (Fig. 18). The portly little dreamer, perched in a treetop, reflects the burlesque humor of Irving's satirical history.

Washington Irving characterized the American Indian as the innocent victim of the European settlers' greed, describing the Indian race as one which lived in harmony with its environment until "the benevolent inhabitants of Europe . . . [beheld] their sad condition . . . [and] immediately went to work to ameliorate and improve it. They introduced among them rum, gin, brandy, and the other comforts of life. . . ."[4] An Indian man, still reacting from the sting of a swallow of strong alcohol, appears somewhat uncertain about this gift from the white man in Parrish's illustration for this passage (Fig. 19). The two-dimensional drawing, in ink, disregards linear perspective and, with the contrasting shading in lithographic crayon to give volume to the figure, creates an unusual juxtaposition of sizes and distances which adds significantly to the interest of the composition. The distant windmill is drawn with the same attention to minute detail as the demijohn sitting on the wall in the foreground. In both his drawings and his paintings the artist regularly exercised with great skill his preference for giving equal attention to details near and distant.

Concurrently with the drawings for *Knickerbocker's History,* Parrish executed between March and August, 1899, the

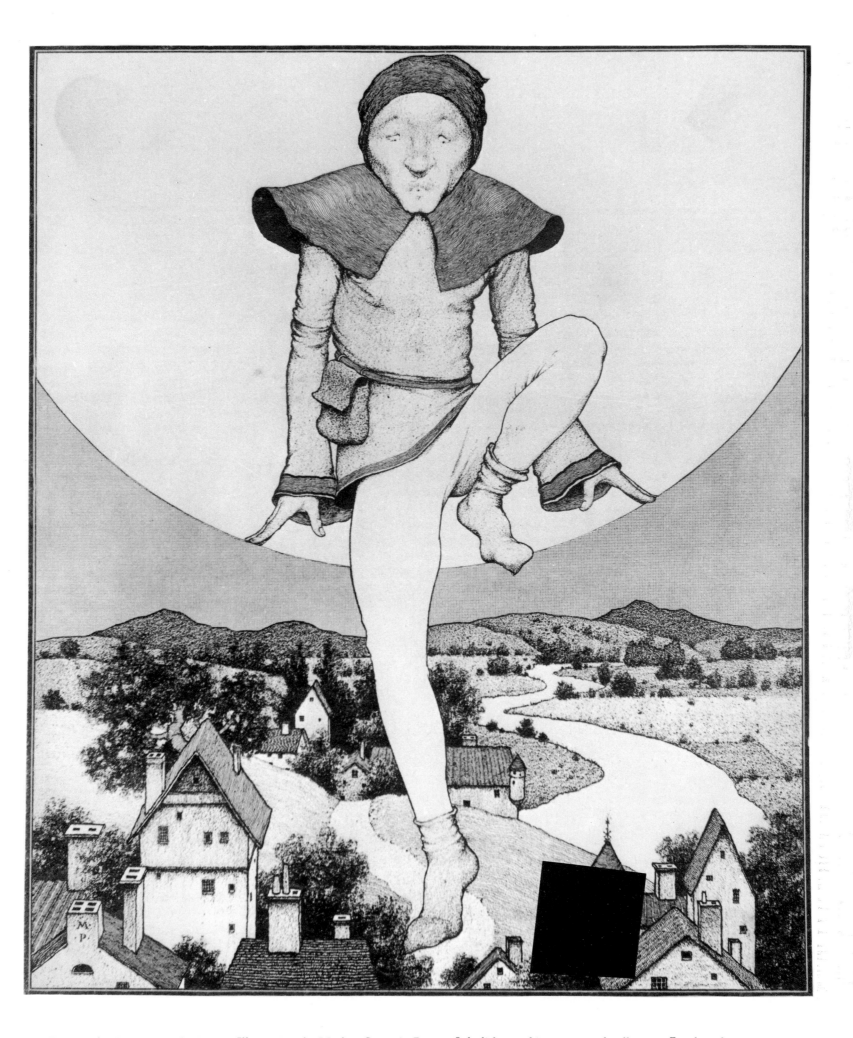

Figure 14. The Man in the Moon. *Illustration for* Mother Goose in Prose *. Ink, lithographic crayon and collage on Rossboard.*

Figure 15. Whist Reference Book. *Title page. November–December, 1897.*

thirty-two illustrations for Kenneth Grahame's *The Golden Age.* Prior to the publication of this book, Parrish was known in Europe primarily for his posters. Because he frequently entered—and won—national competitions for poster designs, one British writer referred to him as having "made a reputation as the most successful artist who ever competed for prizes in America."[5] The edition of *The Golden Age* illustrated by Maxfield Parrish was published simultaneously in New York and London by John Lane: The Bodley Head. Reviewers on both sides of the Atlantic praised the book. A letter from the noted critic Professor Hubert von Herkomer, written to John Lane shortly after he had seen Parrish's illustrations for *The Golden Age,* was later published in the *International Studio.*

Mr. Parrish has absorbed, yet purified, every modern oddity, and added to it his own strong original identity. He has combined the photographic vision with the pre-Raphaelite feeling. He is poetic without ever being maudlin, he has the saving clause of humor. He can give suggestiveness without loss of unflinching detail. He has a strong sense of romance. He has a great sense of characterization without a touch of ugliness. He can be modern, medi-

eval, or classic. He has been able to infuse into the most uncompromising realism the decorative element—an extraordinary feat in itself. [Later in the article von Herkomer defined the decorative element as "an intellectual abstract of natural phenomena and form."] He is throughout an excellent draughtsman, and his finish is phenomenal. Altogether this artist is the strangest mixture I have ever met with. . . . He will do much to reconcile the extreme and sober elements of our times.[6]

Spurred perhaps by Professor von Herkomer's enthusiasms for Parrish's work, William II, emperor of Germany, tele-

graphed to London for twelve copies of *The Golden Age.*

Kenneth Grahame's volume was a book about children, written for the enjoyment of older children and adults. The individual episodes or chapters dealt with the adventures of one or more of the four children in a particular English country family. Their childhood fantasies about the adult world and their relationships with a variety of aunts and uncles, to whom they referred as "Olympians," served as the subject for *The Golden Age* and its sequel, *Dream Days,* also illustrated by Parrish.

The scale chosen by Parrish for the drawings reflects the point of view of the child telling the story. Imaginary serpents from which young maidens must be rescued become gigantic monsters, and fruit orchards are seen as deep, dark woods to be explored with cautious bravery (Figs. 20, 21). Few children, however, ever had imaginations to match that of Parrish, who was a master of fantasy. In these illustrations he chose to avoid the cute and the anecdotal, which entrap so many illustrators of children's books. Instead he has sensitively perceived and re created the spirit of childhood—the feelings of innocence and freedom—which one inevitably loses as he grows older.

In Grahame's story "The Roman Road," from *The Golden Age,* a young boy's imagination is sparked by the old saying "All roads lead to Rome." In depicting the boy's conversation with an artist encountered in his make-believe travels, Parrish has represented the fantastic architecture of Rome and the understanding artist as seen through the eyes of the boy (Fig. 22). Parrish never slavishly "illustrated" Grahame's or any other author's descriptions of scenes. Instead he used the text as a point of departure for his own visual expression. For example, in representing the spirit of the encounter between the boy and the artist, he completely bypassed Grahame's description of the artist, ". . . he wore knickerbockers like myself,—a garb confined, I was aware, to boys and artists."[7] It is a credit to the artist and to his work that he always allowed his own creative imagination to prevail. Rarely, however, have an author and an artist been in more complete

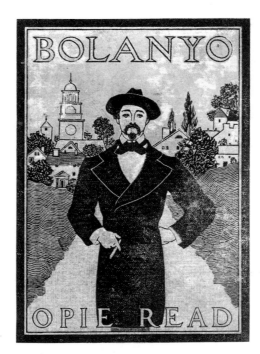

Figure 16. Bolanyo. *Book cover. 1897. Photo: Library of Congress.*

Figure 17. Free to Serve. *Design for book cover and poster. September, 1897. 14" x 9½".*

accord in their treatment of a subject than were Maxfield Parrish and Kenneth Grahame in *The Golden Age* and its sequel, *Dream Days.*

John Lane commissioned Parrish to make the colored drawings for *Dream Days* in the spring of 1900, with a projected publication date for later that fall (Fig. 23). But due to the artist's bout with tuberculosis, his work slowed down, and publication was postponed until 1902. The drawings were begun at Saranac Lake, where Parrish spent the winter of 1900-1901. Most of the remaining illustrations were made in Cornish the following summer, with the last few perhaps being finished later that year in Arizona. The originals of the ten illustrations for *Dream Days* were made in color, with chapter tailpieces being drawn in black and white. Unable to reproduce the illustrations in their original colors, John Lane decided to use a new black-and-white photogravure process which he felt would give better results than had been achieved with the halftone plates of *The Golden Age.* The resultant superior quality and greater tonal range of the photogravure reproductions of *Dream Days* convinced the publisher that a new edition of the earlier book was called for. In 1904 *The Golden Age* was reissued as a companion volume to *Dream Days,* both books having identical bindings designed by Parrish and illustrations reproduced in photogravure.

In the illustration *Its Walls Were as of Jasper* (Fig. 24), appropriately chosen as the frontispiece for *Dream Days,* the child is seen as an astonished onlooker, about to step into the world of fantasy—the book. Within the book, *The Reluctant Dragon* (Pl. 1) is one of the more delightful of Parrish's illustrations. The visual conception of the intellectual dragon, who wrote poetry, discussed art and style, and polished his turquoise scales with a piece of house flannel, bears the unique imprint of Parrish's humor and imagination. Action, such as that portrayed in *A Saga of the Seas* (Fig. 25), is rarely found in the illustrations for the Grahame books, which the artist imbued with an atmosphere of studied calm and aloofness. This atmo-

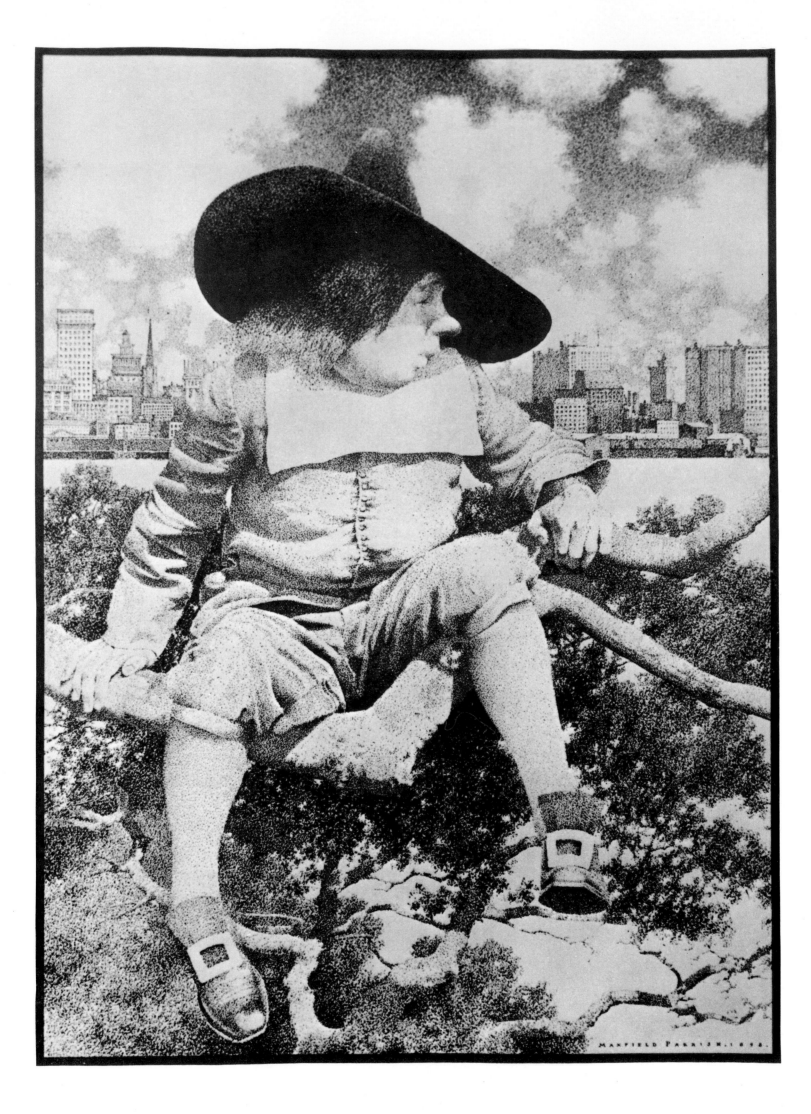

Figure 18. Oloffe the Dreamer up in the Treetop. *Frontispiece for* Knickerbocker's History of New York *by Washington Irving. March, 1898. Ink and lithographic crayon on Steinbach paper, 13⅜" x 8¾".*

sphere of distance placed the illustrations beyond nostalgic associations with actual childhood experiences, in the greater realm of fantasy.

Poems of Childhood by Eugene Field, first published with illustrations by Maxfield Parrish in September, 1904, was destined to become in the United States one of the better known, if not the best known, of all books illustrated by him. The idea to have Parrish illustrate Field's poems originated with Edward Bok at the *Ladies' Home Journal.* When Bok commissioned him to paint his interpretations of five of the poems for the magazine, Charles Scribner's Sons arranged to use the five illustrations in a single volume of Field's poetry. Parrish promised to provide three additional paintings, as well as a cover design, endpapers, and, title page, for the proposed book.

Poems of Childhood was the first book in which Maxfield Parrish's paintings were reproduced in full color. As with prior illustrations, he allowed the author's text only to suggest the subject, and from that point the interpretation was his. This led Bok to remark that there was more of Parrish than of Field in some of the illustrations, but that the artist should not be blamed for that.[8] It was, in fact, a sign of Parrish's artistic integrity and inventiveness that he did not take the more conventional, easier approach toward the interpretation of texts that he was commissioned to illustrate. *The Dinkey-Bird* (Pl. 2), by far the most familiar of the illustrations in *Poems of Childhood,* was conceived by Parrish as a composition to show "the spirit of the swing, just the catch in the turn of the motion."[9] The nude figure of a youth, a symbol of freedom and innocence, heightens the sense of abandon and joy that seems always to be a part of swinging. In expressing the spirit of the swing, Parrish also captured the spirit of the poem.

In an ocean, 'way out yonder
　(As all sapient people know),
Is the land of Wonder-Wander,
　Whither children love to go;
It's their playing, romping, swinging,
　That give great joy to me
While the Dinkey-Bird goes singing
　In the amfalula tree![10]

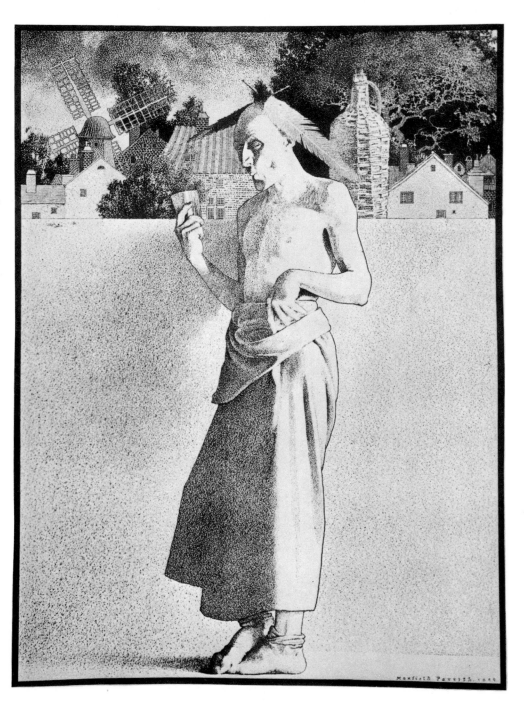

Figure 19. "They introduced among them rum, gin, brandy, and the other comforts of life. . . ." Illustration for Knickerbocker's History of New York *by Washington Irving. March, 1899. 12" x 8¾".*

Figure 20. "Once more were damsels rescued, dragons disembowelled, and giants. . . ." Illustration for The Golden Age *by Kenneth Grahame. June, 1899.*

Certain of the illustrations reflect the bittersweet mood of some of Field's poetry. Others, the endpapers, for example, with the oafish giant riding a brilliant red lobster, are sheer expressions of fantasy (Fig. 26).

The 1904 publication of *Italian Villas and Their Gardens* followed *Poems of Childhood* by about two months. With text by Edith Wharton and pictures by Maxfield Parrish, the volume represented a genuine collaborative effort between the two. Each traveled to Italy to gather material for the project; later they met in Lenox, Massachusetts, to compare notes and to discuss the points of view to be taken in the publication. First serialized in *The Century Magazine* and then released in book form, *Italian Villas and Their Gardens* provided an avenue of expression for Parrish's architectural interests, as well as for his growing desire to paint landscapes. The paintings, as a result, were a sensitive and striking departure from his more fanciful work, to which the public had grown accustomed.

The fanciful and the scenic were combined in two outstanding series of paintings, *The Arabian Nights* and *Greek Mythology,* made by Parrish for *Collier's,* the magazine to which he was under exclusive contract between 1904 and 1910. The twelve *Arabian Nights* paintings first appeared as full-page color illustrations in *Collier's* where a short caption explained the legend upon which each work was based. Charles Scribner's Sons, with whom Parrish had discussed the possibility of illustrating *The Arabian Nights* as early as 1904, purchased the book rights for the series from *Collier's.* Edited for juvenile readers by Nora A. Smith and Kate Douglas Wiggin, the author of *Rebecca of Sunnybrook Farm,* Scribner's 1909 edition of *The Arabian Nights* was considerably more subdued than earlier translations of the tales.

The romantic adventures and exotic settings of *The Arabian Nights* gave Parrish yet another expressive outlet for his fertile imagination to explore. Original in concept and rich in harmonious colors, his illustrations of the various tales were

Figure 21. "For them the orchard (a place elf-haunted, wonderful!) simply. . . ." *Illustration for* The Golden Age *by Kenneth Grahame. April, 1899.*

widely circulated, not only in magazine and book form, but as art prints as well. The two illustrations for the story of Prince Agib, *Landing of the Brazen Boatman* (Fig. 27) and *Prince Agib* (Fig. 28), incorporated the architectural elements and decorative urns which became so closely identified with Parrish's work in the 1920s. Based more or less on reality, the setting for *Prince Agib* combined the circular pool, flowering shrubs and urns from the artist's garden in Cornish. The architecture in *Landing of the Brazen Boatman* was closer to pure fantasy. Upon seeing the magnificent stairs being descended by Prince Agib in the illustration, the actress Maude Adams envisioned it as a grand setting for a stage entrance. Through her manager, Homer Saint Gaudens, Miss Adams arranged to have one of the sets for her production of J. M. Barrie's *A Kiss for Cinderella* designed after the painting. Unfortunately, the Parrish fantasy suffered greatly in its transition to the theater, and one hardly would have connected the stage set with the artist's painting had it not been for the publicity accompanying the production.

The variety of effects produced by the artist in *The Arabian Nights* sustains a high degree of viewer interest throughout the series. Cassim, unable to remember the word "Sesame" that would free him from the Cave of the Forty Thieves, is painted, in subtle chiaroscuro, amid the treasures of the cave (Fig. 29). On the other hand, the pirate ship in *The History of Prince Codadad and His Brothers* (Fig. 30) is pictured in vibrant color, with its great yellow sail and a band of blue water beneath. Parrish's giant, in the *Third Voyage of Sinbad,* (Fig. 31) possesses both humor and pathos. While far less horrible than the giant in the tale, this one appropriately captures the essence of giantism, which the artist chose to represent rather than to concentrate on extreme ugliness. As he had done for Scribner's edition of *Poems of Childhood,* Parrish made original designs for the cover, endpapers and title page to embellish the Scribner's edition of *The Arabian Nights,* illustrated with his paintings for *Collier's.*

Figure 22. "You haven't been to Rome, have you?" Illustration for The Golden Age *by Kenneth Grahame. May, 1899.*

Greek Mythology, the artist's second series of paintings for *Collier's* was bought from the magazine by Duffield and Company to illustrate Nathaniel Hawthorne's *A Wonder Book and Tanglewood Tales.* First published separately in the 1850s, these two books of classical myths, retold informally for small children, were printed in a single volume by Duffield in 1910. Parrish's series for *Collier's* had originally been scheduled to include about twelve paintings; however, several of them were not published because the artist's subdued coloring and chiaroscuro were thought to be too dark to reproduce well in the magazine. When he first began thinking about doing illustrations for *Collier's,* Parrish was asked to keep in mind that the magazine was a weekly newspaper and not an art magazine.[11] This request referred not only to the selection of subjects, but to the reproduction capabilities and limitations of the weekly news magazine as well. Two of the unpublished mythology illustrations, *Jason and the Talking Oak* and *The Fountain of Pirene,* which meanwhile had been purchased by Philadelphia collector Austin Purves, were borrowed by Duffield for *A Wonder Book and Tanglewood Tales.*

Jason and the Talking Oak (Pl. 3) was ideally suited to Parrish's interests in landscape and in the fantastic. Jason, in his search for the Golden Fleece, sought advice from the wise Talking Oak, whose "stately trunk rose up a hundred feet into the air, and threw a broad and dense shadow over more than an acre of ground."[12] In Parrish's interpretation the ancient oak, with its rough bark and knotty branches, dominates the composition, while a humbled Jason awaits the tree's answer from a position on a nearby boulder. Cadmus, on the contrary, dwarfs the landscape as he walks along the crest of a hill sowing the teeth of the dragon that he has just slain in another illustration in the series (Pl. 4). The distant mountain landscape behind the figure of Cadmus recalls the artist's sojourn in Arizona just five years earlier. Here, as well as in *Jason and His Teacher* (Pl. 5), the decorative drapery billows and twists around the figure, adding interesting color and form to the painting. Executed primar-

Color Plate 2. The Dinkey-Bird. *Illustration for* Poems of Childhood *by Eugene Field. May, 1904. 21¼" x 15½".*
Photo: Allen Photography.

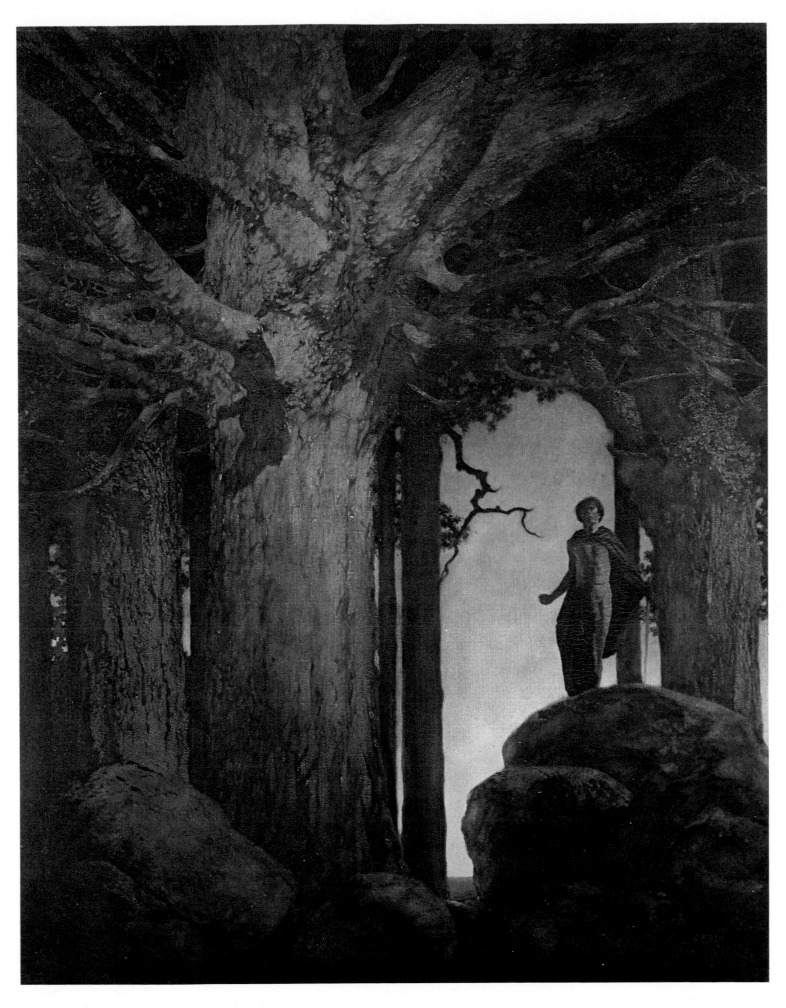

Color Plate 3. Jason and the Talking Oak. *Illustration for* A Wonder Book and Tanglewood Tales *by Nathaniel Hawthorne. January, 1908. Oil on canvas, 40" x 33". Courtesy Vose Galleries, Boston, and Dodd, Mead and Company. Photo: Herbert P. Vose.*

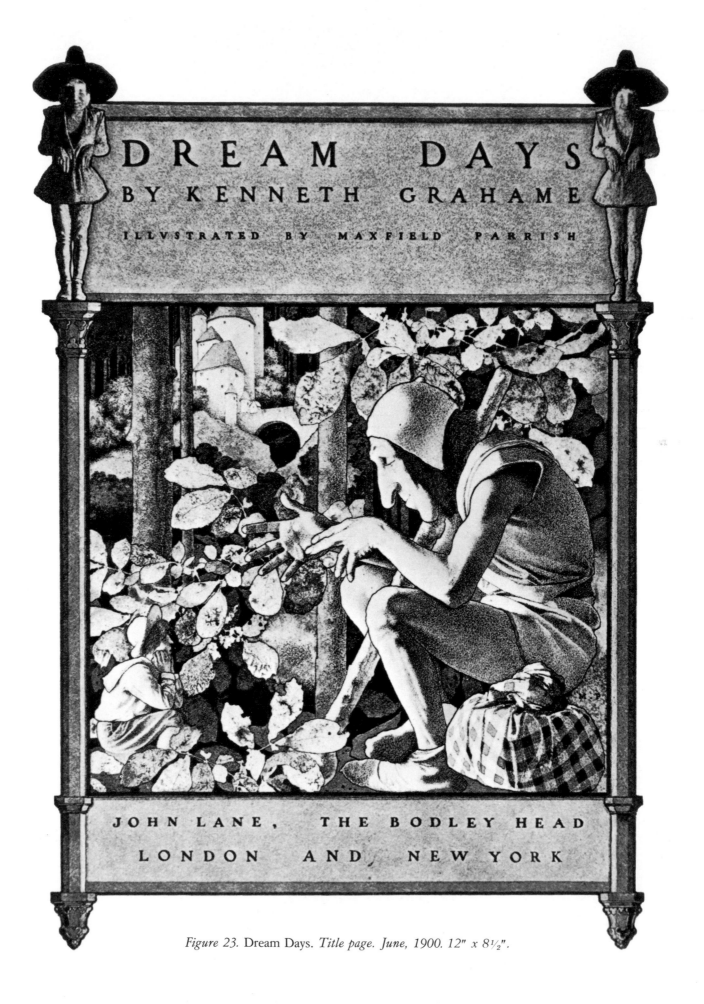

Figure 23. Dream Days. *Title page. June, 1900. 12" x 8½".*

Figure 24. Its Walls Were as of Jasper. *Frontispiece for* Dream Days. *July, 1900. 14⅝" x 10⅜".*

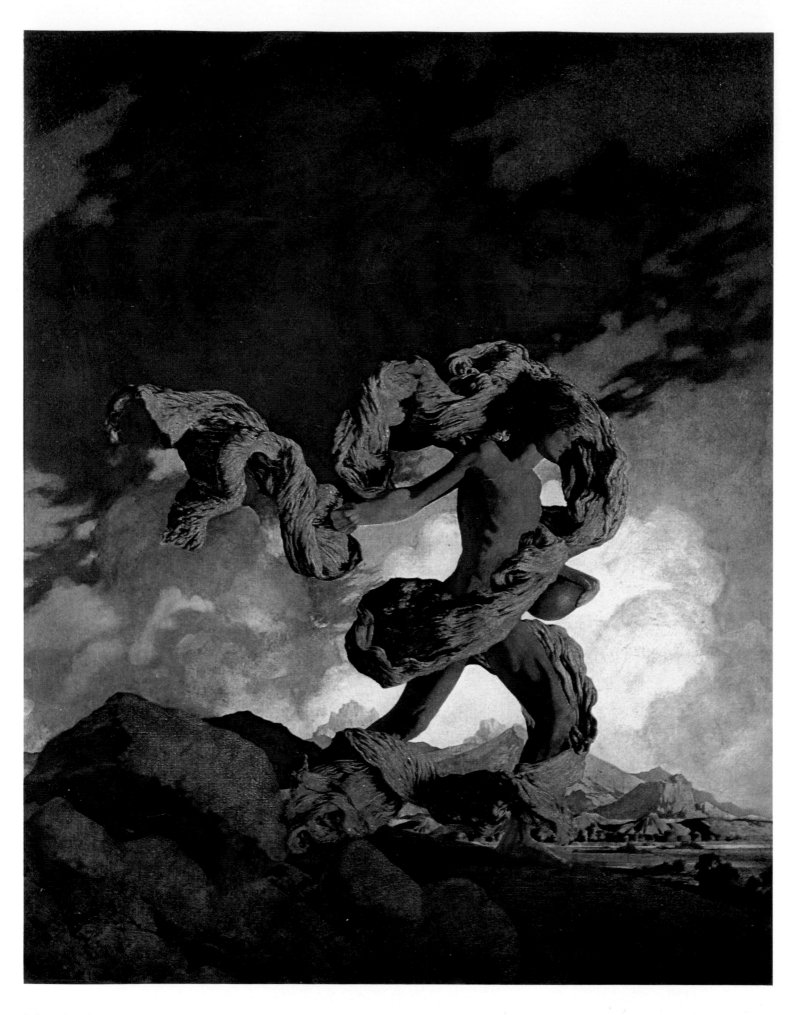

Color Plate 4. Cadmus Sowing the Dragon's Teeth. *Illustration for* Collier's, *October 31, 1908, and* A Wonder Book and Tanglewood Tales *by Nathaniel Hawthorne. Oil on canvas, 40" x 33". Courtesy Betsey P. C. Purves Trust and Vose Galleries, Boston. Photo: Herbert P. Vose.*

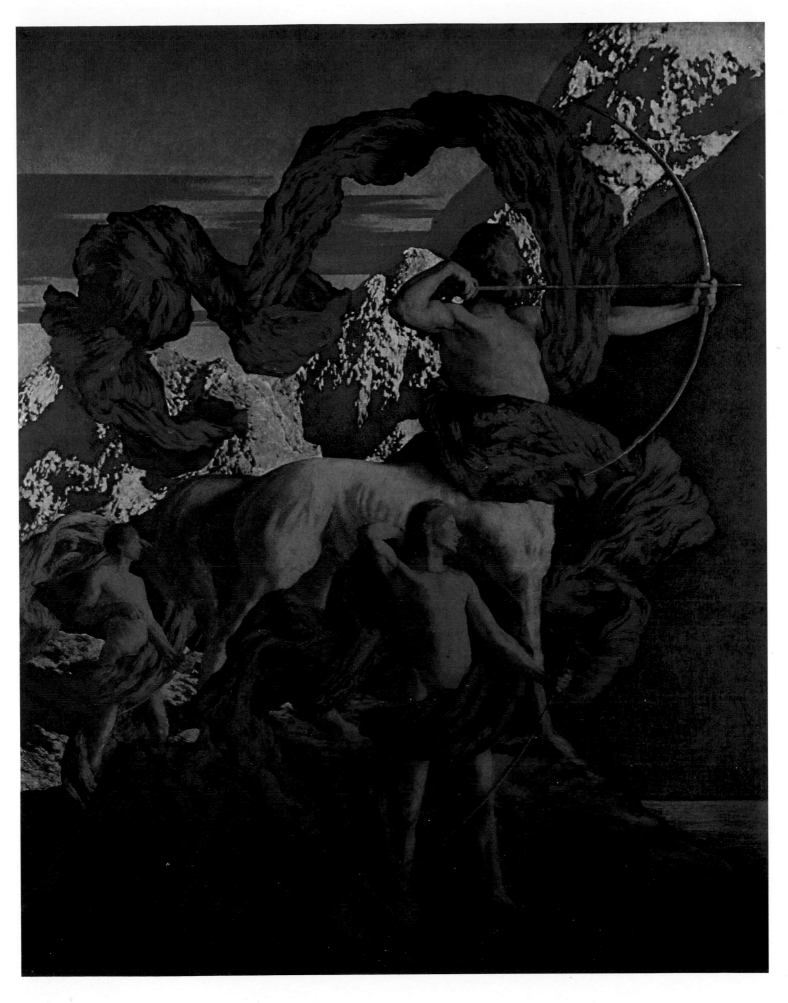

Color Plate 5. Jason and His Teacher. *Illustration for* Collier's, *July 23, 1910, and* A Wonder Book and Tanglewood Tales *by Nathaniel Hawthorne. Oil on canvas, 38" x 32". Courtesy Maxfield Parrish Estate and Vose Galleries, Boston. Photo: Herbert P. Vose.*

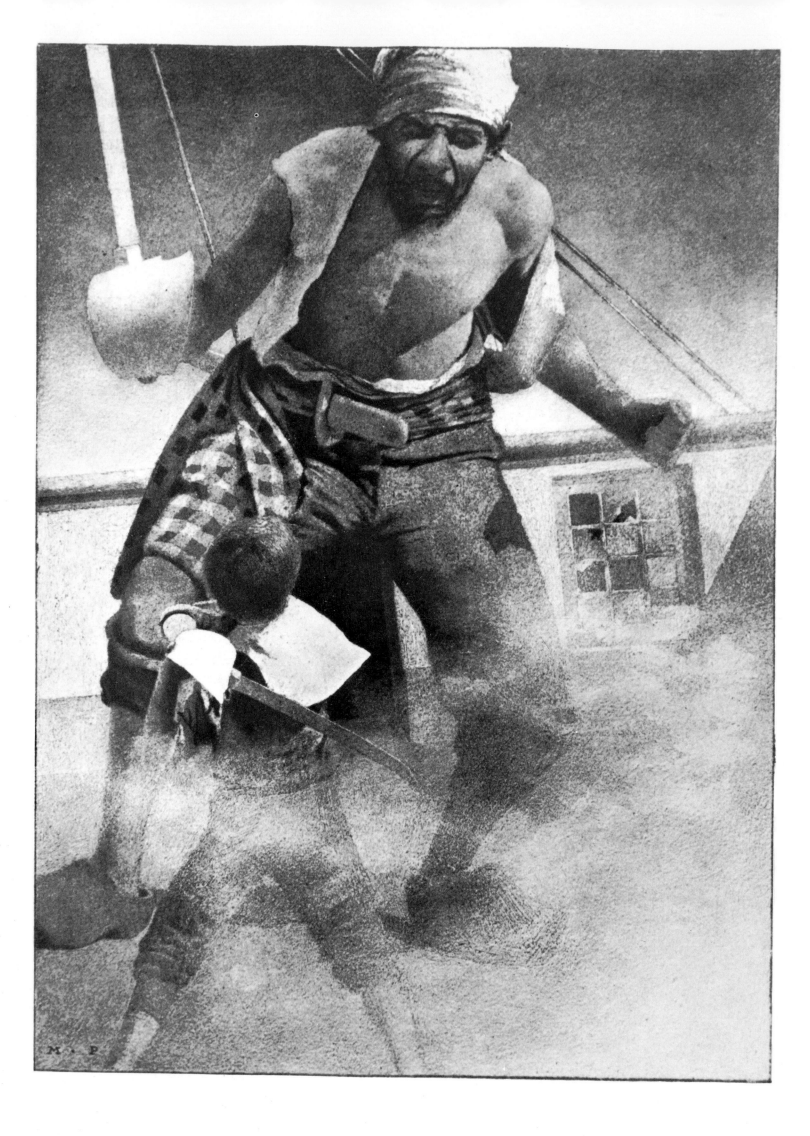

*Figure 25. "All serious resistance came to
an end as soon as I had reached the quarter-deck
and cut down the pirate chief." Illustration for*
Dream Days *by Kenneth Grahame.*
July, 1901. 12" x 8½".

Figure 26. Untitled. Cover linings for
Poems of Childhood *by Eugene Field.*
January, 1904. 13¾" x 21¼".

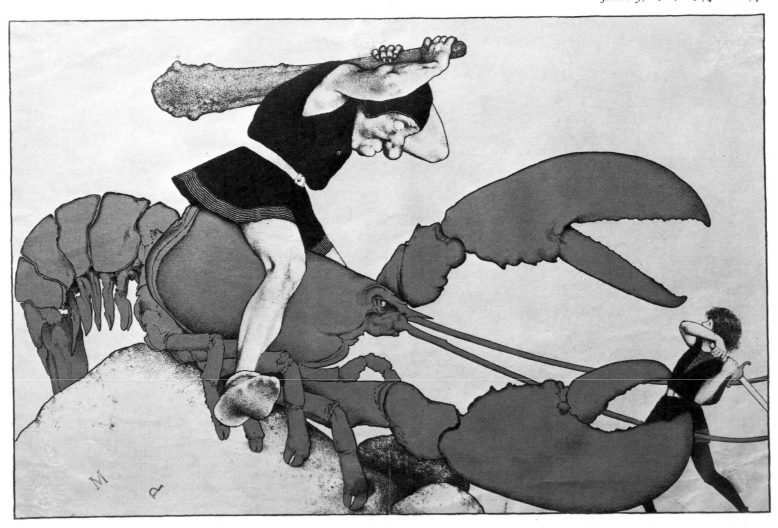

ily in oil glazes on canvas, the *Greek Mythology* paintings averaged about 40" x 32", the approximate size of many other works from this period. Parrish actually preferred to work on a smaller scale, however. Once, in 1894, he exhibited an oil painting only 4" x 5" in size at the Philadelphia Art Club. In the 1930s Parrish's easel paintings again began to grow progressively smaller and more jewellike.

An anthology of well-known poetry, *The Golden Treasury of Songs and Lyrics,* published by Duffield and Company in 1911, was a professional embarrassment to Maxfield Parrish. The book, printed without Parrish's knowledge, carried the artist's name on the cover and spine in letters only slightly smaller than those of the title, giving the impression that the illustrations were his interpretations of the famous poems. The illustrations were, in fact,

only reproductions of cover designs he had made for *Collier's.* More cautious after this experience, in most subsequent contracts Parrish retained stricter control over the future use of his works. When negotiating his copyright arrangement with *Life,* he explained his reason for relinquishing only the magazine rights to the publisher.

. . . when they have served their purpose as covers, is it your intention to use them for anything else. . . ? The reason I ask is that I want to safeguard myself against a dreadful thing that happened to some of my work at Collier's, where the reproduction rights were sold to Duffield with which they illustrated Palgrave's *Golden Treasury of Lyrics.* The . . . bad taste of the thing we won't dwell upon here, but the worst of it was that a book is out over the world now, and for all the public knows, these old cast-off covers are my conception of these beautiful classic lyrics.

It was about the worst ever. Never a word said to me . . . I dare say Collier's were entirely within their rights: they bought the rights from me, and felt they could do as they pleased with privilege . . . now, alas, too late I wish I had known a thing or two.[13]

For several years after 1910 Parrish was occupied primarily with painting the murals for the new Philadelphia headquarters of Curtis Publishing Company. One of the few additional projects that he was able to undertake during this time was a series of paintings based on the general theme of "Once Upon a Time," illustrating well-known fairy tales. The plan called for the paintings first to be used as magazine covers, after which they would be published in book form (see Chapter 3). But, pressed with mural commitments and disappointed at the way the magazine was handling the

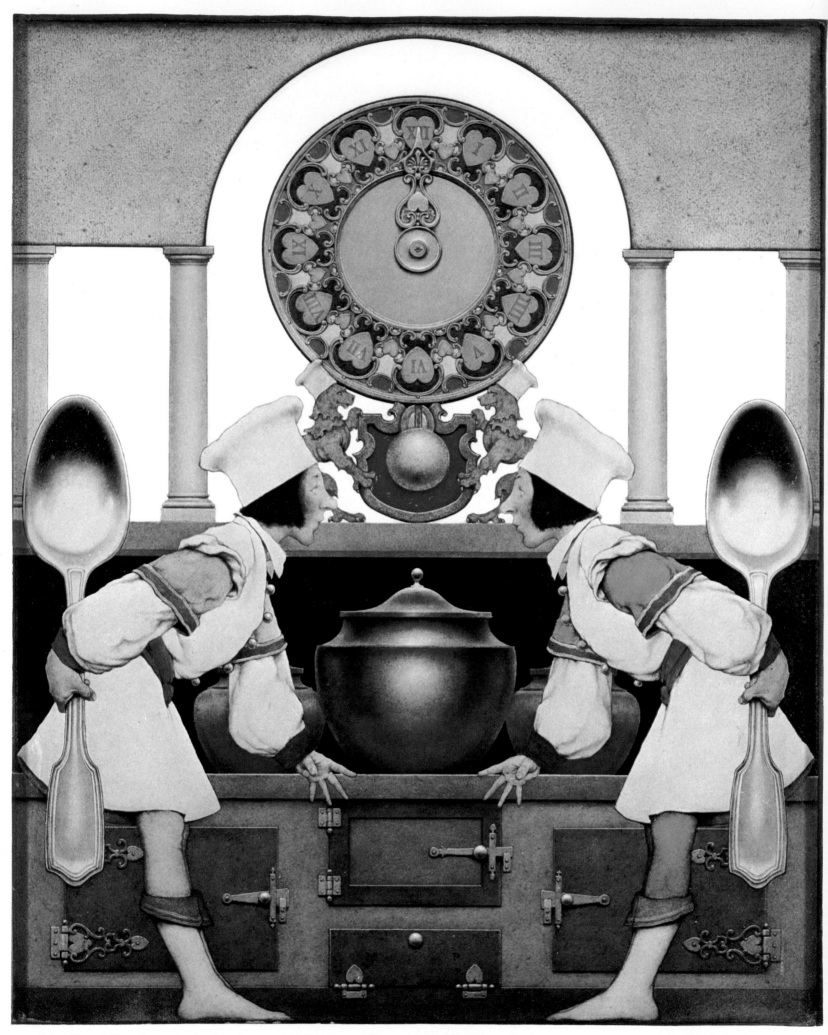

Color Plate 6. Two Pastry Cooks: Blue Hose and Yellow Hose. *Illustration for* The Knave of Hearts *by Louise Saunders. Ca. 1924. Oil on panel, 19¼" x 15⅝". Courtesy Maxfield Parrish Estate and Vose Galleries, Boston. Photo: Herbert P. Vose.*

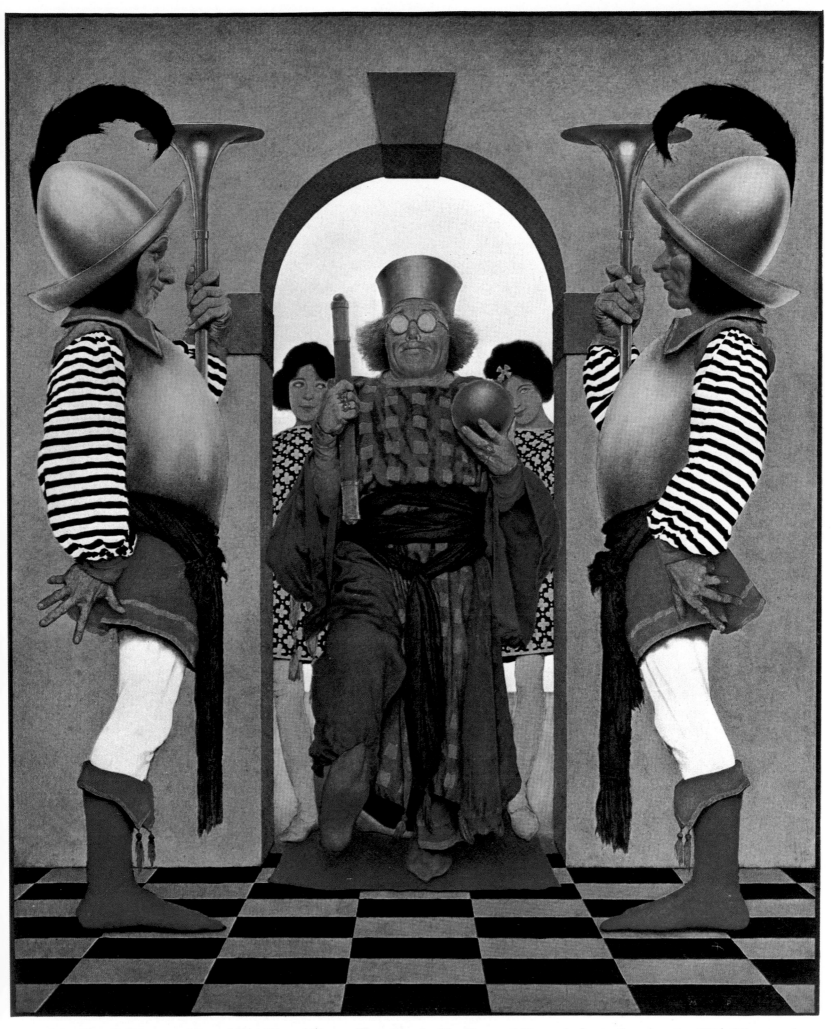

Color Plate 7. Entrance of Pompdebile, King of Hearts. *Illustration for* The Knave of Hearts *by Louise Saunders. Ca. 1924. Oil on panel. Courtesy Charles Scribner's Sons and Maxfield Parrish Estate. Photo: Allen Photography.*

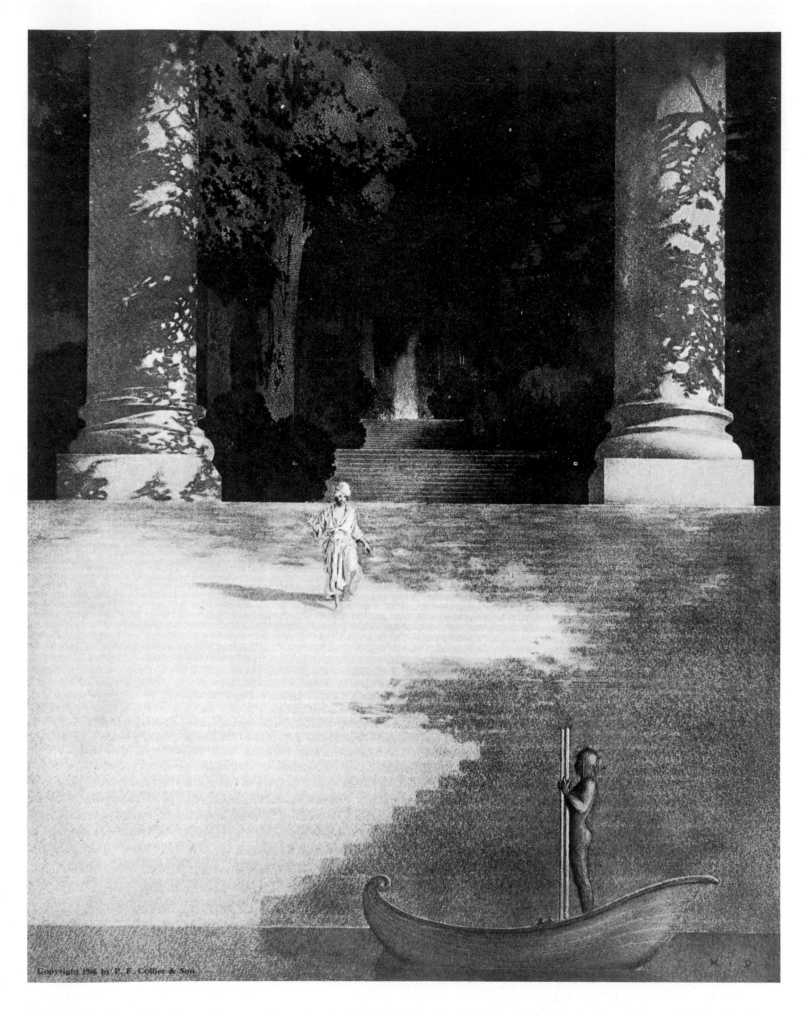

Figure 27. Landing of the Brazen Boatman. *Illustration for* Collier's, *November 9, 1907, and for* The Arabian Nights, *edited by Kate D. Wiggin and Nora A. Smith. 1906.*

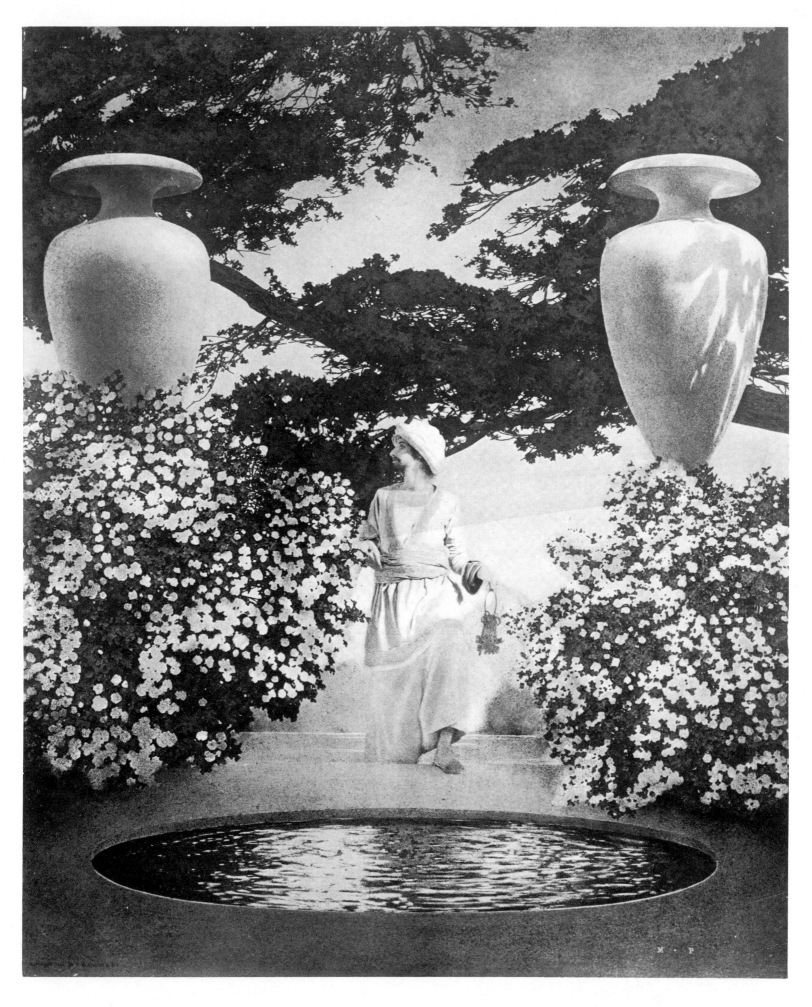

Figure 28. Prince Agib: The Story of the King's Son. *Illustration for* Collier's, *October 13, 1906, and for* The Arabian Nights, *edited by Kate D. Wiggin and Nora A. Smith. 1905.*

Color Plate 8. Chef Between Two Lobsters.
Illustration for The Knave of Hearts
by Louise Saunders. Ca. 1924.
Oil on panel, 8″ x 18″.
Courtesy Maxfield Parrish Estate
and Vose Galleries, Boston.
Photo: Herbert P. Vose.

project, Parrish finished only six of the twelve paintings, putting aside any further attempts at book illustration until about 1920, when he came across a manuscript that he thought well suited to his style of illustration and to the rich, colorful publication he had anticipated for "Once Upon a Time." The manuscript, a play for children called *The Knave of Hearts,* was by Louise Saunders, wife of the renowned Scribner's editor, Maxwell Perkins. Mr. and Mrs. Perkins sometimes summered in Cornish and were friends of the artist. In October of 1920, Parrish wrote to J. H. Chapin at Charles Scribner's Sons, publisher of *Poems of Childhood* and *Arabian Nights,* with an enthusiastic proposal for an illustrated edition of Miss Saunders' play.

Do you remember years ago I said I always had the longing to make pictures for another book? . . . This is just to say that the longing is still there, and of late the longing seems to be growing into something else. I wonder did you ever read a little play called *The Knave of Hearts* by Louise Saunders Perkins? . . . I have read it and seen it acted, and the thought will not down that it would be a most interesting thing to illustrate. . . .

The reason I wanted to illustrate *The Knave of Hearts* was on account of the bully opportunity it gives for a very good time making the pictures. Imagination could run riot, bound down by no period, just good fun and all sorts of things.[14]

The artist's enthusiasm was shared by the publisher, who requested sketches or more precise information upon which to base a cost analysis, as final approval could not be given until the costs were estimated. Parrish prepared an elaborate dummy or mock-up of the proposed publication, complete with watercolor sketches of the illustrations, and sent it to the publisher early in 1921.

It figures out about fifteen pages in full color, a cover and a double page cover lining, a dozen headings and odds and ends, and . . . I dare say the size is too large for you, but of course, the larger the better, as far as pictures are concerned
You must understand all this lay-out to be in gorgeous color. The landscape back of the figures in the cover lining—a very beautiful affair illuminated by a golden late afternoon sun: castles, waterfalls, rocks and mountains. . . .
The next great question will be WHEN? Goodness only knows. As I will get no money until the book begins to sell, it will have to be worked in with other work, and I know I shall enjoy doing it that way, with a sort of rest in between.[15]

The twenty-six paintings for *The Knave of Hearts* were executed within three years, and the book, a sumptuous production, was published on October 2, 1925. The large format (14″ x 11½″) that Parrish had originally suggested was used, and the illustrations, printed in rich colors on heavy, coated paper, were the highest-quality reproductions that could be had. The volume, selling for ten dollars, was packaged in a telescoping box, decorated with one of the illustrations from the book. Coinciding with the publicity surrounding the release of the book, a major exhibition of fifty paintings by the artist was held during November and December at Scott and Fowles, a gallery in New York. Among the large number of paintings sold at the highly successful exhibition were many of the original illustrations for *The Knave of Hearts.* The release of the new book and exhibition at Scott and Fowles, coupled with the previous year's great popular success of his painting *Daybreak,* made 1924 and 1925 two of the most remunerative years in Parrish's career.

The illustrations for *The Knave of Hearts* were both amusing and decorative.

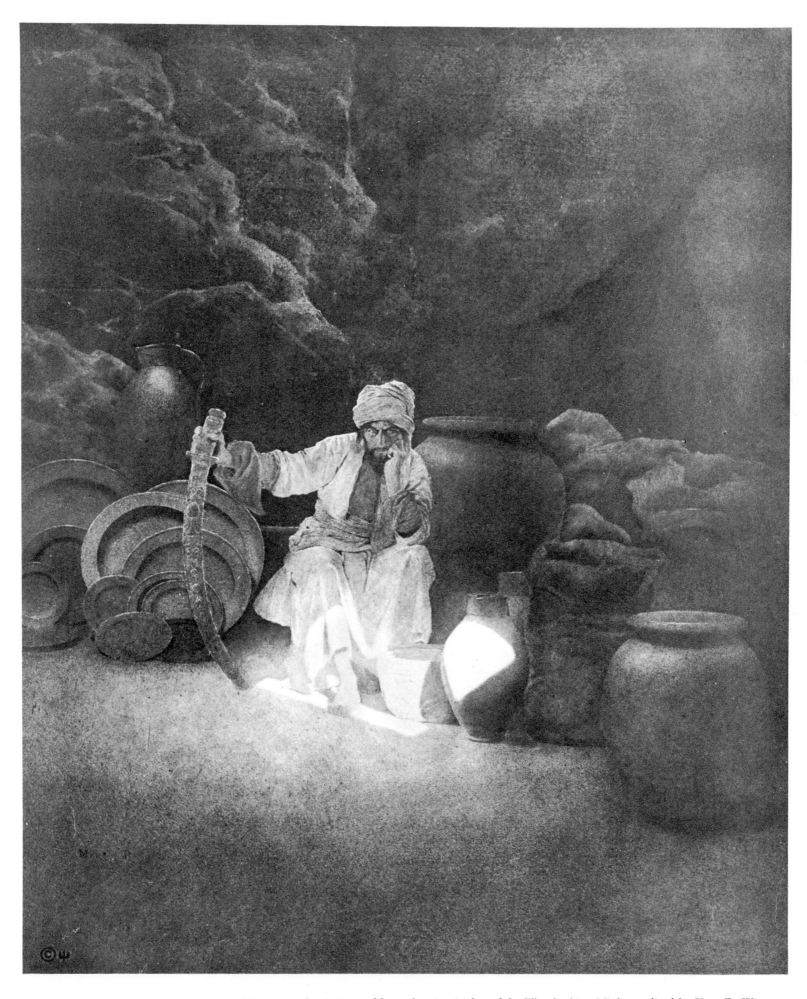

Figure 29. Cave of the Forty Thieves. *Illustration for* Collier's, *November 3, 1906, and for* The Arabian Nights, *edited by Kate D. Wiggin and Nora A. Smith. 1905.*

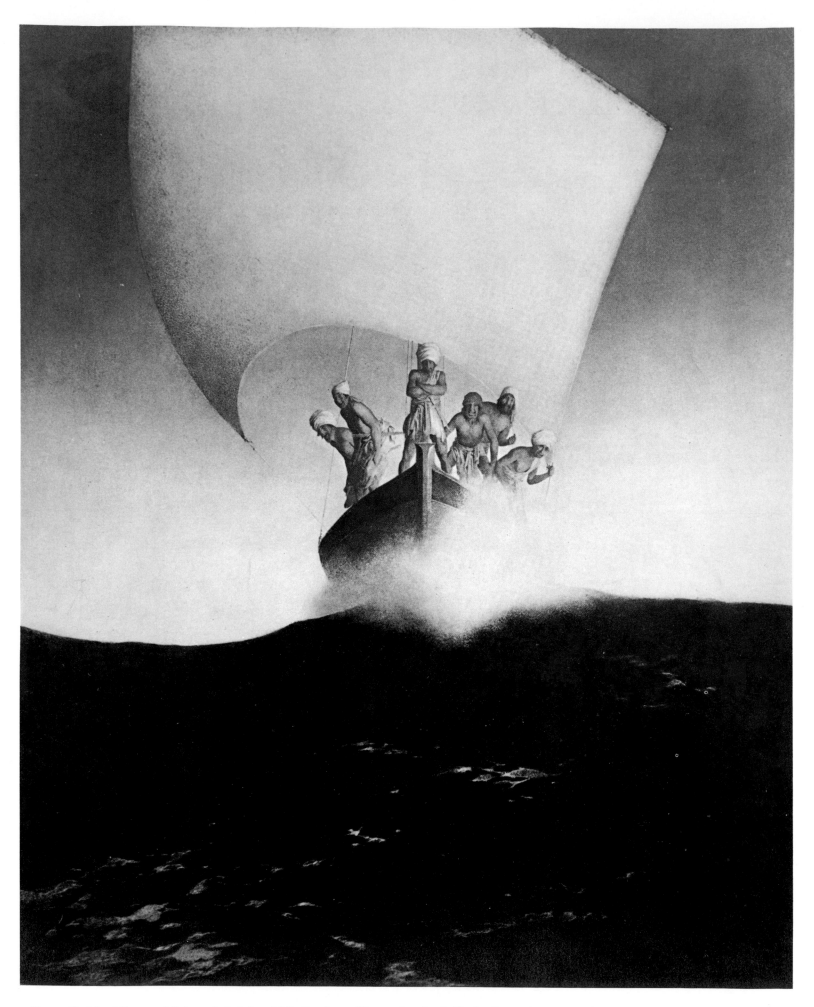

Figure 30. The History of Prince Codadad and His Brothers. *Illustration for* Collier's, *September 1, 1906, and for* The Arabian Nights, *edited by Kate D. Wiggin and Nora A. Smith. 1906.*

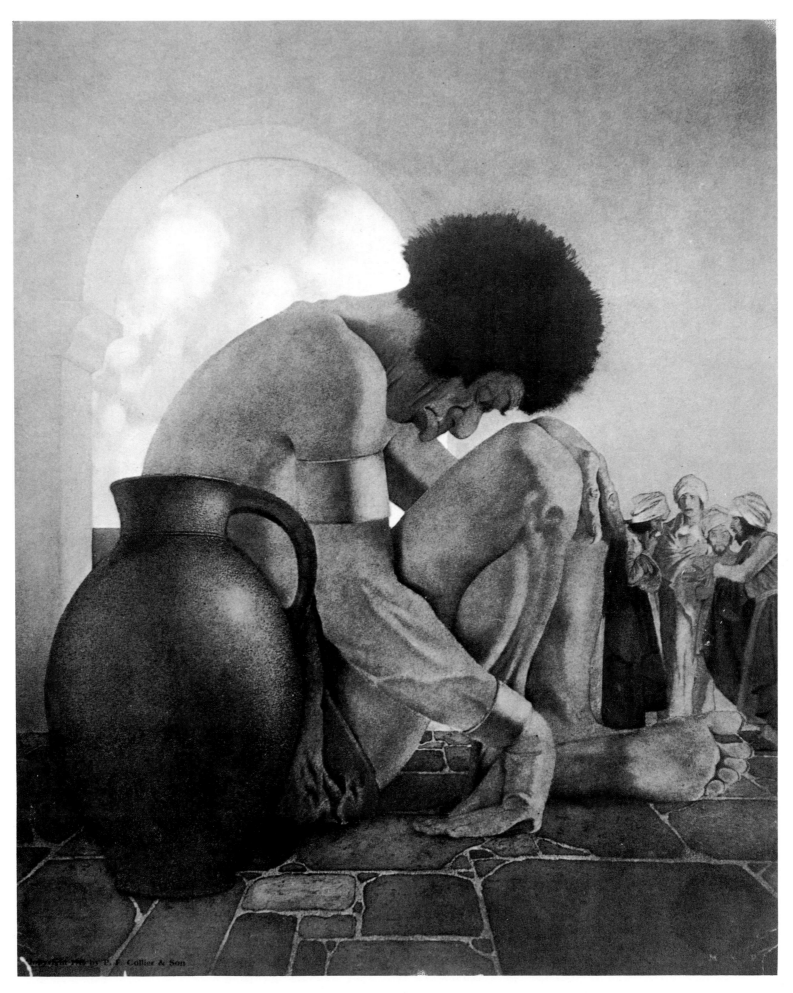

Figure 31. Sinbad Plots Against the Giant. *Illustration for* Collier's, February 9, 1907, *and for* The Arabian Nights, *edited by Kate D. Wiggin and Nora A. Smith. 1906.*

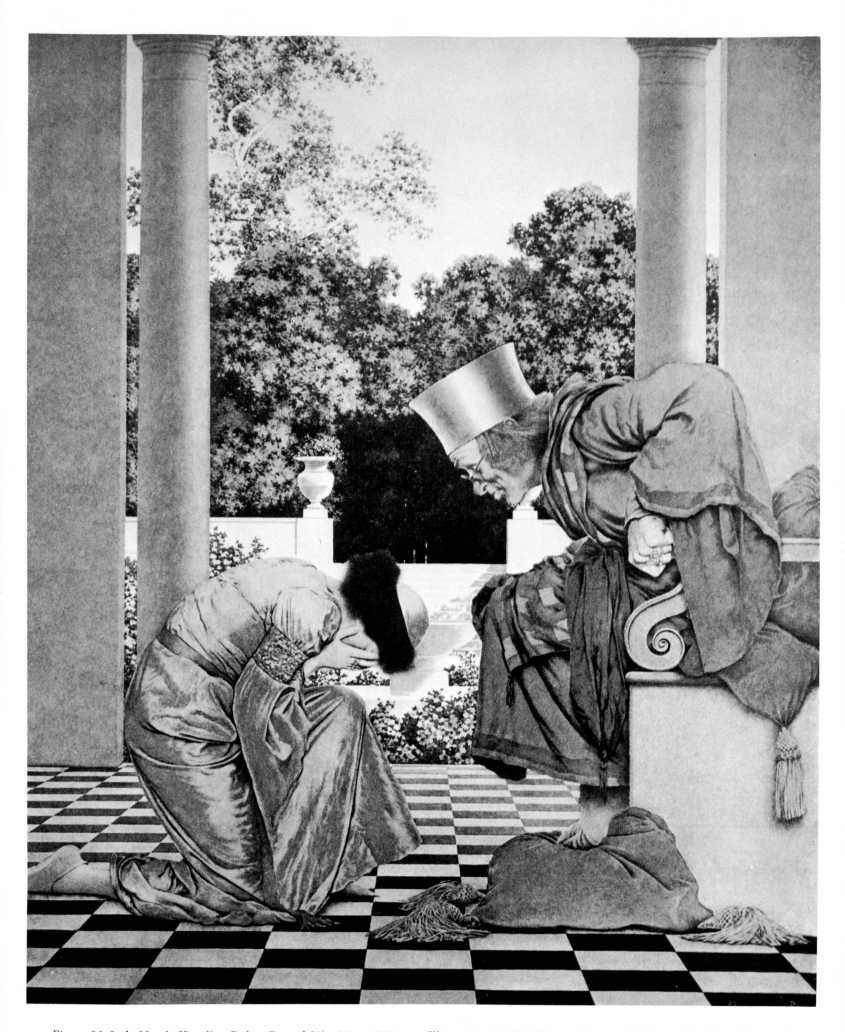

Figure 32. Lady Ursula Kneeling Before Pompdebile, King of Hearts. *Illustration for* The Knave of Hearts *by Louise Saunders. Ca. 1924.*

Standing as stiff as the puppets they are supposed to represent, Blue Hose and Yellow Hose (Pl. 6), the two pastry cooks, are presented by the artist in the formal, balanced composition typical of his approach to many of the illustrations for the book. The gestures and position assumed by the figures in *Entrance of Pompdebile, King of Hearts* (Pl. 7), and *Lady Ursula Kneeling Before Pompdebile* (Fig. 32) reflect the broad dramatic style in which the play was written for an audience of children. Parrish's illustrations are representations of actors in the play, rather than characters in a story. Had he been illustrating the nursery rhyme itself, instead of the play, his approach probably would have been quite different. The delightful headings, such as *Chef Between Two Lobsters* (Pl. 8), which decorate the book without relating directly to the text, frequently have as much appeal as the larger, more theatrical illustrations. *Romance* (Pl. 9), the cover lining of *The Knave of Hearts,* also illustrates no particular scene in the play. Similar in design and color to Parrish's *Daybreak, Romance* was one of several illustrations from the book issued separately as color reproductions by the House of Art.

The Knave of Hearts was successful from every standpoint except one, and that was sales. The ten-dollar price seemed to some people too expensive for a children's book, but the major factor that hampered the book's sales was its size. It was too large for the average bookshelf, and many customers, after admiring it in the store, did not buy it because they did not know how to take care of it in their libraries. Both Parrish and Scribner's agreed, however, that a smaller format would not have been suitable for the illustrations. Although royalties from the sale of the book were low, the project turned out to be a financial bonanza for the artist. The sale of only part of the original paintings to private collectors netted him over fifty thousand dollars, and while Scribner's did not fare so well, they were able to reduce their loss by using the color plates to make color reproductions for the House of Art, puzzles and a spiral-bound edition of the book distributed by another company.

The number of book illustrations made by Maxfield Parrish is considerably less than the number he made for magazines, yet he is remembered primarily as the artist who illustrated children's books and painted the famous blue pictures of the 1920s. Ironically, many of his illustrations used in books actually were made for magazines. Magazines are, and have been for a long time, transitory objects. Readers consume and discard them. Books, on the other hand, generally are a part of a longer experience. They are saved, to be returned to again and again, and it is not uncommon now to find books illustrated by Parrish being enjoyed by the third or fourth generation of children.

Chapter 3

MAGAZINE ILLUSTRATIONS

That part of Maxfield Parrish's career devoted to magazine illustration began quite accidentally early in 1895. Several of the studies for wall decorations he was painting at Philadelphia's Mask and Wig Club, after having been exhibited at the Pennsylvania Academy of the Fine Arts in December, 1894, were sent to New York for an exhibition at the Architectural League in February. One of the visitors to the exhibition, Thomas W. Ball of Harper and Brothers' Art Department, was prompted by these studies to invite the young artist to submit a design for the special cover of the 1895 Easter number of *Harper's Bazar.* Enthusiastic about the possibility of a commission for Harper's, he submitted not just one design, but two. One of them, imbued with a pre-Raphaelite spirit, included as a seasonal motif two young maidens holding stalks of lilies. This one was selected for the special Easter cover of *Harper's Bazar* (Fig. 33) and, to Parrish's delight, the second design was purchased for the 1895 Easter cover of *Harper's Young People.* The success of these two designs as covers, each carrying the stamp of a fresh, unique talent, led to numerous additional commissions for other publications. Thus was launched one of the most extraordinary careers in the history of American magazine illustration.

Between 1895 and 1900 Maxfield Parrish designed covers for at least five different Harper and Brothers periodicals: *Harper's Bazar, Harper's Weekly, Harper's Monthly, Harper's Round Table* and *Harper's Young People.* During this early period most of his cover designs had a strong poster quality. They were intended to be not only aesthetically pleasing but also, through their bold lines and large flat areas of color, were calculated to catch the eye of the customer at the newsstand. In his cover for the 1895 Fourth of July number of *Harper's Round Table* (Fig. 34), a young patriot in a bright red coat defiantly holds the Declaration of Independence aloft in one hand and a sword in the other. Made at the artist's studio at 320 South Broad Street, Philadelphia, this Fourth of July cover was to be used again in 1897 as the cover for *The Knave of Hearts, A Fourth of July Comedietta,* published in New York by R. H. Russell. A permanent cover design that Parrish made in this period for *Harper's Round Table* (Fig. 35) first appeared on the issue of November, 1897. It is an example of a format commonly utilized in the early days of magazine design—a format in which the same ornamental or architectural border would be used on the cover of each issue of a magazine for months or years, while the contents, listed in a fixed place within the border, would change with each issue. Parrish's design for the permanent cover of *Harper's Round Table* was composed of an architectural framework in the classical style, with two young men engaged in casual conversation across the block reserved for the monthly contents listings. The two young men in the design are both self-portraits of the artist at·about twenty-seven years of age.

Parrish continued his work for Harper and Brothers with double cover drawings for both the 1895 Christmas number and the 1896 Bicycle number of *Harper's Weekly* (Figs. 36, 37 and 38, 39), designing for each issue the front covers as well as complementary advertisements for the back covers. Although the double cover of the 1895 Christmas number was printed in black and tan on white paper, Parrish had executed the original designs in ink and white on brown English wrapping paper. The Christmas cover subjects were cooks, each presenting his or her culinary specialty for the viewer's inspection. These poster-like designs were so effective that the use of additional color would have been superfluous, as was demonstrated years later when Harper's reprinted the Christmas cover with color by a staff artist. The complementary covers for the Bicycle number are essentially the same in concept as those for the Christmas number. Two three-quarter figures are shown riding bicycles directly toward the viewer. Parrish did not attempt to show motion, but rather chose to suggest it through the decorative, billowing arrangement of the figures' garments. The surprising masses of plaid material, effectively used against a dark green background, provide an early example of the artist's fondness for using interestingly

Figure 33. Harper's Bazar Easter 1895. *Cover. (Maxfield Parrish's first cover design for a national magazine.) Photo: Maxfield Parrish Estate.*

Figure 35. Permanent cover design for
Harper's Round Table. *1897.*

patterned fabrics as the central element in a design. His covers for the 1896 and 1897 Christmas numbers of *Harper's Weekly* (Figs. 40, 41) are similar to the 1897 *Harper's Round Table* permanent cover in their symmetrical arrangements and architectonic formats. Two other designs for posters or covers were perhaps never published by *Harper's Weekly.* One featured a comic cook carrying a tureen (Fig. 42) and the other depicted Santa Claus at the reins of his sleigh (Fig. 43). Photographs of both were preserved by the artist.

One notices in his work for Harper and Brothers that Frederick Maxfield Parrish, the artist, is not consistent in the method of signing his name. It is almost as if in the mid-1890s, as he was searching for his own identity as a painter, the artist's signature went through a period of transition. Prior to his becoming a professional artist, Parrish had used the name "Fred," and this continued to be the name by which his parents and old friends called him. An etching for an 1887 calendar made for his own pleasure was signed "Fred Parrish." Later, at Haverford, he signed his drawings for college publications "FMP." But much of his professional work around 1895 bore the signature "F. Maxfield Parrish." Within a year he dropped the initial and began to sign his works "Maxfield Parrish." And, very shortly thereafter, "Maxfield Parrish" and the initials "M.P." were used interchangeably—the method of signing his works that he continued to use for the next sixty-five years. His very elaborate and distinctive script signature, which is seen on the *Century Midsummer Holiday Number* poster, was rarely included in a design to be printed. This was his personal signature, and it came to be reserved mainly for business matters and correspondence, although in later years the large loop on the capital "P" was dropped in favor of a less flamboyant one.

J. H. Chapin of Scribner's Art Department provided Maxfield Parrish with the vehicles for some of his most imaginative illustrations. Parrish's first commission for *Scribner's Magazine* was a series of eleven drawings for the August, 1897, issue to illustrate "Its Walls Were as of Jasper,"

Figure 34. Fourth of July. *Cover for* Harper's Round Table, *July 2, 1895. May, 1895.*

a short story from the Kenneth Grahame book *Dream Days.* "Its Walls Were as of Jasper" is the tale of a young boy who, while visiting a neighbor with his aunt one afternoon, becomes absorbed in the pages of an old illuminated manuscript in his hostess' library. When the aunt discovers him using a piece of coal to hold the stiff pages of the book open, the boy is snatched out of his fantasy world by the scruff of the neck. Parrish's illustrations correspond to the first person singular style of Grahame's book (Fig. 44). Drawn from a child's perspective, the pictures are representations of a child's fantasy world and of the adult world as seen from a child's point of view. Abounding with knights, castles, ships, quaint characters and swirling banderoles, these are among the artist's more fanciful drawings. The tailpiece is indicative of the ingenuity and wit with which the artist approached this series of illustrations. In the tailpiece he has juxtaposed the real world, represented by the mantel, the boy, the book and the aunt's hands, with the child's fantasy world of knights and castles. The drawing, in which all of the action seems to

emerge from the pages of the great book, neatly sums up Grahame's story. It was signed by the artist in three different places. In addition to his regular signature in the lower right-hand corner, he inscribed a large "P" on the shield of the knight on the left and spelled out "M-A-X-F-I-E-L-D P-A-R-R-I-S-H 97" in the squares of the blanket worn by the horse on the right. Parrish, who had enjoyed a great fantasy life as a boy, no doubt felt a close kinship with the child in Grahame's story.

While at Annisquam, Massachusetts, in July of 1897, Parrish made the preliminary drawing for the cover design to be used on that year's Christmas issue of *Scribner's Magazine.* In August, the artist himself transferred the design, reducing it to the appropriate cover size, to the lithographic stone from which it was printed. As the cover (Plate 10) required nine printings, the additional stones for color probably were prepared by the printer. Noted for the unusual figures that inhabited many of his posters and magazine illustrations, Parrish drew those on this Christmas cover with features that were suggestively porcine. These droll characters, combined with the symmetrical design and the blend of rich colors and geometric patterns, made this an unusually effective cover. Indeed, its general subject—cooks and waiters with trays of holiday food—was to become Parrish's favorite for Christmas designs. Although he used this theme often, he always painted it with a freshness and variety that never failed to make it amusing. One early variation on the theme was a program or menu cover which the artist gave to J. H. Chapin for the 1897 company dinner; in this drawing, inscribed *The Scribner Christmas Dinner,* two waiters carry an institutional-sized pudding (Fig. 45).

In his designs for the *Scribner's* covers (Pls. 11, 12) for April and October, 1899, and for *The Land of Make-Believe* frontispiece (Pl. 13) (made in 1905, but not published by *Scribner's* until 1912), Parrish drew a beautiful girl against a landscape background. Here began an even more characteristic theme, one which he continued to use into the 1930s. He designed the landscape backgrounds of the April

HARPER'S ROVND TABLE

CONTENTS

date

PVBLISHED BY
HARPER AND BROTHERS
NEW YORK

Figure 40. Christmas. *Cover for* Harper's Weekly, *December 19, 1896*

Figure 36. Advertisement for back cover of Harper's Weekly, *December 14, 1895. Drawn in ink and white on brown English wrapping paper.*

Figure 37. Cover for Harper's Weekly, *December 14, 1895. Drawn in ink and white on brown English wrapping paper.*

Figure 38. Advertisement for back cover of Harper's Weekly, *April 11, 1896. Photo: Cornell University Library.*

Figure 39. Cover for Harper's Weekly, *April 11, 1896. Photo: Cornell University Library.*

and October, 1899, covers around fantasy architecture and expansive skies, two subjects that held much interest for him. In both, the figures sit on a wall running horizontally across the bottom of the composition. This horizontal element served a number of purposes and became almost a standard feature of his cover designs. Parrish wearied of working time and again in the narrow, vertical proportions of magazine covers. By placing a wall or strip of color across the bottom of the composition he reduced its narrow appearance, added variety, and created a more compatible design area. A horizontal element at the bottom of the design also provided a solid base for the composition, a factor that, considering Parrish's sensitivity to architecture, would have been important to him. The wall in the foreground, with a landscape or buildings in the background, suggested distance, helping to free the artist somewhat from the concerns of linear perspective and giving him greater latitude in exploring the possibilities of two-dimensional presentation. When designing a magazine cover, it was important for Parrish to keep in mind how the magazine would look on the newsstand. Most magazines had established formats within which the artist had to work, and he would be given their specifications at the time the commission was offered. Always the title had to be distinct and at the top so that it could be seen when the magazine was placed on the sales rack, because only a few inches of the top of the magazine was likely to be visible. Parrish frequently used a horizontal band across the bottom of the design to help raise more of the pictorial composition into the crucial area of the cover.

Many techniques were employed by the artist in his early magazine work. Drawing with a lithographic crayon on Steinbach paper, he created a delicate stippled effect for the 1898 Christmas cover of Scribner's *Book Buyer* (Pl. 14). Made at about the same time, his pictures for "Wagner's Ring of the Nibelung" required a variety of complex techniques. There were fourteen drawings in the series, some of which were made on Steinbach paper with wash,

HARPER'S WEEKLY

CHRISTMAS

HARPER'S
WEEKLY

CHRISTMAS

Figure 41. Christmas. *Cover for* Harper's Weekly, *December 18, 1897.*

ink and lithographic crayon. Afterwards they were photographed, using Carbutt's process plates, and the print colored.[1] They then were varnished and, when dry, were finished in oil glazes.[2] It is regrettable that a better method of printing was not available when these illustrations were reproduced in *Scribner's Magazine,* for the poorly tinted, engraved reproductions seem only to hint at what must have been the fiendish quality of *Alberich, the Dwarf* (Fig. 46) and the expressive use of photography in *Loki's Fire Charm* (Fig. 47).

As has been pointed out, Maxfield Parrish spent the winter of 1900–1901 at Saranac Lake, New York, where he worked in the wholesome, fresh Adirondack air. Among the paintings made by him at Saranac Lake were those to illustrate A. T. Quiller-Couch's "Phoebus on Halzaphron." This story of an imaginary ancient civilization that existed on the coast of England lent itself well to the poetic imagery of Parrish's less directly commercial work. Also painted at Saranac Lake and in the same romantic vein were the three illustrations for John Milton's "L'Allegro."

Adeline Adams, writing in *The American Magazine of Art,* January, 1918, reported that during 1900–1901 Parrish worked outside on the porch of the Saranac Lake retreat, where it was sometimes necessary for him to paint with one hand while sitting on the other to warm it. "'Today,'" Mrs. Adams quoted a letter from Parrish, "'I have been trying to make a picture of Apollo and St. Patrick walking along a beach by the edge of a summer sea [Fig. 49] . . . but the snow piled up on it, so I had to give it up.'"[3] According to Mrs. Adams, when the ink with which Parrish was drawing froze, he painted in colored glazes, using them almost exclusively in his career after that. Parrish, of course, had painted oil glazes quite extensively before his Saranac Lake experience, but it is true that he used ink and watercolor a great deal less after about 1900-1901.

Having been disappointed with some earlier attempts made at reproducing his paintings in the color halftone process, the process used then by most publishers for color illustrations within magazines, Par-

HARPER'S WEEKLY

CHRISTMAS

Figure 44. Tailpiece for "Its Walls Were as of Jasper," by Kenneth Grahame, Scribner's Magazine, *August, 1897.*

rish decided to utilize a rather subdued color scheme for the "Phoebus on Halzaphron" and "L'Allegro" illustrations (Figs. 49, 50). He suggested that he might do the colored drawings for "L'Allegro" in only two or three tints, so they would reproduce equally well in color or in black and white, should the publisher care to eliminate color altogether.[4] When the color reproductions of the "L'Allegro" paintings appeared in *Century Magazine,* December, 1901, Augustus Saint-Gaudens sent Parrish an enthusiastic letter about his work.

The three drawings for Milton's "Allegro" you have done for the *Century* are superb, and I want to tell you how they impressed me. They are *big* and on looking at them I feel that choking sensation that one has only in the presence of the really swell thing. The shepherds on the hill, the Poet in the valley are great in composition and with the blithesome maid are among the most beautiful things I have ever seen. . . .

It is always an astonishment to me how after all the fine things that have been done and which seem to have exhausted all the possibilities of beauty, some man like you will come along and strike another note just as distinctive and just as fine. It is encouraging and stimulating.[5]

The artist Celia Beaux also sent word to Parrish of her admiration for the "L'Allegro" pictures.

Turn-of-the-century critics lauded the poetic qualities of Parrish's illustrations for the poems "Christmas Eve" (Fig. 51) by Ednah Proctor Clark and "A Hill Prayer" (Fig. 52) by Marion Warner Wildman, both published in *Century Magazine.* Permeated with a dreamlike, airy beauty and a quality of sensuousness and mystery, these exquisite drawings represent a side of Parrish's art that generally was suppressed in his posters and other commercial endeavors.

In the fall of 1901 Parrish accepted an offer from *Century Magazine* to travel to Arizona to make a series of paintings for Ray Stannard Baker's "The Great Southwest." Having spent the previous winter regaining his health in the Adirondacks, Parrish felt that the trip to Castle Creek, Hot Springs, Arizona, would enable him to

THE SCRIBNER CHRISTMAS DINNER

1897

Figure 45. The Scribner Christmas Dinner.
Cover for publishing company holiday dinner
program. November, 1897. 24 x 16½".

Color Plate 9. Romance.
Cover lining for The Knave of Hearts
by Louise Saunders. Ca. 1924. Oil on panel.
Courtesy New York Graphic Society Ltd.
Photo: Allen Photography.

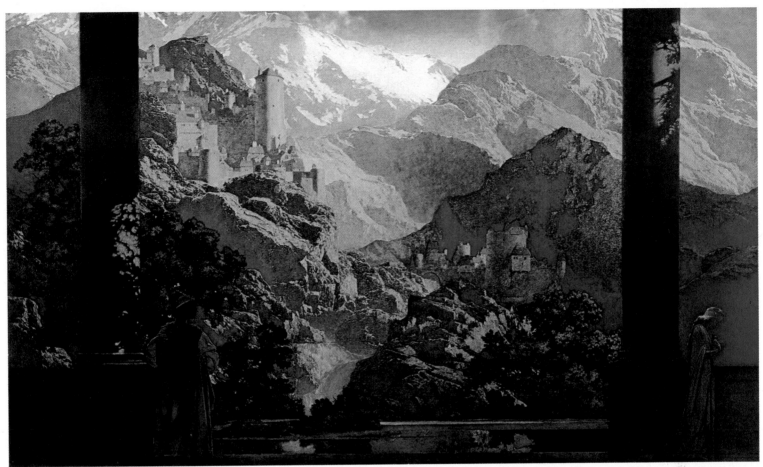

continue his recovery in a winter climate more suitable for painting. Further, the commission seemed to offer some interesting possibilities for painting landscapes. Parrish and his wife left from New York by train for Arizona in mid-November, 1901, changing in Illinois to the Chicago Limited, which ran semiweekly from Chicago to the Grand Canyon. Under the agreement, *Century* paid all travel expenses to and from the Southwest for the artist and his wife and provided lodging and meals for him while he painted for *Century.* The artist assumed his own living expenses while working on commissions for other publishers. In addition, *Century Magazine* paid him $125 for each of the nineteen illustrations for "The Great Southwest."

The spectacle of nature's scenery and the dramatic early morning and late afternoon effects of the sun in the southwestern region made a great impression on Parrish. He was fascinated by the light and shadows created by the sunlight as it played across the various planes and jagged edges of the gorges and canyons and by the feeling of spaciousness in the unencumbered vistas. Now making fewer black-and-white drawings and using color more extensively in his work, he was strongly affected by nature's great show of color, for which the Southwest is noted. The natural chiaroscuro of Arizona's rugged canyons and the qualities of space and distance so carefully studied by the artist for "The Great Southwest" paintings left forever their impression on his approach to landscape painting.

Parrish made a second excursion to Castle Creek, Arizona, the following winter. This time he stayed only two months, as it was necessary to return to the East in mid-February, 1903, to board a ship for Italy. *Century Magazine* was sending him there to illustrate *Italian Villas and Their Gardens,* the series of articles by Edith Wharton, subsequently published in book form. The conditions under which the Century Company sent him to Italy were the same as those under which he had gone to the Southwest—with two important exceptions. First, he would make all the illustrations in Cornish, after his return, from sketches, notes and photographs made by him in Italy. Second, the paintings were to be his, with *Century* receiving only the reproduction rights. (The latter was a standard arrangement that Parrish initiated in the summer of 1902 with all of his publishers. With the exception of advertisement designs, the originals of subsequent illustrations were always returned to the artist.)

Before leaving for Italy, the artist sought the advice of his neighbor, Charles Platt, the expert on Italian architecture and landscape gardening. Platt and artist Ernest Clifford Peixotto gave him tips on getting around Italy and told him of interesting, out-of-the-way places to visit. "I know two words in Italian with a doubtful third," Parrish wrote to his publisher, "but I hope to collect a few more. . . ."[6]

Figure 46. Alberich, the Dwarf. *Illustration for "Wagner's Ring of the Nibelung" by F. J. Stimson,* Scribner's Magazine, *December, 1898.*

Color Plate 10. *Untitled. Cover for* Scribner's Magazine, *December, 1897. Lithograph. Photo: Allen Photography.*

Color Plate 11. *Untitled. Cover for* Scribner's Magazine, *April, 1899. Photo: Allen Photography.*

Figure 47. Loki's Fire Charm. Illustration for "Wagner's Ring of the Nibelung" by F. J. Stimson, Scribner's Magazine, *December, 1898.*

Maxfield Parrish and Edith Wharton did not meet to discuss the project prior to their departures for Italy, and their letters indicate that they could not arrange their schedules to meet there. Mrs. Wharton went to Italy to begin her research in January, 1903, while Parrish was still in Arizona. When he arrived in Italy over a month later, she had already begun her notes on the locations he would be painting. On an itinerary they both were to follow, she traveled around the country visiting various villas and talking with their owners. As she prepared to leave each city (usually a few weeks before Parrish would arrive there), she mailed to the artist at the next hotel on his schedule the list of villas from the area to be included in her articles. When Parrish was in Amalfi, the author was in Florence; when Parrish was in Rome, she was in Milan; and so it went.

In early July, when they both were back in the United States, he called on Mrs. Wharton at her home in Lenox, Massachusetts, to discuss the points of view to be taken in the illustrations and the text. From the beginning he had wanted to avoid painting the most characteristic or standard views seen by every tourist, and Mrs. Wharton had asserted that her text would be above the "sentimental gush"[7] previously published on the subject. What they managed in concert to provide was an unusual look at Italian architecture and its relationship to the landscape around it (Pl. 50). The illustrations, or colored drawings, for *Italian Villas and Their Gardens* (Fig. 53) were made at "The Oaks" during the summer and fall of 1903, at the same time the author was preparing the text in Lenox. Successful in capturing the color and spirit of the Italian scene, the artist illustrated concurrently a second manuscript by Mrs. Wharton, *A Venetian Night's Entertainment,* for *Scribner's Magazine.* One critic, who found the text of *Italian Villas and Their Gardens* too technical for the mass audience for which it was intended, had great praise for the visual portion of the book.

Mr. Parrish has performed his part of the task in a delightful and satisfactory way. He has

Color Plate 12. *Untitled. Cover for* Scribner's Magazine, *October, 1899. Photo: Allen Photography.*

Color Plate 13. Land of Make-Believe. *Illustration for* Scribner's Magazine, *August, 1912 (painted in 1905). Oil on canvas, 40" x 33".*
Courtesy Betsey P. C. Purves Trust and Vose Galleries, Boston. Photo: Herbert P. Vose.

Figure 49. "Twilight had fallen before the Stranger rose and took his farewell." Illustration for "Phoebus on Halzaphron" by A. T. Quiller-Couch, Scribner's Magazine, August, 1901. February, 1901. Oil, 11⅝" x 7¼". Courtesy Schweitzer Gallery.

put the best of his art into the subject, and has succeeded in depicting the beauties of the Italian gardens as they have never been depicted before. His interests in architectural subjects, in color and form, here have found a field giving him ample scope. . . .[8]

Maxfield Parrish's illustrations of Italian villas so impressed the Century Company that they offered to send him to any location that he should like to paint, but the artist chose to remain in Cornish.

In addition to *Century Magazine,* another publication of the Century Company for which Parrish occasionally made illustrations was *St. Nicholas,* the children's magazine. Illustrations for "A Ballad in Lincoln Green" (Fig. 54) and "The Three Caskets" (Fig. 55), appearing in the issues of November, 1900, and December, 1903, respectively, show the change in the artist's style as he switched from the black-and-white medium of the earlier drawing (made prior to his winter in the Adirondacks and his first trip to Arizona) to the color medium of the later drawing. This early illustration for "The Three Caskets" anticipates both *Garden of Allah* and *Daybreak,* his two best-known works of art, painted about twenty years later.

Around the turn of the century Parrish accepted from a variety of popular magazines individual commissions strictly on a free-lance basis. Among them was his only attempt at direct political cartooning— *Happy New Year Prosperity* (Fig. 56). Drawn for *New England Homestead,* published in Springfield, Massachusetts, the cartoon depicts a smartly dressed Uncle Sam holding his old suit, which is covered with patches. On the patches are written such slogans as "Uncertainty—1896" and "Hard Times—1896." A large sign, "Happy New Year Prosperity," nailed to a tree, and a busy little mill town in the background indicate hope for a better year ahead. *The Temptation of Ezekiel* (Fig. 57), one of Parrish's two paintings for *Everybody's Magazine,* was published in the December, 1901, issue. Its poetic mood recalls the illustrations for *Phoebus on Halzaphron,* which appeared earlier the same year in *Scribner's Magazine.* The solitude of Ezekiel is emphasized by the

Figure 50. "Straight mine eye hath caught new pleasures." Illustration for "L'Allegro" by John Milton, Century Magazine, *December, 1901.*

vast marshland and expansive clouds against which the artist has placed the single figure. In quite a different style, his cover design for the 1901 Christmas number of *Success* (Pl. 15) is a typical American holiday genre scene. The sharp diagonal line of the snow-covered hill behind the three figures and the large, perfectly centered, yellow moon give the design interest and enhance its impact.

Edward Bok, the editor of *Ladies' Home Journal,* contacted Parrish in 1901, shortly after his return from Saranac Lake, to see if the idea of illustrating an interesting line or verse from five of Eugene Field's poems

appealed to him. Bok wanted the drawings to appear as full-page black-and-white reproductions in five different issues of *Ladies' Home Journal,* and he offered Parrish one thousand dollars for the series, with the originals being returned to the artist after publication. The poems captured the artist's imagination, and he agreed to illustrate for Bok "The Sugar-Plum Tree," "Seein' Things at Night," "The Little Peach," "Wynken, Blynken and Nod" and "With Trumpet and Drum." Shortly after *Ladies' Home Journal* announced the series to its readers, Parrish, whose physical condition was frail, found it

necessary to leave for the warmer climate of Arizona. Consequently, he was unable to begin the paintings until the following summer. The painting for the artist's favorite Field poem, "The Sugar-Plum Tree," was finished for the 1902 Christmas number of the magazine, with the remaining four illustrations being published the following year. However, even before the first of the illustrations was painted, Arthur Scribner approached Bok and the artist about the possibility of publishing them in book form.

The illustrations were a great popular success in the magazine as well as the book.

Color Plate 14. The Christmas Book Buyer, 1898. *Cover. 1898. Lithographic crayon and ink on Steinbach paper. Courtesy Maxfield Parrish Estate. Photo: Allen Photography.*

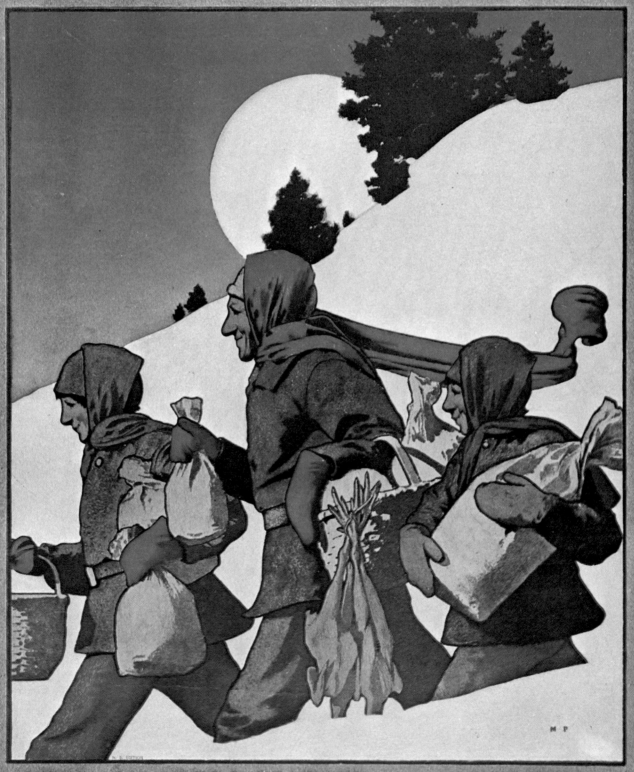

Color Plate 15. Success. *Cover for December, 1901. Photo: Columbia University Library.*

Figure 52. A Hill Prayer. *Illustration for "A Hill Prayer" by Marion Warner Wildman,* Century Magazine, *December, 1899. Charcoal, graphite, ink on white paper, 11⅝" x 7⅝". Courtesy Fogg Art Museum, Grenville L. Winthrop Bequest.*

Figure 51. Mary and Child. *Illustration for "Christmas Eve" by Ednah Proctor Clark,* Century Magazine, *December, 1898. Crayon and wash.*

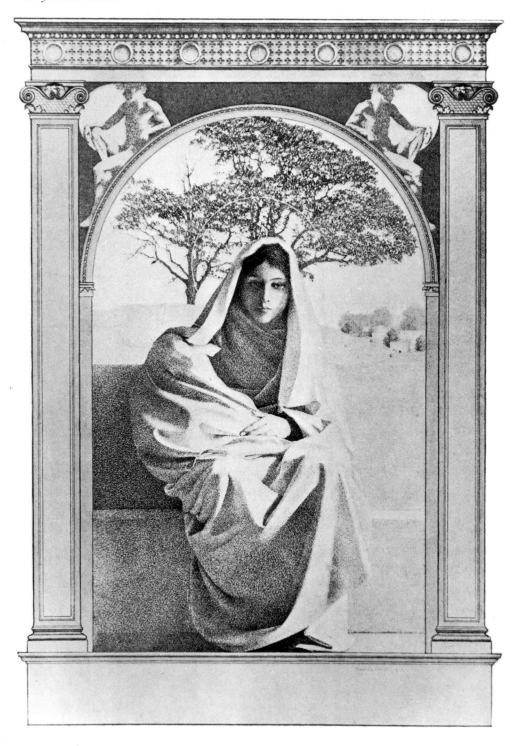

Wynken, Blynken and Nod (Fig. 58) and *With Trumpet and Drum* (Fig. 59), the last two of the series to appear in *Ladies' Home Journal,* effectively captured the spirit of the poems they illustrated. The still moonlight and subdued colors in *Wynken, Blynken and Nod* echo the dreamy lullaby quality of the poem. *With Trumpet and Drum,* on the other hand, fairly reverberates with color and undulating banners to the cadence of the lively poem it illustrates. Particularly effective in the composition is the scale and feeling of bigness, created in part by the ingenious use of the lower edge of the picture plane itself as the surface on which the children march.

To generate publicity for its 250th issue, *Ladies' Home Journal* in 1903 announced a cover design competition with a first prize of one thousand dollars, and in doing so they listed six prominent illustrators who had consented to participate in the contest. One of the names was that of Maxfield Parrish. Rules of the competition imposed no restrictions as to design or subject, the only condition being that the design should be capable of being reproduced in two colors. Submitting a painting which he called *Air Castles* (Pl. 16), Parrish was awarded first prize. Among the other winners were the illustrators Jessie Wilcox Smith and Harrison Fisher. A romantic fantasy in which a semidraped youth daydreams as the bubbles he has blown merge into castles of his dreams, *Air Castles* was printed in full color on the September, 1904, cover of *Ladies' Home Journal.* Additionally, color reproductions or art prints of the painting were offered to the readers of the magazine for ten cents, making it the first of Parrish's paintings to receive widespread distribution in this form.

In 1904 Parrish surprised many of his acquaintances in the periodical publishing business by signing an agreement whereby his future work would be published exclusively in *Collier's.* Why would one of the country's most-sought-after young artists commit himself to an exclusive contract when he seemed to be riding the crest of success working independently? No doubt many factors contributed to his decision,

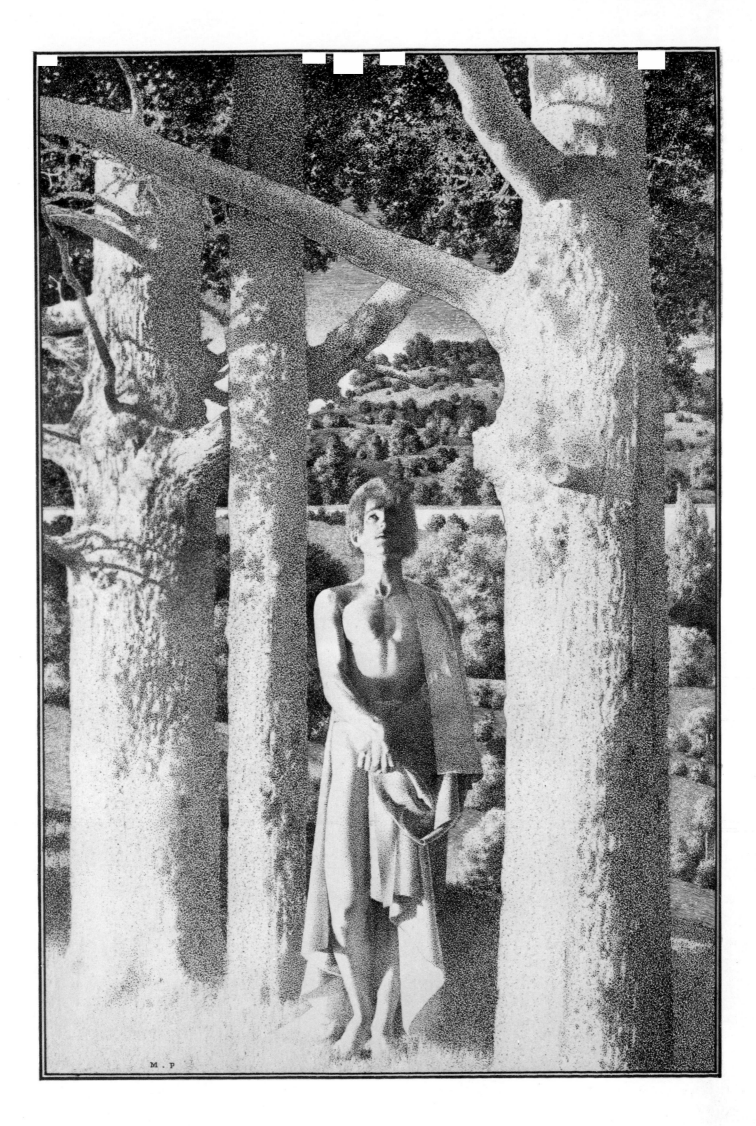

M. P

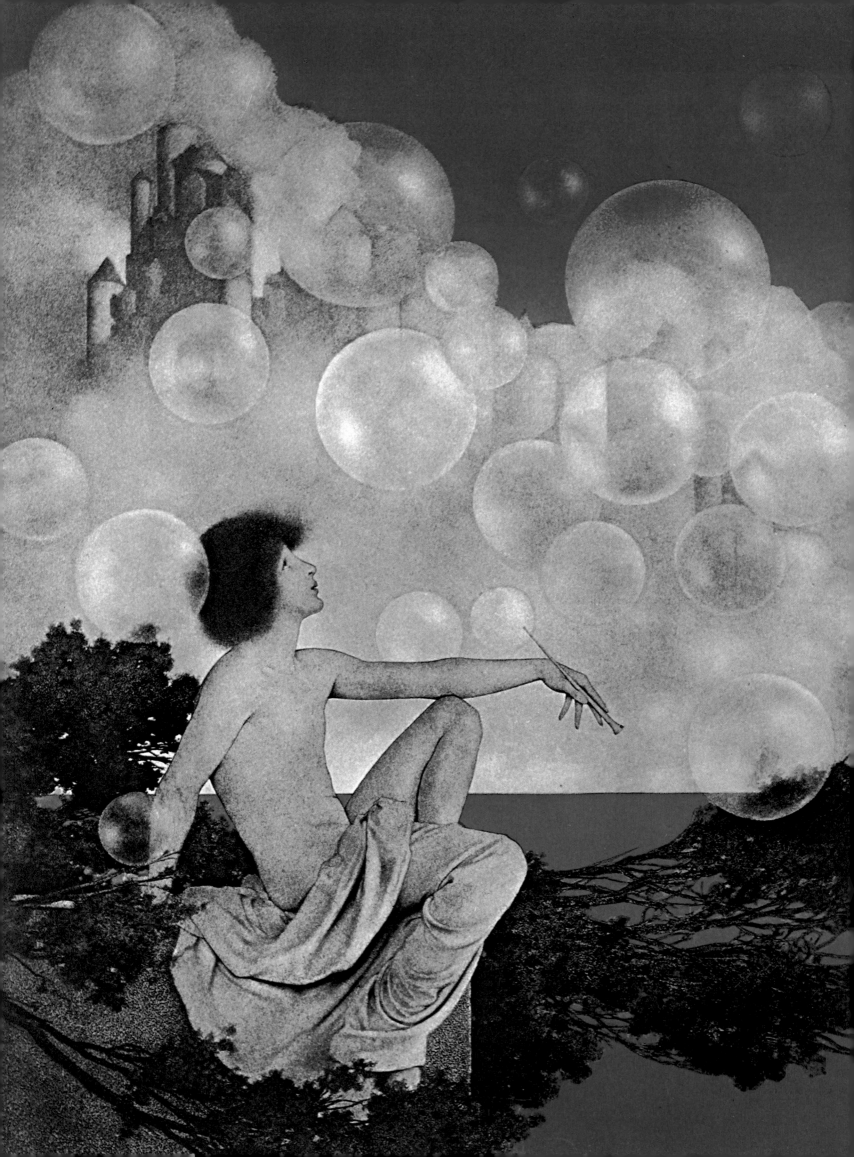

Color Plate 16. Air Castles.
Cover for Ladies' Home Journal,
September, 1904. 29″ x 20″
Photo: Allen Photography.

Figure 53. Gamberaia. *Illustration for
"Italian Villas and Their Gardens" by Edith
Wharton,* Century Magazine, *November,
1903. Oil on canvas, 28″ x 18″. Courtesy
Schweitzer Gallery.*

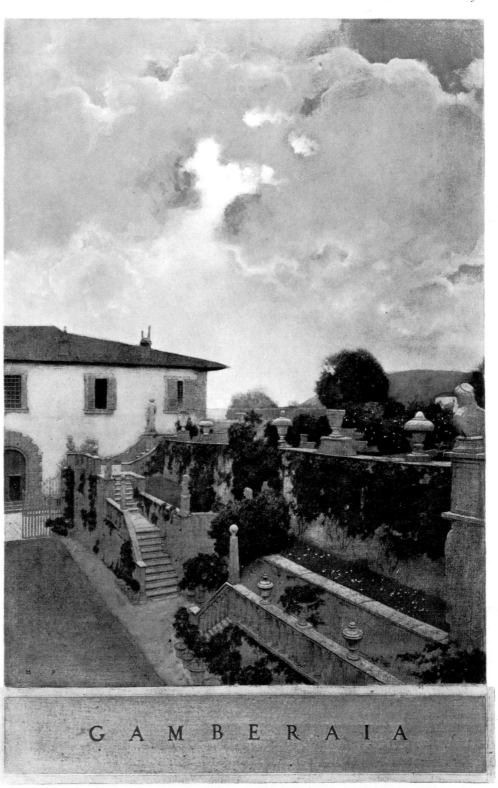

which in the long run proved to be a most judicious one. For one thing, the large size of the *Collier's* pages (15″ x 10¾″) offered him more freedom of design than the smaller magazines and promised to bring a greater faithfulness to the reproduction of his work. Also, in working for a single magazine there would be a consistency of style and format, enabling him to explore and develop certain ideas that he found impossible while working for a variety of magazines. The artist's first son was born in 1904, and, taking this new family responsibility seriously, he could but appreciate this assurance of financial stability. When *Collier's* offered to pay Parrish $1,250 per month for the rights to reproduce his work, with the originals belonging to the artist, he signed the agreement, which remained in effect until 1910.

Among the cover designs that Maxfield Parrish made for *Collier's* are to be found some of his most imaginative and most ingeniously designed productions. The eye-catching splatter of spilled ink as the background for a humorous 1910 cover entitled *Penmanship* (Fig. 60) might not have been amusing to P. R. Spencer, the penmanship specialist, but Jackson Pollock probably would have loved it. Complex arrangements of superimposed numbers and intertwined letters in the *Arithmetic* (Fig. 61) and *Alphabet* (Pl. 17) covers exemplify the precise, objective painting style often used by the artist for its graphic impact. Here, as in *Penmanship,* human interest is provided through the boyish appeal of the artist's son, Dillwyn, who appears as the young pupil in each of these covers. Exploring the optical effects of geometrically patterned fabrics was Parrish's objective in painting *The Idiot* (or *The Book Lover*) and *King with Two Sentries* (Pl. 18), published in 1910 and 1913 respectively. Particularly striking is the treatment of the drapery in *The Idiot* (Fig. 62). Using a black and white polka-dotted fabric, again for graphic effect, the artist has indicated the folds and tucks, not by the use of highlights and shadows as might have been expected at the time, but through the meticulous and accurate foreshortening of the hundreds of small

Color Plate 17. School Days *(artist's title:* Alphabet*). Cover for* Collier's, *September 12, 1908. Courtesy Austin Purves.*

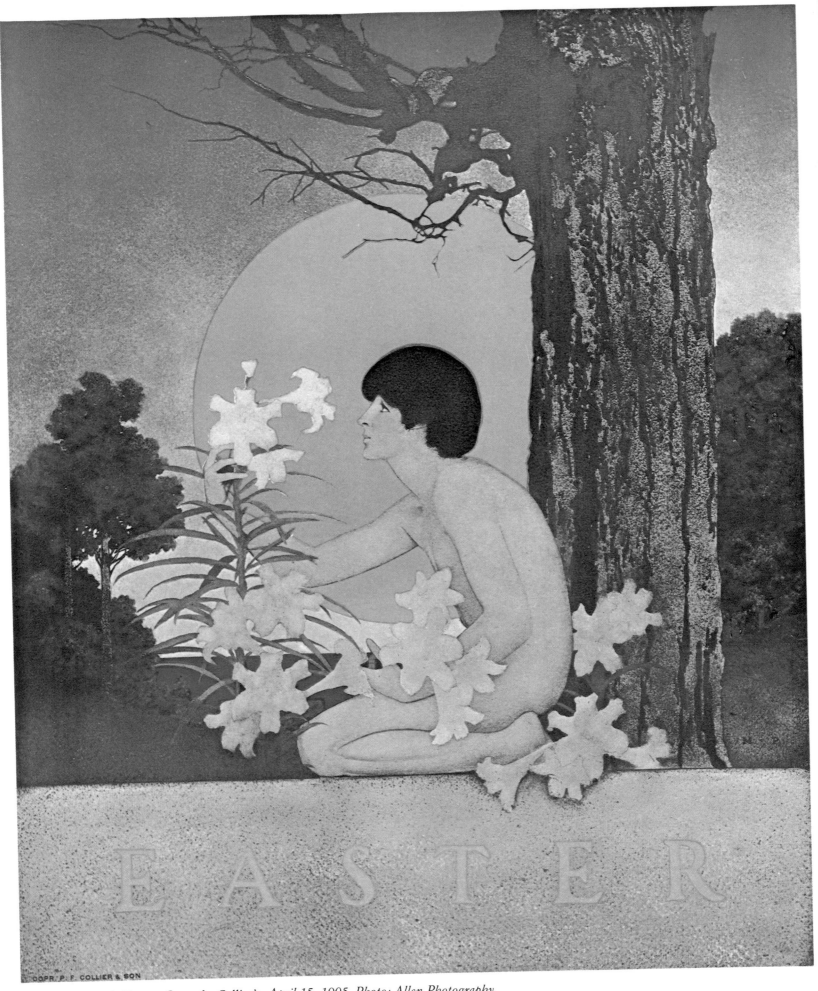

Color Plate 19. Easter. *Cover for* Collier's, *April 15, 1905. Photo: Allen Photography.*

Color Plate 18. King with Two Sentries. *Cover for* Collier's, *November 1, 1913. Cover proof courtesy Maxfield Parrish Estate. Photo: W. H. Allen.*

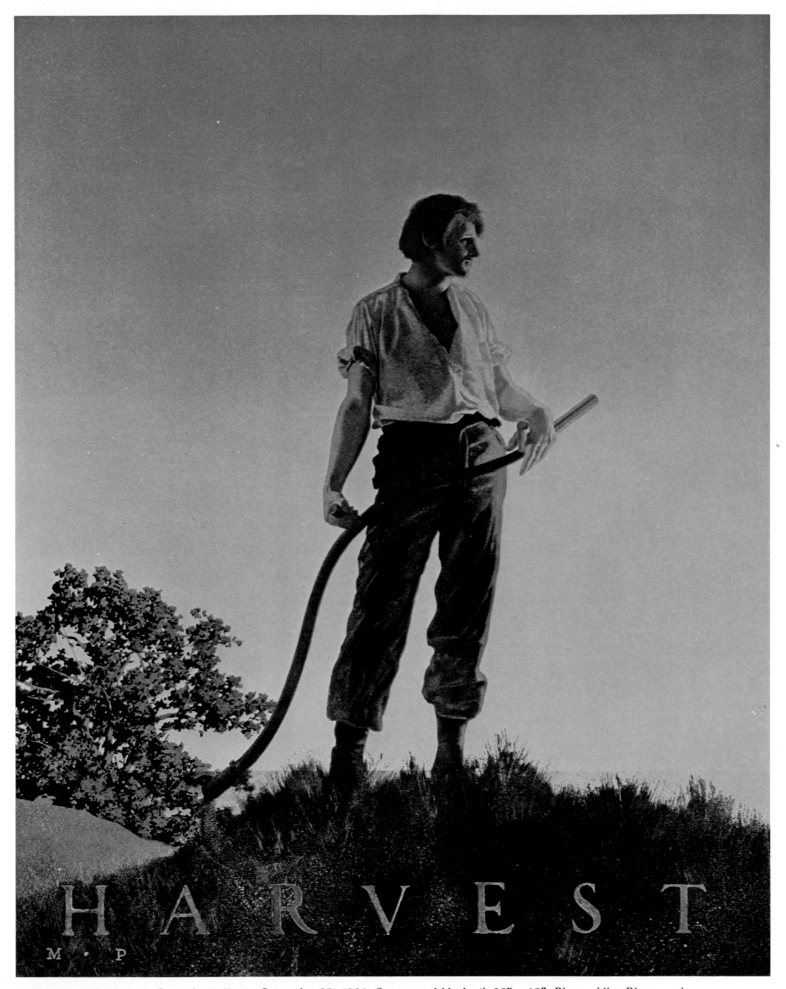

Color Plate 20. Harvest. *Cover for* Collier's, *September 23, 1905. Orange and black oil, 28" x 18". Photo: Allen Photography.*

Figure 56. Happy New Year Prosperity. *Cover for* New England Homestead, *January 2, 1897. Pen and ink, 15" x 15".*

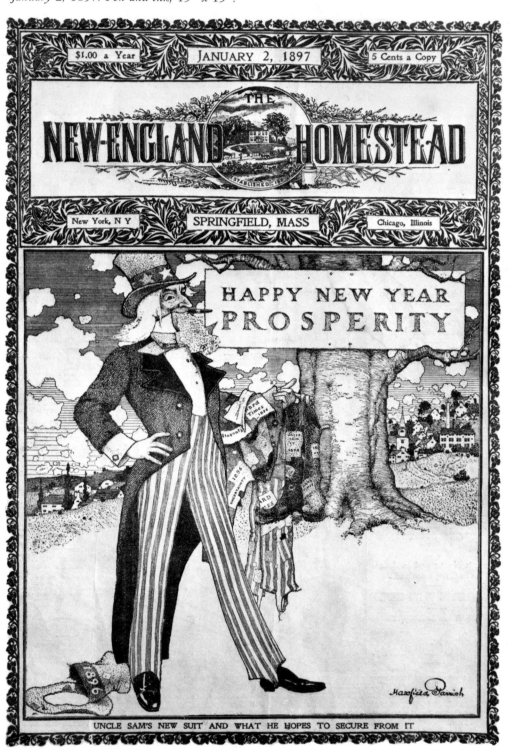

covers for the magazine. Parrish's daughter, Jean, suggested that Jack Frost painting the autumn leaves might be an appropriate subject for an October cover, and she made a quick sketch to illustrate her concept. The artist based his colorful cover (Fig. 63) for the issue of October 24, 1936, on his daughter's sketch and, recognizing her important contribution to the final design, divided with her the reproduction fee that he received.

(Note: The paintings made for *Collier's* to illustrate the two series, *Arabian Nights* and *Greek Mythology,* are discussed in Chapter 2.)

One important project in which Parrish was engaged concurrently with the murals for the Curtis Publishing Company and the studio decorations for Mrs. Gertrude V. Whitney was a series of fairy-tale pictures based on the general theme of "Once Upon a Time." The project was initiated by Will Bradley, the poster artist and graphics designer, who was then the art editor of William Randolph Hearst's *Good Housekeeping* magazine. Bradley was a great fan of Parrish's, having featured his work in the November, 1896, issue of his own magazine, *Bradley His Book.* He visited "The Oaks," and incorporated some of Parrish's ideas about the delight of architecture into the building of his own new home. "Your work gives me greater personal pleasure than that of any living artist,"[9] Bradley wrote to Parrish in 1912. He was exceedingly pleased when the artist agreed to make the series of pictures. Parrish had planned to make the series on his own, offering it to a book publisher when complete; however, Bradley convinced him to let the magazine publish the pictures first.

Maxfield Parrish's agreement with Will Bradley and *Good Housekeeping* was for twelve fairy-tale pictures to be finished within two years from December, 1911. *Good Housekeeping* would pay the artist one thousand dollars for the magazine reproduction rights to each picture, returning the original to him. When the first two covers arrived in the *Good Housekeeping* office in April, 1912, Hearst was so enthusiastic about them that he pulled them

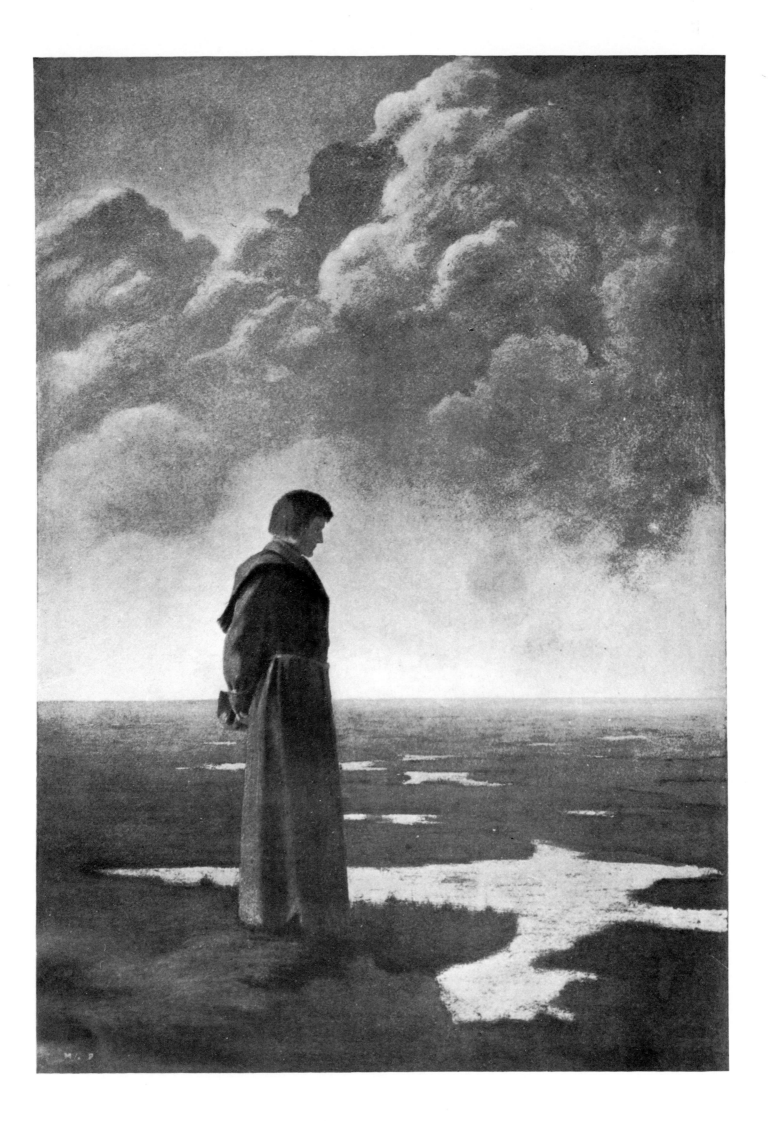

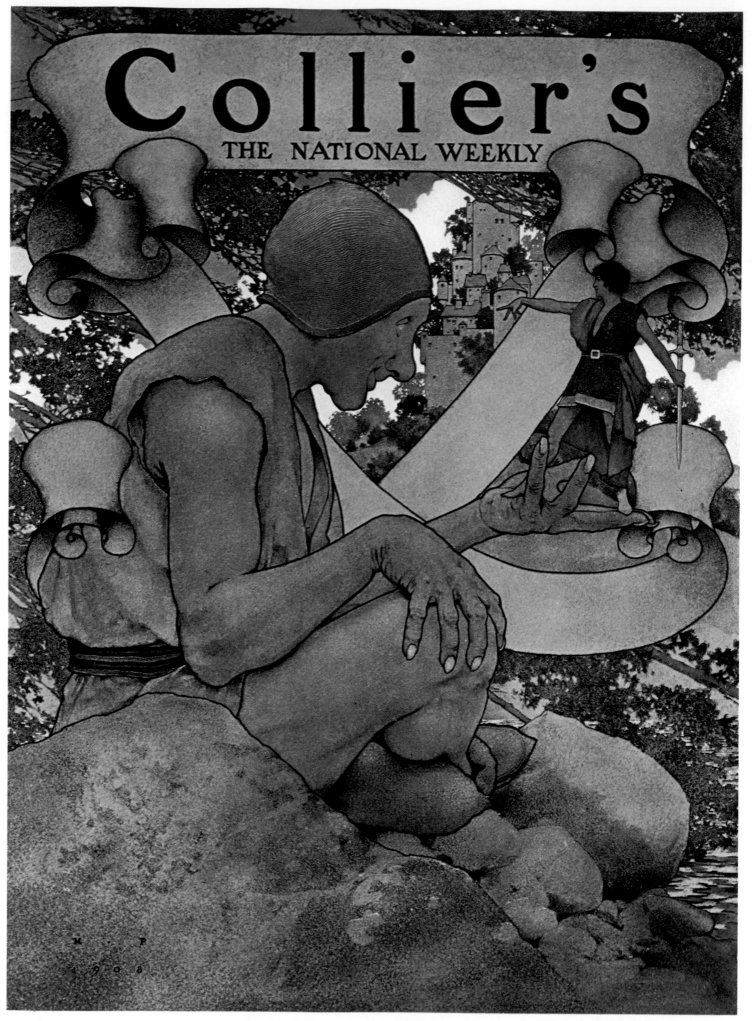

Color Plate 21. *Untitled. Cover for* Collier's, *July 30, 1910. Cover proof courtesy Maxfield Parrish Estate. Photo: Allen Photography.*

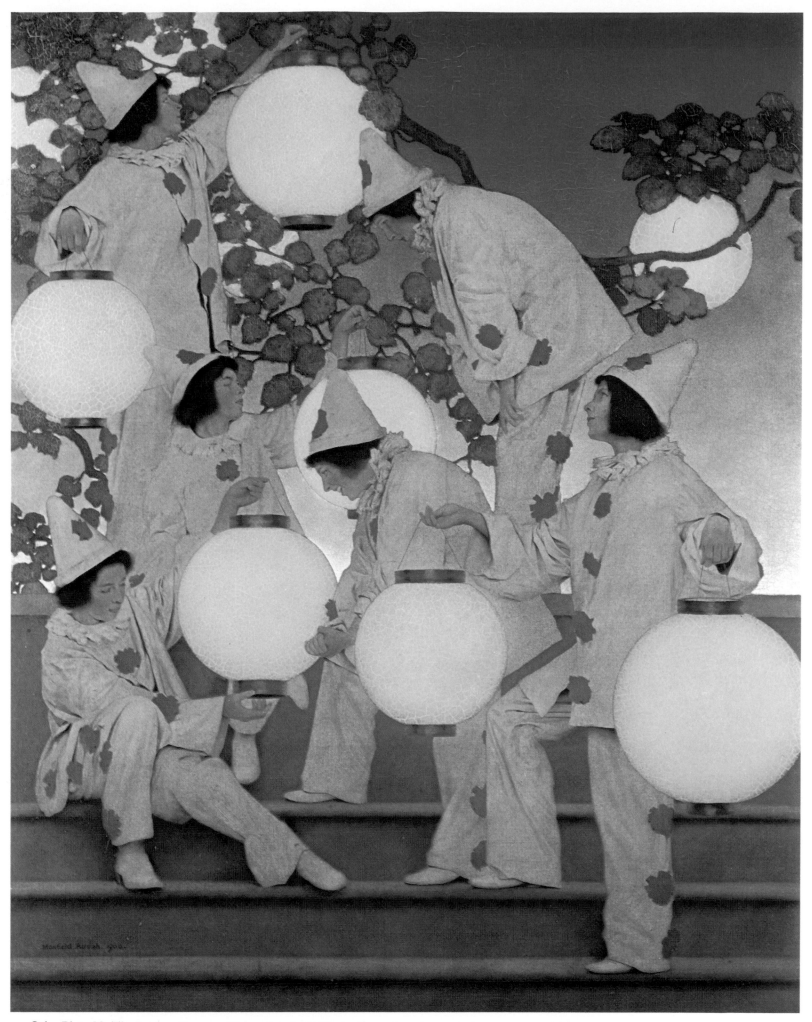

Color Plate 22. The Lantern Bearers. *Illustration for* Collier's, *December 10, 1910. Oil on canvas, 40" x 32". Courtesy Vose Galleries, Boston. Photo: Herbert P. Vose.*

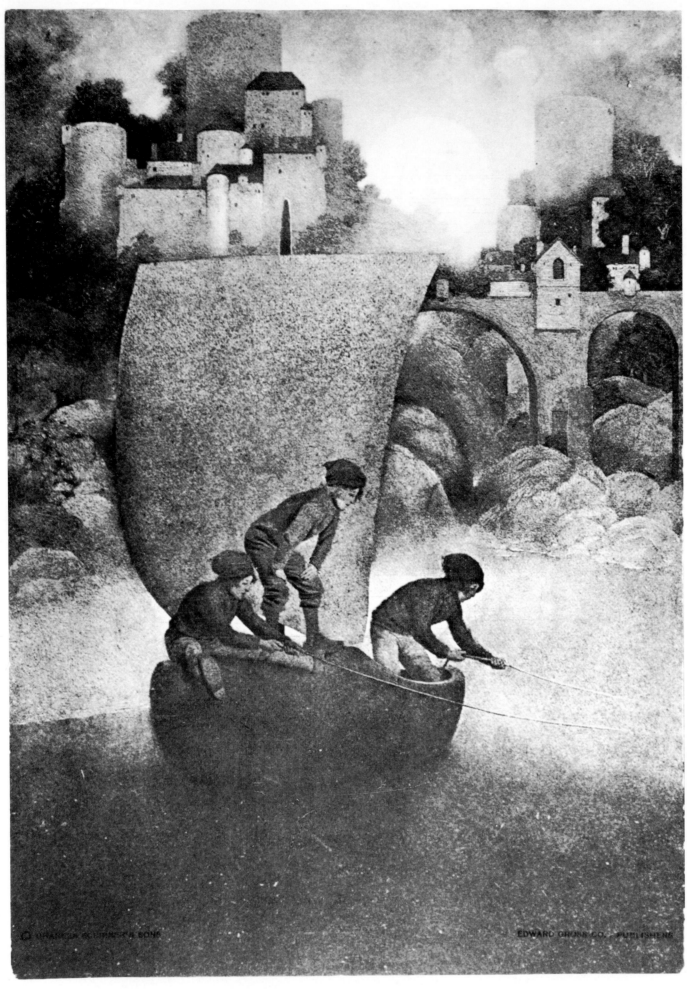

Figure 58. Wynken, Blynken and Nod. *Illustration for "Wynken, Blynken and Nod" by Eugene Field,* Ladies' Home Journal, *May, 1903. 21¼" x 14¾".*

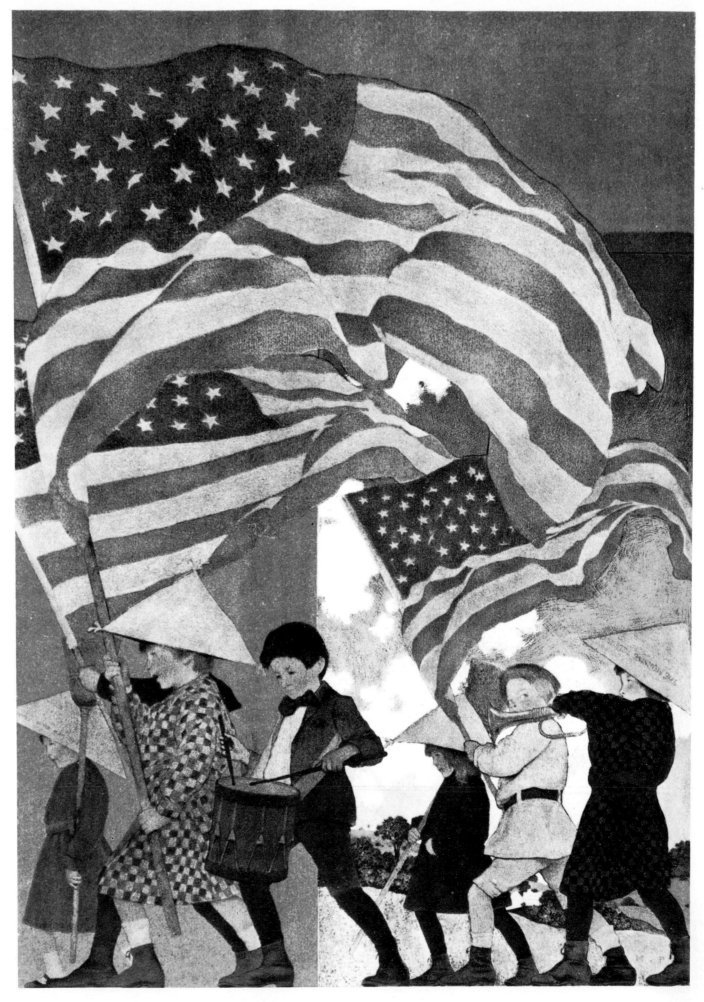

Figure 59. With Trumpet and Drum. *Illustration for "With Trumpet and Drum" by Eugene Field,* Ladies' Home Journal, *July, 1903, 21¼" x 14¾".*

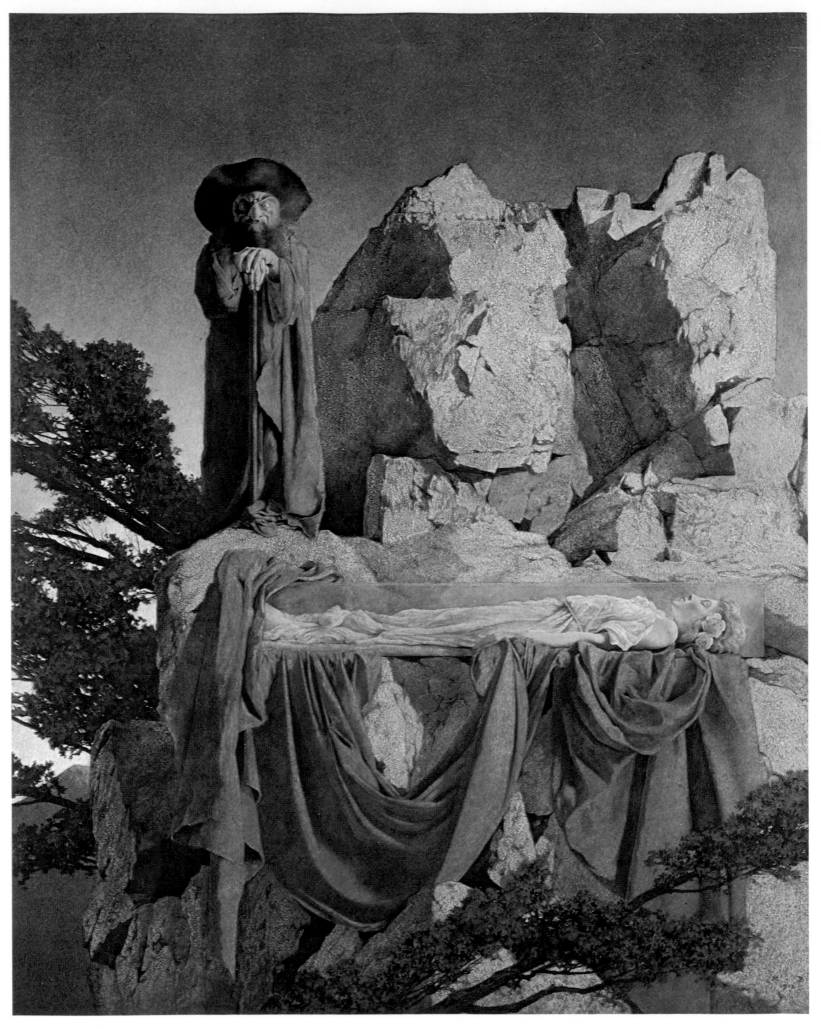

Color Plate 23. The Story of Snow Drop *(artist's title:* From the Story of Snow White*). Cover for* Hearst's Magazine, *August, 1912. Courtesy the California Palace of the Legion of Honor, lent by the Hélène Irwin Fagin Estate. Photo: Schopplein Studio.*

LIFE'S
CHRISTMAS NVMBER

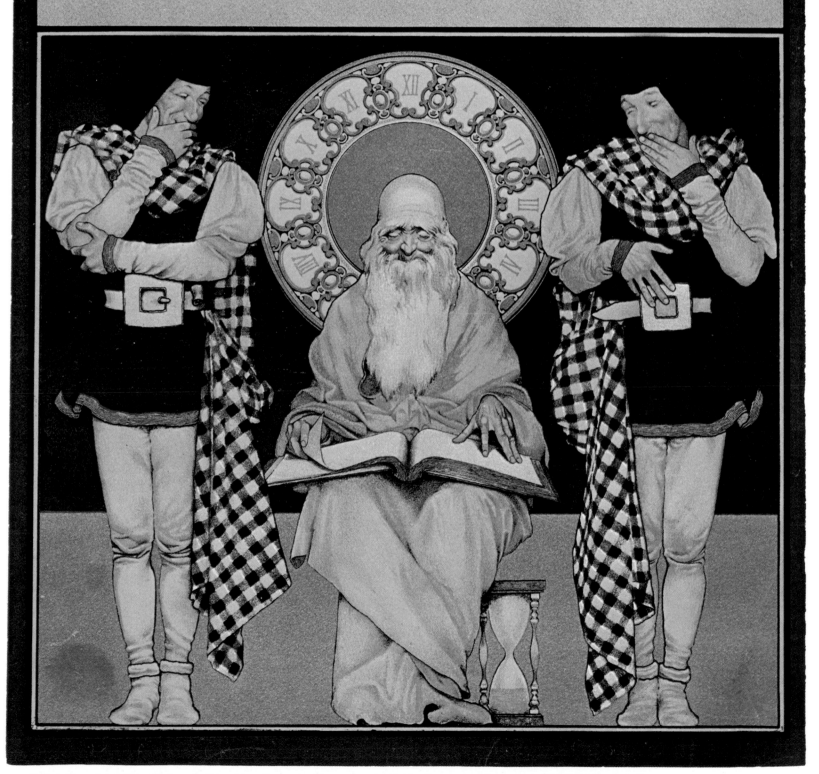

Color Plate 24. Life's Christmas Number. *Cover for December 1, 1900. Cover proof courtesy Maxfield Parrish Estate.*
Photo: Allen Photography.

Figure 62. The Idiot *or* The Booklover.
Cover for Collier's, *September 24, 1910.*
Oil and lithographic crayon (?) on stretched paper,
22" x 16". Courtesy Vose Galleries,
Boston. Photo: Herbert P. Vose.

Figure 60. Penmanship. *Cover for* Collier's, *September 3, 1910.*
Oil on stretched paper, 22" x 16". Courtesy Vose Galleries,
Boston. Photo: Herbert P. Vose.

Figure 61. Arithmetic. *Cover for* Collier's, *September 30, 1911.*
Oil on stretched paper, 22" x 16". Courtesy Vose
Galleries, Boston. Photo: Herbert P. Vose.

away from *Good Housekeeping* to use on the cover of *Hearst's Magazine.* The first of the series, *Jack the Giant Killer,* was published on the cover of the issue of June, 1912. Hearst notified Bradley that he wanted the entire series to run in unbroken sequence, but Parrish, busy with the Curtis and Whitney murals, would not promise a picture each month. The second and third pictures, *The Frog-Prince* (Fig. 64) and *The Story of Snow-Drop* (Pl. 23), were published in July and August. Too busy with prior commitments to make a picture for the September issue, the artist arranged for the magazine to use *Hermes,* one of his previously unpublished originals in the collection of Austin Purves.

Parrish soon became disenchanted with the series. He had lost his personal contact with the publisher when the series was taken out of Bradley's art department at *Good Housekeeping* and given to *Hearst's Magazine,* and the way the pictures were subsequently handled did not please him. The composition of *The Story of Snow-Drop,* he felt, had been ruined in the badly cropped cover print. Although *Hearst's* was paying him twice as much per picture as *Collier's* had, Parrish decided not to continue the series beyond the sixth painting. One additional cover, *Reveries* (Fig. 65), was made for *Hearst's,* but was never published.

It is regrettable that the "Once Upon a Time" series was not continued, for the six paintings that were finished are very per-

sonal interpretations of these standard fairy tales. *The Story of Snow-Drop* illustrates a line from the story: "And the coffin was placed upon the hill, and one of the dwarfs always sat by it and watched."[10] Snow-Drop is seen in the glass coffin as one might expect, but the elaborate drapery beneath it, the craggy mountainside and the truly grotesque dwarf are Parrish touches that are unique. *The Frog-Prince,* with its great bright-eyed green frog and distant castles, is equally imaginative and bears the undeniable imprint of a skillful interpreter of fantasy.

In the years prior to 1936, when *Life* began its long run as a picture magazine, an earlier *Life* magazine had had an equally successful publishing record. This was

Figure 63. Jack Frost. *Cover for* Collier's, *October 24, 1936.*
Oil on panel, 25" x 19". Collection: Pioneer Museum
and Haggin Galleries.

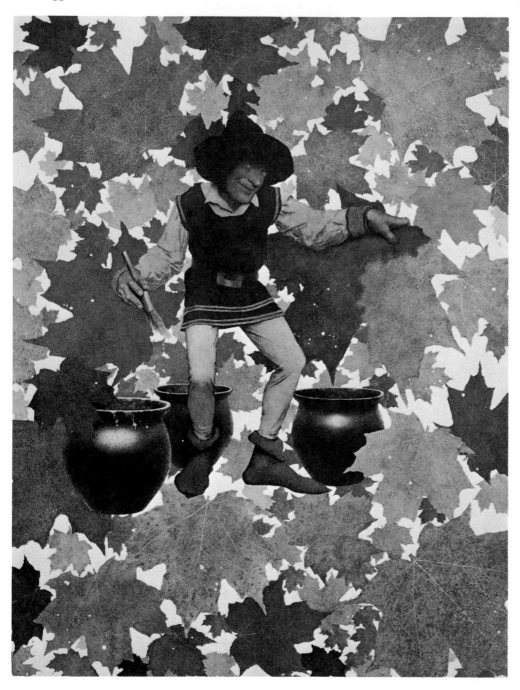

Life the humor magazine, and it frequently amused its readers with whimsical covers by Maxfield Parrish. Prior to making his exclusive arrangement with *Collier's* in 1904, Parrish had designed a number of covers for *Life.* One, a striking gold and purple composition for the 1900 Christmas issue (Pl. 24), depicted Father Time with two attendants. Covering their snickers with their hands, these attendants first established a gesture used several years later in the artist's *Old King Cole* (Fig. 93) mural for the Hotel Knickerbocker. Another early *Life* cover design, *Saint Patrick* (Pl. 25), was made during the artist's second trip to Castle Creek, Arizona, in January, 1903. Exhibited at the 1904 World's Fair in Saint Louis, this richly colored design represents the kindly saint as he might appear in a stained-glass church window. Parrish's contract with *Collier's* and his later mural commitments forced a hiatus in his work for *Life* after 1904.

Charles Dana Gibson was president of *Life* in 1920, when Parrish made his first cover for the magazine in more than fifteen years. The cover, *A Merry Christmas* (Pl. 26), was based on an earlier design for a *Harper's Weekly* cover or poster made in 1898 (Fig. 42). Rather than a single comic figure with a tureen, as in the *Harper's Weekly* design, there were now three, marching in studied rhythm across the page. When the painting arrived at the *Life* Art Department, the excited art director could not wait until the next day to show it to his boss, so that evening he carried it to Gibson's house, where they and several dinner guests spent the evening enjoying the rich colors of the painting placed on a stand before them.

The next day Gibson wrote to Parrish saying that he had only whetted their appetites for more. He told the artist not to be concerned about seasonal or holiday themes, but to paint covers that could be used for any occasion. "What we want from you is just Parrish's."[11]

And they got them. Over the next few years Parrish made at least fifteen additional cover designs for *Life.* A few of the covers, such as *The Canyon* (Fig. 109),

JULY 1912 15 Cents

Hearst's Magazine

The World To-Day

THE FROG - PRINCE Painted by MAXFIELD PARRISH

were painted with greater completeness than most, which were simple compositions depicting comic characters against a plain background. Parrish called this simpler style his "odds and ends."[12] As he retained all copyrights except the magazine rights for these pictures, he arranged for the House of Art, publishers of his art prints, to distribute some of the more detailed cover designs as color reproductions for framing. The "odds and ends" nearly always featured a short comic figure, whose facial features often were roughly based on those of the artist himself, in such covers as *A Good Mixer* (Pl. 27), *A Dark Futurist* (Fig. 66), and the *L-I-F-E* (Fig. 67) contest cover. Parrish loved painting these richly colored comic figures almost as much as painting landscapes and often delayed other

work that he considered more serious to indulge in the sheer pleasure of making these covers for *Life. A Swiss Admiral* (Pl. 28) and *A Man of Letters* (Fig. 68) show Parrish's ability to seize the essence of a personality or a situation and translate it into simple and amusing visual design.

Contests in which the readers submitted captions or titles for drawings were a frequent feature in *Life.* Parrish provided one such contest picture for the magazine (Fig. 67). Typical of Parrish's wit, his L-I-F-E contest cover portrayed the caricature of himself already mentioned, holding a large *L,* with the *IF* from *Life* on the wall behind him and the *E* on the ground. The winning caption was, appropriately enough, "He is a rogue indeed who robs life of its ends, and fosters doubt."[13] The artist found making

the covers for *Life* to be a great source of enjoyment. "I'll say right now that there is a lot of good fun doing these for your crowd down there that I like," he wrote to *Life's* art editor. "I like the spirit of it, and work, I think, is the better for it."[14]

Parrish continued to make cover designs for *Life* until 1923, when the commercial success of *Garden of Allah* and *Daybreak* prompted him to give up all magazine illustration awhile in order to concentrate on making paintings to be published as color reproductions and sold as decorations for the home. Some years later, in the 1930s, he designed a few covers for *Ladies' Home Journal* and *Collier's.* However, his finest and most effective covers were made during the long, fruitful period between 1895 and 1923.

Figure 66. A Dark Futurist. *Cover for* Life, *March 1, 1923. Ca. 14" x 12".*

Figure 67. Contest cover. Cover for Life, *June 22, 1922. A contest was held to name this picture. The winning title: "He Is a Rogue Indeed Who Robs Life of Its Ends, and Fosters Doubt."*

Figure 68. A Man of Letters *(also called* The Mudball*). Cover for* Life, *January 5, 1922. Ca. 14" x 10".*

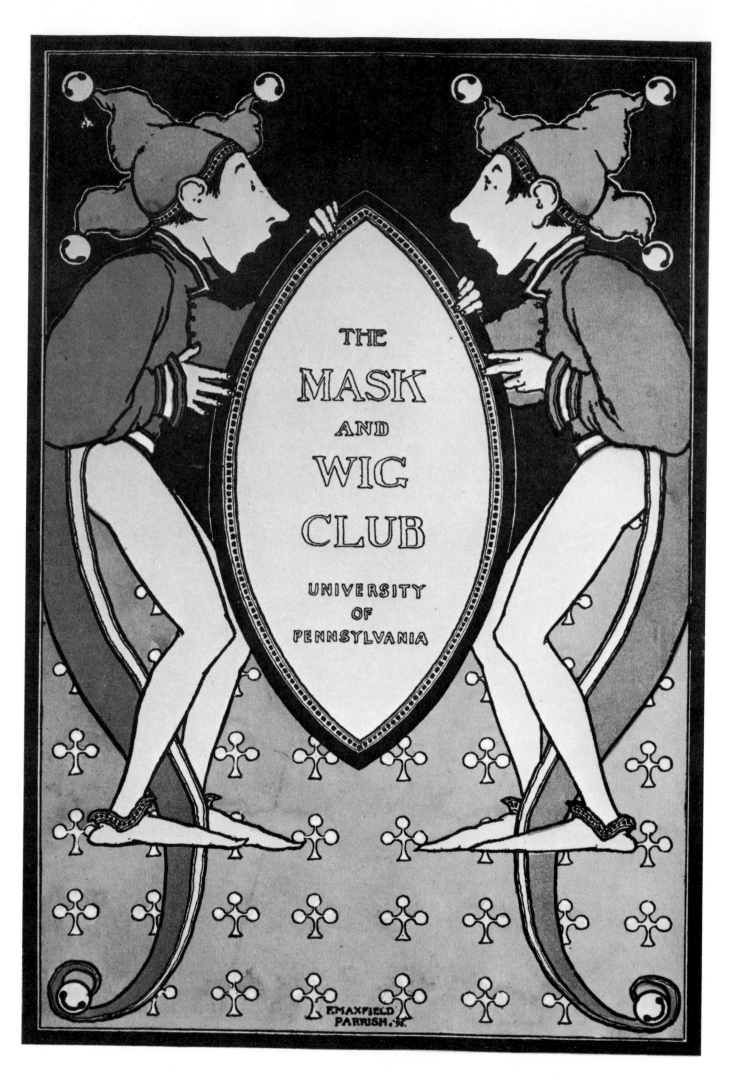

THE
MASK
AND
WIG
CLUB

UNIVERSITY
OF
PENNSYLVANIA

F. MAXFIELD
PARRISH. 95.

Chapter 4

POSTERS AND ADVERTISEMENTS

Maxfield Parrish moved quite naturally from designing posters and program covers for college functions into the commercial art scene in and around Philadelphia. While a student at Haverford College, he accepted numerous commissions for artwork in publications of colleges in the area. In 1891 he designed covers for the *Bryn Mawr College Lantern* and for the program of *The Rivals,* a theatrical production staged by students of Bryn Mawr College. The latter work, an etching on copper, is one of the few known examples of Parrish working in his father's medium. An elaborate cartouche above two pistols, the design is signed "FMP." In 1892 the students of Pennsylvania State College commissioned Parrish to make drawings for their annual *Class Book.*

The Mask and Wig Club of the University of Pennsylvania, following the lead set by Bryn Mawr and Pennsylvania State College, hired Parrish to design and paint wall decorations for its new clubhouse. For four years running he also received the commission to design the cover for the program of their annual theatrical production. The first of these commissions, for the 1895 production of *Kenilworth* (Fig. 69), was an eye-catching design consisting of two long-tailed elfin jesters in motley, cap and bells, holding a shield upon which was written the name of the club. The following year his cover for the program of *Very Little Red Riding Hood* (Fig. 70) was a drawing colored with brilliant red and blue oil glazes. In it Red Riding Hood gazes wistfully at the viewer. Her cloak and ribbons are arranged symmetrically in their frozen motion. Parrish, when working in this early poster style, seemed to prefer to use two-dimensional figures either in profile or facing full front, and rarely, if ever, included three-quarter views. A mood similar to that of *Very Little Red Riding Hood* is depicted in *The Young Gleaner* (Fig. 71), also painted in 1896. In this advertisement for a brewery, the young maid stares straight ahead with piercing melancholy eyes. In contrast to *Very Little Red Riding Hood,* the artist here has relied more on modeling and less on the element of line for his composition. Perhaps because of the

apparent Biblical allusions, the painting was never used as a beer ad.

The 1896 poster for the *Poster Show* (Pl. 29) held at the Pennsylvania Academy of the Fine Arts underscores Maxfield Parrish's position as one of America's leading turn-of-the-century posterists, along with Will Bradley, Edward Penfield and Louis Rhead. Adhering to the basic principles of poster design, *Poster Show* is attention-getting, with a message that is simple and easily read. The bold design with its effective distribution of light and dark masses and the subtle use of browns and tans, rather than brighter colors usually associated with posters, contributes much to the strength and interest of this exceptional work.

During the summer months of the mid-1890s Parrish enjoyed painting landscapes at Annisquam, Massachusetts, and at Windsor, Vermont, where he often visited his father. Meanwhile, with each successful poster or advertisement, there came more and more opportunities for him to apply his talent to commercial art and, by the end of the century, nearly all of his painting was being done on commission. He accepted a wide variety of commissions, among which were an advertisement for N. K. Fairbank Company (Fig. 72), a poster for the Philadelphia Horse Show Association (Fig. 73), and a menu cover for the Bartram Hotel (Fig. 74).

In order to stimulate interest in their advertising, as well as to locate outstanding designs and fresh talent, magazines and advertising companies frequently held competitions for poster designs, advertisements and magazine covers. These competitions created excitement not only among the artists but also among the hundreds of Americans who had become avid poster collectors. Parrish entered many such competitions and gained something of a reputation as a regular winner in them. As early as 1890, during his Haverford days, he had entered a competition for advertisement designs for N. K. Fairbank's Santa Claus Soap. Nearly a thousand designs were submitted and, of the twenty finally selected, six were his. In 1896 he received first prize of $150 in a competition for a poster

Figure 69. The Mask and Wig Club. *Program cover for theatrical production* Kenilworth. *March, 1895. Courtesy Maxfield Parrish Estate.*

Figure 70. Very Little Red Riding Hood.
Program cover. February, 1897. Drawing
colored with oil glazes, 24" x 18".
Courtesy Mask and Wig Club, University
of Pennsylvania. Photo: George Gelernt.

VERY LITTLE RED
RIDING HOOD THE
MASK AND WIG CLVB
UNIVERSITY OF
PENNSYLVANIA

design for H. O. (Hornby's Oatmeal) and first prize of $250 from among five hundred and twenty-five designs entered in the Pope Manufacturing Company poster competition for Columbia Bicycle.

Parrish made a design (Pl. 30) in April, 1896, to be entered in a competition to select a poster for the *Century Midsummer Holiday Number, August.* The rules of the contest stated that the design could require no more than three printings. Among the panel of judges to review the several hundred entries and to select the winning design were the artists Elihu Vedder and F. Hopkinson Smith. Parrish's design, which included a nude young girl sitting in profile on green grass, her arms clasped about her knees, with patches of light shining through a dense growth of trees in the background, did not adhere to the requirements of the competition. It required not three, but five, printings. Because his work was not within the guidelines of the competition, the judges could not award Parrish first prize. That honor went to J. C. Leyendecker. But Parrish was named for the second prize, and his poster, published by the Century Company in 1897, went on to become one of the most widely reproduced American posters of the era. A poster he made in June, 1897, for the *Scribner's Fiction Number, August* (Pl. 31) was hanging on the newsstands and in the bookstores at about the same time as the poster for the *Century Midsummer Holiday Number.* The designs were strikingly similar; however, in the *Scribner's* poster the figure faced right and was holding a book. The subtle, rich shades of brown and green and the graceful lines of the figure give this poster its own identity in spite of its similarity to the *Century* poster. The *Century* poster is divided horizontally into three separate areas—one for lettering, one for grass, and another for trees. In the *Scribner's* poster the artist brings the landscape, the figure and the lettering together into a more cohesive, more pleasing design. The startling color of the *Century* design, however, gives it greater impact as a poster.

The *Adlake Camera* poster (Pl. 32) was drawn by Parrish in November, 1897, just after he finished the illustrations for *Moth-*

Figure 71. Young Gleaner. *Poster. August, 1896. Oil on canvas, 42" x 28¼". Courtesy Schweitzer Gallery.*

er Goose in Prose. Were it not for the fact that the poster was in color and the Mother Goose illustrations in black and white, one could easily have mistaken the poster for an illustration from the book. Since Adams and Westlake Company, the manufacturer of the Adlake Camera, had its headquarters in Chicago, where the book was published, it is likely that he received the poster commission through his publisher, Way and Williams. In the illustrated panel of the Adlake poster, two quaint child characters sit facing one another with toes nearly touching. The boy aims his camera at the young girl, who, posing with her cat, smiles prettily for the snapshot. Although the girl is in contemporary attire, the boy wears tights, stockings, and a jerkin of some bygone, vaguely medieval, time. As in the drawings for *Mother Goose in Prose,* the artist here has accomplished the shading in the figures and in the attire through the use of stipple rather than a continuous tone or wash. The profile silhouette of the black cat, seen here at the side of the young girl, was frequently to be included in Parrish's advertisements and cover designs, but it did not become associated in the public's mind with his work as the cat image did, for example, with the work of the French posterist Theophile Steinlen.

Parrish made posters and advertisements in the late 1890s for *Harper's Weekly,* the *Evening Telegraph,* the American Water Color Society, for Sterling Bicycle, No-To-Bac, Royal Baking Powder, and the Improved Wellsbach Light, and he executed numerous catalog covers for Wanamaker's of Philadelphia (Fig. 75). One of the faces most familiar to magazine readers around the turn of the century was that of his Dutch Boy for Colgate and Company (Fig. 76). Parrish received twenty-five dollars for this design, submitted in competition for the company's Cashmere Bouquet poster. His simple, symmetrical design of a Dutch boy washing his hands in a bowl quickly became identified with Colgate. Although Parrish made no additional designs for Colgate and Company, other draftsmen adapted his Dutch Boy— and several identical sisters and brothers—

to every imaginable Colgate product. Those advertisements were published in the popular magazines for several years. One of the ironies surrounding the tremendous success of this advertisement is the fact that Parrish had used the same figure a year earlier in a similar ad for H. O. That the Dutch Boy became associated with Colgate rather than H. O. is probably directly attributable to the frequency with which it was used by Colgate.

Aside from a poster for the *Toy Show and Christmas Present Bazaar* held at Madison Square Garden in 1908, Parrish gave up poster and advertising designs for over ten years to concentrate on illustrating magazines and books and painting murals. It was not until about 1915 that he reentered the field of advertising art. One should note that his later designs for advertisements were made to be reproduced not only as posters, but in a variety of ways —on billboards, in magazines, as window cards, etc. Still, Parrish usually referred to them as posters rather than as advertisements.

A small painting of a crane, standing on one leg, seen against a background of mountains and a lake, was one of Parrish's designs that marked his return to advertising art. This painting was made to decorate the lid of the 1915 gift boxes of Crane's Chocolates. Clarence A. Crane, owner of the Cleveland candy firm for which Parrish made the advertisement, would eventually have an important effect on Parrish's career as an artist. Neither man, however, could have suspected this in 1915. (Parrish's work for Crane's Chocolates will be discussed in Chapter 5.)

When an advertising agency contacted Parrish to ask if he would consider painting a "fantastic" subject to be used as a perfume advertisement for Djer-Kiss Cosmetics, he replied that he would do it for one thousand dollars, this being the price he was being paid for the designs for candybox covers for Crane's Chocolates. Parrish painted the advertisement (Fig. 77) in July, 1916. In it he placed a young girl in a swing surrounded by flowers against a blue mountain background. A panel formed the base of the design and provided space for the

Figure 72. *Advertisement. Appeared in* Harper's Bazar, *March 28, 1896.*

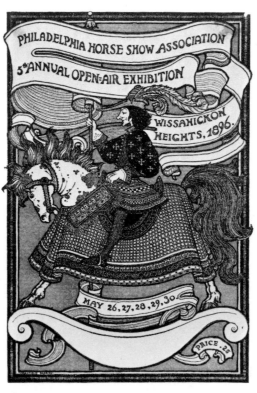

Figure 73. *Poster. 1896. Courtesy Maxfield Parrish Estate.*

advertising copy.

As news spread that Parrish was again making a few designs for advertisements, he was deluged with more offers for commissions than he cared to accept. The telephone calls and letters from potential advertisers interrupted his concentration and his work schedule to such a degree that he soon found it advantageous to form a more or less exclusive arrangement with Rusling Wood, owner of an advertising lithography firm in New York. Potential commissions would be referred to Parrish by Wood, who also had among his clients N. C. Wyeth and Jessie Wilcox Smith. Parrish reserved the right to decide whether or not a product and advertising concept offered interesting possibilities for his particular style of interpretation before accepting the commission. In 1914, when Wood had first contacted Parrish about a possible design, Parrish felt that the product did not offer much potential for illustration. He wrote to Mr. Wood:

There are some ideas or subjects that would not interest me. . . . But—if you have an idea that IS interesting I should be very glad indeed to have a try at it. And by interesting, I mean something extremely simple, just a figure, something that can be made with a "punch" to it, something the public will recognize wherever they see it. . . .

If you have an idea you would like worked out, say something on the same order as the Dutch Boy on the Colgate soap ad, let me know about it; I will gladly undertake it, and if I do not see a result that will do justice to myself or to you or to the product advertised, I will tell you frankly that I do not want to undertake it.

The art of pictorially advertising interests me very much, but I do think it is one of the most difficult arts to put across, and what makes success is an extremely subtle affair.[1]

In the arrangement with Rusling Wood, the advertiser would pay a specified amount for Parrish's design, and the lithographer would then make his profit on printing it as a 24-sheet billboard, or as a poster, window card or whatever was required. One well-known series of advertisements arranged through Rusling Wood's agency was that for Fisk Tires. There were four designs printed in the series, *The Magic*

Figure 74. The Bartram's New Year Greeting. *Menu design for Bartram Hotel, Philadelphia. December, 1897. 5½" x 7". Courtesy Maxfield Parrish Estate.*

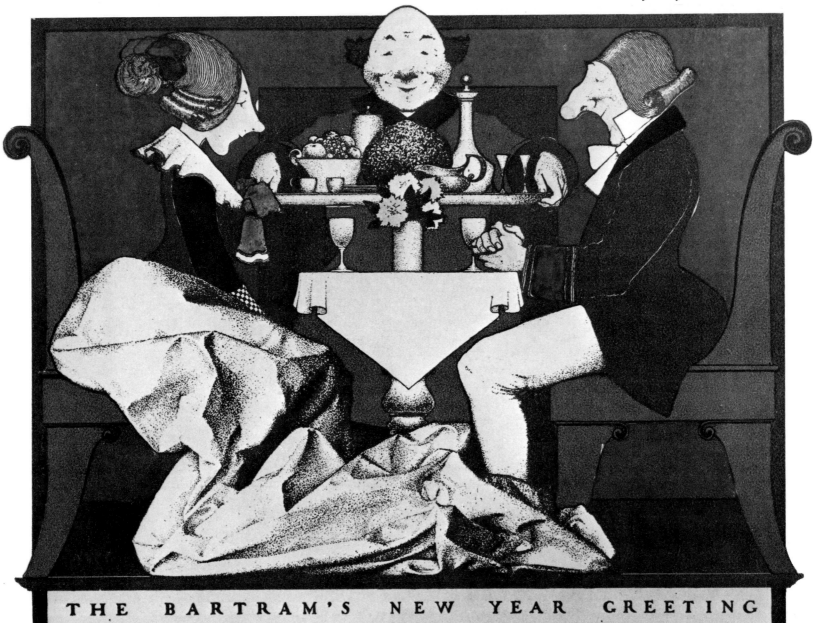

THE BARTRAM'S NEW YEAR GREETING

Shoe (1917), *Fit for a King* (1917), *Mother Goose* (1919), and *The Magic Circle* (1919). It had been suggested that Parrish try to incorporate into his designs for Fisk Tires the famous "Time to Retire" yawning boy, but he preferred not to work with another artist's trademark. Consequently, Parrish's designs for Fisk Tires were as amusing and varied as their titles suggest. In *Fit for a King* (Fig. 78), two sentries watch as two pages present a Fisk Non-Skid Tire for the king's approval. The sentries are self-portraits of the artist, painted from photographs for which he posed in the appropriate costume (Fig. 79). The face of Mother Goose in the 1919 advertisement (P. 33) also bears a close resemblance to Parrish, and it is likely that he served as the model, wearing the same felt, hat, for that figure as well. The accurate representation of a goose just beginning its flight was needed for the same advertisement, so Parrish purchased from a local farmer a cooking goose which he photographed and sketched for the design. A special family dinner, his son recalls, ended the modeling career of the goose.

A fifth painting for Fisk Tires, *There Was an Old Woman Who Lived in a Shoe* (Fig. 80), was never published. Parrish did incorporate into this design the Fisk yawning boy trademark—he can be seen through the open window just above the old woman's head. Some years later when Rusling Wood suggested that it might be converted into an advertisement for breakfast cereal, Parrish refused, saying that the design would be ineffective if changed. With tongue in cheek he added, "Have you tried the Birth Control League? I should think it would make a grand poster for them."[2] Although he frequently made changes of his own choice in his finished paintings, Parrish was generally opposed to suggested adaptations which would alter the compositional balance and harmony of a work as he had conceived it. He wrote to Rusling Wood about this matter in December, 1919:

I hope you don't think I'm a crank about my ideas of changing the original design, but

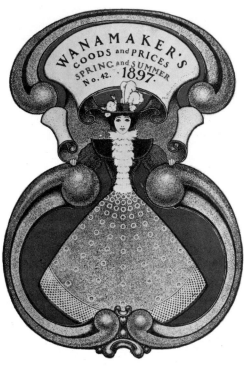

Figure 75. Wanamaker's Goods and Prices. Spring and Summer, No. 42. 1897. *Catalog cover. January, 1897. 15″ x 10½″.*

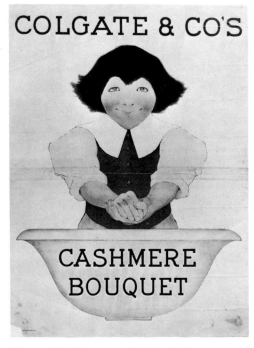

Figure 76. Colgate and Co.'s Cashmere Bouquet. *Poster. (This Dutch boy became the widely used symbol of Colgate products.) February, 1897.*

really I know I am right. There are a few of my architectural friends who seem to know what I am after, but I'm darn if anybody else does. You like my work, but I wonder if you know why you do. Well, putting modesty aside, I do think some of it, the best of it, has a quality of design about it that most of this kind of work lacks. By design, I mean a certain kind of studied subtle composition, a harmony of line and mass and color, just for all the world the stuff you find and enjoy in music. Now if you take a couple of bars out of *The Maiden's Prayer* and stick it in *The Star Spangled Banner* you are going to spoil both (though in this instance I am not quite sure). So that, in taking a figure out of the composition, out of his studied surroundings, and putting him somewhere else, something is going to suffer, believe me.[3]

Between 1916 and 1923, Parrish painted a series of four advertisements based on nursery rhymes and fairy tales for the D. M. Ferry Seed Company. The first two, *Peter, Peter, Pumpkin Eater* and *Peter Piper*, were simple designs with comic figures placed against plain backgrounds. Parrish realized the effectiveness of plain backgrounds and large areas of blank space in poster design. Unfortunately, he was seldom able to work in a true poster style after his landscapes became well received, for what the advertisers usually wanted, when they came to him with a commission, was a Maxfield Parrish landscape behind their products. "I do want some day to make a poster in which the blank spaces count," he wrote in 1917, "for I consider them of the greatest value in poster quality." In *Mary, Mary* (Fig. 81) and *Jack and the Beanstalk,* his last two designs for Ferry's Seeds, Parrish introduced an interesting poster quality by making the figures larger than life. Bringing the viewer down to the eye level of the kneeling Jack and the sitting Mary, the artist made the figures seem eminently larger. Mary, modeled by Parrish's young daughter Jean, even looks down from her seated position, placing the viewer slightly below her. The bottom edges of the pictures themselves served as the bases for the oversized figures, which dominated the picture areas. While there was only a suggestion of middle ground, the backgrounds were scaled down like theat-

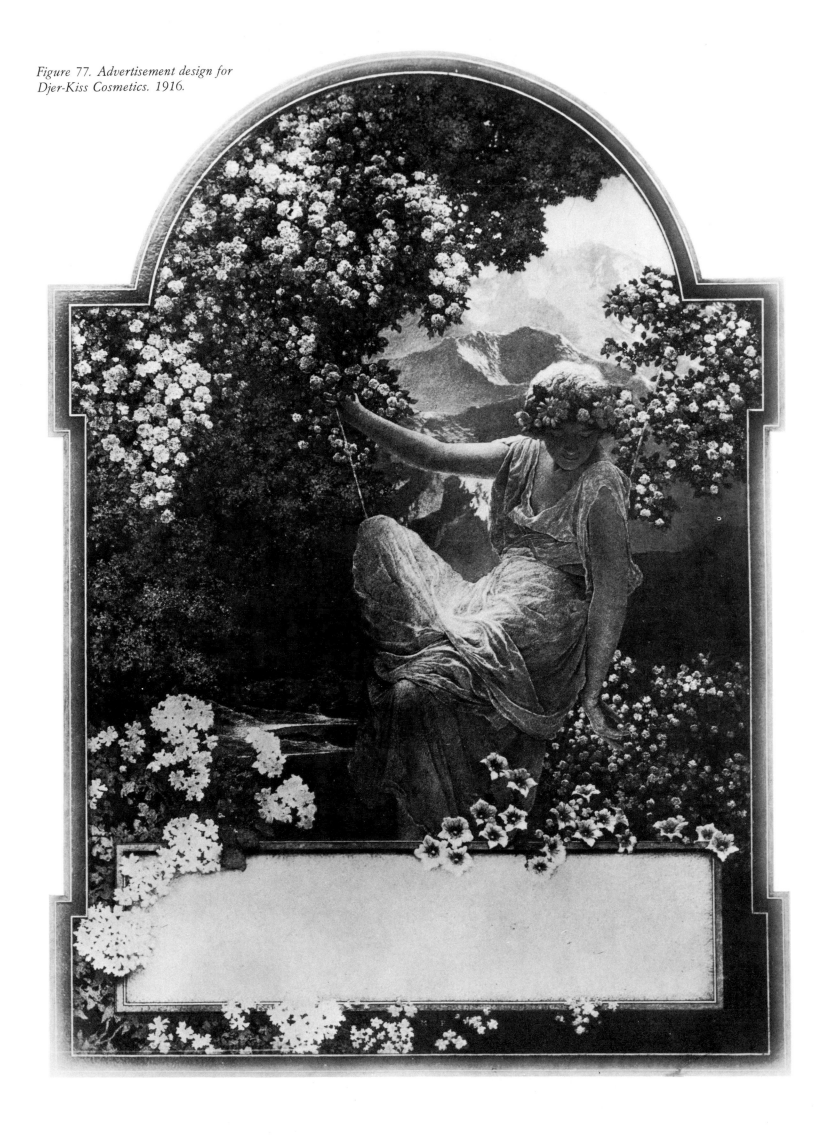

Figure 77. Advertisement design for
Djer-Kiss Cosmetics. 1916.

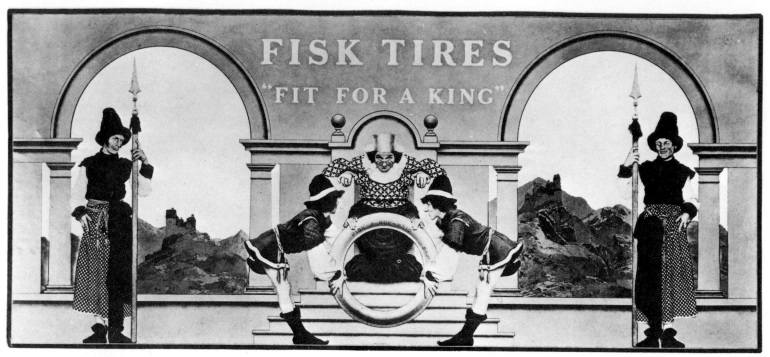

Figure 78. Fisk Tires—Fit for a King. *Advertisement for billboard, window card and magazine use. December, 1917.*

Figure 79. Parrish posing for photograph to be used in painting sentry in Fisk Tires—Fit for a King. *Courtesy Maxfield Parrish Estate.*

rical backdrops, again emphasizing the largeness of the figures and creating the impact essential in posters.

It is not known whether the poster that Parrish designed for the Red Cross during the First World War (Fig. 82) was ever actually used as a poster. The unusual design consisted of four panels in a single wooden frame. Two upper panels each contained a red cross inside a garland or wreath. In the lower left panel an old man and children, some of whom wear wooden shoes, receive Red Cross food packages. In the right panel a Red Cross nurse attends to a wounded serviceman, who rests in a deck chair. There is an attempt to unify the four panels by making the sky continuous throughout. As interesting as the individual panels might be, when taken together as a single unit they are not representative of the artist's more effective posters. In contrast to many war posters, these panels reflect some humanitarian aspects of the tragic conflict, and express something of Parrish's own personal philosophy.

Two pages present a large chest of silver for the approval of the viewer in Parrish's 1918 advertisement for Oneida Community Plate (Fig. 83). The setting suggests

Italy, although a tiny distant New England landscape can be seen between the bottom of the chest and the edge of the tile floor. With its Tuscan yellow arches and purple-robed pages, this advertisement reflects the Italian mood of the Curtis Publishing Company murals that he had finished painting only two years earlier. It also predicts the style of the illustrations for *The Knave of Hearts,* which would be painted four or five years later.

Parrish enjoyed good food and, consequently, many of his magazine and book illustrations and posters had subjects that dealt with the preparation and serving of food. It is not surprising, then, that some of his most delightful posters were those made to advertise food products. Jack Sprat and his not-so-plump wife enjoyed Swift's Premium Ham in a 1919 advertisement (Pl. 34) that was an updated version of the artist's amusing 1897 Christmas cover for *Harper's Weekly.* (Fig. 41) A billboard design for Hires Root Beer (Pl. 35) presented two gnomes as tasters for the drink, which was being carefully brewed in a large copper cauldron by a smiling cook. This proved to be one of Parrish's more popular advertisement designs. Not only

was it reproduced on a 24-sheet billboard and in magazines, but decals of it were made for glass doors of establishments serving Hires Root Beer. The two gnomes were reproduced as cutouts several feet high to be used with a Hires banner as a window advertisement. The rich purples and brilliant oranges of the landscape along with Parrish's comic characters brought many compliments from admirers, who felt that he was single-handedly upgrading outdoor advertising. Ironically, in 1939 Parrish designed a poster for the Vermont Association for Billboard Restriction in which the message admonished the public to "Buy Products Not Advertised on Our Roadsides."

Parrish wanted to paint subjects of his own choosing rather than to make posters, and whenever he accepted a commission he did so with reluctance. Early in his association with Rusling Wood, he made it clear that he wanted only a limited amount of advertising work.

I only want a little of this kind of work, for I find that the way I do it does not pay anywhere near as well as what we may call my regular work: pictures for plain people, overmantel panels, etc. I like it as a relief and a

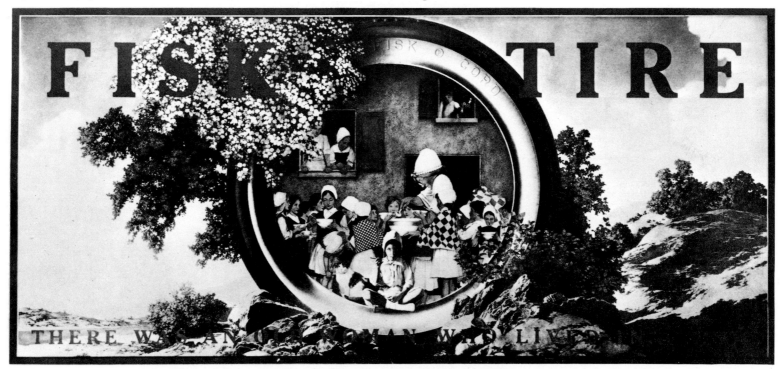

Figure 80. Advertisement. (Not published.) January, 1920. Courtesy Maxfield Parrish Estate.

Color Plate 25. Saint Patrick.
Cover for Life, *March 3, 1904.*
Oil on panel.
Photo: Columbia University Library.

Figure 81. Mary, Mary, Quite Contrary.
Poster for Ferry's Seed, 1921. Courtesy
Ferry-Morse Seed Company, Inc.

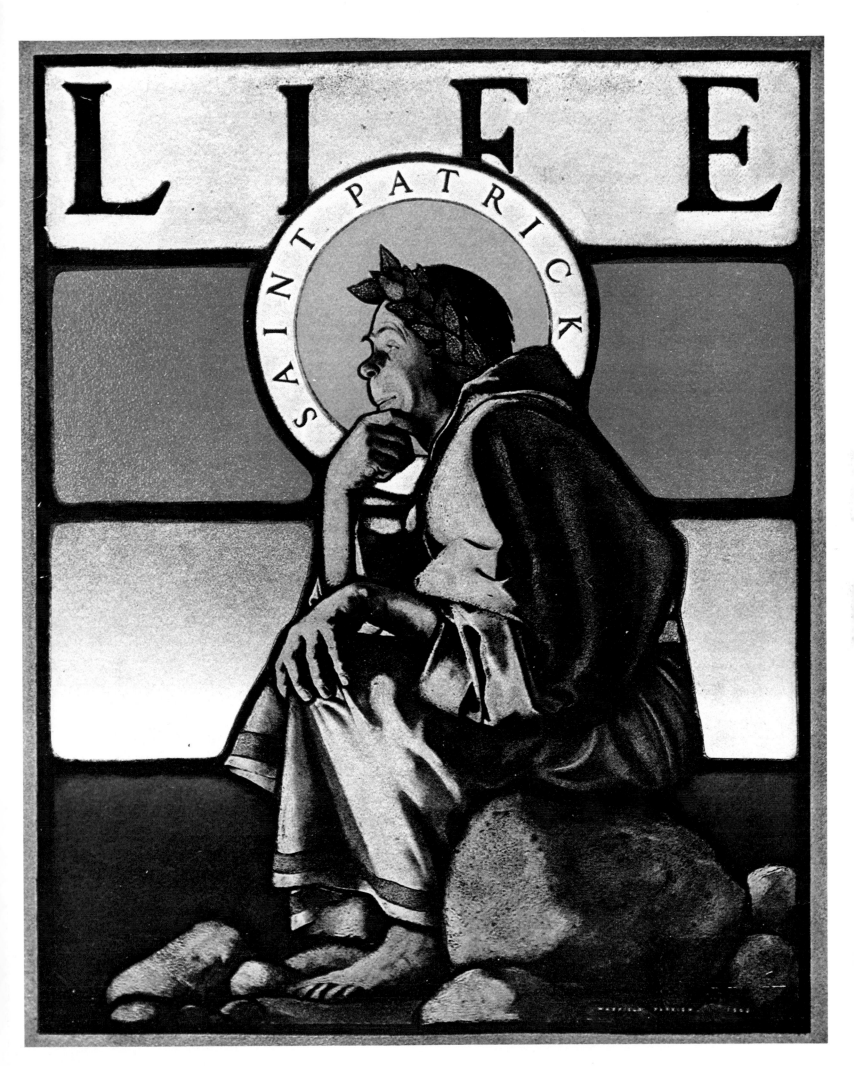

Figure 82. Untitled. Poster for Red Cross. Ca.1917.

Figure 83. Community Plate. *Advertisement. 1918. Courtesy Oneida Silversmiths.*

variety, and it is that, but too much of it wouldn't be good business. . . .[5]

A panel commissioned by Clark Equipment Company (Fig. 84) provided an opportunity for Parrish to paint what he liked painting best—landscapes—with only a hint of advertising included. The company, a manufacturer of axles, steel wheels, etc., commissioned twelve artists in 1920 to paint their own interpretations of "The Spirit of Transportation." Each artist was paid for his painting, and the twelve were entered in competition for a one-thousand-dollar bonus prize. Among the artists who participated in the project were Alphonse Mucha, Frank X. Leyendecker, Coles Phillips, James Cady Ewell, Jonas Lie and Maxfield Parrish. Parrish painted an extremely precipitous rocky gorge, devoid of plant life except for a single large pine tree at the right. Traveling down a precarious mountain road in the left center of the picture, two cargo trucks relate the landscape to the stated theme of the competition. The scene was particularly striking, and the painting a jewel of color. In the competition for the bonus prize, the judges were unable to select a single winner. Instead, they divided the award money among Parrish, Lie and Ewell. A few years later, in 1925, when the Clark Equipment Company wanted to have the Parrish painting reproduced as an art print for framing, the artist consented to remove the trucks from the original, leaving just the rocky landscape without a touch of commercialism. Parrish chuckled when people attémpted to give his painting a title. Once, when it appeared in an advertisement as "The Royal Gorge," he wrote to his publisher, "I was amused at the title. . . . The tree was taken outside my studio window here; the brook was from the back of Windsor, the rocks were from Bellows Falls, and a mountain or two from Arizona. And yet I've heard some say they had been just to that spot."[6]

Two Jell-O advertisements for the Genesee Pure Food Company were among the last works that Parrish did for Rusling Wood. The first of these, *The King and Queen Might Eat Thereof and Noblemen Besides* (Pl. 36), painted in 1921, was

Color Plate 26. A Merry Christmas. *Cover for* Life, *December 2, 1920. Courtesy old* Life *magazine. Photo: Allen Photography.*

Color Plate 27. A Good Mixer. *Cover for* Life, *January 31, 1924. Oil on panel, ca. 14" x 10". Courtesy Maxfield Parrish Estate and Vose Galleries, Boston. Photo: Herbert P. Vose.*

Figure 84. Spirit of Transportation. *Maxfield Parrish and eleven other artists were commissioned by Clark Equipment Company to paint their interpretations of the theme "The Spirit of Transportation," in competition for a one-thousand-dollar prize. Parrish's painting tied with two others for first place. 1920. Courtesy Clark Equipment Company.*

based on an idea that Parrish had earlier considered, but not developed, as an advertisement possibility for Lowney's "High-brows" Chocolates. In September, 1915, he had written to Rusling Wood:

. . . Suggesting the use of Lowney chocolates by "High-brows" . . . it just occurs to me that could we carry it up to royalty we could get something very good in the way of design . . . a king and queen upon their respective thrones being presented with a box of the subject in question. As a design and a vehicle for holding color I think it would work out quite effectively. Also, there is a good chance for the human interest: the action of the three people can be made to express their appreciation of the confection. The king and major domo could be made mildly humorous and the queen as pretty as possible. I do have a faint idea that it would be a contrast to the usual run of realism and prettiness. I know I could make good with this idea, as it seems to be in my own line.[7]

It was six years after he had written this description before Parrish had an opportunity to make the advertisement, substituting a dish of molded Jell-O for the box of chocolates. The design fairly glowed with richness and color. The artist was able to keep the picture of the product small by placing it at the center of interest as well as at the geometric center of the composition. In this way he could concentrate on the figures and their surroundings. A slight change was made in the design by the artist after its first appearance as a magazine advertisement. The advertiser wanted to reproduce the design forty inches wide in cutout form for use in store displays, but before this was done Parrish was asked to make some changes in the lettering of the word *Jell-O*. As he had never felt that the brilliant pink of the molded gelatin suited his color scheme, he took this opportunity to get rid of it. In doing so he eliminated the intermediate serving dish and placed a large mold of lemon-yellow Jell-O directly on the platter being held before the king. The change was judicious, for the larger mold of yellow Jell-O was more harmonious with the total design in scale and in composition. The second Jell-O ad, *Polly Put the Kettle On*

Color Plate 28. A Swiss Admiral. *Cover for* Life, *June 30, 1921. Courtesy Maxfield Parrish Estate and Vose Galleries, Boston. Photo: Herbert P. Vose.*

Color Plate 29. Poster Show, Pennsylvania Academy of the Fine Arts. *Poster. Lithograph, 1896. Sheet, 44" x 28"; composition, 30" x 23¾".
Courtesy Pennsylvania Academy of the Fine Arts. Photo: Allen Photography.*

Figure 86. Venetian Lamplighter. *1924 calendar for General Electric Mazda Lamps. 1922. Oil on panel. Courtesy General Electric Company.*

and We'll All Make Jell-O, was painted in 1923.

Parrish was determined to stop making advertisements. He was building a considerable reputation in the art-print market, and he knew that he could depend on a handsome annual commission for the General Electric Mazda Lamp calendar for which he had provided a painting each year since 1918. The other advertising work was becoming more trouble to him than it was worth, and his disenchantment could be seen regularly in his letters to Mr. Wood.

. . . As I told you I want to get out of advertising work on account of the endless interruptions it causes from men with the best intentions in the world coming to see me, or what is just as bad, making me spend days and days writing them letters telling them not to. I am perfectly sincere in this.[8]

Another thing, I am now very happy in the kind of work I am doing. Even making covers for *Life* is mighty good fun. They pay just as well as posters for only the reproduction rights: the originals come back to me, of which I have the exclusive print rights, should any be suitable for that purpose, and I can sell the originals. . . . I also want to do some serious painting for publication as prints for it would be a grand satisfaction to have an income three or four times the price of one poster for a number of years, and own the original as well. This is plain arithmetic, not to mention common business sense. . . .[9]

What I am doing nowadays, is to build up the print business. A successful print is a pretty good thing all round. In the first place I can paint exactly what I please, and then, if it's successful it means an income, a pretty big one, for a number of years. I have just finished an ambitious painting [*Daybreak*] for Reinthal and Newman, of whom I have a high opinion, and I'll wait and see what the picture is going to do for me. . .[10]

Parrish's success in the color-reproduction or art-print market is what eventually delivered him from the general advertising business, which he had come to regard as too confining. As his fame spread with paintings such as *Garden of Allah* and *Daybreak,* he was able to price himself out of the general advertising business and choose only those clients with whom he especially enjoyed working.

Figure 87. Dream Light. *1925 calendar for General Electric Mazda Lamps. 1924. Oil on panel. Courtesy General Electric Company.*

For example, his association with the Edison Mazda Lamp Division of General Electric was a pleasant and highly profitable one both for him and for the client. It began with a commission for Parrish to design the 1918 Mazda Lamp calendar. After his first Djer-Kiss Cosmetics advertisement was published in 1916, and advertising agents realized there was a possibility that he might once again accept commissions for poster work, Parrish regularly began to receive offers of such commissions. He refused most of them, for he simply was not enthusiastic about getting back into the area of poster design, which had occupied so much of his time around the turn of the century. But, as has been seen, he was persuaded to take up this kind of work again for about eight years, from 1915 until 1923. One of the calls that came following the appearance of the Djer-Kiss advertisement was from the Forbes Lithograph Manufacturing Company of Boston. Forbes wanted Parrish to design the 1918 Mazda Lamp calendar and offered him two thousand dollars to do it. He accepted. In *Dawn,* his first calendar for Mazda Lamps, the artist established the subject that he was to interpret again and again for them—a beautiful girl sitting on a rock surrounded by a mountain landscape. So great was the popular appeal of his calendars for General Electric that soon Mazda Lamps began to be identified with Maxfield Parrish's art.

Spirit of the Night (Fig. 85), the 1919 calendar, had Parrish's two familiar pages posed at attention before the steps on which a beautiful maiden pauses to adjust her shawl. The figure of the girl, bathed in light, stands out against Parrish's blue night sky. Forbes Lithograph Manufacturing Company spared no effort in making the reproductions of the Edison Mazda calendars as faithful to the original paintings as possible. *Spirit of the Night,* for example, was lithographed using twelve different colors, each of which required a separate press run. Subsequent calendars required from ten to fourteen colors. J. L. Conger, who handled the production of the Maxfield Parrish calendars for General Electric, wrote in an article in *The Artist*

Color Plate 30. Century Midsummer Holiday Number, August. *(Copyright, 1897.) Poster. April, 1896. Original design, 31½" x 22½"; lithograph, 19¾" x 13½". Photo: Allen Photography.*

Color Plate 31. Scribner's Fiction Number, August *(1897). Poster. June, 1897. Lithograph, 20" x 14½".*
Photo: Columbia University Library.

and *Advertiser* that the intricate lithographic process he used in reproducing the calendars was undertaken with utmost care. If required, as many as fourteen color-separation photographs would be made of the original painting. These would then be printed on separate lithographic stones to serve as guides for the lithographer in making the actual drawings on the stones. The lithographer always had the original painting in front of him when he was working on these drawings. Because the stones would not endure the number of printings required to make over a million calendars, they were used only as patterns for the more durable aluminum plates from which the actual printing was done. The paper on which the calendars were to be printed was coated and then kept in the press area, where the atmosphere was carefully controlled. The paper had to achieve and maintain an equilibrium with the constant atmosphere of the pressroom. Had the humidity in the room been allowed to increase or decrease, the paper would have expanded or contracted accordingly, causing the color registration (the matching of the images of the different impressions) to be inaccurate. One can understand the complexity of the problem upon realizing that the 1930 calendar alone required twenty-one million press impressions to complete the run.[11] The Parrish calendars were eagerly sought by housewives, many of whom removed the date pads at the year's end and framed the prints to use in decorating their homes.

Most of the calendars were issued in two sizes, a large size (38″ x 18″) for intra-organization use and a small size (19″ x 8½″) for distribution to the public—although there were three sizes of the 1919 calendar and only one size for the 1932 number. The editions of the small calendar are almost staggering. They increased steadily from 400,000 copies of *Spirit of the Night* (1919) and 750,000 of *Prometheus* (Pl. 37) (1920) to 1,250,000 copies of *Venetian Lamplighter* (1924) (Fig. 86) and 1,500,000 of *Dream Light* (1925) (Fig. 87). Editions of the large calendar ranged from 10,000 in 1918 to 45,000 in 1930. In addition, pocket calendars (3¾″ x

2½″) were issued in editions ranging from 100,000 to 250,000; these were printed in four colors on celluloid. And quantities of playing cards decorated with the calendar designs were handed out. Between 1917 and 1931 over 17,000,000 of the regular calendars and 3,000,000 of the celluloid pocket calendars were distributed. General Electric estimated in 1931 that if each of the regular calendars was seen by one person each day in the year that it was current, they would have delivered about 7,000,000,000 advertising messages for Edison Mazda Lamps since 1918.[12] If Maxfield Parrish was not already known to nearly every man, woman and child in the United States through his illustrations and poster designs, his name certainly became a household word through the Edison Mazda calendars.

At the suggestion of the advertiser, a series of designs depicting the history of light was begun in 1920. *Prometheus* (Pl. 37), the first in the series, was a painting of which Parrish was proud. He felt that he had been successful in achieving the feeling of space that he had sought, but he was especially pleased with the rendering of the wispy cloud which appeared to float in space at the feet of the Greek god bringing fire to mankind.

In September, 1919, Parrish was too busy to travel to Boston, as he had done in some previous years, to discuss the subject for the 1921 calendar. So representatives from Forbes Lithograph and General Electric went to Cornish to confer with him there. Every imaginable subject from "Vestal Virgins" to "Roman Home Life" was considered before the decision was made to depict the use of fire for heat and light in the domestic life of *Primitive Man*. It was also decided that the third calendar in the series should be based on Cleopatra, showing the limitations of artificial light during her time. This subject, as finally painted, was called simply *Egypt*. Parrish did not like the idea of a series of fixed subjects, for he felt that it imposed upon him the same restrictions as general commercial advertising, from which he had been attempting to free himself.

I hope you will understand [he wrote to Mr. Morgan at Forbes Lithograph] . . . it is foolish for me to do any commercial work which I am not interested in. I mean also that this, what we might call "dictated" work is becoming more and more irksome to do, and as I make more money from the work that I really care for, and get far more enjoyment from it, naturally I cannot be blamed for disliking the other. . . . I would be ever so glad if I could give up the Primitive Man and the one to follow, because they are not the kind of thing that I would choose to do: I will do them, of course, as well as I know how, because I said I would, but I would make more money and be very much happier if they were pictures of my own choice.[13]

He was somewhat consoled when told to paint the pictures in any manner that would please him, without restrictions. But Parrish felt as any serious artist would feel— that he wanted to select his own subjects and paint them according to his own ideas. The final two paintings in the "History of Light" series were *Lamp Seller of Bagdad* (1923) (Pl. 38) and *Venetian Lamplighter* (1924) (Fig. 86). The Arabian Nights setting of the *Lamp Seller of Bagdad,* in which an exotic young maiden is seen examining the wares of an old lamp peddler at the city gate, helped to make this a delightful picture of the genre in which Parrish is most at home. By placing the larger foreground figures in shadow and the smaller background figures, bargaining over some unknown deals, in brilliant sunlight, he has called attention to the ambiance of the Bagdad street vendors rather than to a single transaction between the two foreground figures.

When the final painting in the series was finished in December, 1922, Parrish did not begin another calendar for Edison Mazda Lamps. He was determined to accept no further commissions for work made to order, work that inhibited his freedom of expression and gave him no real satisfaction. His painting *Garden of Allah* was having at the time extraordinary success in the art-print market, and in the same month that he had finished the last Edison Mazda calendar, *Venetian Lamplighter,* he also had finished a painting of his own choosing, *Daybreak.* This painting, he felt,

had a chance of achieving some success as an art print. At any rate, it was the kind of painting that he enjoyed. He realized, at the age of fifty-two, that if he were ever going to do the serious landscape painting he had always wanted to do, he had better get started.

Daybreak was sent to the publisher, and it was arranged that Parrish would travel to New York in June, 1923, to check the proofs of the reproduction. Forbes Lithograph asked if he would return to Cornish by way of Boston so that he might discuss the possibility of a 1925 calendar subject with a representative of General Electric. The Parrish calendars had become a necessary part of the Mazda Lamp image, and the company felt that the tradition must continue. Parrish, on the other hand, knew that if he painted pictures to be reproduced as art prints he could paint the subjects he felt he did best, and that in addition he would receive a great deal more money doing it. General Electric had paid him two thousand dollars for the first calendar, gradually raising the fee to five thousand for the last one. "For the life of me," Parrish wrote to Forbes Lithograph, "I cannot see how . . . [General Electric] can offer terms that compete with the same picture being made for a print instead of a calendar."[14] But he underestimated his importance to Edison Mazda Lamps.

At the meeting in Boston an arrangement was made which Parrish and General Electric honored for many years to come. He agreed to continue painting calendar subjects for Edison Mazda Lamps, but there would be no more assigned themes such as the "History of Light." He would paint whatever he considered to be appropriate and interesting, submit it to General Electric, and if they used it he would receive his fee. If they did not wish to use it, he would still have his painting to dispose of in any way that he pleased. According to the arrangement, General Electric no longer would purchase the paintings outright. They were to have use of the paintings for one year only, to reproduce as calendars, advertisements, etc., but they could not reproduce them as art prints to sell. At the end of the year, the original

paintings were to be returned to the artist, and General Electric would have no further claim on them. In order for the distributor of the color reproductions of Parrish's work to be able to use the calendar subjects as art prints, it was also agreed that the familiar Edison Mazda coat of arms and ribbons with the name of the product no longer would be a required part of the picture itself. The borders, which Parrish always had found routine and time-consuming to prepare, in the future would be prepared by the lithographer. And the fee that he would be paid for the year's use of each painting would be ten thousand dollars. *Dream Light* (Fig. 87), which Parrish called *Girl in a Swing,* was the first calendar to be made under this new arrangement, and Parrish seemed pleased with the results.

In this particular one, I was fairly well satisfied with the girl, as telling the story, telling it quietly, naturally, without any frills. I was a little suspicious of it, however, when my carpenter Ruggles thought it the best thing I'd ever done. There was quite a "varnishing day" here of people to see it before it was put in its box, and the popular appeal seemed

very genuine, but that, of course, has nothing to do with the reception by more enlightened ones in more effete localities. . . . As a picture for this particular purpose I do not like it as well as the Bagdad one; that, with its brilliance and poster quality I think the best of the series.[15]

Parrish did not paint another calendar for General Electric the following year, but received from them a fee for the use of a painting he had done earlier, *Cinderella.* This had been sold years before to the Hearst Corporation, which used it in 1914 as a cover for *Harper's Bazar.* The title was changed to *Enchantment* for the Edison Mazda calendar. Each New Year thereafter, for the next eight years, a new Maxfield Parrish calendar greeted the users of Edison Mazda Lamps. Each of them depicted one or two beautiful young maidens in a rocky or wooded landscape.

Parrish attempted in his 1930 calendar (Fig. 88) to vary the theme and format from what he had been using. He wrote to General Electric that he had "in mind a single figure, fairly large, expressing ecstasy. I don't know at all if I can do such a thing, but I can make a try at it anyway."[16]

Having for some time been a firm believer in the principles of Dynamic Symmetry, he decided to forgo the tall thin shape that had become traditional for the calendar subject and make the picture shorter. Parrish wrote to Mr. McManis at General Electric, and in his letter explained what he meant by Dynamic Symmetry.

For the 1930 I would advise the picture to be shorter.

Of late years I have been doing all my work on a layout, so to speak, of Dynamic Symmetry, a rediscovery on the part of Jay Hambidge of the old Greek method of making rectangles. Those familiar with this method consider that these dynamic rectangles are far more pleasing than just arbitrary rectangles, and not only that, but by their subdivisions they permit every feature of the picture to be a harmonious part of the whole panel. If done with intelligence there is a certain balance to the design which is of great value. . . .

Now these dynamic rectangles are very simple things, but they are fixed, and you can have only certain ones, or compound ones.—This may sound like sheer lunacy, but take my word for it, there is a lot in it. . . .[17]

Color Plate 32. The Adlake Camera.
Poster. November, 1897.
Courtesy Maxfield Parrish Estate.
Photo: Allen Photography.

Color Plate 33. Mother Goose.
Advertisement. 1919.
Courtesy Maxfield Parrish Estate
and Fisk Tires, Uniroyal Tire Company,
division of Uniroyal, Inc.
Photo: Allen Photography.

In the early 1930s the popularity of the Edison Mazda calendars began to wane slightly. The figure for the 1934 calendar had not been thought to have particular advertising appeal, causing General Electric to reduce the edition to 750,000. (As soon as the original painting was returned to him a year later, the artist removed the figure and painted the spot where it had been to match the background.) Parrish realized that he had lost interest in painting figures for calendar subjects, and that he preferred to paint pure landscapes. Having been asked for a number of years, he agreed to paint a simple landscape to be reproduced by Brown and Bigelow, one of the nation's larger distributors of calendars and greeting cards. Up until this time Edison Mazda had enjoyed what amounted to the exclusive use of Parrish's work as calendar subjects, and the company was not particularly pleased that the artist's calendars would now be available to any local advertiser. To all parties it was obvious that the time had come to discontinue the Maxfield Parrish calendars for Edison Mazda Lamps. The 1934 calendar, painted in 1932, was the last of the series.

Shortly before painting this last calendar for General Electric, Parrish had his notable "Girl-on-Rock" interview with the Associated Press.

I'm done with girls on rocks. I've painted them for thirteen years and I could paint them and sell them for thirteen more. That's the peril of the commercial art game. It tempts a man to repeat himself.

It's an awful thing to get to be a rubber stamp. I'm quitting my rut now while I'm still able.

Magazine and art editors—and the critics, too—are always hunting for something new, but they don't know what it is. They guess at what the public will like, and, as we all do, they guess wrong about half the time.

My present guess is that landscapes are coming in for magazine covers, advertisements and illustrations. . . .

There are always pretty girls on every city street, but a man can't step out of the subway and watch the clouds playing with the top of Mount Ascutney. It's the unattainable that appeals. Next best to seeing the ocean or the hills or the woods is enjoying a painting of them.[18]

True to his word, Parrish, who was sixty years old at the time, soon stopped painting the familiar girls-on-rocks. His creative efforts for his remaining thirty years were directed toward the painting of landscapes for his own pleasure and for reproduction by Brown and Bigelow.

There can be no doubt that Maxfield Parrish executed some of the unique and most memorable posters and advertisements of the 1890s and early 1900s. There can also be no doubt that he enjoyed doing it. He was young, full of talent and vigor, and he had a lifetime ahead to establish his reputation as a serious landscape painter. But later, after not having designed advertisements for over ten years, he found himself in his late forties and early fifties being pulled back into commercial advertising by the lucrative fees, and then he indicated that the enjoyment was not so keen. He wanted desperately now to live his dream of painting only landscapes. But, being a man with family responsibilities who earned his living painting, Parrish knew that he must find a way to maintain his income through his landscapes if he were going to paint them exclusively. Eventually, his alliance with Brown and Bigelow provided this opportunity.

Figure 89. Cleopatra. *Decoration for 1917 gift boxes of Crane's Chocolates. Oil on panel.*

Chapter 5

COLOR REPRODUCTIONS

The American passion for art reproductions was born and nurtured in the nineteenth century. Although certain wealthy and well-educated Americans had collected paintings, sculptures and engravings for some years, it was not until about the time of the Civil War that a popular culture of broad scope began to emerge. Currier and Ives prints and Rogers Groups plaster casts were among the more popular, mass-produced works of art made especially for this new audience. Later on, Timothy Cole's engravings introduced the great masterpieces of European art to the readers of the popular magazines, and eventually the development and refinement of the various color printing processes made accurate reproductions of both European and American paintings available to the public at prices nearly every family could afford. Color reproductions suitable for framing became a profitable concern for many an enterprising businessman, and a lucrative sideline for numerous magazines.

Maxfield Parrish's paintings were first made available as color reproductions toward the end of 1904. The *Ladies' Home Journal* offered its readers color reproductions of his prizewinning cover design *Air Castles* (Pl. 16) for ten cents. Shortly thereafter Charles Scribner's Sons issued as color prints four of the illustrations from Eugene Field's *Poems of Childhood.* Three of the Scribner's reproductions had been painted originally for the *Ladies' Home Journal,* from which the reproduction rights had been purchased. The fourth, *Dinkey-Bird* (Pl. 2), was painted especially for Scribner's edition of the Field book. The reproductions were widely distributed, and Scribner's acknowledged the artist's creative role in the project by paying him a royalty on each reproduction sold. Some years later many of the illustrations that Parrish regrettably had sold outright to *Collier's* and other magazines were published as art prints by the Dodge Publishing Company. As Parrish no longer held any legal claim to the copyrights for these works, he shared none of the income from the reproductions and had no control over how the designs were used.

Until the 1920s, all of the available art prints of Parrish's paintings were actually reproductions of works originally made for other purposes. Although Parrish enjoyed a small royalty income from some of them, he did not make any paintings with this kind of reproduction in mind. Oddly enough, it took Clarence A. Crane, a candy manufacturer from Cleveland, Ohio, to make Parrish understand the real potential of his works as mass-produced wall decorations for middle-class American homes.

Clarence Crane, the owner of a chain of candy shops and restaurants which manufactured, packaged and distributed chocolates in Cleveland and New York, elevated the reputation of his product by providing quality merchandise in luxury wrappings. He was a hard-working, self-made businessman. Sometimes, seeming envious of colleagues who possessed a more refined background and a knowledge of the arts, he expressed regret at not having had an opportunity as a youth to learn about these things. But until he encountered Maxfield Parrish, who was once referred to as "a businessman with a brush," Crane had never considered the financial possibilities of art. The fact that his teen-age son, Harold Hart Crane, showed more interest in literature than business was difficult for him to understand, and he joked about sending young Harold (who later dropped the "Harold" and used his middle and last names—Hart Crane) to Cornish to see if some of Parrish's ability to combine business and art into a successful career would not rub off on him.

Parrish was finishing up the last of the murals for the Curtis Publishing Company when Crane first contacted him to make a small decoration, a kind of logo, for the 1915 cover of Crane's Chocolates Christmas gift boxes. About ten thousand of the packages with Parrish's design, a large, white crane standing on a banderole on which was inscribed the name of the product, were sold. Based on this success, Clarence Crane immediately placed an order for a 1916 Christmas gift-box decoration. What Crane wanted was a package with a certain prestige that would appeal to his upper-middle-class clientele. Consequently, he attempted to raise the candy

Jack Sprat could eat no fat,
His wife could eat no lean—But when they had

Swift's Premium Ham

They licked the platter clean

Painted by MAXFIELD PARRISH

SWIFT & COMPANY, U.S.A.

Color Plate 34. Jack Sprat.
Advertisement. 1919.
Courtesy Swift and Company.
Photo: Library of Congress.

Color Plate 35. Ask for Hires and Get the Genuine.
Advertisement. Ca. 1920. Courtesy Maxfield Parrish Estate
and the Hires Company. Photo: Allen Photography.

box from the pedestrian level by commissioning popular art with exotic themes, suggested by himself, for the package decorations. The first of these special package illustrations, commissioned from Parrish for the 1916 Christmas gift box, was to have Omar Khayyam as its subject. Crane suggested the subject, and Parrish responded with his ideas for its interpretation.

My idea is to make this picture very rich in color and have the scene in a late afternoon golden light with strong lights and shadows. There should be a very fine old tree, and off in the distance the desert with desert mountains blue and purple in the rich afternoon light. Of course the lady should be as beautiful as possible, and Omar I suppose should be reading to her from the book. The jug will be there, but inoffensively.

Now, should there be a box of Crane's there or not? Just as you say.[1]

This last statement by Parrish is a clear indication that he conceived the design as an advertisement, just as those he would soon make for Jell-O and Fisk Tires. The finished work (Pl. 39), about thirty inches long, had neither jug nor box of Crane's— only Omar under a large, old tree reading to a beautiful maiden from the *Rubaiyat*.

The copy or lettering was not painted on the advertisement itself, but was done on a separate sheet and applied to the box lids through the use of a hot press. This way Crane was able to use the original copy-free painting as a decoration in his home, where it was hung over Hart's piano.

Both Parrish and Crane made a mistake at this point in their business relationship, for neither of them thought of drawing up a formal agreement concerning future publication rights of the illustrations. Crane naively believed that if he purchased the original illustration he owned all rights to its future publication. Parrish, having already suffered embarrassment and financial loss in what he considered the unethical use of his old *Collier's* covers to illustrate Palgrave's *Golden Treasury of Songs and Lyrics,* should have insisted on a clear, written agreement. Instead, not a word about future use or royalties was mentioned by either man at this point.

When the *Rubaiyat* panel was mailed to Cleveland on March 6, 1916, Parrish explained that, being familiar with the peculiarities and limitations of reproduction methods, he had painted the panel so that the reproduction, not the original, would be more faithful to his conception.

I think a word or two is necessary by way of explanation. In making this design I have tried to keep in mind the fact that the final result will be much smaller, probably not over ten inches long, and the scheme I had in view was one of a rich jewel-like brilliancy. Therefore the original, to my thinking, is a bit too brilliant, if the result is to be considered for a picture of the size of the original. We all know how, in the process of reproduction and the reduction in size, this life and brilliancy is lost . . . [so] I have made the design stronger in this respect than would be warranted if this were a painting plain and simple, not intended for reproduction.[2]

Crane was delighted with the illustration and, in addition to the small reproductions to be attached to the top of the candy boxes, he ordered two thousand of the same size as the original picture. He thought that the small picture on the package would create an appetite for a larger one, and he therefore planned to include an order blank for the larger print in each box of candy, making it necessary for the customer to purchase a box of candy in order to obtain the larger picture. Even before the *Rubaiyat* proofs were received from the printers, Clarence Crane was busy planning for the 1917 holiday candy sales. He decided that

the subject of the next box decoration must be Cleopatra, and Parrish agreed to paint it.

Cleopatra is welcome here, or any lady of history of undoubted charm. She was not particularly good looking they tell me, but had a "way" with her. . . . Of course there are no end of subjects. All I care about is something that can hold color and be made effective.[3]

Parrish considered the reproductions of the *Rubaiyat* to be a total disaster. The subtle rendering of the afternoon sun's glow in the original appeared garish in the reproduction. He blamed the lithographic process used in making the reproductions for the aesthetic failure of the *Rubaiyat* print. "Oh, anything but that color lithography," he wrote to Crane about the printing process to be used in future editions. "I cannot bear the Omar. The cook loved it, and I gave it to her."[4] Further, Parrish disapproved of Crane's using his name to imply an endorsement of the product. The candy manufacturer had worked out a business arrangement with Mary Garden which allowed him to issue a candy box patterned in musical notes with the inscription "Music by Mary Garden. Candy by Crane." But when Parrish got word that the *Rubaiyat* box was to be called "The Maxfield Parrish Package," he put a stop to it (although the first edition was already being marketed). "You see," he protested, "I do not mind your saying that the design is by me, but I somehow don't like the idea that the article sold, or rather its container is mine. Because if I did many things of this kind for different kinds of merchandise, I would become the god-father of each article. . . ."[5] Parrish was assured that in subsequent editions his name would be removed.

The *Cleopatra* gift box was to be an unusually fine production, with Parrish's illustration on the top and cloth-of-gold paper imported from France on the side panels—and a price of five dollars per pound. Looking ahead, Crane asked Parrish to commit himself to an annual decoration for the candy boxes. The artist, in November, 1916, interrupted work on the painting of *Cleopatra* to reply.

I cannot promise to make one every year. To tell you the truth, some day soon I hope to give up this kind of work entirely. I mean, I've been looking forward to the day for years when I could do my own work, just the things I want to do, and no orders, nothing but just to try to express the things that are inside me. Landscapes mostly, or figures when I want to. The time isn't quite ripe yet, perhaps, but I feel it is coming along sooner than it was some years ago. . . .[6]

Cleopatra (Fig. 89) arrived in Cleveland on April 16, 1917, to an enthusiastic reception. The unusual design, with subjects in costumes reminiscent of silent-film exotica, combined several bare-chested oarsmen, a female attendant, and Cleopatra in a loose robe reclining on a bed of roses in a frame of frozen moonlight. The lapis lazuli blue water and the typical Parrish blue starlit sky were separated at the horizon by white mountains. Polka-dotted and checkered fabrics, used as the lap robes of the oarsmen and the headdress of the standing figure, were a favorite motif of the artist. He used them boldly for their full optical effect, but with the exception of *The Idiot* (or *Booklover*) and several covers for *Life,* the geometrical, optically illusory effects seldom became the main thrust of the composition. These precursory motifs of the Op Art movement usually were employed only for accent or contrast by Parrish.

While vacationing with his wife at Saint Simons Island, Brunswick, Georgia, in May 1917, Parrish received word that the subject for the 1918 Crane's Chocolates gift-box decoration would be the Garden of Allah. Parrish was extremely busy with commissions for other clients and not at all certain that he wanted to do another candy-box decoration. He was certain, however, that he wanted to stop making paintings based on subjects dictated by clients. When he returned to Cornish, he wrote a letter to Crane that marked the beginning of the end of his dealings with the candy manufacturer. In this letter he attempted to suggest a satisfactory arrangement regarding royalties for the use of his illustrations.

Now, maybe, I can sit down and write to you with a better imitation of intelligence than was possible down on that little lazy island. A picture goes off in an hour or so, rushed to death on it as usual, and believe me, right here, it is the last thing I will ever do that has to be rushed. To say nothing of wearing you all out, it makes bad work, and that makes you mighty unhappy.

About the next one. You do seem to have an admiration for my work that is not entirely justified. I wonder how you would like one that I really liked? . . . I like your suggestion of the Garden of Allah, but I am not quite sure what you mean. . . . There is a book about it which I have not read, but I think we have it here in the house. Then there was a silly play I saw in New York, beautifully given, with wonderful effects of desert and moonrise. Was it that you had in mind? To tell you the truth I am not very strong on subject pictures, historical affairs, like Cleopatra or Omar. I would much rather do things like ideal gardens, spring, autumn, youth, the spirit of the sea, the joy of living (if there is such a thing). And what is more, I think the vast public likes them better when the artist can get his idea "across," to borrow from Wordsworth. They are the hardest things in the world to do, and consequently the most interesting. I kind of wish you had seen the one [*Dream Light,* Fig. 87] I did for the General Electric people, a sort of calendar they are to bring out in the fall to remind the public that they make a good lamp.

. . . I think I got a little of the spirit of the thing. Enough so anyway, to fool the G. E. people, who phoned and wired and wrote to tie me up for one every year till the crack of doom. Oh yes, it was rushed too, and it might have been better. Do you know what I mean by getting the spirit of the thing? I mean the spirit of the things in which we take most joy and happiness in life. The spirit of out of doors, the spirit of light and distance . . . that is a quality not lost on the public, I feel sure. . . .

Now, here is another thing. Very sordid. I have a snug little income that dribbles in now and then from royalties, a by-product from the sale of prints. Where I have made paintings, and where the prints of them are offered for sale, the publishers divide one half the royalties with me; that is they take one half and send me the other half. These have always been offered to me, I have never asked for them, so that I have come to believe it is

Figure 90. Study for Daybreak *(Pl. 41).*
Courtesy Maxfield Parrish Estate.

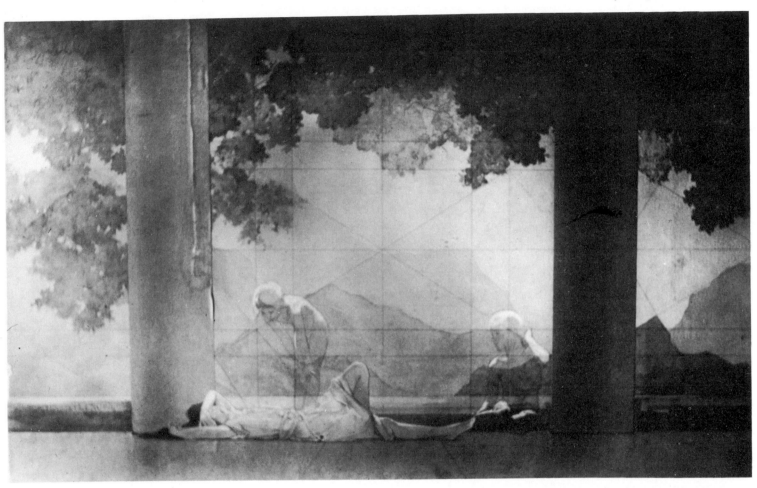

fair business to expect them. Now how would you feel about sharing the royalties with me on work I did for you that was put out for sale in print form? I never mentioned this to you because somehow it never occurred to me that you would sell the prints of the paintings. And right here, let me add that you had every conceivable right to do so. I would like to make some more covers for you, but if I do, they are to be done in advance and no rush whatsoever. I'll begin the next one sometime this summer for 1918 Christmas, if you wish to go on with them.[7]

Although Crane had little understanding of the rules of print business or the sharing of profits in the form of royalties, he indicated that he was willing to pay the customary percentage, if this would be acceptable to Parrish. At this point neither the artist nor his client could predict that thousands of dollars eventually would be made from the sale of reproductions of the candy-box

illustrations. Crane regarded the art prints as a means of building prestige for his firm and a moderately profitable service he might provide for his customers who wanted replicas of the candy-box illustrations suitable for framing.

Maxfield Parrish paid Clarence Crane a visit in early July, 1917, stopping en route to see Niagara Falls, and perhaps traveling by lake steamer from Buffalo to Cleveland. The purpose of the trip was not primarily to visit Crane, however, but to meet with Mr. and Mrs. Seiberling of Akron, to study a wall area in their home for a possible mural decoration. The mural commission never materialized, but the trip gave Parrish and Crane an opportunity to visit and to discuss past and future commissions.

Garden of Allah (Pl. 40) was begun by Parrish in mid-January, 1918. Work on the 15″ x 30″ painting progressed rapidly,

and it was delivered in Cleveland scarcely two months later on March 9, 1918. Although Crane had suggested the subject, Parrish's interpretation of it was far less exotic than he had expected. He had simply painted a garden scene with a reflecting pool and lovely maidens. The only suggestion of desert was the headdresses worn by the women.

The Garden of Allah was another favorite subject in the popular culture of the early twentieth century. Robert Hichens' 1904 novel, *The Garden of Allah,* was widely read into the decade of the 'teens, and the play based on the subject had enjoyed a successful New York run. It was the play that had given Parrish his idea for the interpretation of Crane's suggested title.

As to the conception of the Garden of Allah, I fear I went entirely upon a scene I saw in

Color Plate 36. The King and Queen Might Eat Thereof and Noblemen Besides. *Advertisement. 1921. Courtesy Maxfield Parrish Estate and General Foods. Jell-O is a registered trademark of General Foods Corporation. Photo: Allen Photography.*

Color Plate 37. Prometheus.
1920 calendar for General Electric Mazda Lamps. 1919. Oil on panel. Collection Arthur F. Loewe. Courtesy General Electric Company. Photo: McDonald Studio.

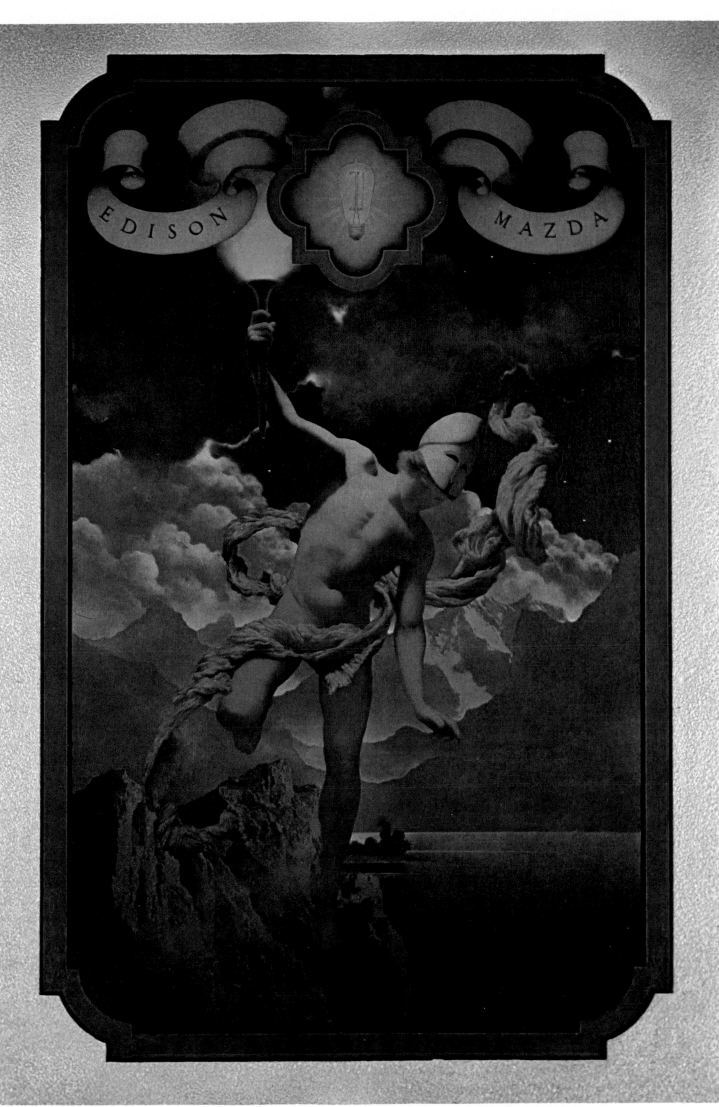

the play. This was the garden scene, the Garden of Allah, for a swell gent in a white flannel suit who seemed to own it, said so. It was the most gorgeous bower of trees and flowers and water and things, and two wicker chairs. So I took for granted that the place was some kind of fairy-land oasis somewhere in the Sahara, a great deal more than just a few date palms and the usual water hole. I looked it up in all our research material here but could find nothing of that name.[8]

Parrish's *Garden of Allah* was peopled with three stylish young maidens relaxing at the edge of a reflecting pool. Their attire—his familiar modified peplos gathered at the waist with a yellow girdle—was much like that popularized by Isadora Duncan. Four large vases, two in the foreground and two in the middle ground, were arranged so as to force the perspective and give the composition depth. Because the glazing technique used by Parrish required thorough drying between coats, painting the shadows of leaves on the vases could have been a problem if the artist had attempted it in a natural setting. The changing position of the sun would have caused moving shadows with changing colors impossible to capture with his time-consuming technique. According to the artist's son, Maxfield Parrish, Jr., his father solved this problem by hanging tree branches between vases and an artificial light source in his studio. The shadows then became stationary and could be turned on with the flick of a switch whenever they were needed.

The Chicago Art Publishers, who earlier had made the color prints of *Cleopatra,* was given the job of reproducing *Garden of Allah* in small sizes to be used on candy-box lids and in large sizes to sell as prints for framing. When Parrish learned that plans called for the use of seventeen press runs on reproductions, he began to worry. He realized that seventeen press runs meant seventeen chances for error. "If you have this reproduced by that bum lithography, I doubt if you sell very many," he warned Crane. "Seventeen printings. And the best reproductions I ever had took only four."[9] (He considered the original prints of his *Arabian Nights* illustrations to be

the most accurate reproductions of his work to date.)

"Abominable" was how Parrish described the reproductions of *Garden of Allah.* They had been printed at an investment of nearly twelve thousand dollars for Crane, who was upset at the artist's reaction to them. Parrish wanted perfection, but Crane, being much less critical in matters of art, thought them quite acceptable. The demand for reproductions of Parrish's decorations grew so great that Crane arranged for the House of Art, the New York fine arts publishing and distributing firm, to handle the marketing of the prints. The House of Art took over the distribution, and sales skyrocketed. By July, 1919, little more than six months after the *Garden of Allah* reproductions were finished, the candy manufacturer was making a handsome profit on them. Crane even arranged for his son, Hart, to be employed in the order department of the House of Art in New York. Grateful for his father's assistance, Hart began his new job as a combination office boy and stock clerk in August. But for the young, brilliant poet, who already had worked for the *Little Review* and who had been a contributor to *The Pagan,* the menial tasks to which he was assigned in the publishing company's order department soon became unbearable, and after about three months he left to find more stimulating employment.[10]

Realizing now the financial potential of art prints, Crane offered Parrish five thousand dollars to make another decoration for him. It took the artist several days to answer, for he needed some time to think about his reply. He was not happy with the present status of his business association with Crane. On the afternoon of Sunday, July 20, 1919, a "bit of a musical," in Parrish's words, was presented for the artist's family and friends, including President Woodrow Wilson and his family, who were spending the summer in Cornish. A small permanent stage concealed at one end of the large Parrish music room by the sliding panels of an oriental screen was frequently used for such intimate concerts. When all the guests had departed and the quiet of evening had descended upon "The Oaks,"

Parrish settled down to write a long letter to Crane. His letter implied that he was finally about ready to give up advertising art and begin painting subjects of his own. He also revealed to Crane that the House of Art had asked him to paint pictures directly for them. They would be pictures of his own choice, painted for his own pleasure, and distributed by the House of Art as color reproductions.

Crane played an extremely important role in Parrish's finally being able to give up advertising to concentrate on landscape painting. It was he, a candy manufacturer, not the House of Art, who had first seen the real potential in Parrish's paintings as color reproductions, and it was he who risked his own money to have reproductions made of *Rubaiyat, Cleopatra* and *Garden of Allah.* This speculation paid off well for Crane and for Parrish. The artist received nearly fifty thousand dollars in royalties from the sale of prints of these three subjects. Also, Crane's reproductions helped to create an unprecedented public demand for Parrish's paintings in the art-print market and with it the assurance of continued financial security for the artist.

It was August, 1920, when Parrish first committed himself to making a painting directly for use by the House of Art. By this time he knew his audience and its taste. If the public had liked *Garden of Allah,* he would paint a picture that they liked even better. In the past Parrish had made paintings for a specific use—magazine covers, book illustrations, advertisements, etc. Now he was to make paintings to be sold as color reproductions to a particular audience. A. E. Reinthal and Stephen L. Newman, owners of the House of Art, knew their business, too. Theirs was a large firm with offices in New York and London. When an artist was creating a painting specifically for them to reproduce and distribute as prints, they were able to offer practical suggestions to make the work more saleable. Size and shape were important, and they recommended that, based on their recent experience with *Garden of Allah,* a composition that would reproduce in the horizontal form and size 15" × 30"

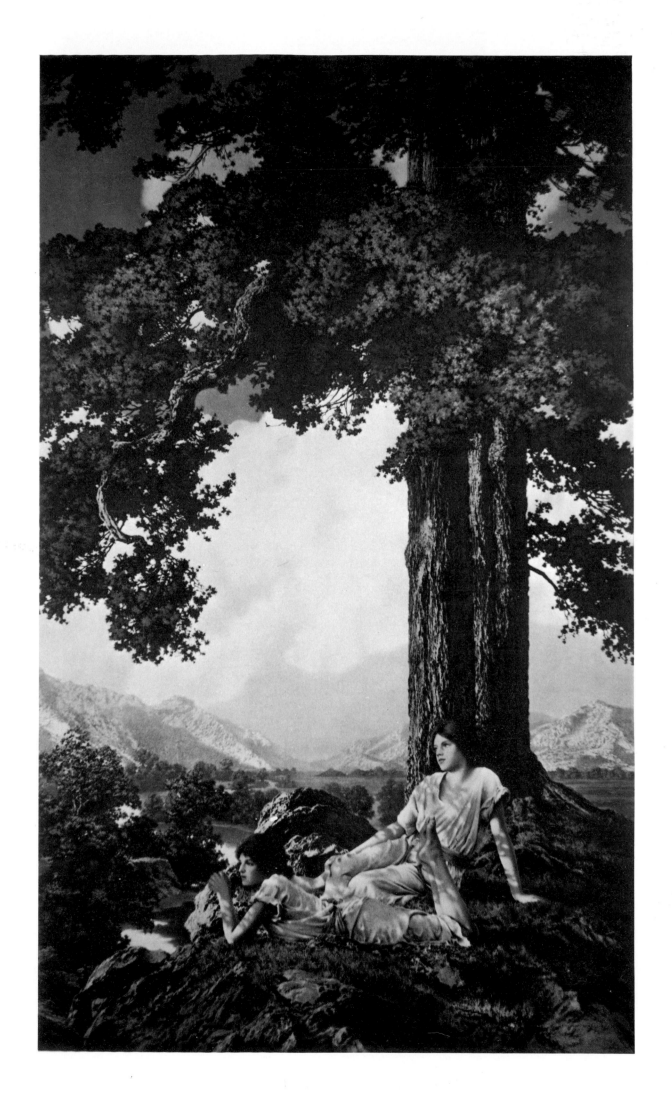

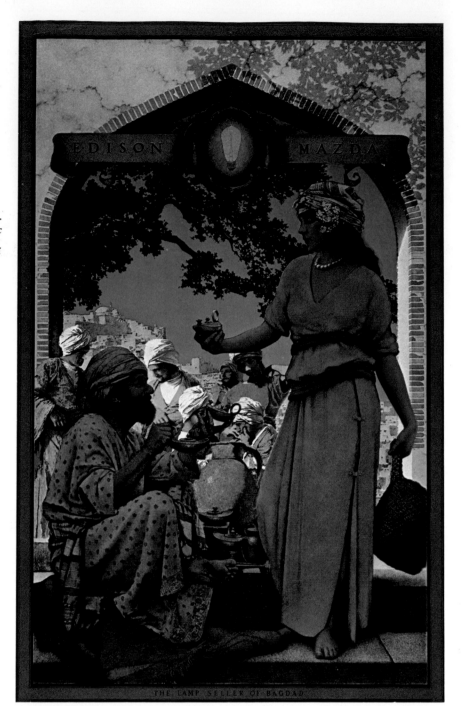

Color Plate 38. Lamp Seller of Bagdad.
*1923 calendar for General Electric
Mazda Lamps. Oil on panel.
Courtesy Maxfield Parrish Estate
and General Electric Company.
Photo: Allen Photography.*

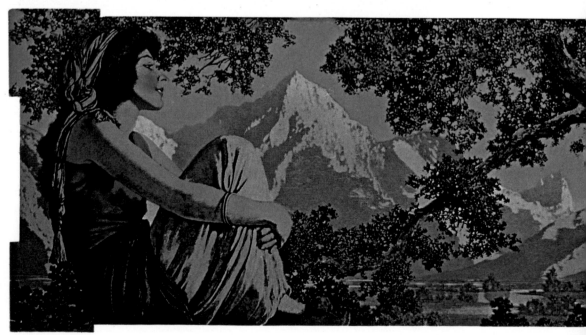

Color Plate 39. The Rubaiyat.
*Decoration for 1916 gift boxes
of Crane's Chocolates.
Oil on panel. Length, ca. 30".
Photo: Allen Photography.*

would be best suited to use in home decoration.

Parrish had not yet begun the painting for the House of Art in mid-March of 1921. He had some ideas in mind, but he had gotten no further with the actual painting than to begin preparing the panel with gesso. As Reinthal and Newman corresponded with him about the work and its progress, they started to refer to it as "the great painting." Parrish had hoped to have his first picture for Reinthal and Newman finished long before 1922, but January came and went with the actual painting not yet begun. He would be busy that year with a number of other projects, including the illustrations for Louise Saunders' *Knave of Hearts* and *Venetian Lamplighter* (Fig. 86) for General Electric. "As to the 'great painting,'" he wrote to Newman, "its beautiful white panel is always on the wall before me, and I am thinking great things into it. I have thought so many beautiful things into it that it ought to make a good print just as it is. Have patience."[11] "The great painting" could not be considered a misnomer, in terms of the artist's career. It would become one of the most popular paintings of the century.

The owners of the House of Art and the artist realized that the time was right for another Parrish reproduction to follow up the success of *Garden of Allah.* He suggested that prior to his finishing "the great picture" they might want to issue some of his *Life* covers as prints.

I have the complete print rights of these covers, *Life* buying only the right to use them as covers. Once in a while there will be some that I have tried to make a picture of beauty instead of humorous and I dare say some would make prints with a popular appeal.

There was one issued last summer of a twilight scene with a little girl on a rock in the foreground, and there is one I am at work upon now, a spring scene, with a sort of Alpine scenery and the girl seems to show promise of being attractive.[12]

Both the artist and the publisher thought the covers would sell as upright companions to *Garden of Allah* and "the great picture," which were horizontal.

On the first of April, 1922, Parrish left for a few weeks' vacation with his family in Florida. In Cornish he could avoid publicity and lead a fairly routine life as a citizen of that small New England community, in which famous artists and authors were seen often enough not to cause a great stir. But in Florida Parrish was treated like the national celebrity that he had become. The *Literary Digest* ran a photograph of him with the caption: "CAUGHT IN FLORIDA— Maxfield Parrish, the celebrated maker of pictures, has seldom been put into a picture himself. This photograph was taken by an enterprising photographer in Miami."[13]

Upon his return to Cornish, Parrish learned that work was underway on the reproduction of the two *Life* covers, which were to be issued in the fall under the titles *Evening* and *Morning.* Since these small prints were not capable of bringing in the revenue of a reproduction comparable to the *Garden of Allah,* the publisher was anxious to get another large Parrish print on the market. In October he suggested that they negotiate for the rights to reproduce the mural *Interlude* (Fig. 100), also called *Music,* that Parrish had just painted for the Eastman Theater in Rochester, New York, and that the royalty be divided between the Eastman Theater and the artist. Parrish concurred that the mural would probably make a popular print, so arrangements were made with Eastman's staff to publish the mural in its original vertical format and also in a horizontal version,

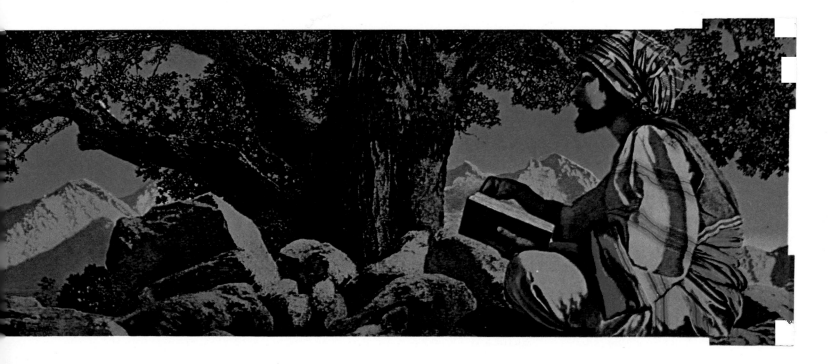

Figure 92. Dreaming *(artist's title:* October*). (See also Pl. 64). 1928. Oil on panel, 32" x 50". Courtesy New York Graphic Society Ltd.*

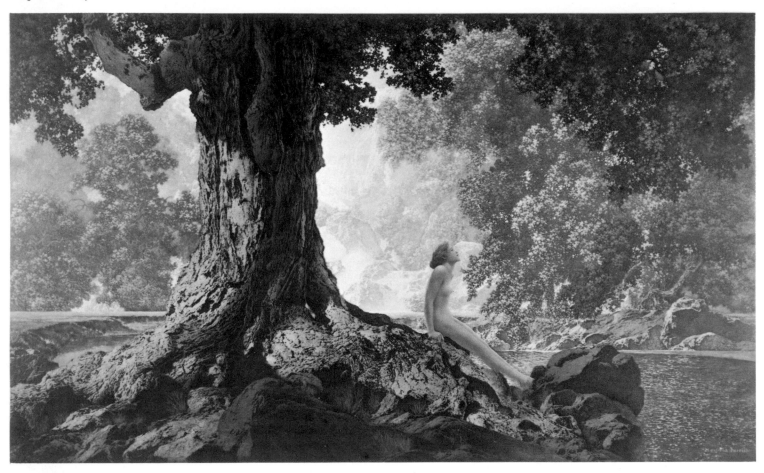

cropped to eliminate the trees and blue sky, of which the upper half of the picture was comprised.

It seemed to Parrish that the printers would never be able to make faithful reproductions of his pictures. When he saw the discouraging proofs of the two *Life* covers that were being issued as prints, he became very apprehensive about what might happen to "the great picture" in reproduction. "I dread seeing the Magnum Opus reproduced," Parrish, in November of 1922, wrote to Stephen Newman. ". . . I want to do all I can to see that we get a good print on the market, and to that end will gladly stand over the proofs from the very beginning, come down to New York and give suggestions. . . ."[14]

Parrish called "the great picture" *Daybreak* (Pl. 41), and on December 16, 1922, filled with anticipation, he shipped the painting to Reinthal and Newman. He had worked on the painting most of the fall, having made sketches and photographs of

the figures during the summer. *Daybreak* featured a portico or colonnade, of which only the floor and two large columns could be seen. In the distance were an azure blue lake and mountains bathed in the golden rays of the rising sun. Leaning over to speak to a maiden reclining near the base of one of the columns was a nude young girl. As may be seen in the sketch (Fig. 90), Parrish at one point considered including a third figure, which, perhaps to avoid crowding the center of the composition, was omitted in the final painting. The sketch also reveals that the composition was very carefully laid out according to the principles of Jay Hambidge's Dynamic Symmetry. Often it was difficult for Parrish to find suitable models in Cornish during the winter months, but when the summer residents arrived, there almost always would be children of the artist's friends who would pose for him. The reclining figure in *Daybreak* was modeled by Kitty Owen, the lovely granddaughter of William

Jennings Bryan, who also was painted by Parrish in *Morning, The Canyon* and *Wild Geese.* The standing figure in *Daybreak* is Jean Parrish, the artist's young daughter.

The publishers were delighted with *Daybreak.* Determined to obtain the best color reproduction possible, they sent the painting to Forbes Lithograph Manufacturing Company in Boston. The artist had recommended Forbes, for he liked their work on the Edison Mazda calendars. As Forbes could not begin printing *Daybreak* for half a year, the job was given to the Brett Lithographing Company, Long Island City, New York. Proofs of the medium-sized reproduction were sent for the artist's comments in April, 1923.

. . . I think they have done very well indeed, the thing as a whole hangs together, and what suggestions I would make are very small ones.

It is the old question of relative values, and we can go into that in detail when the large one is under way, and with the original

before us can point out definitely just what is meant by the term relative values. As I remember, the high light on the shoulder of the standing figure is the lightest note of these two figures, all other high lights are toned down a little compared to it. A small point, yet, it makes for bigness and quality in a painting.

I would suggest that the teeth in the reclining figure are much too white: it is a white spot now that jumps right out at you. The yellow in the high lights of her dress are too strong. I would have them grayer. It might be better, too, if the water was not quite so intense a blue; it looks a little out of color scheme. These are minor suggestions as I think it a very faithful reproduction. . . .[15]

Parrish went to New York in July to review the proofs of the large (18″ x 30″) reproduction of *Daybreak* with the lithographer, making certain that the final results measured up to his expectations. Thinking it might add to the appeal of the picture, Reinthal and Newman asked Parrish to write a statement about *Daybreak* which could be distributed with the reproductions, but he refused.

Alas, you have asked the very one thing that is entirely beyond me, to write a little story of *Daybreak*, or, in fact, of any other picture.

I could do almost anything in the world for you but that. I know full well the public want a story, always want to know more about a picture than the picture tells them but to my mind if a picture does not tell its own story, it's better to have the story without the picture. I couldn't tell a single thing about *Daybreak* because there isn't a single thing to tell; the picture tells all there is, there is nothing more.[16]

The popularity of the color reproductions of *Daybreak* was greater than Parrish or the House of Art ever had anticipated. College students decorated their rooms with them, people gave them as wedding gifts, hotels exhibited them in their lobbies, housewives placed them over the mantels—in short, *Daybreak* became the decorating sensation of the decade. Whenever color reproductions were placed in windows of department stores and frame shops, crowds gathered to admire. "News of *Daybreak* filters into these remote parts, and I am getting comments in almost every mail,"[17] wrote the artist, who had received fan letters from as far away as Capetown, South Africa. "I heard of a business man who carries a large sized framed print with him on his journeys to and from New York and the West. I wish there was some way to reach him and suggest that he buy two."[18]

At the end of 1923, after *Daybreak* had been on the market for only a few months, Parrish's royalty on sales amounted to almost twenty-five thousand dollars. The demand for his color reproductions continued to rise steadily through 1924, and in 1925 his royalty on the sales or reproductions for that year was more than seventy-five thousand dollars.

In 1924, the Eastman Theater mural was released as a color print called *The Lute Players* (Fig. 100). It was meant to be a follow-up to *Daybreak*, but somehow the mural lacked the popular appeal of the painting made especially for the color-print market. Scribner's planned to publish the following year Louise Saunders' *The Knave of Hearts*, which Parrish had profusely illustrated. The artist felt that his painting *Romance* (Pl. 9), made for the cover lining of *The Knave of Hearts*, was a far better painting than *Daybreak*. He was pleased that it had some qualities of "real illumination."[19] Hoping for another popular subject, the House of Art arranged to distribute color prints of *Romance*, as well as *The Page* and *The Prince*, all illustrations from *The Knave of Hearts*. In order to get the best possible quality reproductions for the print trade, Reinthal and Newman had Scribner's run their edition of color reproductions before the plates were used for the book. However, they agreed to withhold these prints from the market until after the release of the book.

Parrish was enthusiastic about his next painting for the House of Art. The field had become flooded with imitations of *Daybreak*, and he was determined that his next painting would not be a carbon copy. He was searching for something that would have as strong an appeal as *Daybreak* had when it first appeared, but something that would be unique and fresh. He expressed his idea in a letter to Stephen Newman, written in June, 1925.

For the next, I have in mind the two upright panels. One, at least, should be a marked departure in color scheme, for we must not always have this tiresome M.P. blue in every print. They are to be a rich gold tone, and needless to say, as beautiful as possible, with a great landscape behind the figures. . . .[20]

Scott and Fowles, Parrish's New York gallery, used the occasion of *Daybreak*'s success to schedule a major exhibition of the artist's original paintings for the months of November and December, 1925. Fifty paintings, including *Daybreak*, *Romance*, and many of the illustrations for *The Knave of Hearts*, were viewed by six thousand visitors to the gallery. The brilliant enamellike quality of Parrish's glazed surfaces led some viewers to remark that they must be lighted from behind. Others speculated, as had Parrish fans for many years, on the secret ingredient of the Maxfield Parrish blue paint. The most popular assumption was that he painted with lapis lazuli that had been ground to a powder. But there was, in fact, no mysterious ingredient. It greatly embarrassed Parrish when a syndicated newspaper column erroneously reported that one of his paintings had been sold by Scott and Fowles for eighty thousand dollars. Actually, twenty-eight paintings were sold at the exhibition, with the highest prices of ten thousand dollars each being paid for *Daybreak* and *Romance*.

Reinthal and Newman went to the exhibition to see whether any of the paintings had potential as subjects for color reproductions. One which particularly interested them was a painting called *The Beach, Evening*. Parrish informed Newman that he was working on a painting for them called *Stars* (Pl. 42), in which he hoped to achieve the same effect.

. . . the figure in the new one is of a younger girl, seated in profile. . . . There is something about the picture in the show I did not like; it was a bit realistic, looked a little like a real person. Whereas I think nudes (especially for our purpose) want to be idealized.[21]

Color Plate 40. Garden of Allah.
Decoration for 1918 gift boxes of Crane's
Chocolates. 1918. Oil on panel. 15" x 30".
Photo: Allen Photography.

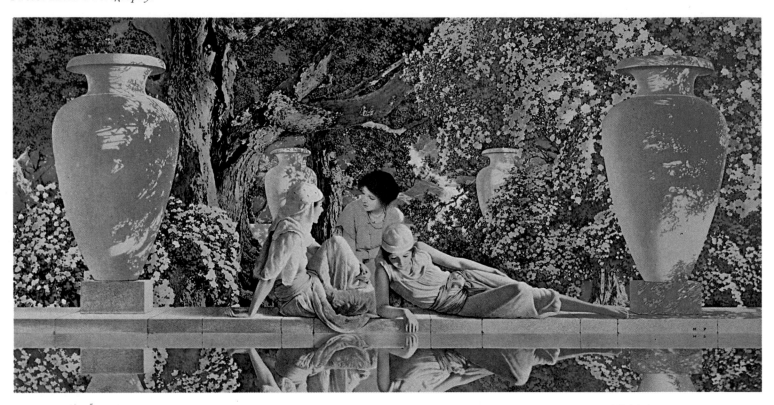

I am sort of hoping one called possibly *Hilltop* [Fig. 91] will be a fit companion to *Stars.* It will be of two girls under a big tree at the top of a hill, with a great distance beyond, late afternoon all flooded with golden light, and needless to say, all depending upon the message carried by the figures—their joy or quiet contemplation of the environment.[22]

The two figures in *Hilltop* are draped (it is still winter up here) in about the same clothes as the reclining figure in *Daybreak.* Somehow or other the scene seemed to call for drapery rather than nude, as it is a very real place.[23]

When the pictures were shipped to the publisher, the artist insisted that the proportions not be altered in the reproduction.

I do not know if you are familiar with Dynamic Symmetry or not, a rediscovered rule of thumb practiced by the ancient Greeks and the Egyptians before them, of laying out designs and compositions. It is a very simple system used by many of our leading artists and by those of England. I will not bore you with it further than saying that every division in a picture like *Stars* bears a very definite relation to the rectangle as a whole, and as

soon as you change the proportions of the rectangle, you knock the carefully thought out design into a cocked hat.[24]

It appeared to Reinthal and Newman that *Stars* would repeat the success of *Daybreak.* In making the reproductions, the proportions of the original were preserved as the artist had requested. Twelve different colors were required for the printing, five of which were various shades of blue. When the reproductions were finished, the House of Art exhibited one alongside the original painting in its showroom to demonstrate to customers how accurate the reproduction was. Although the release of *Stars* as an art print inspired a rash of amateur poems, which were sent to the artist from all over the country, sales of it and its companion, *Hilltop,* were disappointing. Part of the problem was due to the publishers' maintaining a top price on Parrish's reproductions (for example, the large size of *Daybreak* sold for ten dollars framed, six dollars unframed) while cheap imitations were available in every five-and-ten-cent store. "It was

the same in my father's day," Parrish wrote to Reinthal, "when etchings became more or less the rage and every school girl took it up. It drove out the good ones . . . [who] had to take much less."[25]

Dreaming (Fig. 92), which Parrish called *October,* was the last painting that he made for the House of Art. Having first made the studies for *October* in the fall of 1926, the artist spent the next year and a half completing the painting. As he usually completed the landscape first and then painted the figures on a white ground or imprimatura stenciled on top of the landscape, Parrish was no doubt well underway with the painting before he had located a suitable model for the figure.[26]

I am making studies for the next one. . . . But it is going to be a problem to get the figures as I have imagined them. This one is going to be under a great tree, and sunlight and shadow flickering on the figures as it comes through the foliage. There is a big panel in the roof of the studio that takes off, and I lay branches of trees over the opening and the light comes through thus upon the figures.[27]

October, painted in rich bronze and amber shades of autumn, had as its main feature a large tree trunk, against the roots of which rested a single nude female figure. The figure, stiff and artificial, detracted from the composition and was later removed by the artist after the reproductions had been made (Pl. 64). Parrish had included the figure only because his publishers thought that refined nudity aided the sale of reproductions. The painting was, in fact, conceived as a simple landscape.

This particular painting was inspired by a fine old oak tree in rather wild country north of here. It looked centuries old, and growing almost entirely out of a rocky ledge had to send its roots in every direction for a living.[28]

This figure was the result of much study, and is the seventh figure I had in the picture before I got something to give satisfaction. I dared not have a larger figure, for as soon as I did, it destroyed the scale and grandeur of the tree. And having a small one, I realized much would go out of her features in the smaller reproductions, so that I concentrated particularly on her pose, her general silhouette or outline to tell the story.

In the vast majority of figure painting the figure is featured, in the lime light, and her surroundings are treated merely as background. My own aim in this kind of work is to keep the figure in its place out of doors, not feature it, emphasize it any more than a rock or tree. If this is done you get a quality of reality and consequently a beauty of truth. . . .[29]

Just as the color prints of *Dreaming* (*October*) were placed on the market, Orion Winford of Brown and Bigelow asked Parrish to paint a landscape for his company to add to its calendar line. He put no restrictions on the subject, nor any time limit. Parrish did some very serious thinking about the offer. It appeared that with Brown and Bigelow he would be able to paint the landscapes that he loved above all else to paint. For some time he had felt inhibited by the limitations of painting for the art-print trade. He had given up advertising art, with the exception of the General Elective calendars, because he had found little opportunity for self-expression in that area, and now he had encountered the same restrictions in painting pictures for the mass public market. Each new painting had to be enough like the preceding one to appeal to the large audience that enjoyed his work, but it had to be sufficiently distinctive to create new sales.

When *Dreaming* failed to bring in the expected revenues in 1929, the publisher suggested that perhaps it was because people were framing that year's General Electric calendar subject by Parrish, *Golden Hours,* instead of buying color reproductions. Parrish, on the other hand, knew that trying year after year to repeat the success of *Daybreak* was futile. He wrote to his publishers:

I am a commercial artist, who, ever since his beginning has made his living by having his work reproduced. People who like attractive pictures are going to cut them out and possibly frame them no matter in what form, illustrations in books, in magazines, calendars, etc.

This whole question of pictures made to order is a darn peculiar form of merchandise. You know that. As a gamble, poetry and music and literature are not far off. A man makes a great hit, a best seller, with a novel. His publishers are frantic for him to repeat, and the chances are his first success proves to be his last. You may order another best seller from me, and god knows I'm willing enough, but—can I deliver the goods? I have given the matter no end of thought and analysis, for I am just as keen as the next one to make money and not one bit ashamed to own to it. . . .

. . . They [the public] all seem to like the tiresome M.P. blue, for one thing, and girls having a pleasant chat, for another. They must look pleasant. . . . The contemplative kind, such as *Hilltop,* not so popular.

. . . You know, and I know, that what people like is a beautiful setting with charming figures, clothed or otherwise, and probably no one special feature. Whatever it is, it's elusive. *Stars* did not have it, nor *Hilltop.* Needless to say the good art quality has no particular appeal; that is only for those who know. . . .

There are countless artists whose shoes I am not worthy to polish whose prints would not pay the printer. . . .

The question of judgement is a puzzling one. I am beginning to doubt my own. . . .

. . . this particular vein of mine may be petering out. It wouldn't be surprising. Maybe the public knows before the artist does. . . .[30]

Parrish decided to make no more paintings for the art-print market. Although the House of Art issued several more of his paintings, they were ones that the artist had made for other purposes and to which Reinthal and Newman subsequently had acquired the print rights. Two of these, *Tranquility* (Pl. 51) and *Twilight* (Pl. 52), were landscapes painted for Brown and Bigelow, the calendar company, which used its plates to make color reproductions for the House of Art. For many years Reinthal and Newman continued to sell quantities of reproductions of *Garden of Allah, Romance, Stars* and other Parrish subjects. Except for *Garden of Allah,* none of these ever approached the popularity of *Daybreak.*

Why were these two paintings so appealing to the mass audience of the American middle class? Parrish had written to Reinthal that "what people like is a beautiful setting with charming figures, clothed or otherwise, and probably no one special feature."[31] He also believed that a symmetrical composition was a feature that the masses found attractive. Exoticism obviously had something to do with the pictures' appeal—and implied eroticism; however, the latter was so carefully clothed in innocence that even the most circumspect person would not have balked at hanging *Daybreak* over the mantle on this account. As color reproductions, the paintings, especially *Daybreak,* had the appearance that art was expected to have. In it Parrish had painted a modern version of a nineteenth-century academic subject—carefully designed, accurately drawn, exquisitely painted, idealized, exotic—yet not too foreign and above all pleasant. The paintings were calculated to appeal, as reproductions, to the widest possible audience. This was the aim of Maxfield Parrish in making the paintings, and in accomplishing this aim he was overwhelmingly successful.

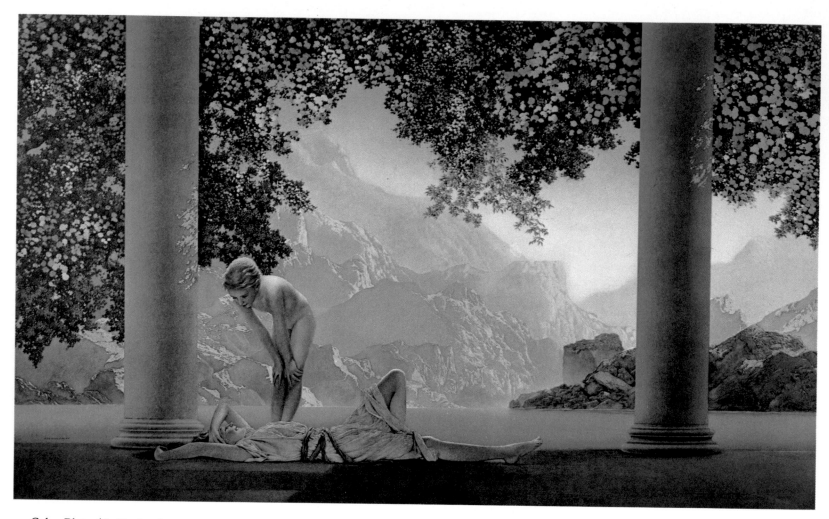

Color Plate 41. Daybreak.
1922. Oil on panel.
Courtesy New York Graphic Society Ltd.
Photo: Allen Photography.

Color Plate 42. Stars.
1926. Oil on panel, 35⅛" x 21¾".
Courtesy New York Graphic Society Ltd.
Photo: Allen Photography.

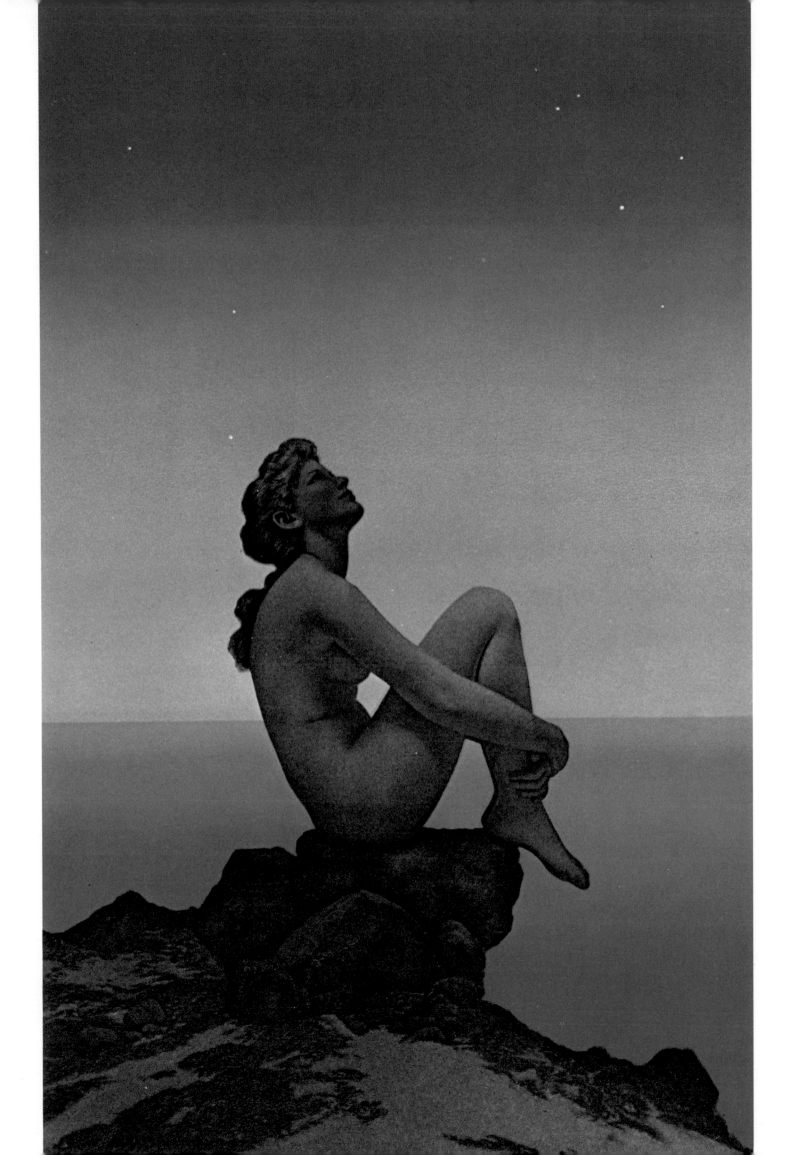

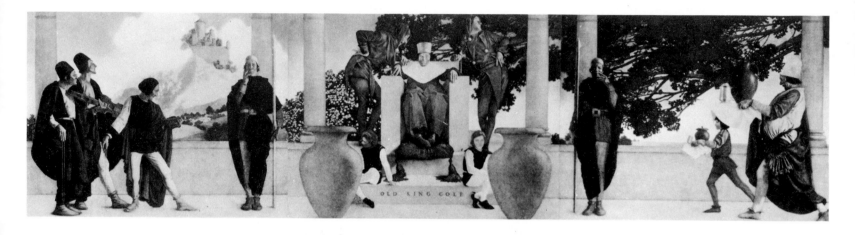

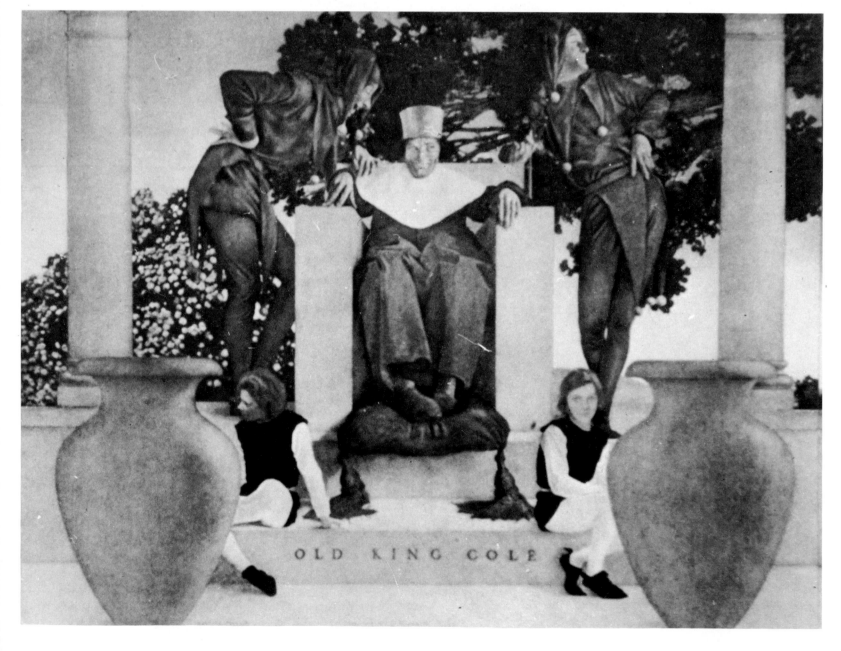

Chapter 6

MURALS AND PAINTINGS MADE FOR SPECIFIC ARCHITECTURAL SETTINGS

Mention Maxfield Parrish to a knowledgeable New Yorker and the name is apt to evoke any number of stories about the legendary *Old King Cole* mural (Fig. 93), which has hung since 1935 in the King Cole Room of the St. Regis Hotel. Perpetuated by a long succession of friendly bartenders, the most popular of the King Cole legends would have one believe that the artist depicted his Royal Highness as a flatulent monarch, much to the amusement of the royal attendants, who attempt to disguise their reactions to the embarrassing situation. Even the artist admitted that the picture really does seem to illustrate just that, but, as much as he enjoyed the story, Parrish insisted that "when I painted it my thoughts were 110% pure. . . .[1]

The mural was commissioned in 1905 by Nicholas Biddle for the bar of Colonel John Jacob Astor's Knickerbocker Hotel. Biddle, a friend of Parrish's, in jest advised him not to let his Quaker sensibility prevent him from accepting a commission to do a painting for a bar, and suggested that an old Dutch Knickerbocker scene might be appropriate. The thirty-five-year-old artist, busy erecting a studio at his home in Cornish, almost refused the commission. But the temptation of filling such a large space that "sure calls for a painting,"[2] and the five thousand dollars that Colonel Astor was willing to pay for the painting were too much to resist.[3]

Old King Cole, the subject finally chosen, was painted in Cornish in 1906. Inasmuch as the large mural studio that Parrish later built was not yet available, *Old King Cole,* with its three large panels, had to be painted in a rather small room. Each panel would just fit diagonally into the corners, leaving very little space for the artist himself. As the original plan called for mounting the canvases directly on the wall of the bar, they were stretched on rigid frames. Fortunately, these canvases were never cemented to the wall, and their rigid frames were replaced with keyed stretchers when the mural later was moved to the St. Regis.

Reflecting in its composition the theatricality and architectural concern evident in much of Parrish's work of this period,

Old King Cole was painted in the glazing technique which the artist already had been using for about a decade. He described the technique in a letter to the St. Regis in 1936.

As far as I can remember, there was first painted a monochrome in raw umber and white lead, and over this when dry was glazed the color, such as ultramarine and cobalt blue, rose madder and raw siena, and ivory black. In some places, between the different glazes I think spirit varnish was used, but the principal varnish throughout was Winsor and Newton's Amber Varnish, an oil varnish.[4]

In the days before motor trucks it was no simple task to transport large works of art five miles from Parrish's Cornish studio to the Windsor, Vermont, train depot. So when *Old King Cole* was finished and carefully crated, Parrish hired a local driver to carry the painting to the depot by horse and wagon. Naturally there had been a great deal of talk in the village about the mural that a local artist was making for the famous Colonel Astor, and no doubt word of its five-thousand-dollar price tag had got around. When the driver arrived, braced with a jigger to calm his nerves for the important job he was about to perform, *Old King Cole* was tied securely to the wagon. The driver, who by this time had assumed the role of keeper of the mural, headed the team toward the Windsor depot—right down the middle of the road. It is said that each time he met another wagon he would stop and shout, "Be careful! I have here the greatest painting ever to come out of Cornish." And with that he would make the other driver drive off the road to get around him. This indeed was a merry beginning for King Cole, whose benevolent smile would greet patrons in some of New York's most elegant drinking places before, during and after Prohibition.

The bar of the Hotel Knickerbocker at Broadway and Forty-second Street quickly became a popular meeting place of stage celebrities of the pre-World War I era, and a favorite drinking sport was the spinning of yarns about *Old King Cole.* In *Good Night, Sweet Prince,* Gene Fowler wrote

(Top) Figure 93. Old King Cole. Mural for Hotel Knickerbocker. 1906. Oil on canvas, ca. 8' x 30'. (Left) Detail of center panel.

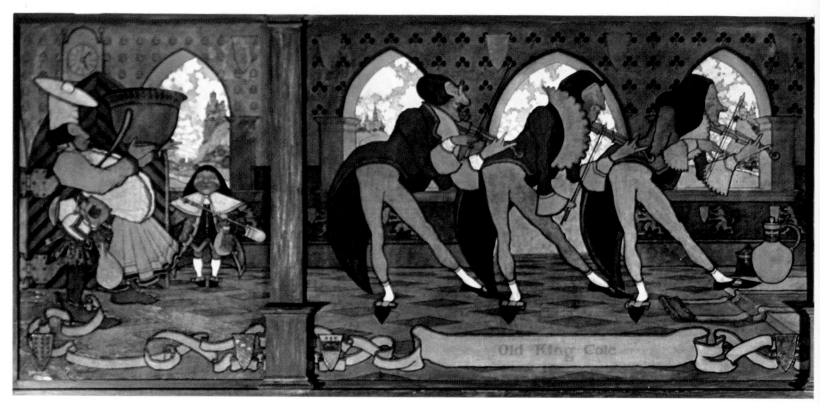

Color Plate 43. Old King Cole. *1895. Oil on canvas,* ca. *5' x 12'. Courtesy Mask and Wig Club, University of Pennsylvania, Philadelphia. Photo: George Gelernt.*

Color Plate 44. The Pied Piper. *1909. Oil on canvas, 7' x 16'. Courtesy the Pied Piper Bar, Palace Hotel, San Francisco.*

of John Barrymore, ". . . he so often had met friends at the bar, above which the Maxfield Parrish painting of *Old King Cole* was hung. He frequently had been the guest of Enrico Caruso, a resident of that hotel. They had sat up late, discussing the merits of caricature, of which branch of art the great tenor had been a talented amateur."[5] Fowler recalled that later, upon visiting the St. Regis to see the *Old King Cole* mural in its new location, Barrymore reminisced about Jim Corbett, George M. Cohan, David Belasco, James Montgomery Flagg, William Warfield, and dozens of others who used to gather at the bar below "the *Old King Cole* painting, which had seen Broadway in its green and salad days."[6]

Prohibition forced the demise of New York's bars and the Hotel Knickerbocker was converted into an office building. *Old King Cole* was crated and placed in a warehouse, where it remained for several years. Its retirement was interrupted in 1922 for shipment to Chicago, where it was included in an exhibition of mural paintings at the Art Institute. In 1924 Colonel Astor decided to lend the mural to the prestigious Racquet Club. And in July of that year, Parrish made a trip to New York to supervise its installation. He wrote of the mural's appropriate new location a few years later, ". . . the original now hangs in the grill room of the Racquet Club, and serves to distract attention from the very many and commodious lockers of the members round about."[7]

Old King Cole returned to a public location once again in 1935, when it was transferred to the elegant St. Regis Hotel, where a room was named in its honor. The artist traveled to New York at the request of the St. Regis to advise on the cleaning of the painting, being undertaken by William A. Mackay, and to make some recommendations for decorating the room in which it was to be installed. Everything that he could recall about the technique used in making the painting thirty years earlier he related to the conservator, for the artist understood better than anyone the difficulty in removing only the protective varnish film from a painting made of what was essen-

tially layers of colored pigments between layers of varnish. The cleaning and re-stretching of the mural was accomplished with excellent results. It was not placed in a modern streamlined bar as originally planned, but the room's decor reflected "some good old Victorian changes" that Parrish had recommended as a more appropriate setting for his painting. *Old King Cole* still delights patrons of the King Cole Room. Although *Daybreak* and *Garden of Allah* are more famous because of their wide distribution as color reproductions, certainly no work by Maxfield Parrish is better known through contact with the original painting than *Old King Cole.*

This bar mural was not the artist's first encounter with Old King Cole. The nursery-rhyme monarch had been the subject of one of the paintings he made early in his career for the Mask and Wig Club in Philadelphia (Pl. 43). In 1893 the Mask and Wig Club of the University of Pennsylvania purchased an old disused stable (formerly a church) on Quince Street for its clubhouse and theater. Wilson Eyre, the architect chosen to make the conversion, decided to preserve the existing Tyrolean flavor of the building while adapting it to the needs of the club. (Eyre recently had designed Northcote, the home of Maxfield Parrish's father at Cornish.) Young Parrish, who was just finishing his studies at the Pennsylvania Academy of the Fine Arts, was commissioned in 1894 to design and execute wall decorations for the building. Fascinated with having an entire building to decorate and with the possibilities of expression open to him through architectural decoration, he attacked the assignment with youthful vigor and enthusiasm.

I am working away all day at designs—or rather one design—for the first thing to be done is to decorate the proscenium arch of the theatre [he wrote to his father in Windsor, Vermont, in early April]. After that there probably will be no more funds left to pay for anything else, as the Club, so I'm told, is mad at the moment at the amount of money Eyre is spending. It may be quite a while till I get something that will suit. I first have to try this and then that, and each

Figure 94. Decorations for beer-mug pegs. 1895.
Painted in oil on dark oak wainscot in grill room
of Mask and Wig Club, University
of Pennsylvania, Ca. 12" x 12" each.

"this" or "that" takes a couple of days to do, so 'tis slow, but interesting.[8]

His enthusiasm and self-discipline made work on the proscenium decoration progress rapidly, and two weeks later, when he wrote to his father again, he was almost half finished.

Work is coming on very well indeed, and all parties concerned thereby seem highly pleased. . . . I have one side nearly finished, and the other I think will go on much quicker since I will know just how to economize labor. It is great fun—and I have constantly to keep a check on myself. I get so excited and carried away with what I am doing that 'tis bad for one's nerves: but there is in it at times a wild fiendish delight which partakes of all sorts of sensations, of what is possible in art and in me and in everything. However as time goes on I am getting myself better under control I trust. I have sailed in knowing nothing whatsoever about fresco work and have been trying experiments of my own which I think are highly successful—and

have a few wrinkles in store for Cornish which I think will be successful. . . .[9]

The proscenium decorations were not true frescoes, but were painted in oil, turpentine and distemper on smooth, dry white plaster (a durable medium, as the paintings are in good condition today). On opposite sides of the arch a male and a female figure were portrayed holding shields emblazoned with the masks of comedy and tragedy. The delicate color scheme originally selected by the artist proved to be too light, so in December he painted over it with stronger color and a heavy black outline. The decoration, both in color and style, is reminiscent of the illustrations of Walter Crane and the early work of Howard Pyle, under whose influence Parrish passed only briefly.

One of the features of the grill room of the Mask and Wig Club was a six-foot-high wainscoting of dark tongued and grooved boards, to which were attached

wooden pegs for the members' beer steins. Upon completing the proscenium decoration, Parrish painted fanciful caricatures combining comic figures with the names of the mug owners around several dozens of these pegs (Fig. 94). These colorful decorations were simple caricatures much like those the artist had drawn as decorations on letters to relatives and friends since the age of ten or twelve. Additional commissions for the Mask and Wig Club included a decoration around the ticket window, a design for a bulletin board, and his most important work there, a large painting of *Old King Cole* for the grill room.

Parrish described his collage technique when writing about the study for *Old King Cole:* "[It is a] watercolor drawing on manilla paper with here and there pieces of paper of various colors cut out and pasted on thus making many different qualities of tone. Between the glass and drawing is a sheet of transparent celluloid upon which is painted the sky."[10] When the studies for *Old King Cole* and the ticket-window decoration were exhibited at the Pennsylvania Academy of Fine Arts in December, 1894, the academy purchased the *Old King Cole* study for its permanent collection. The same piece received notice in *Harper's Weekly* during its exhibition at the Architectural League of New York in February, 1895, giving the young artist his first national publicity.

This early *Old King Cole* mural, filled with an opulence befitting the subject, again reflects Parrish's affinity for architecture, not only in the painting itself, but in the design of a work of art for a particular location. He carefully planned the perspective of the composition to be enhanced by the regular pattern of the dark exposed wooden beams of the room's ceiling. The arches behind the king and his attendants, and even the divisions of the three sections of the painting itself, carefully correspond to the beams in the ceiling of the grill room. The frame, also designed by the artist, completes the harmonious relationship between the painting and its surroundings. Parrish's decorations

Figure 95. My Duty Towards My Neighbor *and* My Duty Towards God. *Two panels in one frame for mantel in guild room, Trinity Episcopal Church, Lenox, Massachusetts. March–July, 1898. Oil on panels (old white pine drawing boards, the left one being mounted with heavy canvas fastened with glue). each 33" x 24".*

for the Mask and Wig Club were some of his very earliest commercial endeavors.

My Duty Towards My Neighbor and *My Duty Towards God,* two panels painted in 1898 for the Memorial Chapel to Mrs. Parsons at Trinity Episcopal Chruch, Lenox, Massachusetts, have the interesting pre-Raphaelite quality sometimes seen in the products of the Arts and Crafts Movement in America (Fig. 95). Parrish was well acquainted with the work of the pre-Raphaelites, having studied the collection of pre-Raphaelite paintings belonging to his cousin, Samuel Bancroft, and having visited several times the art centers of Europe. Their work left its imprint of mysterious romanticism and attention to detail on some of Parrish's early paintings. When in 1908 Samuel Bancroft

purchased one of Parrish's paintings, the artist asked, "How are your Rossetti's going to like it? It sure is breaking into high society. Indeed I wish I could get down to Wilmington someday. You have no doubt many more pictures since I was last there."[11]

The old saying that nothing succeeds like success could be applied with accuracy to Maxfield Parrish's career just after the turn of the century. His illustrations for magazines, books and posters were in constant demand. Hotel owners, upon seeing the *Old King Cole* mural at the Knickerbocker, commissioned nursery-rhyme and fairy-tale paintings to enhance their own establishments.

The Pied Piper (Pl. 44) was painted for the Palace Hotel in San Francisco and

Sing a Song of Sixpence (Pl. 45) for the Hotel Sherman in Chicago. Long a favorite with the heads of San Francisco's financial community, it is said that many important deals were made and many fortunes won and lost in the rich surroundings of the Pied Piper Bar at the Palace Hotel. According to another barroom legend, the mural was cut from its frame and carried to safety moments before the hotel was consumed by the fire that destroyed much of San Francisco after the 1906 earthquake. It is the kind of story that allows the teller much freedom for elaboration with each new round of drinks. In reality, *The Pied Piper* was painted for the Palace Hotel Company in 1909, three years after the fire. True to the fairy tale, Parrish depicted the Pied Piper leading a group of

Color Plate 45. *Study for* Sing a Song of Sixpence. *1910. Study, 8″ x 20″; mural, 5′8″ x 13′9″. Courtesy Maxfield Parrish Estate and the Sherman House, Chicago. Photo: Allen Photography.*

Figure 96. Untitled. Detail of one of four murals for reception room of Mrs. Gertrude Vanderbilt Whitney's studio, Wheatley Hills, Long Island, New York. 1914. Oil on canvas, each ca. 5'6" x 18'6". Courtesy Maxfield Parrish Estate and Architectural League of New York.

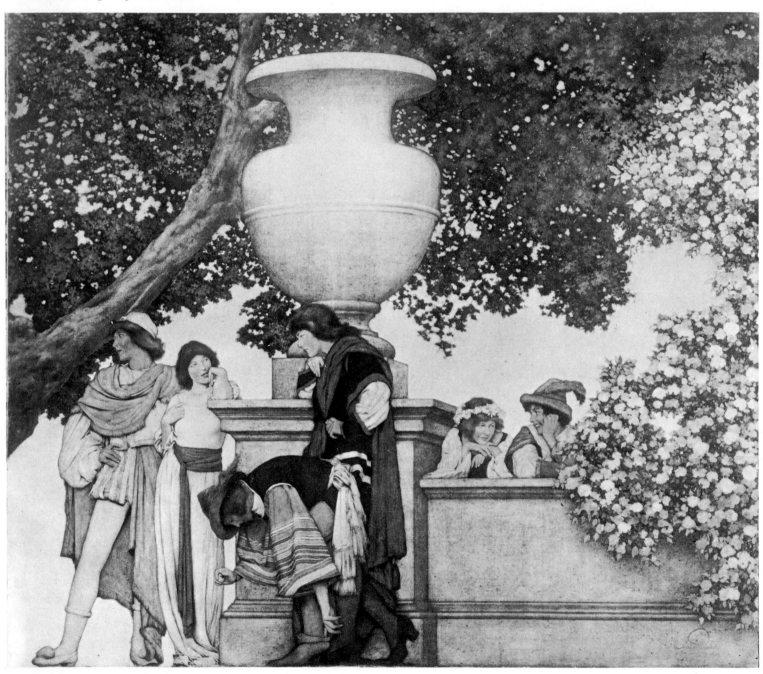

(Right) Figure 97. Love's Pilgrimage. One of eighteen panels for girl's dining room, Curtis Publishing Company. 1911. Oil on canvas, 10'8½" x 3'5". Courtesy John W. Merriam.

(Far Right) Figure 98. Lazy Land. One of eighteen panels for girls' dining room, Curtis Publishing Company. 1911. Oil on canvas, 10'8½" x 3'5". Courtesy John W. Merriam.

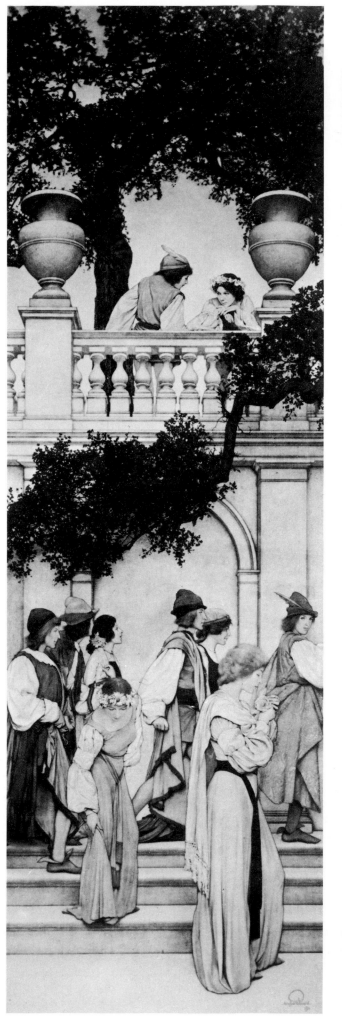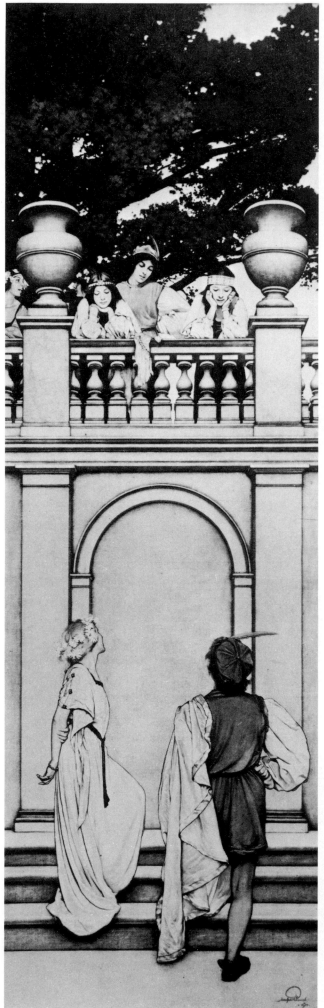

Color Plate 46. Dream Castle in the Sky. *1908. Oil on canvas. 6' x 10'11". Courtesy the Minneapolis Institute of Arts.*

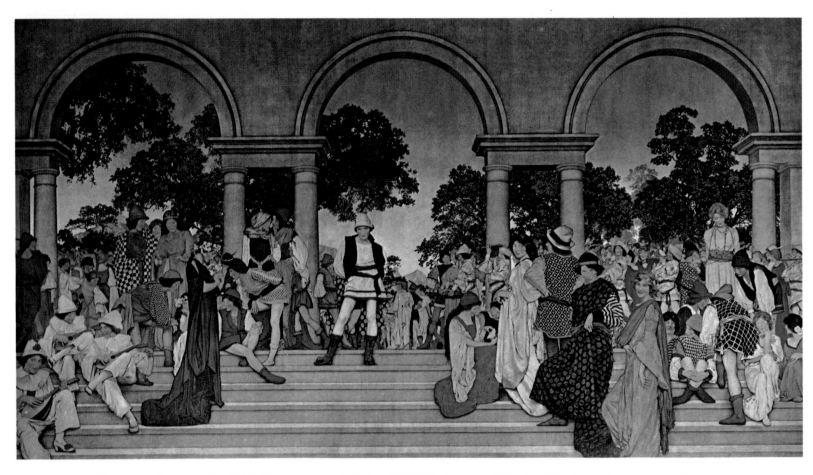

Color Plate 47. Florentine Fete *(detail). 1916. Oil on canvas. 10'2" x 16'11½". Courtesy John W. Merriam. Photo: George Gelernt.*

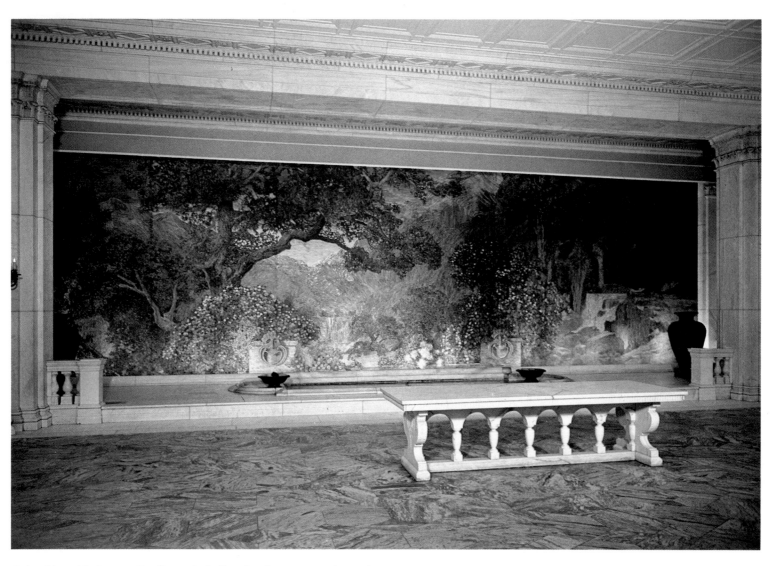

Color Plate 48. Dream Garden. *1916. Favrile glass mosaic after a design by Maxfield Parrish. Executed by Tiffany Studios for the lobby of the Curtis Publishing Company building, Philadelphia. 15' x 49'. Courtesy John W. Merriam. Photo: George Gelernt.*

children (twenty-seven, to be exact) from the city of Hamelin into the mountains. The artist's older son, Dillwyn, posed for the figure of the rather impish young boy climbing across the rocks a few feet behind the piper, while the younger Maxfield, Jr., is seen as the child running at the piper's side. Neighborhood children posed for the remainder of the figures, and the residents of Cornish, it is said, often delighted in trying to identify individual portraits from reproductions of the painting.

When asked once why he chose the Pied Piper as a subject to adorn a bar, Parrish replied,

. . . I don't exactly know, except that I must have thought it an attractive one, as I do now. Seems to me I heard somewhere that it was not a subject quite suited to increase the receipts of a bar, as guests in draining a glass were apt to note a child in the painting that resembled a little one at home and then and there cancel their wish for a second glass.[12]

In contrast to the specific subjects that Parrish seemed to prefer for his murals in public places, those painted for private residences more often suggest general themes or reflect a pleasant atmosphere. On one occasion he refused to paint scenes from *Tristan* and *Parsifal* to decorate the music room of a private home because such specific subjects would limit his freedom of artistic expression. It was this same matter of assigned, restrictive subjects that later caused him to discontinue the "History of Light" series for General Electric Mazda Lamps. He explained his objection to the *Tristan* and *Parsifal* scenes as subjects for paintings to the prospective patron.

Scenes from any of these operas are grand, grand subjects.

Concerning them, I have just one little suggestion to offer. These are pictures made by music, and I am wondering if it is wise to attempt to render them in a medium that is so much inferior. They are pictures you feel and do not see, pictures of the mind, we'll say, and I think that music takes up the rendering of such things and thoughts where painting has to leave off and go no further.

About the only thing painting could do with them would be to go beyond the limita-

tions of the stage, have more heroic people, grander settings, and obtain greater beauty in form and composition and color, and place about them a real but imaginative nature.[13]

The lunette-shaped overmantel panel, *Dream Castle in the Sky* (Pl. 46), executed in 1908 for the Lincoln, Massachusetts, residence of James J. Storrow, was the kind of subject Parrish enjoyed painting for private dwellings—the effects of light on rocks, trees, water and mountains—atmosphere. The spatiality realized between the foreground and the trees and meadows beyond the lake in this painting, and the exquisitely painted figure of the pensive Pan, exemplify the artist's exceptional technical skill and his sensitivity in dealing with the beauty of the human figure in its ideal form.

In the fall of 1909 Parrish was planning decorations for the residence of Mrs. Gertrude Vanderbilt Whitney, when he was notified that the Whitneys had purchased what was formerly Mr. Whitney's father's home opposite Central Park. His decorations were to be postponed until Mrs. Whitney determined whether she wanted them for her new home or for her proposed country studio. In the spring the decision was made to have Parrish decorate the four walls of the studio's reception room. Secluded in the Long Island woods, the studio building being designed by architects Delano and Aldrich would have a gallery for Mrs. Whitney's best sculpture to the left of the main entrance, and to the right would be the reception room, where the Parrish murals would be installed. For the back of the building there was planned a large work area opening onto the garden and swimming pool.

The dark oak wainscoting of the reception room was made seven feet high so the doors and windows could be placed in it without cutting into the upper part of the walls reserved for the four paintings, each of which was to be almost six by nineteen feet in size. Construction of the building progressed rapidly; however, during the original postponement Parrish had accepted a commission to paint "acres" of decorations for the girls' dining room of the new Curtis Publishing Company build-

ing. He found it necessary to delay work on the actual panels for Mrs. Whitney but sent sketches for her approval so that he could begin them as soon as there was time. He explained his scheme in a letter accompanying the sketches in July of 1912.

As a companion tone to the rich brown of the wood work, I want to have a band of rich beautiful evening blue; those to be the two big notes of the room. I feel sure you will agree with me, that, outside of Niagara Falls there is nothing more beautiful in all nature than figures against a sky of r.b.e. blue. . . .

The idea of the whole scheme has not changed in all these years, but will be sort of a fete or masquerade in the oldentime. The real goings on will be in the loggia on the North wall, and the people will have sauntered off on to the other walls, as though it were a court or garden. They will all be youths and girls, as we would wish things to be.[14]

It was two years after the sketches were approved before the artist was ready to deliver the first two panels (Fig. 96). Parrish was delighted with the freedom he had been allowed in rendering the murals and thought the results were better because of it. He expressed his appreciation to Mrs. Whitney: "It is tremendously interesting to have this chance to revel in color as deep and as rich as you please. . . ."[15]

Upon their arrival at Long Island the paintings were cemented to the east and west walls of the reception room by T. R. Fullalove, a professional craftsman who frequently installed mural paintings for Parrish, Blashfield and other artists. When the murals were put in place, it was found that Parrish had been given the wrong measurements and the canvases were 1 1/4 inches too tall and 2 inches too narrow. Fullalove was able to remove the strip at the top and use the extra pieces to fill in the two-inch shortage until Parrish could make a trip to Long Island to correct the mistake. In future mural commissions Parrish made certain that the wall measurements submitted to him were confirmed.

The first two panels in place, a proper method of lighting them was sought. The artist suggested they be illuminated by available light only.

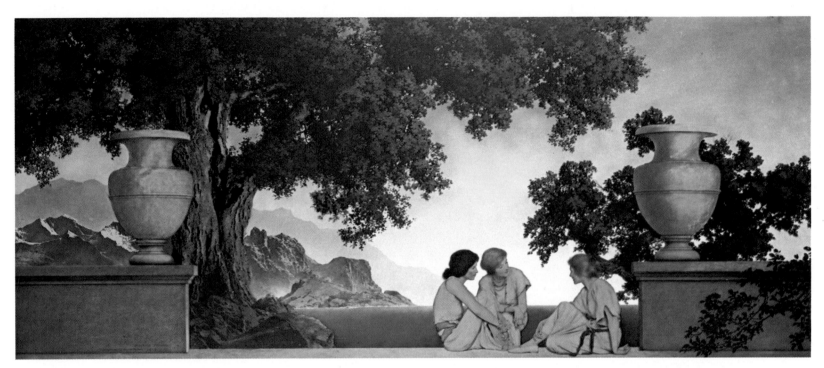

Color Plate 49. *Untitled overmantel panel. 1920. Oil. 3'5" x 7'10". Photo: Ken Smith.*

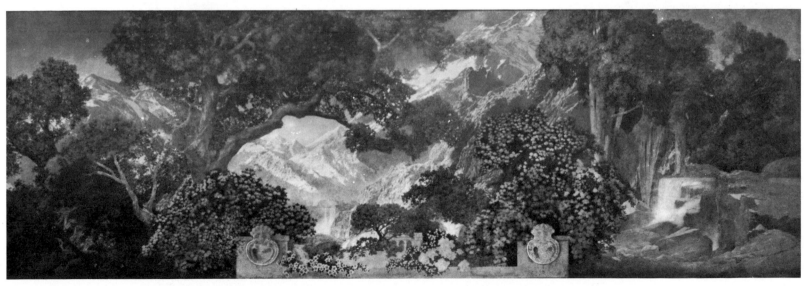

Figure 99. Dream Garden. *Study for Favrile glass mosaic executed by Tiffany Studios (Pl. 48). 1914. Oil on panel, 2'1½" x 6'6". Courtesy Mr. and Mrs. John W. Merriam. Photo: George Gelernt.*

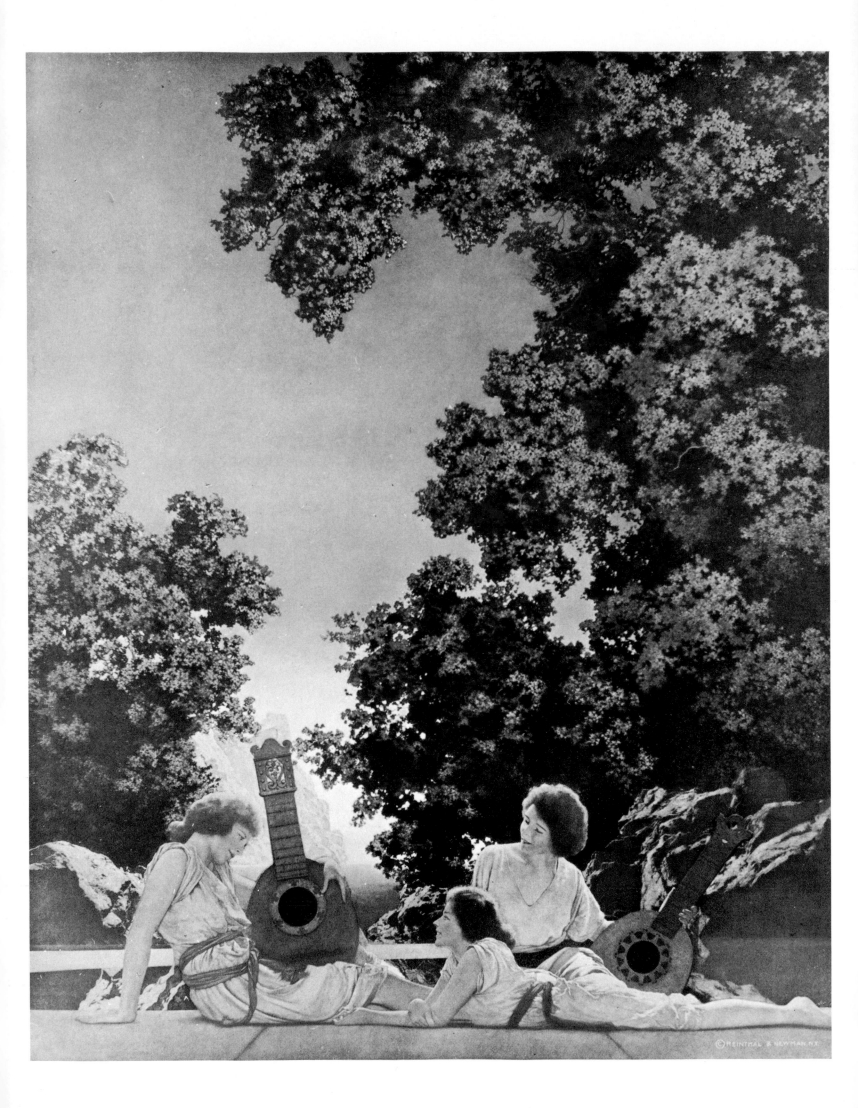

Figure 100. Interlude *(other titles:* Music; Lute Players*). Mural for Eastman Theater, Rochester, New York. 1922. Oil on canvas, 6'11" x 4'11". Courtesy New York Graphic Society Ltd.*

The idea is simply this: don't light the decorations at all, but let them get what light they can after the room is lighted to suit living requirements. To my mind, decorations should decorate and they should not have attention called to them by specially directed light any more than wall paper or a rug or a piece of furniture.[16]

A disappointment was in store for both the artist and the client when, in 1918, the two final panels were installed. The main panel, a mosaic of color crowded with figures at the masquerade or fete, was supposed to give meaning to the entire scheme. But somehow it was out of scale with the other three. The project, sandwiched into the artist's schedule for the Curtis Publishing decorations, had taken nine years to complete; now, in his judgment, it was not successful. Perhaps the time lapse between the execution of the panels had contributed to the lack of harmony of the final panel. The artist returned the four-thousand-dollar check sent in payment for the last painting, requesting that it be returned to him and that the space be filled with paneling to match the wainscot. But the painting was not returned, and apparently it remained in the studio with the other three. Years later, reflecting on the Whitney murals, Parrish questioned his own ability as a mural painter.

I think I was once persuaded to try mural decoration, but I know only too well I was never meant for it, was never able to understand the requirements, or feel at home in it, as may be the case with smaller things. The panel in question is only too good a proof of it, for I . . . had a chance to study it longer than anything I had ever done, but to this day I do not know just why it is a failure.[17]

Contrary to his own self-evaluation, Parrish was a capable and effective muralist. There can be no question that the eighteen mural panels painted for the Curtis Publishing Company are among his most significant achievements. Each of the panels is an example of his genius in the use of color and of his technical virtuosity. Taken as a unit, the eighteen panels reflect a composition conceived with an understanding of murals not merely as decoration but as an extension of architecture.

Edward Bok, the innovative editor of *Ladies' Home Journal* who introduced inexpensive, tastefully simple architecture and the art of interior design to the American populace through the pages of his magazine, was responsible for commissioning Parrish to paint the murals for the new headquarters of Curtis Publishing Company. The building, which at the time was considered the most beautiful and most completely equipped periodical plant in the world, was being constructed at Independence Square in Philadelphia to house not only *Ladies' Home Journal* but all of the Curtis publications. As a large number of young women were employed by the company, an attractive dining room for them was planned for the top floor of the building. The areas between the dining room's thirteen enormous colonial windows and a 10' x 17' area on the south wall seemed to Mr. Bok to be ideal for mural decorations.

At first Parrish regarded the spaces between the windows as being too tall and narrow for any real artwork. (They were 10' 8 1/2" x 3'5", with those at the corners somewhat wider.) He suggested that Bok have a decorator paint some trellises and vines in the spaces. However, upon reconsidering the south wall area and the free rein that Mr. Bok offered, he accepted the commission. The theme of the eighteen paintings was to be a Florentine fete and, like those being planned for Mrs. Whitney's studio at about the same time, one panel would contain a kind of party or fete (Pl. 47), while the others would depict happy young people enroute to the gathering (Figs. 97, 98). In 1910 he wrote to Mr. Bok:

I will make a suitable painting for the south end of the room representing a carnival or masquerade. The scene will be in a white marble loggia: the foreground will be a series of wide steps extending across the entire picture, leading up to three arches and supporting columns. . . . On the steps and in the loggia in the gardens beyond and on the terraces will be crowds of figures . . . it will be my aim to make it all joyous, a little unreal, a good place to be in, a sort of happiness of youth. . . . In the narrow panels extending around the room, it is my intention to show figures coming to the fete or carnival.[18]

[A year later he elaborated further on the theme.] . . . All the people are youths and girls; nobody seems old. It may be a gathering of only young people, or it may be a land where there is youth, and nobody grows old at all. . . . What is the meaning of it all? It doesn't mean an earthly thing, not even a ghost of an allegory: no science enlightening agriculture: nobody enlightening anything. The endeavor is to present a painting which will give pleasure without tiring the intellect: something beautiful to look upon: a good place to be in. Nothing more.[19]

Parrish prepared half-sized sketches for many of the panels for Bok's approval and then set about making the actual paintings on canvas in his large mural studio in Cornish. His procedure, when executing such large paintings, was to paint the figures and other detailed parts first. When they were finished, he would concentrate on the larger areas and perfect the tonality of the entire work. In his technique of painting with glazes thorough drying was critical and he preferred to dry the panels by baking them in the sun. Smaller ones could be lifted into the sun, but for the larger panels he constructed a derrick to assist him. In the cold winter months he dried his paintings by the stove. When Bok wrote in January of 1912 to ask if he could finish some of the panels ahead of schedule for an exhibition at the Pennsylvania Academy of the Fine Arts, Parrish replied, ". . . it is now purely a question of drying. Sunday it was 35 below zero in the Town of Windsor. Wood simply dissolves in the stove, it does not seem to burn, and drying is an uncertain affair. Therefore, I know it is wiser to say they cannot be ready. . . ."[20]

The seventeen smaller panels were completed within two years, the last ones arriving in Philadelphia in March, 1913, and were installed by the customary method of cementing the canvas directly to the wall. The large panel for the south wall, which was installed on a stretcher, was not finished until 1916.

The murals were considered a great success. The subtle tans of Tuscan walls and buildings, contrasted with the verdure of the Italian gardens and the joy and beauty of youth, were arrestingly captured

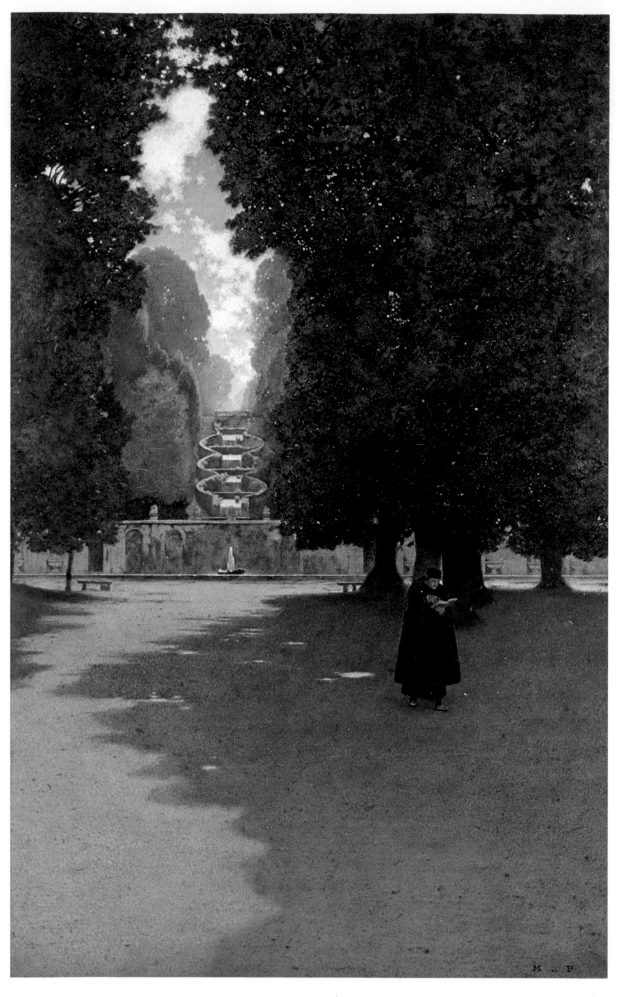

Color Plate 50. Torlonia. *Illustration for* Italian Villas and Their Gardens *by Edith Wharton. 1903. Oil, 28" x 18".*
Courtesy Vose Galleries, Boston. Photo: Herbert P. Vose.

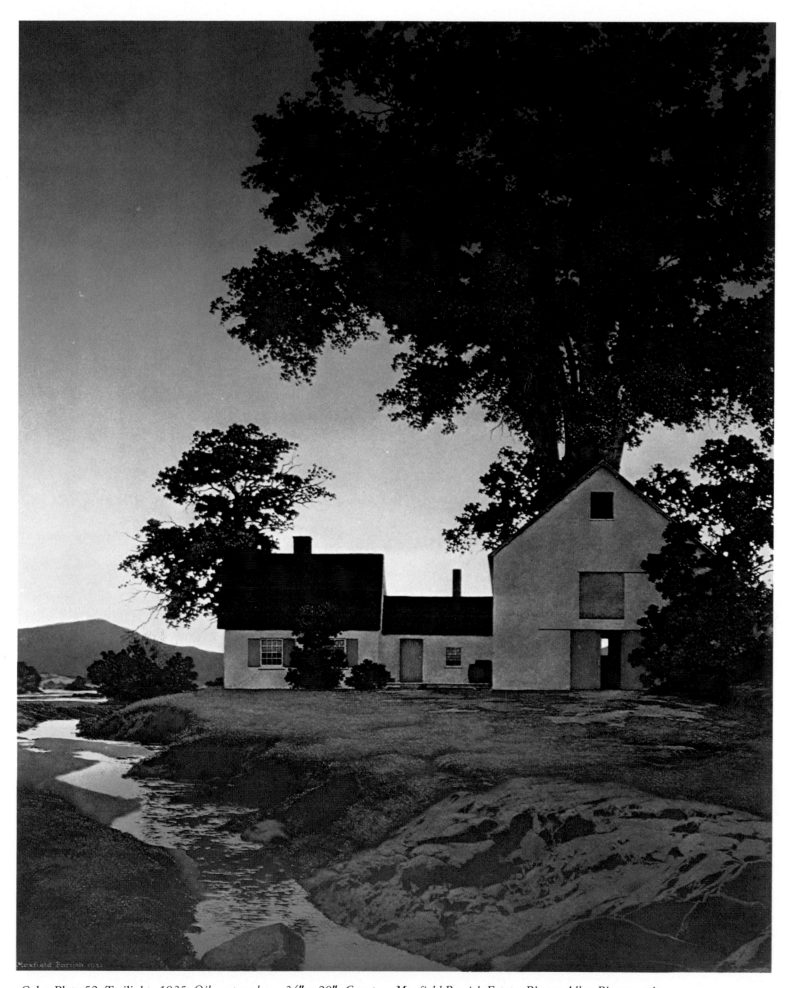

Color Plate 52. Twilight. *1935. Oil on panel, ca. 34" x 20". Courtesy Maxfield Parrish Estate. Photo: Allen Photography.*

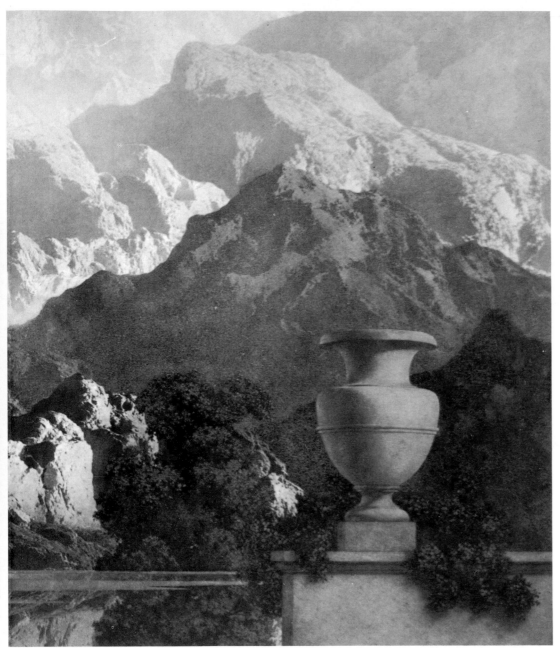

tions for shipping and transferred to the Curtis Building (Pl. 48).

Three later wall panels or murals by Maxfield Parrish were closely related in style and subject matter although painted over a span of thirteen years. These were the overmantel panel painted in 1920 for the Pennsylvania residence of Philip Collins, business manager of Curtis Publishing Company (Pl. 49); *Interlude* (Fig. 100), painted in 1922 for the Eastman Theater in Rochester, New York; and the music-room decoration painted in 1933 for the Delaware home of Irénée du Pont (Fig. 101). Landscapes with distant mountains, reflecting pools, trees, urns and an occasional lovely maiden—Parrish's trademarks in the two decades prior to 1930—provided the subject matter for these paintings from the genre of *Garden of Allah* and *Daybreak*. In each of them the artist created the feeling of space and distance that he thought essential to wall decorations for architectural interiors.

Although Parrish preferred the scale of easel paintings to that of murals, his knowledge of architecture and his architectural approach to many of the problems of painting provided him with an exceptional sensitivity toward mural painting and caused him to regard murals as integral to the architecture rather than as separate entities. He was of the opinion that murals should not call attention to themselves, but should exist in harmony with the architectural environment. In numerous instances, the most notable of which are the dining-room murals for Curtis Publishing Company, the architectural elements are brought into the compositions themselves. A firm believer that murals should open up interior spaces, Parrish included peaceful, distant vistas in nearly every one he painted. Although many of his murals or wall decorations are in locations to which the public does not have easy access, Parrish, throughout the years, has maintained an important position among American mural painters on the strength of his decorations for the Knickerbocker and Palace Hotels. As more of his murals are acquired by museums, his abilities in this area are certain to become more widely acknowledged.

several sections, which, enlarged, served as the cartoon for the mosaic. Although it was understood that Parrish would have the final word on any questions regarding the translation of his painting into glass, he trusted the ability of Tiffany's artisans and, after checking the photographs of his study to see if the scale had been preserved in the enlargements, he left the rest of the project to them. Only once, while waiting for a train in New York, did Parrish go to Tiffany Studios to check on the progress of the mosaic. When he learned that Mr. Tiffany was not there, he briefly observed the men at work and quietly left without making his identity known.

When it was completed in the spring of 1915, the *Dream Garden* mosaic measured fifteen feet by forty-nine feet in size. It was exhibited at the Tiffany Studios in New York for a month, and more than seven thousand people came to admire the glittering, iridescent composition. The mosaic then was disassembled into sec-

by the artist. The architectural elements of stairs and balustrades continuing through each of the small panels brought them successfully together into a cohesive scheme. The main tableau on the south wall, *Florentine Fete* (Pl. 47), was striking with its Veronese-like arches and the colorful costumes of the young people. One face seemed to stand out because it was repeated again and again in the murals. This was the face of Sue Lewin, the young girl who often modeled for the artist.

An enthusiastic reception was given the paintings in Philadelphia. The officials of the Curtis Publishing Company announced the completion of the panels in the *Ladies' Home Journal* and even used reproductions of several of them as cover designs for the magazine. Hundreds of visitors came weekly to view the paintings. When a distributor of color reproductions began negotiating for permission to issue them as prints for framing, Parrish was asked to provide a title for each panel, but he refused.

I am the last one in the world to invent titles for pictures. I loathe titles even when they might fit, and in the case of the dining room murals, I threw up my hands. The panels are really sections of one large picture, technically what are known as fragments, and what to call each one—why, it's well nigh impossible.

Could they be Opus No. 4, like music? Or, "A Pair of Vases," "Another Pair," "Even Two More," etc. . . . As to the sentimental titles, for Heaven's sake let's not have that.[21]

While Maxfield Parrish was painting the panels for the girls' dining room, Edwin Austin Abbey was working on a single large mural, *The Grove of Academe,* for the impressive lobby of the same building. When Abbey suddenly died, Bok began to search for a replacement in order to have a mural in place in the lobby for the building's opening, and Parrish was invited to serve as a judge on the panel to select the artist. George de Forest Brush was considered for the commission, but he decided to withdraw from the competition. Parrish had visited the studio of Barry Faulkner in New York, and he recommended Faulkner over Boutet de Monvel,

who also was being considered and whose work Parrish thought looked too "foreign." Faulkner's sketches, however, did not impress the rest of the panel favorably, and Boutet de Monvel suddenly died before all of the panel members had even the opportunity to study his sketches. Bok attempted to persuade Parrish to paint the lobby mural, even though he was so busy with the murals for the dining room that he could not have accepted had he had the inclination. Finally, in October of 1913,

Parrish met with Bok at the Hotel Manhattan in an attempt to arrive at a solution for the lobby decoration. At the meeting Bok revealed that he was discarding the idea of a painted mural in favor of a mosaic to be executed in Favrile glass by the Tiffany Studios. At his request both Maxfield Parrish and L. C. Tiffany submitted designs for the mosaic, and it was Parrish's design, *Dream Garden* (Fig. 99), that eventually was selected.

Dream Garden was photographed in

Color Plate 51. Elm, Late Afternoon *(other titles:* Peaceful Valley; Tranquility*). 1934. Oil on panel. Courtesy Maxfield Parrish Estate. Photo: Allen Photography.*

Color Plate 53. The Country Schoolhouse. *1937. Oil on panel, 30" x 24". Courtesy the Everson Museum of Art, lent by the Olive Moyer, Walter Pratt and Hazel Northam Estates. Photo: Anthony Chelz.*

Chapter 7

LANDSCAPES

Maxfield Parrish's fondness for landscape painting was apparent from the beginning of his career. In his record book there is entered as Number *10* a small landscape entitled *Moonrise,* painted in oil at Annisquam, Massachusetts, in August, 1893. A note by the young artist indicated that it was "Painted in one sitting over an orange ground. The impression was received after a walk across Cape Ann at 2 o'clock in the morning with V.C. The stillness and moonlight being just wonderful."[1] This small landscape, exhibited at the Philadelphia Art Club in November, 1893, was the first oil painting by the artist ever to be included in a public exhibition.

In the early 1890s Parrish spent several summers painting landscapes at Annisquam. Describing the summer quarters he shared with his father in 1892, he wrote to his mother in Philadelphia:

Our studio is by this time all fixed and we are thoroughly enjoying the coziness of it. . . . Our divan being made of a bed-stead given by our landlady E. is quite a piece of furniture. We took away the stairs leading to the western platform as taking up entirely too much room, and put a ladder in their stead. We each have a good solid table, and have the floor covered with a large sail, which keeps the wind out, and makes a good surface to walk on. The stove is the greatest success. There are miles of pipe for a thimble of a stove at the other end. But what it lacks in quantity it makes up in quality, for put a match therein and the place is warm. Indeed I should sleep in it and live in it (the studio) were I alone here, although the chinks would no doubt let in much cold air in winter.[2]

Stephen Parrish, Maxfield's father, received critical acclaim for his etchings of the coastal towns around Cape Ann, including Annisquam and Marblehead. He enjoyed a very warm friendship with his son, who credited his father with teaching him the essentials of art. "My own art school work was simply terrible," Maxfield Parrish wrote to a young art student in 1952. "I didn't know what it was all about, only by actually doing it could I get anywhere. I got a lot from my father who was an artist, who called my attention to many hundreds of things in the visual

world to which most of humanity are blind."[3]

Maxfield Parrish, during his schooldays, did not devote his entire attention to landscape painting. Still searching for his medium, while at Haverford he designed a silver lamp for Mr. and Mrs. Cameron Forbes (Forbes subsequently became governor general of the Philippines) which was to be presented as an achievement award by them, and a year or so later at the Pennslyvania Academy of the Fine Arts he designed a clock face and a stained-glass nursery window. Apparently his mother had written to him at Annisquam concerning the direction he was intending to take in his art, for his reply from there on September 20, 1893, indicated that painting already interested him most.

About sculpture—thee[4] might be right. An artist here declares my hands were cut out for a base-ball player, so opinions differ. I truly love it, but it is not for me; as I care for color more than any other phase of art. And don't be afraid of my ever sticking to "easel pictures" alone.[5]

Parrish's skill as a colorist developed along with his interest in the landscape as a subject. In the first decade of this century critics time and again hailed the effectiveness with which he used color, both subtle and bold, in illustrations and posters. Even when painting the most commercial advertisement or making illustrations which called for interior scenes, his interest in landscapes persisted. There nearly always was a small landscape tucked away in the background or seen through an open arch or window.

The two trips to Arizona between 1901 and 1903, and the trip to Italy in the late spring of 1903, had a profound influence on Parrish's development as a landscape painter. The dramatic effects of the southwestern sunrises and sunsets, with their reflections of brilliant orange hues and shadows of purple and blue, and the craggy terrain of the canyons became forever a part of Parrish's artistic vocabulary. As late as 1950, at the age of eighty, he painted a blue and orange canyon scene which he called *Arizona* (Fig. 102). The

Figure 102. Arizona. 1950. Oil on panel, 20½" x 17". Courtesy Maxfield Parrish Estate and Vose Galleries, Boston. Photo: Herbert P. Vose.

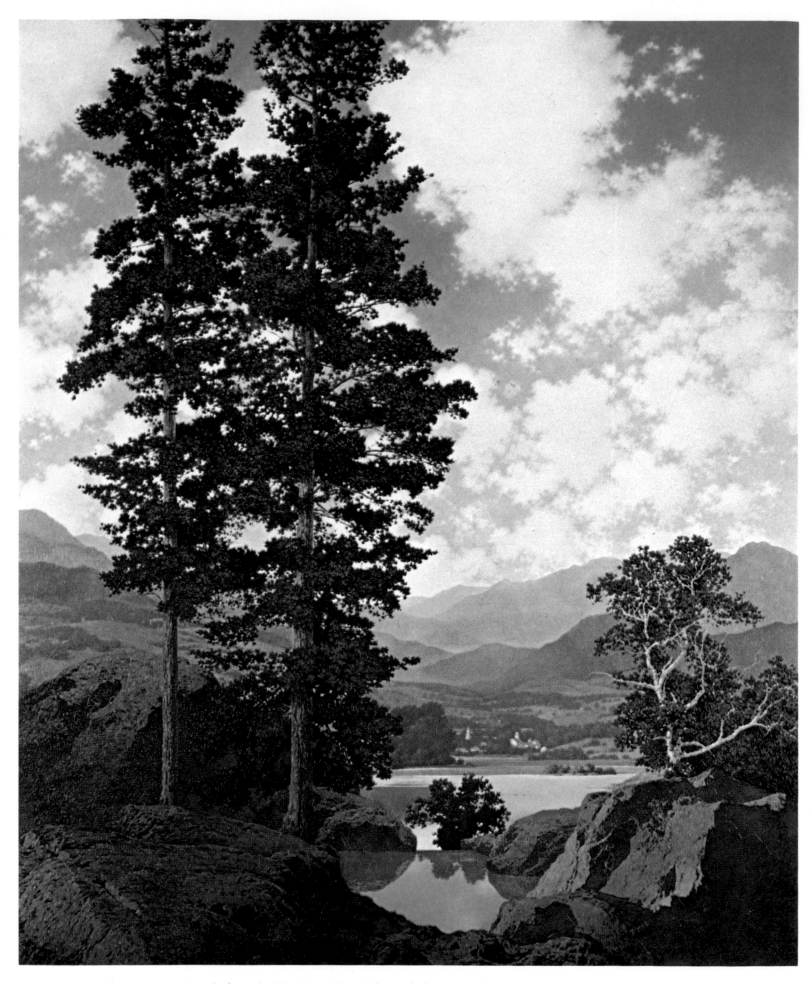

Color Plate 54. New Hampshire *(other title:* Thy Templed Hills*). 1936. Oil on panel. Courtesy Windsor County National Bank. Photo: Atwood Studios.*

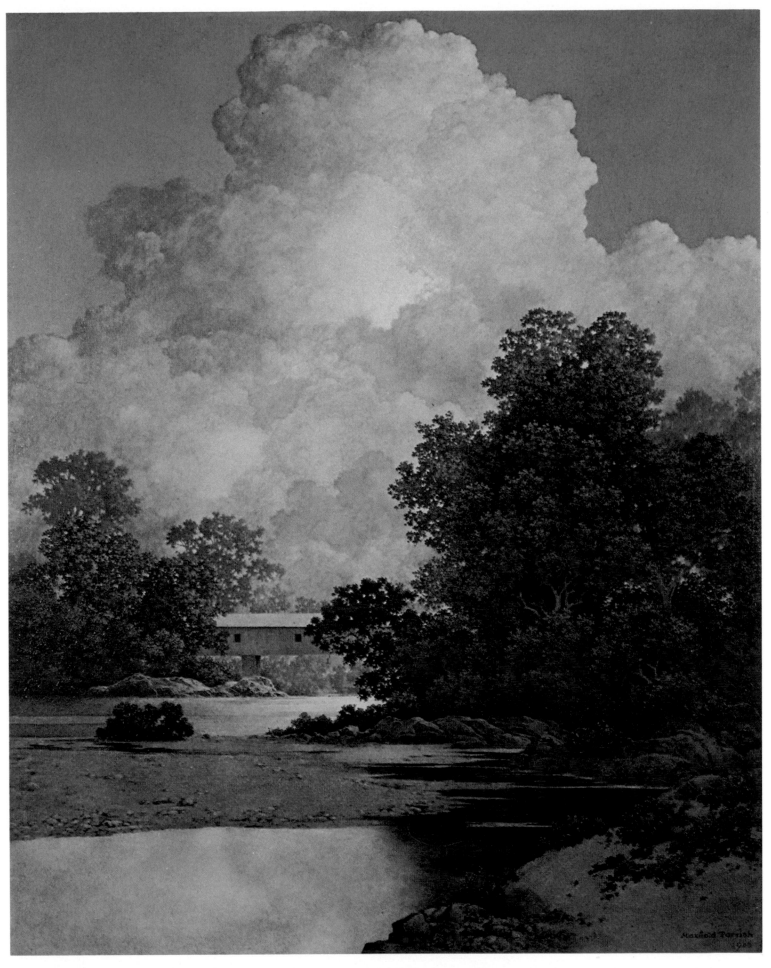

Color Plate 55. Thunderheads. *1943. Oil on panel, 22½" x 18". Courtesy the Everson Museum of Art, lent by the Olive Moyer, Walter Pratt and Hazel Northam Estates. Photo: Anthony Chelz.*

Figure 103. The Broadmoor. *1921. Oil on panel, 26" x 36". Courtesy the Broadmoor, Colorado Springs, Colorado.*

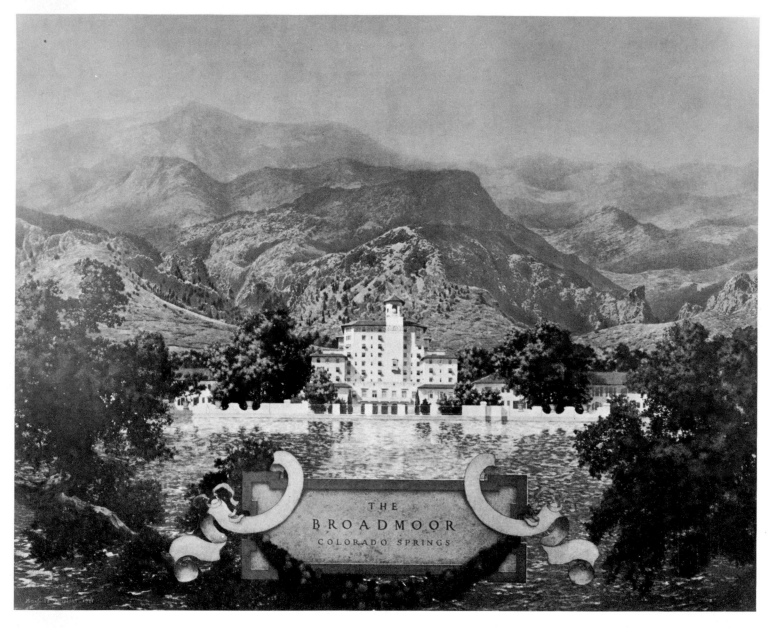

Italian experience provided a balance for the impact of the dramatic colors of the Southwest. The low-keyed coloring of the Italian landscape, with its rich browns and tans, sienas, and variety of greens, was beautifully captured by him in such illustrations as *Torlonia* (Pl. 50), painted for Edith Wharton's *Italian Villas and Their Gardens.* Since the purpose of the trip was to make the photographs and color notations to use upon his return, the artist's observations had to be keen and accurately recorded. The trip amounted to three months of concentrated study of Italian architecture and the local color of the country.

Although Maxfield Parrish painted landscapes throughout his career, it was not until the early 1930s that he began to paint them almost exclusively. While making the annual calendars for General Electric Edison Mazda Lamps, Parrish declined several invitations to paint landscapes for Brown and Bigelow, the calendar and greeting card company in Saint Paul, Minnesota. He felt that it might seem disloyal to General Electric for him to make calendars for another company. When it was decided that the 1934 calendar would be the last in the General Electric series, Parrish was free to accept Brown and Bigelow's offer.

Elm, Late Afternoon (Pl. 51), one of the artist's most powerful landscapes, was selected for his premiere effort with Brown and Bigelow. Filled with colors of autumn, the composition consisted of a large russet elm in the left foreground, under the branches of which could be seen, far off in the valley, a small New England village and mountains bathed in the afternoon sun. One of the major strengths of the painting is the contrast between the elm

and the distant clouds. Painted in minute detail, but with an overall impact similar to that of Blakelock's tree silhouettes, the elm is the point from which the eye measures the carefully defined space between the foreground knoll and the rolling mountains in the background. It is an idealized landscape, as were all of Parrish's landscapes, put together with jewellike brilliance and calculated precision. The long periods of drying required for different layers of glazes in the technique used by Parrish prohibited his painting out of doors. Consequently, his landscapes were painted in the studio and often, but not always, were a composite of elements from several locations brought together into one composition. The artist elaborated on his ideas about landscape painting in the following quotations, the first two of which were written with regard to his painting for the Broadmoor, Colorado Springs, Colorado (Fig. 103).

Should I ever be able to come out there and paint the place, I would do it just as I did the series on the Italian Gardens, make many photographs and studies on the spot and then paint the actual picture at my home. In some ways this is better, for with a certain temperment [sic], a literal rendering of the material facts can be avoided, and the part that stays in the mind can the better be brought out, the spirit and atmosphere of the place.[6]

I remember going out to Colorado Springs once to make a postery sort of picture for the Broadmoor Hotel. Besides the hotel they had two features of which they were very proud: an artificial lake and the Rocky Mountains. But you could not see all three from any one position. So what did we do but put the lake on the other side of the hotel, thus showing all three attractions in one picture. We did not dare drag in Pikes Peak, but took liberties only with what man had done.

Strange as it may seem, I would much prefer to paint such pictures here, away from the actual place, because I feel that the most important qualities of such scenes are their sense of vastness, space, color and light, fleeting qualities, which can best be portrayed in retrospect.[7]

The magic and spirit . . . you feel instead of actually see, and if you don't get it in a painting a colored photograph would do as well, if not better. Just a faithful "portrait" of a locality, factual, would never do. I feel sure all great landscape paintings were at least finished indoors, for there is no such thing as copying the more illusive qualities as light playing over the scene, the sense of air and space and color, distance and the great dome of the sky, for these things last but for a moment anyway. The material objects, "stage properties" so to speak, one has to have to help get the message across, trees and rocks, hills and valleys, rivers and mountains, but unless you get the other, the thing is a failure.[8]

The artist was pleased to learn from Brown and Bigelow that *Elm, Late Afternoon* (1936 Brown and Bigelow title: *Peaceful Valley*) was the first landscape in the history of the company to lead an entire line in sales during an initial selling period. "It means a lot to me," he replied, "for I have felt for a number of years that I have a better grasp on landscape than on any other subject."[9] At sixty-four, an age at which many men are retiring, Parrish was entering full speed into a new phase of his career.

Remembering the difficulty he had had, in the art-print business, of trying to repeat the success of *Daybreak* with each new painting, Parrish was determined to avoid such pressure in his new endeavor. In making his second Brown and Bigelow calendar landscape, he indicated that he was searching for an effect, rather than for a specific subject.

I feel that the broad effect, the truth of nature's mood attempted, is the most important, has more appeal than the kind of subject. "Broad effect" is a rather vague term, but what is meant is that those qualities which delight us in nature—the sense of freedom, pure air and light, the magic of distance, and the saturated beauty of color, must be convincingly stated and take the beholder to the very spot. If these abstract qualities are not in a painting it is a flat failure. You might just as well have the typical art calendar, a collection of familiar things around the "Home Sweet Home": the old well sweep, duck pond, barn yard gate, and the cows coming home.

If *Peaceful Valley* is a success we must be careful not to repeat it. I would not advise having a quaint little village nestling among trees in every picture. . . . There is only one rubber stamp permitted, each and every picture must represent one grand good place to be in.[10]

In 1930 a small, rather hastily done painting of Parrish's called *Twilight* appeared in *American Magazine*. It had brought such a favorable outpouring of mail that he thought a larger, more finished version might make a good calendar subject for 1937. The small version, a horizontal landscape of a homestead under two trees painted solely for the artist's own pleasure, had a softness and painterly quality that were lost in the larger, more precise calendar version; but the color, tonality and general design of the earlier composition were retained in the later painting (Pl. 52). One additional small detail, which the artist felt counted in large part for the great success of *Twilight* as a calendar, was an open barn door on the right side of the picture. Through this door one could see an open window in the back wall of the barn and, through that, the sky and mountain beyond. The small patch of light coming through this window brought the viewer's focus to an otherwise subdued area of the composition. The open door was also considered to be a sign that the place was inhabited as well as a sign of welcome, two important considerations in calendar design.

The Glen, the 1938 calendar subject, was a departure from the two more picturesque earlier subjects. Concentrating on a very small rocky area of a glen flanked by two massive tree trunks, the artist concerned himself with the effect of the place rather than its scenic quality. His intention here, in his own words, was "to get that peculiar cathedral quality of a dark glen in the woods, like entering another world from the sunlit fields outside."[11] As appealing as the effect was, the subject was considered by Brown and Bigelow to be too involved and to lack the punch of effective calendar art.

Three landscapes were submitted to Brown and Bigelow in 1937 for consideration as possible future calendar subjects. The selection committee decided to use one of them, *The Country Schoolhouse* (Pl.

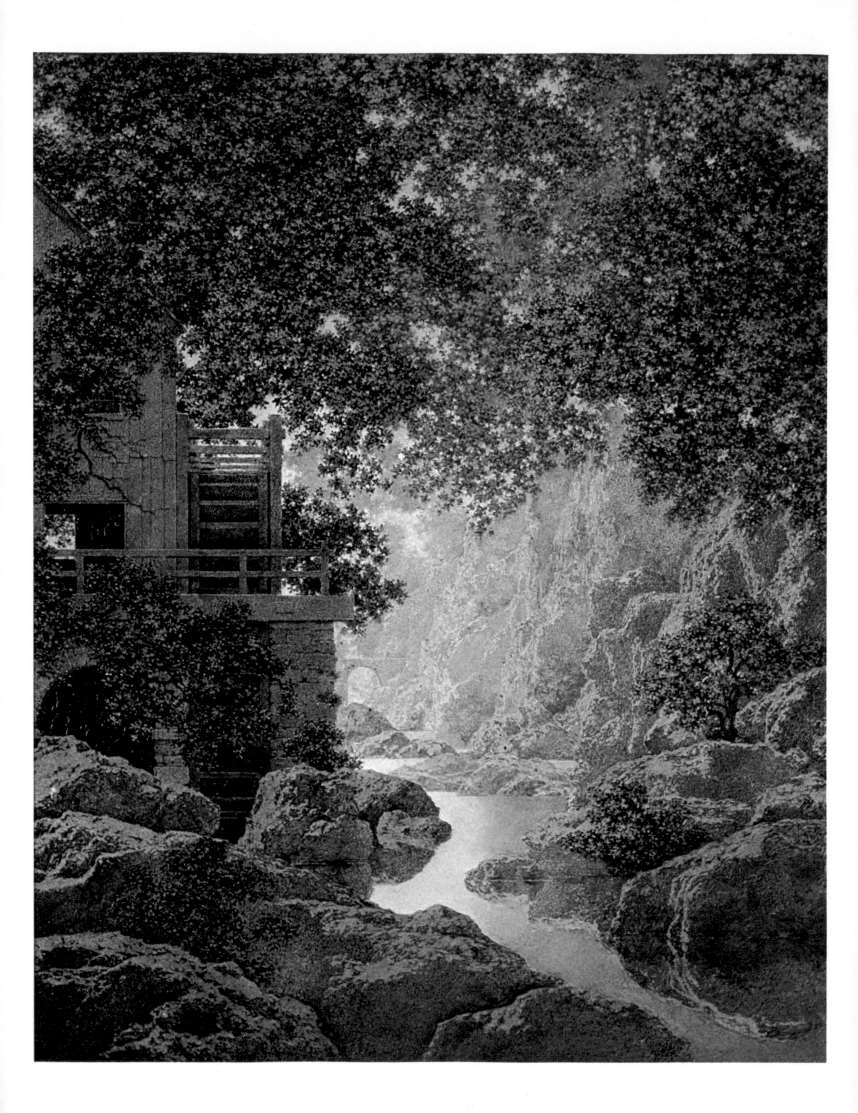

Color Plate 56. The Old Glen Mill.
*1950. Oil on panel, 23" x 18½".
Courtesy Maxfield Parrish Estate
and Vose Galleries, Boston.
Photo: Herbert P. Vose.*

LANDSCAPES 177

53), in the 1940 calendar line and to make plates of the other two, *The Old Birch Tree* and *New Hampshire* (Pl. 54), to be put in storage for future use. As it happened, *The Old Birch Tree* (Brown and Bigelow title: *Evening Shadows*) was used in the 1940 line, *New Hampshire* (Brown and Bigelow title: *Thy Templed Hills*) in the 1942 line, and *The Country Schoolhouse* was never published. *Thy Templed Hills,* painted in 1936 as the summer poster for the State of New Hampshire, used the concept of space and distance, proven so successful in *Elm, Late Afternoon,* to depict the scenic splendor of New Hampshire. Where the elm stood in the earlier painting, Parrish placed two tall pine trees. The trees used as models here grew in just this position outside Parrish's Cornish studio. In the painting the pine trees stand at the top of a waterfall, beyond which one sees a river, village, mountains and blue sky filled with white clouds.

Maxfield Parrish often said, "'Only God can make a tree.' True enough, but I'd like to see Him paint one."[12] The statement reflects the kind of painting skill and knowledge of nature that Parrish knew was required for painting trees as he painted them—with subtle variations of color and gradations of light and shadow, accurately depicting light filtering through the layers of precisely detailed foliage. When finishing the painting *The Village Church* in 1939, he wrote to the art director at Brown and Bigelow, "Give me a hundred years more and I really think I can paint a tree that satisfies me."[13]

Each year, when Parrish submitted his landscapes to Brown and Bigelow, there was always some apprehension about the way they would appear in the format of calendar or greeting card. Aside from the fidelity of the reproduction itself, there were two other factors that caused him much worry. One was whether the composition would be cropped in the reproduction to such a degree that his carefully studied Dynamic Symmetry would be destroyed. "Some day, to be sure," Parrish wrote to Brown and Bigelow, "prints will be made on a rubber sheet, and owners can stretch them to suit wall space or the frames they

happen to have."[14] The second concern was with the kind of printed border or mat the painting would be given. Parrish's own personal taste ran toward plain, deep-toned frames. In the early years he often framed his paintings in wide, simple frames painted black or dark gray, or made them of wide, unornamented gilt moldings which he toned down with dark paints or stains. For his later landscapes he preferred to make the frames of Masonite strips about two and one-half to three inches wide, which he varnished to bring out their rich, brown color. He strongly disapproved of placing a white border adjacent to any of his paintings, and frequently voiced this feeling to Brown and Bigelow, as when he saw the 1941 calendar, *The Village Brook.*

Of all things to put a white border on a dark picture! It simply kills it. It's the first thing that hits you bang in the eye; takes all the life out of the subject and leaves it dead . . . You'd never think of framing a dark picture in white to hang on a wall, and for that reason that applies equally well in a border to a print.

You see it isn't a matter of taste, it is a matter of the laws of contrast and juxtaposition. My tiresome blue we seem to hear so much about is just ordinary blue you can buy around the corner, but what I put next to it is what makes it what it is. The gilt frames I use have to be toned away down from their original state, else they would blind the observer so he couldn't see the picture.[15]

The dimensions of many of Parrish's landscapes painted in the late 1930s were around 30" x 24", but in the early 1940s he began to make them about 22½" x 18", as he felt that his smaller paintings seemed to him more aesthetically successful than the larger ones. It was a wise decision, for his brilliant, enamellike surfaces and intricately detailed subjects called for the smaller size. Size also determined the price that Parrish charged for his original paintings, after they had been published and returned to him by Brown and Bigelow. "I used to feel that merit should determine the value," he once wrote, "but as it is notorious that an artist is no good judge of his work's merit, size seems to be the best way."[16]

Clair Fry, himself an artist, became assis-

tant director of the Creative Department at Brown and Bigelow in the early 1940s. Over the years there developed between Fry and Parrish a warm and cordial business relationship and a mutual respect for one another's opinions on art. As he traveled around the country on his annual visits to all the artists who painted for Brown and Bigelow, Fry would call on Parrish at his studio one day each summer. The two men usually enjoyed lively conversation as they lunched on the porch of the studio overlooking the Connecticut River valley. Parrish, by then over seventy, was always buoyed by the younger artist's visits and the stimulating conversation.

Feeling that Parrish's wit and charm and the beautiful environment in which he worked would make a good feature story, the people at Brown and Bigelow suggested that a free-lance writer be sent to Cornish to interview the artist. Parrish, who deplored notoriety, would have no part of it.

There is nothing I dislike more than any kind of personal publicity, the so-called write up or "story." I've endured the torture for the past forty years and have only allowed it once in a while just to be decent, and now in my old age am thankful that there seems to be an end of it.

There isn't any story here. So many in the past have tried to find one; jumped at the conclusion that because I painted pictures of a certain kind there must be something decidedly interesting about the artist: he must live in a tree, eat nuts and berries, or something . . .

If you are going in for interesting publicity give the public mystery. The Greta Garbo kind is the very best, and it keeps up. . . . I am happier in my work for you people than I have ever been, but if this publicity by-product has to be a part of it, it detracts a lot.[17]

Aside from not wanting the personal publicity of newspaper and magazine articles, Parrish did not like the flow of visitors that each story brought. He appreciated his public and therefore, whenever, possible would stop his work to talk with the people who came to his studio. But he could not understand why the public did not respect an artist's need for uninterrupted periods

Color Plate 57. The Millpond. *1945. Oil on panel, 22½" x 18". Courtesy Ralph A. Powers, Jr. Photo: Robin L. Perry.*

Color Plate 58. Peace of Evening *(other title:* Evening Shadows*). 1950. Oil on panel, 23" x 18¾". Courtesy the Everson Museum of Art, lent by the Olive Moyer, Walter Pratt and Hazel Northam Estates. Photo: Anthony Chelz.*

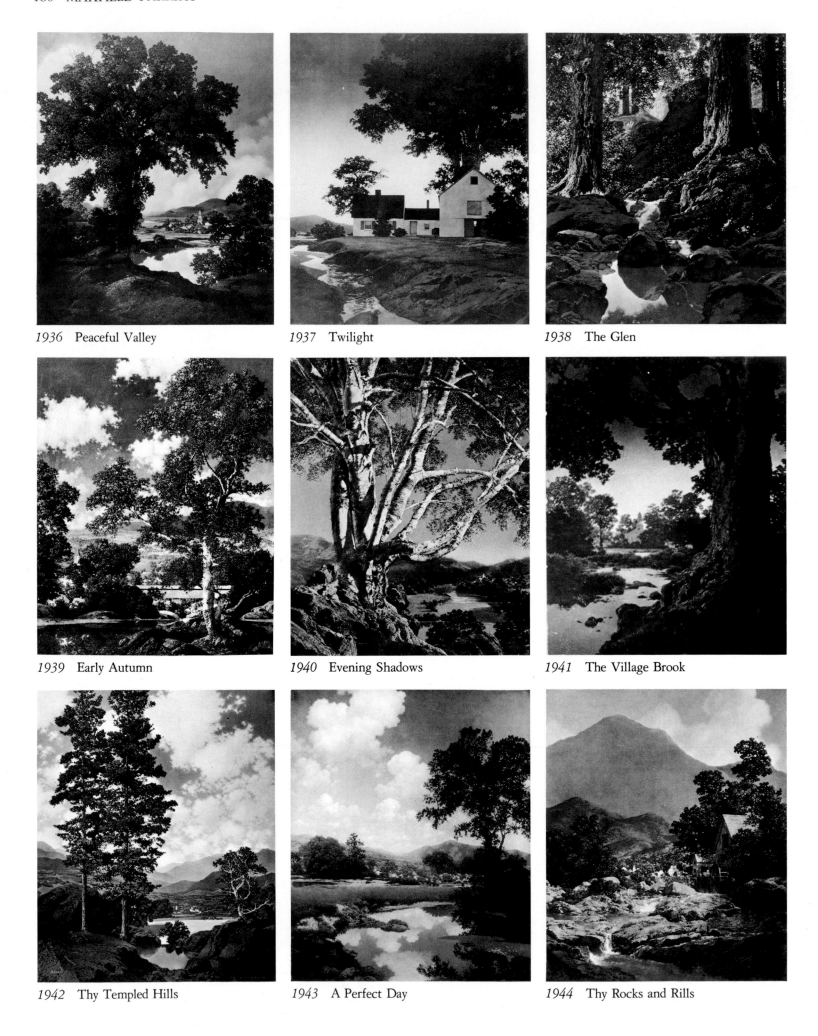

1936 Peaceful Valley

1937 Twilight

1938 The Glen

1939 Early Autumn

1940 Evening Shadows

1941 The Village Brook

1942 Thy Templed Hills

1943 A Perfect Day

1944 Thy Rocks and Rills

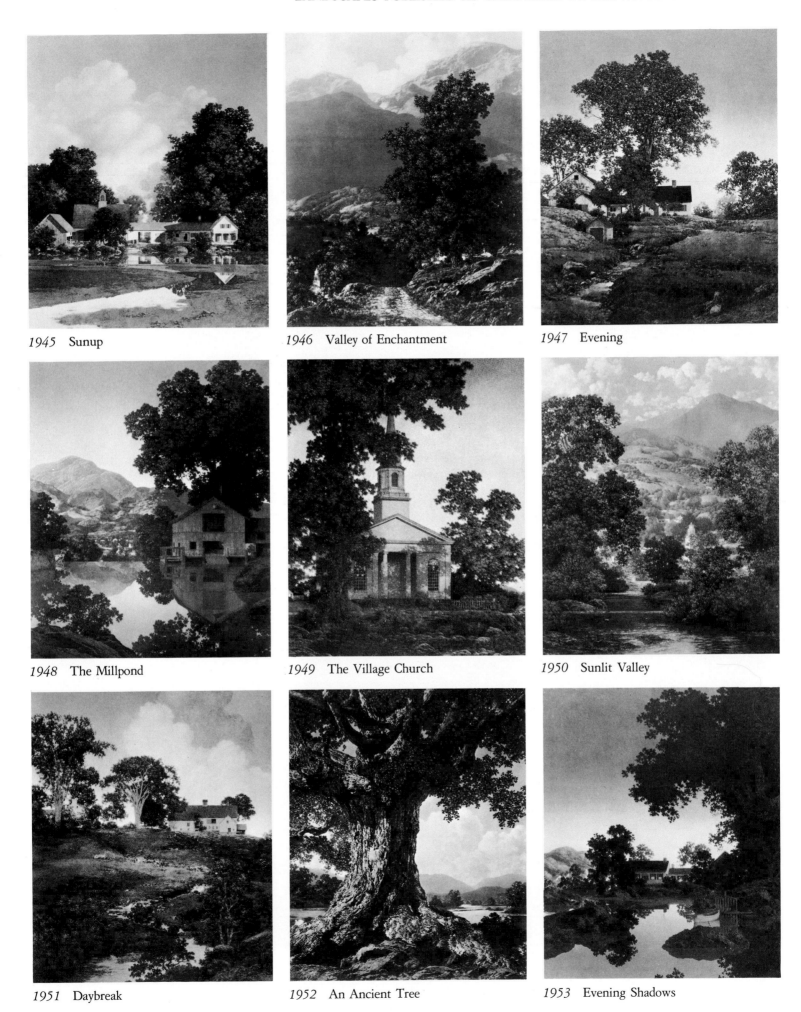

1945 Sunup

1946 Valley of Enchantment

1947 Evening

1948 The Millpond

1949 The Village Church

1950 Sunlit Valley

1951 Daybreak

1952 An Ancient Tree

1953 Evening Shadows

Color Plate 59. Swift-water *(other title:* Misty Morn*). 1953. Oil on panel, 23" x 18½". Courtesy the Everson Museum of Art, lent by the Olive Moyer, Walter Pratt and Hazel Northam Estates. Photo: Anthony Chelz.*

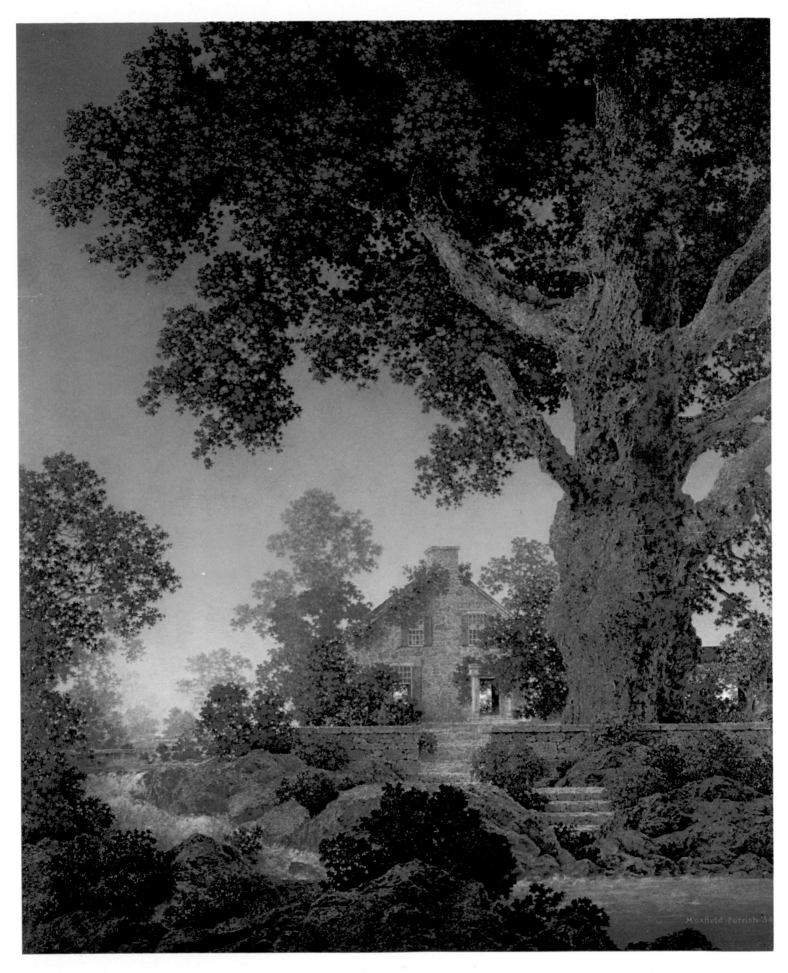

Color Plate 60. Little Stone House *(other title:* Morning Light*). 1954. Oil on panel, 23" x 18½". Courtesy the Everson Museum of Art, lent by the Olive Moyer, Walter Pratt and Hazel Northam Estates. Photo: Anthony Chelz.*

of work and concentration. He often said that one who would never dream of paying a social call on a dentist at work would not hesitate to drop in unexpectedly on an artist in the middle of the morning or afternoon.

In 1943, with all the available manpower involved in the national defense effort, Parrish put aside his painting for the month of August to get ready for winter. Ordinarily a hired man performed these chores, but one was not available in this war year. At age seventy-three, Parrish rolled up his sleeves and put a new roof on his studio building. All of his life he had enjoyed manual and mechanical work, and even at this advanced age it seemed to stimulate him.

Earlier in the summer Parrish had submitted five landscapes to Brown and Bigelow from which they were to make calendar and greeting card selections. The company by this time had added a second Parrish subject to its annual collection. In addition to the regular calendar, a small winter landscape was now included in their engraving line of greeting cards and small calendars. Clair Fry believed that *New Moon,* one of the newly painted small landscapes in the horizontal greeting card proportions, had much potential as a regular calendar subject. It seemed to have the same kind of appeal as *Twilight,* the popular 1937 calendar. At Fry's suggestion Parrish agreed to make a second painting of *New Moon* in the vertical calendar proportions. This second version eventually was included in the 1958 calendar line. *Thunderheads* (Pl. 55), another of the landscapes submitted in 1943, was not selected for calendar use, possibly because of the ominous-looking clouds; in 1952 the artist agreed to its publication as a magazine cover.

A fantasy gorge like those in *Spirit of Transportation* and *Arizona* provided the setting for *Old Glen Mill* (Pl. 56), the 1954 calendar subject. It is similar to the 1933 General Electric calendar, *Sunrise,* in the concept of depicting the play of light on distant rocks as seen through a cavelike opening created by objects in the foreground. But in *Old Glen Mill* Parrish has substituted an old New England mill for the

1954 The Old Glen Mill

1955 Peaceful Valley

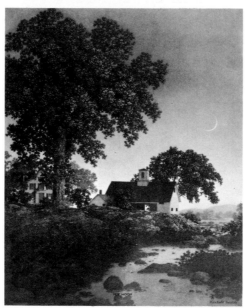

1958 New Moon

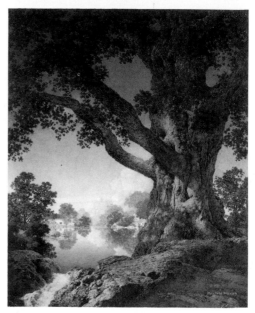

1959 Under Summer Skies

Italianate palazzo of the earlier painting.

The Millpond (Pl. 57), painted in 1945 and used for the 1948 calendar, had a posterlike directness and romantic setting that made it the most commercially successful calendar landscape of all those Parrish created for Brown and Bigelow. Clair Fry, writing to the artist in 1955, pointed out the elements that make a picture a good calendar subject.

The three pictures that stacked up the greatest volume were "Mill Pond" in 1948—number one, "Evening Shadows" in 1953—number two, and "Evening" in 1947—number three. In comparing these three prints with all the rest of them, the thing that impresses me about them is the strength and simplicity of the color and value patterns.

There seems to be a direct relationship between the amount of effort required to grasp the essence of the picture and its acceptability

. . . [as a calendar subject]. The subtle and complicated compositions invariably show a decrease in volume.

Another thing, the most successful pictures seem to be created around a structure of some kind that is immediately grasped at a glance. Where the structure is cropped too much or obscured by light and shadow patterns, the picture seems to be less desirable to the general public. . . .

The one thing I am really sure of is that a successful calendar picture must have strength and simplicity that catch the attention and is [*sic*] comprehended at a glance. This is the one factor that is evident in every successful calendar picture in our experience.[18]

When Fry suggested that Parrish try to put a little more excitement in one particular farm scene that was being considered as a greeting card subject, he replied that the only way he could make it more

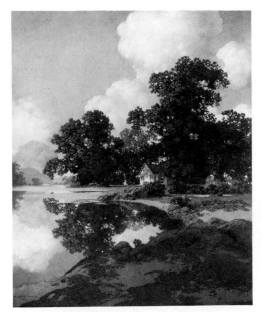

1960 Sheltering Oaks

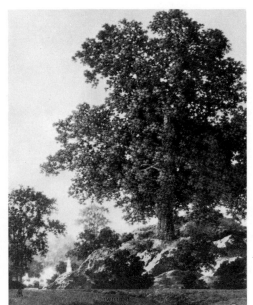

1961 Twilight

1962 Quiet Solitude

1963 Peaceful Country

exciting would be to set the barn on fire. Parrish frequently said that he put too much into his painting because he liked painting too much to stop. In his landscapes, as calendar subjects, the brilliant and unorthodox use of colors compensated for their occasional lack of simplicity. Such paintings as *Peace of Evening* (1953 Brown and Bigelow title: *Evening Shadows*) (Pl. 58), *Swift-Water* (1956 Brown and Bigelow title: *Misty Morn*) (Pl. 59), and *Little Stone House* (1957 Brown and Bigelow title: *Morning Light*) (Pl. 60), all painted when Parrish was in his eighties, are good examples of his using familiar objects in nature as a vehicle for expressing a sense of place and space. Although *Peace of Evening,* with its small boats, lighted windows and smoke curling from the chimney, comes very close to being the kind of typical calendar subject that Parrish tried so hard to subordinate to the broader

values of landscape, its color transcends the subject, giving real interest to the work.

Of the numerous winter landscapes painted for the engraving line (small calendars and greeting cards) of Brown and Bigelow, none is perhaps better known than *Church at Norwich, Vermont* (1953 Brown and Bigelow title: *Peaceful Night*) (Pl. 61). In this composition the artist has chosen to use a white church and white snow as a background against which to explore the effects of shadows cast by the moon. While working on this painting to tone down the shadows from the dark purple color in which he had originally painted them, Parrish wrote, "I'll admit, moonlight in snow time is puzzling. Each time you go out to study it you find it is a different color."[19] Painting winter landscapes in the summer months when there was no snow often presented much difficulty. It is perhaps for this reason that in these winter

scenes, no matter how much snow is on the ground, there is rarely any on the trees. Also, it is not unusual to see green trees in Parrish's winter landscapes. Some of them, as in *Church at Norwich, Vermont,* are evergreens. Others such as the large tree in *Twilight Time,* the 1960 winter subject, have the appearance of large oaks or maples in full foliage. If the composition of a winter subject seemed to call for a mass in a certain area, Parrish would not hesitate to place in it a tree covered with leaves. He once wrote, "In my painting of trees any resemblance to those in nature is purely accidental."[20] What he meant was that the tree was a vehicle—a property—used to express some larger quality, and that one should not be too concerned about the botanical accuracy.

Afterglow (1950 Brown and Bigelow title: *A New Day*) (Pl. 62) and *When Day Is Dawning* (Pl. 63), the 1954 winter subject, are representative of Parrish's winter landscapes. If the use of color in some of the calendar subjects stops short of surrealism, *Afterglow* goes one step closer. The natural representation of the scene appears to be of secondary significance in this composition divided into three horizontal bands of color. This expressive use of color takes *Afterglow* beyond the naturalism which the drawing of the subject suggests.

Maxfield Parrish summed up his philosophy on landscape painting in 1952, when replying to a student who had written for information about studying art—especially "realism."

You mention "realism": that, I think, is a term which has to be defined: realism should never be the end in view. My theory is that you should use all the objects in nature, trees, hills, skies, rivers and all, just as stage properties on which to hang your idea, the end in view, the elusive qualities of a day, in fact all the qualities that give a body the delights of out of doors. You cannot sit down and paint such things: they are not there, or do not last but for a moment. "Realism" of impression, the mood of the moment, yes, but not the realism of things. The colored photograph can do that better. That's the trouble with so much art today, it is factual, and stops right there.[21]

Color Plate 61. Church at Norwich, Vermont
(other title: Peaceful Night*).*
1950. Oil on panel, 21½" x 17½".
Courtesy Maxfield Parrish Estate
and Vose Galleries, Boston.
Photo: Herbert P. Vose.

Color Plate 62. Afterglow *(other title:* A New Day*). 1947. Oil on panel, 13½" x 15". Courtesy Maxfield Parrish Estate and Vose Galleries.*
Boston, Photo: Herbert P. Vose.

Figure 104.
Synthetic rocky landscape as laid out on
a piece of plate glass by Maxfield Parrish.
Field stone, powdered stone and plate glass,
ca.26" x 28". Photo: Maxfield Parrish.

Chapter 8 TECHNIQUE

Throughout his long career Maxfield Parrish was widely acknowledged as an artist of superior technical ability. His method of painting, which remained a mystery to most people even at the height of his popularity, was one at which he arrived by a great deal of critical observation and personal experimentation. As a young, developing artist, Parrish possessed an innate interest in technical matters and a compelling concern for perfection in the execution of his work. Aware that his preoccupation with the mechanical approach to art might be, in fact, a detriment to his aspirations to do more creative work, he wrote to his mother in 1893, "And about the mechanical—it may come in handy some day, but at present I am wrestling with its evil tendencies as shown in my work, for it is hard to rid myself of the love of a good neat job, which doesn't improve artistic expression one bit."[1] Parrish investigated almost every medium, from etching to photography, in the process of arriving at the one he felt best suited to his individual approach to artistic expression. He chose to use colored glazes as the medium in which he worked almost exclusively after about 1900, but he never stopped experimenting with new techniques within this medium.

As his father was an etcher, it is not surprising that some of Parrish's earlier efforts, aside from sketching and drawing, were in the area of printmaking. A few examples of his etchings made between 1887 and 1891 were preserved by the artist, who found this printmaking experience to be of great value later in making paintings to be reproduced by commercial printers.

Parrish was an accomplished draftsman by the time he was twenty, having from an early age spent much of his spare time filling sketchbooks with technical drawings and decorating scores of letters with humorous cartoons. It was not, however, until he reached the age of about twenty-five that he began to develop the style that brought him early recognition as a magazine illustrator. Underlying his drawing was a strong analytical interest in mechanics and architecture, which gave his designs a great sense of strength and balance but sometimes deprived them of spontaneity. "I'm no earthly good at the little telling sketch," he wrote to J. H. Chapin at Charles Scribner's Sons in 1923. "The few strokes of the pencil were never my medium: couldn't even make a drawing on The Players' Club table cloths."[2] If his drawings lacked spontaneity, they made up for it in imagination, design and technical skill, in all of which Parrish excelled.

The artist's records indicate that his drawings in the late 1890s were frequently made on Steinbach watercolor paper with pencil, India ink, ink, crayon, lithographic crayon and wash. He used these materials in a variety of combinations, but most often the combination was India ink and lithographic crayon. The India ink was used for drawing the outlines and fine details, while the shading and contours were done with lithographic crayon (Fig. 19). The stipple effect in many of his drawings was created in part by drawing with lithographic crayon on textured paper; however, certain detailed areas, where greater control was necessary, appear to have been done in India ink with a stipple brush or a fine pen point.

When his drawings called for color, Parrish colored the finished black-and-white India ink drawing with transparent glazes of pigment, mixed only with a little linseed oil and protected by a layer of varnish. Coloring the boldly outlined areas with a single glaze was a simple matter, much like coloring the drawings in a coloring book. When glazes of several colors were used one on top of the other, the matter became considerably more complicated. In such drawings as the program-cover designs for the 1896 and 1897 Mask and Wig productions of *No Gentlemen of France* and *Very Little Red Riding Hood* (Fig. 70), he used colored glazes, as well as opaque pigments, to color the clothing of the figures, leaving the faces and other detailed areas in black and white. Made with this same technique, many of his early paintings for posters and magazine illustrations were essentially drawings colored with glazes. In his correspondence the paintings for *Dream Days, Italian Villas*

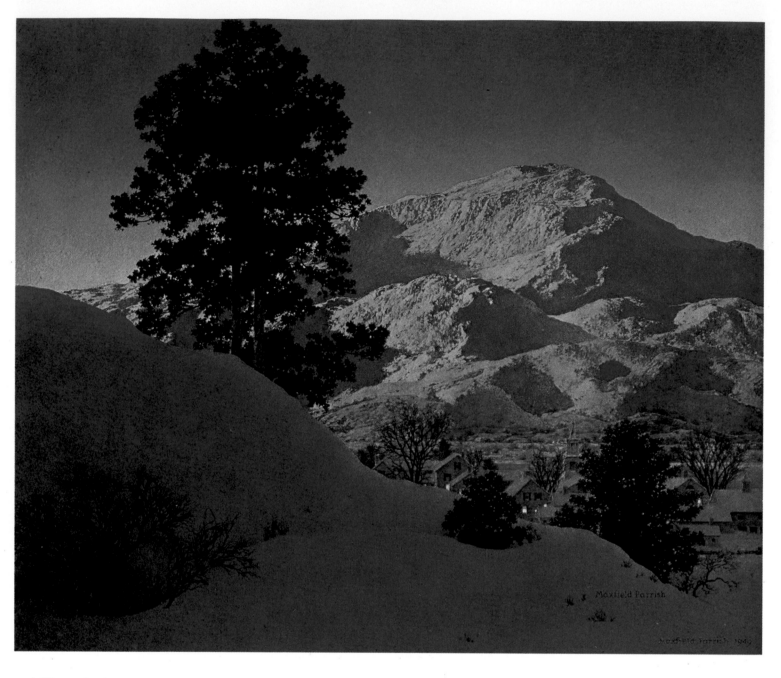

and Their Gardens and *Poems of Child-hood,* to mention only a few, were often referred to as "colored drawings." From these drawings colored with glazes there was a logical and natural progression to the use of transparent colored glazes almost exclusively in all of his painting.

The poster designs and magazine illustrations made by Maxfield Parrish were intended for reproduction, and it was necessary, therefore, for him to understand the method of reproduction in order for the publisher to obtain the best results. Although the separate color plates were handmade by the printers, the artist had more control over the final product if he knew what method of reproduction was to be used and planned his painting with that in mind. Frequently Parrish made paintings to be reproduced in two, three and four colors, with the number of layers of glazes corresponding roughly to the

number of press runs in the painting.

Among the most interesting of the techniques used by Parrish for making colored drawings was that by which several of the drawings for "Wagner's Ring of the Nibelung" were made in 1898 (Figs. 46, 47). The drawings first were made on Steinbach paper with wash, ink and lithographic crayon. Afterwards they were photographed using Carbutt's process plates, and then the print was colored, most probably with oil glazes. Other drawings in the series were made on Steinbach watercolor paper with crayon and ink, after which they were varnished and then finished in oil.

The pigments most regularly used by Maxfield Parrish were those manufactured by Winsor and Newton. When corresponding with Irénée du Pont in 1950 about the materials he used for painting murals, he wrote, "From my own start I have used

none but good old Winsor and Newton English colors. . . . Their catalog tells you the composition of each color and frankly states the quality, good, not so good, and bad."[3]

Parrish painted on a variety of supports, often around the turn of the century using Whatman's paper that had been dampened, attached to a wooden stretcher frame and allowed to dry. According to the artist, he preferred to paint on white paper because "the painting can be done like a pure miniature on ivory, the white showing through the transparent color, and avoiding the use of the deadly white paint. I consider it more permanent than canvas, if done with due regard to thorough drying."[4] Another support frequently used by Parrish which provided the preferred ground of white paper was made by gluing the paper to a composition board. "I have used Upson Board in my work for a number of years,"

Color Plate 63. Winter Sunrise
(other title: When Day Is Dawning*).*
1949. Oil on panel, 13" x 15".
Courtesy Maxfield Parrish Estate
and Vose Galleries, Boston.
Photo: Herbert P. Vose.

Color Plate 64. October *(other title:* Dreaming*).*
(See also Fig. 92. After publication, the artist removed
much of the original painting with the idea
of making some major changes in the composition.
The panel remained unfinished at the
time of his death.) 1928. Oil on panel, 32" x 50".
Courtesy Maxfield Parrish Estate
and Vose Galleries, Boston.
Photo: Herbert P. Vose.

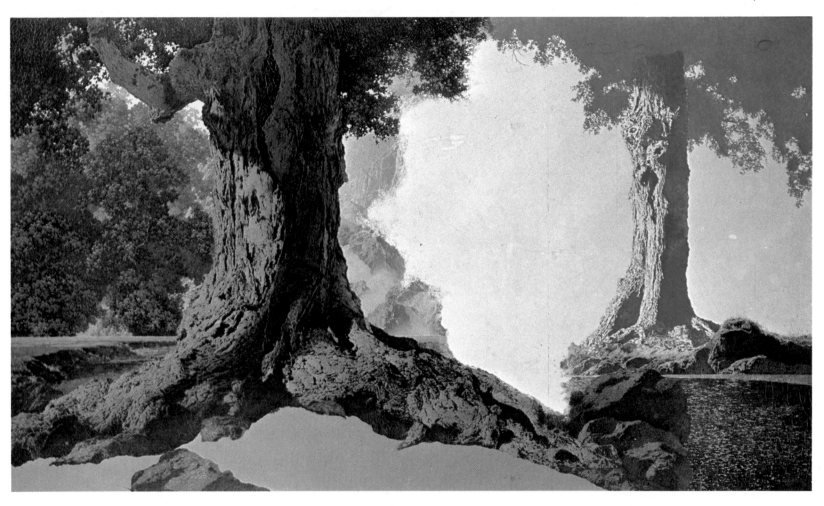

he wrote the Upson Company in 1924. "It is my practice to paste [with Higgins' Drawing Board Paste] dampened Whatman's paper on each side of three-eighths thick Upson Board, so that when dry the pull of the contracting paper is the same on each side. Panels made in this way are very firm and remain perfectly flat."[5] Early in the century he did a number of large paintings on canvas, but later, when large supports were required, he made them of Presdwood or Vehisote prepared in the following manner:

It [Vehisote] is light in weight and sufficiently strong. It comes in sizes suitable for large mural decorations. It has great affinity for oil and very little for moisture. If furnished sanded on both sides and treated alike both front and back, it will remain perfectly flat. Indeed, I know of nothing that can in any way compare to it. . . .

It is my practice to give the raw material

two or three coats of good rubbing varnish, or half varnish and half turpentine. Glue or shellac is not as good, for the bond between Vehisote and varnish is very strong. This may be followed by white lead or zinc or one's favourite ground color. Bake in the sun before painting any of the coats, or do it all in a hot room . . . so that all surface moisture is driven off before varnish or paint is applied. For those very few who care at all for craftsmanship the time will not be begrudged for thorough drying between coats.[6]

After the mid-1930s, he painted on panels of five-sixteenths-inch Masonite with a white ground of Permalba prepared by F. Weber Company of Philadelphia. When heat lamps became available, Parrish, during winter months or humid weather, dried the panels and the layers of glaze and varnish under a 250-watt heat lamp twenty inches from the surface.

The glazing technique as practiced by

Parrish was a slow, meticulous process, limiting his output in later years to three or four paintings annually. Parrish described his technique in 1950 in a letter to F. W. Weber, manufacturer of artists' colors and drawing materials:

You ask for a description of my technique? Well—this method is very simple, very ancient, very laborious, and by no means original with me. It is somewhat like the modern reproductions in four color half tone, where the various gradations are obtained by printing one color plate over another on a white ground of paper. In painting it is an ancient process, as anyone can read in the many books written about the methods of the old masters, telling how each one had his own particular way of going about it: some by starting with a monochrome underpainting, some with a few colors, over which were glazed more or less transparent colors.

Yes, it is rather laborious, but it has some advantages over the usual ways of mixing

Figure 105.
"Ah never in this world were there such roses
As once from that enchanted trellis hung."
Illustration for "Potpourri" by H. G.
Dwight, Scribner's, *August, 1905.*
Oil on stretched paper, 16" x 14".
Courtesy Memorial Art Gallery,
Rochester, New York.

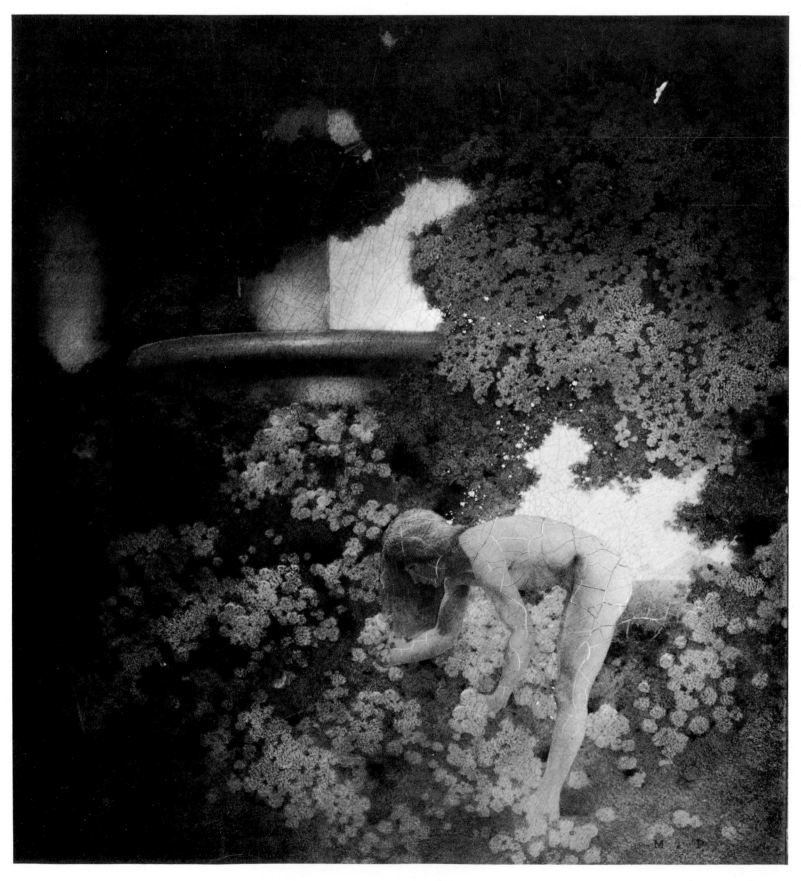

colors together before applying them. It is generally admitted that the most beautiful qualities of a color are in its transparent state, applied over a white ground with the light shining through the color. A modern Kodachrome is a delight when held up to the light with color luminous like stained glass. So many ask what is meant by transparent color, as though it were some special make. Most all color an artist uses is transparent: only a few are opaque, such as vermillion, cerulean blue, emerald green, the ochres and most yellows, etc. Colors are applied just as they come from the tube, the original purity and quality is never lost: a purple is pure rose madder glowing through a glaze of pure blue over glaze, or vice versa, the quality of each is never vitiated by mixing them together. Mix a rose madder with white, let us say, and you get a pink, quite different from the original madder, and the result is a surface color instead of a transparent one, a color you look on instead of into. One does not paint long out of doors before it becomes apparent that a green tree has a lot of red in it. You may not see the red because your eye is blinded by the strong green, but it is there never the less. So if you mix a red with the green you get a sort of mud, each color killing the other. But by the other method, when the green is dry and a rose madder glazed over it you are apt to get what is wanted, and have a richness and glow of one color shining through the other, not to be had by mixing. Imagine a Rembrandt if his magic browns were mixed together instead of glazed. The result would be a kind of chocolate. Then too, by this method of keeping colors by themselves some can be used which are taboo in mixtures. Verdigris, for instance, is a strange cold green with considerable power, with an exceptional luminous quality, rare in greens. If in contact with coal gas it will change overnight, but when locked up in varnish it seems to last as long as any. Alizarin Orange, given up by color makers, is another. I have examples of both done forty years ago which show no signs of change.

I used to begin a painting with a monochrome of raw umber, for some reason: possibly read that the ancient ones often began that way. But now the start is made with a monochrome of blue, right from the tube, not mixed with white or anything. Ultramarine or the Monastral blues, or cobalt for distance and skies. This seems to make a good foundation for shadows and it does take considerable planning ahead, and looks for all the world like a blue dinner plate. The rest is a build-up of glazes until the end. The only time opaque color is used is painting trees. The method of early Corots and Rousseau is a good one, suggested by nature herself, where a tree is first painted as a dark silhouette and when dry the outside or illuminated foliage is painted over it. This opaque may be a yellow or orange as a base to glaze over with green, as the problem may demand.

It must be understood that when transparent glazes dry they look like nothing at all, and their glazes [color] must be brought back to life by a very thin coat of varnish. This varnish also protects one color from another should protection be called for. And it must also be understood that this varnishing is a craft all by itself and cannot be too carefully done. Hurry it, and put it on too thick and too cold, and disaster follows. Fortunately colors in their transparent state are dry when they feel dry, these glazes are extremely thin and have a chance to dry much faster than heavy impasto, whereas whites and opaque yellows seem to take forever to become thoroughly inert. Varnishing should be done in a very warm room where the painting and varnish

Figure 106. Maxfield Parrish posing for photograph to be used in painting figure in illustration for "Potpourri" (Fig. 105). Note strings running to camera shutter, enabling the artist to take his own picture. 1904. Courtesy Maxfield Parrish Estate.

have been exposed to the warmth for some hours. This is to drive off all invisible surface moisture and to make the varnish flow better and thinner, to be applied as thin as possible. Also, the varnished surface should remain warm until set. Days should be waited until this varnish coat is thoroughly dry: then a light rubbing of pumice flour and water takes off dust particles and makes a surface somewhat better to apply the next process. . . . Copal Picture Varnish is the varnish used.[7]

An excellent example of Parrish's technique is seen in the present state of the 1928 painting *October* or *Dreaming* (Pl. 64). Sitting beneath the large tree in the original composition was a nude female figure, which the artist had included because the publisher felt that refined nudity enhanced the sale of color reproductions (Fig. 92). When the original painting was returned to him, Parrish, never having been pleased with the figure, removed the right half of the composition in which it was located. He reinforced the white ground area and stenciled in with blue glaze the imprimatura or underpainting for a second tree. With gray pigments he also painted in the lower foreground the imprimatura for what probably was to have been an area of shaded grass. The repainting was never finished beyond this first layer of glaze and varnish, leaving in a single painting a valuable graphic example of Parrish's technique as it appeared in a finished work and while in progress.

When painting a figure in a landscape, it was Parrish's practice to complete the landscape first, including the area where the figure was to be located. Then he carefully would cut a stencil of the silhouette of the figure, and with a fine stipple brush would stencil the imprimatura for the figure on top of the finished landscape. His technique for painting figures in large mural compositions was just the opposite. Here he would paint the figures first and then the background, with the final step being the careful application of glazes and varnishes to perfect the overall tonality of the composition.

Maxfield Parrish, Jr., who often observed his father at work and who discussed with him in detail the various aspects of

Figure 107. Composite of the two photographs of Kitty Owen used in designing the Easter cover for Life, *March 29, 1923. Photos: Maxfield Parrish.*

Figure 108. Cutout figure used in intermediate stage of designing the Easter cover for Life, *March 29, 1923. Courtesy Maxfield Parrish Estate.*

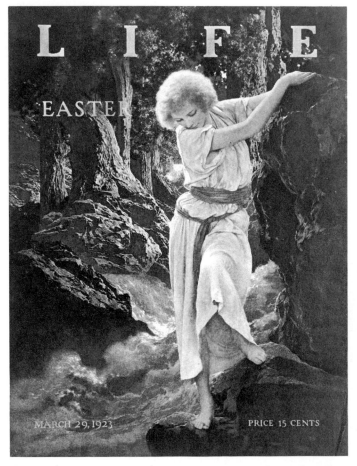

Figure 109. Easter *(artist's title:* The Canyon*). Cover for* Life, *March 29, 1923. Oil on panel, 19½" x 15"*

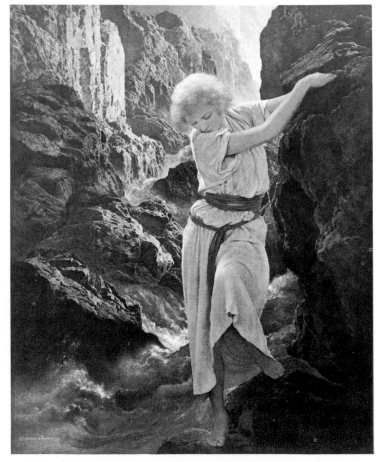

Figure 110. The Canyon. *Original version painted for* Life, *March 29, 1923. Major changes in background made by the artist during summer of 1923. Oil on panel, 19½" x 15".*

glazing, has written a scholarly and authoritative monograph on the technical aspects of his father's work. Mr. Parrish, having himself received early training in painting restoration, is uniquely qualified to write about his father's technique. It is through his generosity that the following extract from his heretofore unpublished manuscript is presented.

It was not so much that Parrish could conjure up effective and striking compositions and work them into eye-arresting textural differences, but the range of color intensities he dared to use that was the one thing that set his work apart from the other painters of his time.

He claimed his ability to handle successfully a high-keyed palette was due primarily to his technique of painting, not using mixed pigments, but glazing, where only pure colors are used. He also claimed that the brighter the colors you used, the subtler your control of them must be to avoid chromatic chaos, and only glazing gives you this control.

The term *glaze,* as used in this description of the glazing technique used by Maxfield Parrish, refers to a layer of pure transparent pigment used as it comes out of the tube, or thinned with turpentine, linseed oil, or other diluent. M. P. [Maxfield Parrish's family and close friends affectionately referred to him by his initials] used linseed oil usually. A layer of glaze must be preceded by a layer of varnish which has thoroughly dried. After the glaze is thoroughly dry, it must have a layer of varnish put on top of it before another glaze is added. Any color has three characteristics—hue, value and chroma. I will use these terms here in rather restricted meanings. Hue refers to the actual color, such as red, blue, green and yellow. Value refers to the relative darkness or lightness of a color without reference to its hue. Chroma refers to brightness, purity, saturation or intensity without regard to its value or hue.

From 1892 to 1900 M. P. experimented with numerous techniques. His father, Steen Parrish (1846–1938), during this formative period gave him much valuable advice and information, for Stephen had been a competent painter himself since the age of 18, and by the time M. P. was beginning to think of a career as a professional artist, Stephen was, in addition, a competent pen-and-ink draftsman and expert etcher as well. Sometime during this period M. P. started experimenting with glazing. His father, from beginning to end of his painting career, used mixed pigments only.

Evidence indicates that from 1903 on, M. P. did most of his finished work in glazes, even though preliminary sketches were done in pencil, fountain pen, watercolor, India ink, mixed pigment oils, and glazes. Occasionally the glazed sketches were as finished as the final painting, only smaller in size. Sometimes, just to get the action of one figure, he would use show card tempera, rather crudely daubed in.

One of the oddest techniques of all was his lifelong habit of using heavy brown paper and scissors to get the exact profile of an important figure in an illustration. Preliminary pencil lines were not always necessary, only freehand scissor cuts in the blank paper. This particular means of recording an imagined outline was undoubtedly an outgrowth of a childhood hobby of making paper cutouts with scissors alone. This early-developed skill apparently gave him a confidence in the coordination of eye, hand and mind that he used all his life.

Today by far the commonest technique used in oil painting is with mixed pigments. All pigments, whether opaque or transparent, are treated as if opaque by the majority of painters, and are put on in such thick layers that transparency is purposely lost. The aim is to make a layer so dense and concentrated that no previous layer of paint, either now or in the future, will ever show through it.

In the mixed pigment technique, a color is lightened by mixing it with white, darkened by mixing it with black, and grayed by mixing white and black in appropriate proportions. The primary colors are red, yellow and blue, and the secondary colors green, purple, and orange. There also are the complementary colors of the primary colors. Mixing complementary colored pigments produces varying shades of muddy brown. Mixing two primary colors theoretically gives the secondary colors. Mixed pigments, when applied to a panel or canvas, reflect from their surface certain colors of light. Other colors of light are absorbed and disappear.

In the glazing technique, the aim is just the opposite from that of pigment mixing. Transparency is aimed at throughout for the maximum effectiveness of glazing. Therefore, only transparent colors are used. Starting with a pure white ground, the artist covers his picture area with thin layers of transparent paint which act as color filters. The white light shining down through them is reflected back up and out again from the white ground below. When the work is finished, the once white ground may still be seen over the entire area, dimly where the shadows are and brightly in the highlights. The picture would appear dead and lifeless if some light did not shine back through almost every part of the area. Much of the charm of glazed paintings is in the luminous shadows this technique makes possible.

All colors are used pure as they come out of the tube, mixed only with a transparent vehicle such as linseed oil, turpentine, etc. For maximum lightness the glaze is very thin dimensionally, though the viscosity is adjusted to suit the manner of applying it. Much of the light shining on a lightly glazed spot is reflected back out, colored only to the extent that part of the spectrum of white light has been removed by the glazed filter.

To lower the value of a given area it is darkened by a glaze of ivory or lampblack. To lower the chroma of another area, the predominant color there is neutralized by glazing with its complementary color, suitably thinned so as not to cancel it completely, which would result in complete black, a thing to avoid in glazing. Hue is shifted readily around the color circle, and no combination of glazed colors one over another produces mud color, only black.

Painting a transparent color filter on top of a white ground removes from the light shining in and out through it certain of the constituents of white light. Another and different color filter painted on top of the first one removes still more constituents of white light. The more different colors you add on top of each other the more you rob white light of its normal components. Fewer colors are reflected back up through your series of filters, and the area appears darker, but what is reflected back is purer, more nearly just one color. This, perhaps as well as anything, explains why the glazing process tends toward clarity and maintains it even in the deep shadows, down to very low levels of illumination.

However, when you start removing various regions of the spectrum of white light, you no longer may use the empirical rules that hold for pigment mixing. You have to go by the rules of light mixing when planning future chromatic strategy. The primary colors for light mixing are orange (sometimes more accurately defined as "yellow-red"), green and

Figure 111. Wooden model of mill and sketch of tree silhouette reflected in a mirror. Model constructed and photographed by Maxfield Parrish, and photograph used by him in painting The Millpond *(Pl. 57).*

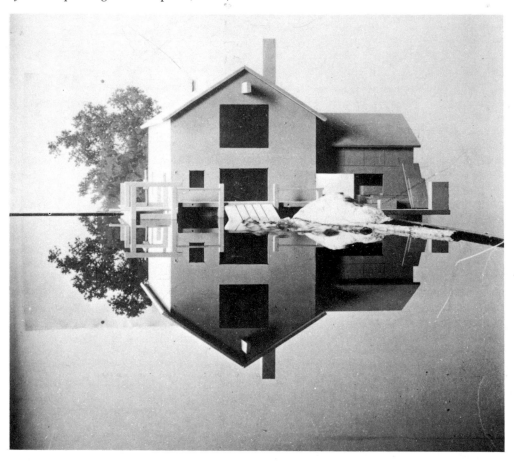

blue. The complementary color of orange is blue-green, of blue is yellow, and of green is violet.

This perhaps upsetting new set of rules should not cause consternation to a painter who has up till now known only the rules for mixing pigments. Thanks to a peculiar and unique advantage of glazing, when you mix colored light by putting one filter on top of another, when you find you have mixed the wrong light, you can "unmix" it at little cost in time and pigment. The first glaze having dried and having been protected with a varnish layer, now also dry, whatever you put on top of it may be wiped off at any time before it gets tacky. If you find the glaze was the right color but too thick, you can smooth it out and remove it selectively with the various sizes of stipple brush. And if too thin, you can always add more.

In the early 1890s M. P. became aware of the basic philosophy that motivated him the rest of his working life in regard to what he wanted to do in painting. That philosophy was that the most important thing in all painting was to depict dramatically the play of light on the things of nature, hills, trees, clouds, peo-

ple. It also was the hardest thing in art to do.

This same philosophy appears to have been dominant in the minds of the old masters since they, like M. P., also chose glazing as their method of painting, time consuming and tedious though it was, because it gave such ease in the control of light.

How M. P. Practiced Glazing (A Step-by-Step Account)

The primed panels on which M. P. painted were stiff, flat and had a smooth surface composed of basic lead carbonate and linseed oil which had dried for a year or more. Glue and whiting gesso was not white enough. In later years he used F. Weber's Permalba-primed Masonite panels and found them quite satisfactory.

On top of the white ground M. P. would outline in pencil where the first underpainting was to go. (See later details of how this penciled outline was derived.) The underpainting would be a transparent color, fairly dense and strong for it would be the dominant color in that area, and, though tempered and altered, it would appear in the finished product essen-

tially the same hue as it started.

When the underpainting had been put on and was thoroughly dry, M. P. would warm the panel and the varnish (Winsor and Newton's Amber Varnish, light shade) preferably in the hot sun. It was very important that the panel and the varnish both were warm; the panel so that an invisible layer of moisture would have been driven off, thus avoiding the possibility in the future of bloom (a cloudy white haze caused by condensed water particles). Also, the warmed varnish would flow easily and could be brushed on in a thinner layer than if cold. The applied varnish would be exposed to the direct rays of the sun, when possible, until completely dry. It was then rubbed for a very brief interval with a dampened piece of felt dipped in fine, dry, powdered pumice stone—rubbed just enough to remove the inevitable dust particles that get stuck on drying varnish, smooth down any irregularities, and give the surface some microscopic scratches to hold the next layer of glaze more firmly. It was then washed with a wet cloth, and dried with a dry one before glazing again.

Every glaze layer was kept as thin (dimensionally) as possible to promote fast drying time. Linseed oil was M. P.'s usual thinner, which took somewhat longer to dry than varnish. Viscosity and amount of diluent were determined largely by the covering power of the transparent pigment used. Some are so dense that, unless diluted or used in unmanageably thin layers, they are actually opaque, which will not do in glazing.

To get the proper mix for optimum transparency quickly and easily, M. P. would squeeze a suitable amount of pigment on a 4″ x 5″ glass plate mounted over a piece of white flat cardboard, and with a small palette knife mix it with linseed oil or turpentine. Here, as he mixed and spread out a smear of paint and thinner, was a preview of how the glaze would look with white light passing down through it and up again to your eye, just as it would look on the panel.

The glaze, once put on with an ordinary brush, was patted and flattened out with various sizes of stipple or pounce brushes until all modeling of shadowed areas had been done to suit. The panel was then put to dry in the direct sunlight whenever possible. When dry, it was varnished again with amber varnish, light shade, and allowed to dry, again in direct sunlight. When thoroughly dry the same treatment with pumice stone and damp felt was given it. After the final glaze, when

the painting was thoroughly dry, a final thicker coat of protective varnish was applied.

The very extended drying time for each glaze, its protective varnish layer, and the processing each layer took, used up far more time than the work of actual painting, even in summer with the hot sun to speed up drying. To nullify the adverse effects of these delays on his yearly output, M. P. arranged to have a number of paintings simultaneously drying while he worked on one of them. In his prime, call it 1915 to 1945, he often had ten or a dozen at once out facing the noonday sun.

Because of the extended drying time of each glaze (ten days to two weeks) it is mandatory that no changes in the design are made after a number of glazes have been laid out. There is much work to be done before any paint is put on a panel—rough pencil sketches and detailed color sketches must be made. Should the general plan be forgotten during the drying periods, these outline and color sketches serve to refresh the memory.

Perhaps the most important statement about how M. P. used glazes is that he handled them as a French chef handles foods, always seasoned to taste, and always with some mysterious ingredient.

M. P. made use of many tools and methods from trades not closely associated with oil painting. One of the most valuable tools he used in glazing was the pounce, or stipple brush made from the hair of the fitch (a European cousin of the skunk), which is used in the china decorating trade.

Paint is applied with the end of the stipple brush, which is flat, in an up-and-down motion perpendicular to the canvas. It transfers paint only on the ends of its bristles, picking it up from a spot of concentration of paint and transferring it to a spot of less concentration. It does this by making hundreds of painted dots at each stroke up and down. The dots are surrounded by blank spaces, but a few times repeated on the same small area, and the dots coalesce into one rather surprisingly smoothly painted area. Its ability to smoothly grade a darkly painted strip of paint to a much larger area tapering off into almost no paint at all is very real and can be used with great effectiveness.

M. P. was fond of making the sky in a landscape a very deep blue at the zenith and tapering it uniformly almost to white at the horizon. This was done with a stipple brush, the size used being determined by the size of the picture. He would paint a stripe of blue (usually cobalt blue) across the top of the picture and then use a stipple brush to taper it out down to the white or almost white horizon.

The viscosity of pigments to be smoothed out with a stipple brush should be a little runnier than for usual hog-bristle-brush painting. They therefore are more readily absorbed by porous backgrounds, so, remember that the surface they are to go on must be varnished, or sprayed with a fixatif or acrylic clear lacquer, and this must be completely dry. If the surface to be glazed is absorbent, the bottom edge of the paint stripe strikes in and the stippler won't spread it evenly at that point. The boundary will always be seen.

I have described how M. P. graded his skies. He also used the same technique on much smaller areas with the smallest-size stipple brushes. Occasionally he used the middle finger of his right hand, the hand held flat just above the place to smooth, and the middle finger rapidly moved up and down as the hand moved. And sometimes he'd do just one tap, and wipe the finger, and then another tap and wipe. With a very thin glaze this can be a useful effect, besides making an unforgeable mark of authenticity. A strong color and properly done, one's fingerprint is there for viewing for all time.

M. P. had many other tricks for modulating and "patterning" glazes, such as the use of coarse-textured blotting paper, used once and thrown away. It was used in patterning a glazed rocky cliff with alizarin orange to give the look of a very rough cleavage plane with the low rays of the setting sun just hitting the high lights, but not the lows. The glaze was patted on, flattened with stipple brush, and the blotter was then carefully blotted onto the surface once, with no sideways or rubbing motion, and lifted off. When deftly done, and with random patterning, the similarity to a rough mountainside at sunset was quite striking.

M. P. used to buy cheesecloth by the bolt, and he used many yards of it in a year for wiping brushes and removing large areas of glaze that weren't the right color. He also used it in a rolled-together wad to pat a large glazed area that looked dull and uninteresting and needed a broken-up texture. Perhaps one of the easiest ways of breaking up a too-evenly smoothed-out (by stipple brush) glazed area is not to carry the smoothing out too far. Leave it a bit on the mottled side. Saves time, and makes an interesting texture. The pattern of the threads in a woven canvas also make an interesting halftone background if exposed by wiping away part of a glaze layer that is still wet. M. P. occasionally let the pattern of the canvas show in glazes by not wiping off more than 50 percent, leaving glaze in the valleys between threads.

The main color of M. P.'s skies was cobalt blue thinned just slightly with linseed oil. But cobalt is a trifle on the harsh side, so, when dry and varnished, he would put on a thin glaze of emerald green, and a trace of titanium white, Indian yellow and rose madder.

Other special glazes he reveled in were not subtle ones, but very strong, such as verdigris and bitumen. These two wondrous colors he used with great success until they were dropped from the list of manufactured pigments. When used as pure glazes they were as permanent as any, but when mixed with other pigments, they went to pieces. The same was true with another transparent color, alizarin orange. As a glaze it stood up for 60 years at least, used pure between two layers of varnish. M. P. was desolate when he couldn't get it any more, but made a fairly good substitute out of mixed Indian yellow and rose madder.

M. P. often made his skies a lot more intense blue than a strict realism would call for. He therefore made his shadows bluer than they otherwise should be by about the same proportion.

Pencil knives, I think they were called, were an unusual tool used extensively by M. P. in his painting. They were made with the wooden-cover part shaped much like a carpenter's pencil, a long rectangle and chamfered corners. Instead of graphite as the core they contained a strip of hardened, tempered, knife-blade type of carbon steel. You had to carve down the end of the wood part with a penknife to expose the core, and this was then ground to whatever shape you found convenient. Used for erasing India ink or for making intricate cuts on various types of prepared boards, these pencil knives are associated generally with black-and-white work. Long after M. P. gave up black-and-white work entirely he kept a good supply of pencil knives and used them much of the time in the clean-up work of delicate tracery such as leaves, twigs, and other fine painted work. The stipple brush leaves a ragged edge, even the smallest-diameter one, and the pencil knives were ideal for cleaning the edges of small glazed areas. Such corrections were made after the glaze had dried to a fudgelike consistency, not really hard, and the edge of the knife had been purposely rounded so

as not to scratch the dried layer of varnish below, but just remove the glaze where wanted.

The Advantages of Glazing

Many of the advantages of glazing have already been hinted at in the text. Summed up, they are these:

1. For the artist whose major interest is in the light effects of nature, glazing is the logical method to use, as it reproduces on your panel, crudely and on a small scale, the same thing, in the same way, that outdoor light effects are produced by nature.

2. Pigments are not mixed in glazing, only the light that shines through them is. If one pigment is dry and the varnish on top of it is also, and a wet pigment is put on top of the first, the light that shines through both of them is mixed. If the mixed light is not right it may be "unmixed" by wiping off the top pigment and trying something else.

3. The subtlest kind of shading, grading, removing and strengthening of a given area is easier and quicker with glazing than mixed pigments.

4. All sorts of things can be tried and removed from half-finished work that represents much previous time and effort, without in any way obliterating what you already have done.

5. When using the darker colors of the color circle, blue, mauve, magenta and purple, muddiness is hard to avoid when pigments are mixed. These colors, when used in glazes, maintain their richness and purity right down to almost black.

As you remove the constituents of white light by superimposing more and more different-colored filters over a white ground, what light is left that does come up and out is weaker, but also purer.

6. Most pigments are chemical compounds and, though picked for their freedom from reacting with other compounds, some do react when mixed. This rarely happens to glazes, which are pure and are separated from other compounds by inert layers of varnish.

7. The cost in time as well as money is a lot less for a given amount of experimentation with glazes than with mixed pigments.

The Disadvantages of Glazing

1. First on the list of the disadvantages of glazing is the time it takes for a number of layers of varnish and glazes each to dry thoroughly before the next one is put on.

2. The possibility of varnishes turning brown in 30 to 40 years, although almost none of M. P.'s paintings have shown any signs of turning brown.

3. The possibility of paint cracking off the panel if adequate time has not been taken to thoroughly dry the glazes and their varnish covering layers.

(Note: All three of these faults perhaps can be remedied by the advent of new synthetic water white lacquers, which do not turn brown with age, dry more quickly than natural varnishes, and do not shrink during the last stages of drying.)

4. For the artist who likes to draw a hazy outline on canvas and go at it right there on the spot, painting from nature, making his abstractions and decisions as he goes, glazing is out; a stultifying straightjacket to the imagination as well as inspiration.

5. To capitalize to the fullest on the special effects of colored-light control that glazing gives you, you have first to lay out rather exactly just where various glazed areas stop and other ones start. This means quite precise sketches in pencil and/or India ink — more like maps of color areas than sketches. A pretty complete watercolor or mixed pigment color layout should be made, too, before any glazes are laid down. If these steps are not done, during the long delays for varnish and glazes to dry you may forget just what you'd planned and where.

Maxfield Parrish and Photography

M. P.'s extraordinary coordination of eye and hand shows up in his early letters from Europe to various members of his family and his cousin Ned Bancroft. His ability to draw not only accurately what he saw, but to give it a flourish and a style in addition, shows up shortly after the age of 16. In his early twenties his almost surrealistic imaginative conceptions were all the more impressive for being drawn in a most realistic way. He would paint a dragon as if drawn from a time-exposed photograph.

Some time not long after 1890 M. P. must have come to a decision about the pencil-drawn image by eye versus the photographic image by camera. He knew he could draw an image almost as accurately as the camera, and he knew his imaginative lighting, conception, and coloring would sell, using very realistically drawn fairyland characters, improbable beasties, and events scientifically impossible. The decision he made was this. Since his aim always had been accuracy of drawn outline, and he had developed great draftsmanship skill, the actual difference between what he could draw and what the camera would record, of the same figure, would not be recognizable to the average art-oriented person. And this being so, why not do as much of your sketching as possible with a camera, instead of a pencil and sketch pad? There were of course many main figures, scenes, landscapes, details and layouts that couldn't be photographed because they could not be found anywhere on earth, but for all the detailed, difficult-to-draw things, clumps of foliage of trees for one, the folds of drapery on a human figure, these all consume much time and effort—why not sketch them with a camera? His answer was, use the camera where you can. And this he did.

He had a number of different-sized cameras at different times, but the one he used by far the most often in his artwork, judging from the massive amount of exposed film in his studio storage closet, was one that used a 4" x 5" glass plate with fine-grained black-and-white emulsion. Most of his carefully catalogued file of people, rocks, trees, scenery, clouds, and mountains were taken on this film in an old 4" x 5" camera with a long extension bellows with a Goerz Dagor lens in a compound shutter, 6.8 the fastest stop, and bulb time 1 sec., 1/2 sec., 1/4 sec., etc. He used a good stout and substantial wooden-legged tripod and time exposures whenever necessary. He developed using Eastman chemicals in a tank more often than in a tray in his own darkroom.

Many of the top illustrators of the present and recent past used photography as a great time-saver in their work, though few have described in any detail how they worked from a photograph. Since M. P. carried this technique further than probably any others of his time, it might be worthwhile describing his method and apparatus. The following is a description from memory going back 35 or more years and, while some details are a trifle vague, in general this is what M. P. did in working from photographs.

A negative of a subject he liked would be contact printed on another glass plate, emulsion to emulsion, by exposure in a darkroom to an incandescent light. When developed,

this positive would then be projected by magic lantern on to a piece of paper or canvas, the size being adjusted by moving the paper closer or further from the projector.

Sometime not long after 1900 he used a rather crude and cheap Bausch and Lomb "magic lantern" to project photographs or parts of them on to paper, and in a darkened room traced around the image with pencil. Using this technique, he was able to complete in a relatively short period the ordinarily time-consuming preliminary drawings for such paintings as *The Pied Piper,* which contained over two dozen actual portraits of children from the Cornish and Plainfield neighborhood.

Around 1925 he designed and built a really sophisticated projector. This piece of optical apparatus closely resembled a professional photographer's enlarging camera except that its projection table was not equipped to hold photographic print paper, and there was no provision for complete darkness in the room where it was erected, his studio. The projector unit was mounted securely on a steel arm about 2′ long, which in turn was mounted on a carriage and counterweighted, enabling it to travel up and down a six-foot-tall 2″ pipe with very little manual effort. Bolted to an extension arm, the projector swung into an 18″ deep closet when not in use, keeping it dust free and out of the way.

For medium-to-small-sized pictures a table was used to hold the surface on which the image was traced, and adjustment of the size of the image was done by careful raising and lowering of the unit on its pipe frame. Once adjusted, a clamp screw locked it securely. For extra-large pictures, the projected image had to be on the floor, or on a panel laid on the floor, with the projector raised nearly to the top of its travel.

With a desired glass positive on the projector's focal plane and everything in readiness, a white panel with a piece of tracing paper taped at the corners to it, pencils sharpened and ready, the image was sharply focused on the tracing paper and the drawing of the image was begun.

M. P. would first study the projected image for quite a time, deciding what to exclude, what to keep. The hard part at this stage, according to M. P., was deciding what to ·leave out, the same as if you were sitting in a camp chair under a parasol sketching the same subject out in a field. In drawing a tree, for instance, the malformed limbs,

broken-off stumps, and branches that accidentally grew parallel with one another and showed as one for a confusing distance—the decision to exclude all these was almost automatic. But with the ease of drawing all the rest of the tree, one was forever tempted to put in too much and had to guard against it.

It would have been perfectly easy to project the desired image directly on to the primed panel and start painting from the penciled line, and undoubtedly in some pictures he did just this. But from the large number of surviving tracings of well-known paintings, I think he projected onto tracing paper first, and used transfer paper to get the image onto the primed panel or canvas. This also gave him a second chance to redraw the image outline in the full light of the studio (whose large plate-glass window faced east, not north) with the curtains retracted, and refine or change things under good illumination where errors of shape showed up better. Carbon paper was not used to transfer the line from the tracing to the panel. Turpentine or linseed oil tend to dissolve the dye of carbon paper enough to make it run into light areas. Graphite-coated transfer paper avoids this risk.

It was probably after his refined-image stage that an outline was put onto a piece of hard, moderately stiff stencil board, whose function was to absorb the runover of the large-size stipple brushes used to smooth out the sky glaze. For small pictures these stencils were often cut the same size as the picture panel and the outline of the boundary between sky and ground traced on them and then cut with scissors and pencil knives along this boundary line, producing a matching pair of jigsawlike puzzle pieces, the bottom one being used to catch the slop-over from the sky glaze, and the upper one to prevent the glaze from the horizon getting on the sky. These guard stencils were taped to the edges of the panel at a number of places when in use.

The grounds for trees and figures were also frequently stenciled onto the panel. In applying the later glazes of the foliage M. P. would use a small stipple brush in one hand and a library file card in the other, sometimes cut roughly to a general outline, and hold this at an edge he wanted protected from his foliage glaze. When glazes got into small areas where they didn't belong, they were wiped off while still wet with a piece of cloth wrapped around a small paint brush handle, or were later scraped off with a slightly dulled

pencil knife when the glaze reached a leather-hard stage. This scraping away was done extensively in the foliage areas.

The photo projector was very useful in advertising and poster work where considerable amounts of lettering had to be interspersed with natural and human images. Lettering could be reduced or enlarged with the photo projector. M. P. was quite fussy about the correct look of all lettering he did and took considerable pains with it. His claim was that the shape of the letters was rather important, but the spacing of them was most important. The line of print with white spaces between each letter should average out to a uniform gray the whole length of the line. He had a carefully designed set of black-and-white letters cut out of cardboard, of his favorite Roman alphabet from the time of Trajan, with a number of duplicates, and with these he would carefully lay out a line of print, spacing them by eye. When the layout of the line seemed just about perfect, he'd photograph it and enlarge it to the appropriate size.

Many of the distant mountains that M. P. used in his pictures never existed, but were synthesized right in his own studio on his cast-iron framed worktable, using a number of carefully selected rocks picked up in the rugged back pasture of his house. He had a collection of about 20 or 30 pieces of granite, schist, quartz and other sedimentary and igneous rocks weighing from a pound or two to ten pounds. These all were painted a light neutral brown. Rottenstone powder was mixed with varnish and turpentine and had the color of light-tinted mud.

He would arrange these on his worktable in his studio, usually on a piece of plate glass, and pour around the bases of the rock powdered rottenstone, dry and finely powdered, and the angle of repose, after a few sharp raps on the edge of the table with a piece of stove wood, made it assume more or less the same shapes as the talus slopes one sees around the base of weathered cliffs and mountain faces. He would then close the curtains of the studio, and with a single student lamp try illuminating the synthetic landscape with this single source of light at various angles till he got the effect he wanted. The upside-down reflection of the whole from the upper surface of the glass at a low angle gave a quite realistic-looking landscape surrounded by a placid body of water [Fig. 104].

The warped cleavage planes of mountains are not always the same general shape as those

found in portable rocks in a New Hampshire pasture. One has to select only those rocks that do resemble in the small what exists in the large. When he had gone through his collection and everything was to his liking, he would set up his camera and take a time exposure from only the light of the student lamp, develop, and print a positive, develop that and project his homemade mountains onto canvas or tracing paper.[8]

One of the surprising aspects of Parrish's technique is that only a few colors were required in a painting to achieve a wide variety of color effects. The pure colors simply were glazed over one another until the desired tint was obtained. Because the sable and fitch brushes left no brushstrokes in the thin transparent glazes, many people thought that Parrish used an airbrush. He used a makeshift airbrush only once, discovering that it gave "a soft velvety surface entirely out with the rest of the painting. I once made a sky of pure transparent cobalt over a white ground and sprayed it on with a drug store atomizer and a bicycle pump, a 4' x 7' surface. It worked," Parrish wrote a museum director who had inquired about his painting technique, "but never again. The picture got some of it, but I took in enough blue to color my entire existence ever since."[9]

Parrish never painted from live models. Instead he photographed the models for a given composition in several poses and then painted from the photographs. He refused to use professional models in his work, preferring to enlist members of his family or of the families of friends and neighbors to pose for him. Professional models, he once remarked, seemed to lack the quality of innocence that was necessary for the kind of paintings he made. The person who most frequently posed for the female figures was Susan Lewin, who, as studio assistant and later housekeeper, was employed in the Parrish household for many years. A favorite model for works painted in the early 1920s was Kitty Owen. The artist himself often posed for the male figures and, as seen in the illustration for "Potpourri" (Fig. 105), he sometimes modeled for the female figures as well. The glass-plate photograph (Fig. 106)

shows Parrish, posed for the nude study, pulling the string which tripped the shutter of the camera, taking his own picture. The only change made between his photograph and the figure in the "Potpourri" illustration is the addition of a female head.

Two photographs of Kitty Owen, shown here as a composite (Fig. 107), were used for the figure in the cover design of the 1923 Easter number of *Life* (Fig. 109). Miss Owen, posing with one foot on a set of portable steps and her arms resting on a ladder, focused her attention on a leaf placed on the floor by the artist. The placement of the figure in the composition was carefully thought out before the photograph was made. By having the model focus on the leaf, the artist was able to simulate the body position of a person carefully picking her path down the side of a treacherous canyon. The cutout (Fig. 108) assisted the artist in arriving at a suitable position for the figure before actually drawing or stenciling it onto the panel. After *Life* returned the original painting, Parrish replaced the trees in the background with a rocky gorge (Fig. 110). The House of Art then reproduced the painting as an art print entitled *The Canyon*.

Just as Maxfield Parrish enjoyed making paper cutouts as a child, he also passed many pleasant hours making wooden models of buildings which served as backgrounds for the great pageants performed by his cast of paper characters. In 1931, when Irénée du Pont was corresponding with him about a mural that he anticipated commissioning, Parrish asked, "I wonder what relation you are to Pierre? A thousand years ago I used to play with him when they lived on Powelton Avenue in West Philadelphia. Solemn Pierre: I sold him a toy theatre once for a dollar, and to this day I feel I over-charged him. Possibly he does not feel it now."[10] Irénée du Pont replied that Pierre was his older brother. He remembered the little theatre well and said that he could still visualize some of the paper characters in it.[11]

The artist applied his experience in making architectural models to his painting technique by making wooden models of the buildings (real and imaginary) that he

intended to paint. The architectural models were illuminated with the desired effects of light and shadow and photographed in the studio. The glass-plate photographs were then used by the artist in laying out the composition. One such interesting photograph from the artist's studio collection shows the model setup used for *The Millpond* (Pl. 57), published in 1948 by Brown and Bigelow. The elaborate wooden model made by the artist is seen reflected in a mirror, representing the reflection in the still water of the millpond (Fig. 111). The model is detailed even to the tiny boards leaning against the side of the storage shed and the logs floating in the water. A silhouette of a tree painted on a sheet of paper is attached to the wall behind the model with a thumbtack. The artist created in this studio still life all the major elements of the painting. By using such models and props he was able to manipulate the scene and the lighting until he arrived at the exact effect that he wanted to paint. Another model of a farmhouse and adjoining buildings was used in several paintings, including Brown and Bigelow's 1945 calendar, *Sunup*. This was an accurate scale model of a farmhouse belonging to Parrish's neighbor, Willis K. Daniel. The architectural model was painted with regular housepaint so the reflection of the artificial studio lights would represent as accurately as possible the reflection of sunlight off the actual building.

Maxfield Parrish was a master craftsman. Meticulous in every detail of his art, he carefully sanded and painted the insides of the boxes he custom-made for shipping his paintings, as he regarded one's first impression upon opening the box as all-important. The painting technique in which he chose to work was slow and laborious, but he never rushed, never cut corners. Experimenting with many materials and devices, he adopted only those which facilitated the artistic expression of his ideas and concepts through accuracy of line and purity of color. Parrish's technical skills not only enabled him to achieve extraordinary visual effects, but also assured his paintings of a stable, well-preserved existence.

CONCLUSION

The period during which Maxfield Parrish began his painting career was one in which the professional opportunities were almost without limit for any artist with ambition and a talent for illustration. For good reason the period has since become known as the Golden Age of Illustration. It was a time when the print media were the mass media, and a profusion of weekly and monthly illustrated magazines occupied a position as significant as that of television today.

For many years magazines had reproduced illustrations from wood engravings, but it was not until the last decade of the ninteenth century that the new mechanical halftone process, which provided for rapid, accurate black-and-white reproduction, became increasingly general in its application. Lithography often was used with excellent results for printing the colorful, posterlike covers of the magazines. This process, in its color applications, was costly and time-consuming and, therefore, not feasible for general use in printing colored illustrations within the magazines. In time, the techniques of color reproduction on a mass scale were developed, and around the turn of the century the amount of color used within magazines began to increase rapidly. This innovation created new demands for illustration and opened new vistas to the illustrator.

The use of photography in magazines was just beginning to come into its own in the 1890s and did not yet present a threat to the illustrator. Photographs generally were not used to illustrate the literary features, which comprised a large part of many of the more popular magazines. And, as color photography had not been perfected, all color illustration was still the domain of the artist.

The work of no American artist was, perhaps, more familiar in the United States during the first three decades of this century than that of Maxfield Parrish. His unique combination of color, exotic characters and fanciful castles was particularly esteemed by the mass audiences, who had access to his work through the popular magazines and the books that he illustrated. He was, in essence, a public artist painting for a national audience rather than for an exclusive few. When F. Scott Fitzgerald described the reflection in a restaurant window as being the color of Maxfield Parrish moonlight[1] or Philip Wylie wrote that buildings seen from a boat were like Maxfield Parrish's pink cities floating on a sea of blue,[2] no one had to explain to whom they were referring. The artist's paintings had made his name a household word, and in spite of a sustained resistance to any kind of personal publicity, Maxfield Parrish became a national celebrity.

Parrish worked entirely outside the several schools or movements that emerged in American art during the more than sixty-five years in which he was active. In every sense he was an independent artist. Reflected in both his life style and his painting style is his determination to be his own man. At about the time he was finishing his academic training he made the decision to enter the realm of commercial illustration, that is, to make paintings on commission for mass reproduction in books and magazines. This decision puzzled many who saw commercial illustration as a waste of his talent. For Parrish it was a natural way of applying his abilities to the matter of earning a living. He established rigid standards for himself, and when a commission called for him to make an advertising design, he approached it with the same concern for aesthetic beauty and technical perfection as he did his other art.

During the early part of his career Parrish's illustrations were looked upon with admiration by critics and reviewers who praised his inventiveness and technical skill. Wrote John La Farge, "I know of no artist today, no matter how excellent, with such a frank imagination, within a beautiful form, as is the gift of Mr. Parrish."[3] But in the late teens, as modern art (given impetus in the United States by the Armory Show in 1913) began to gain wide acceptance, his romantic imagery increasingly lost favor with the critics. Though they continued to have great popular appeal, Parrish's paintings were dismissed by his detractors as "commercial art," then considered poles away from "fine art." Parrish

was also criticized for daring to paint carefully detailed landscapes (in which every square inch of the picture surface was given the same meticulous attention) throughout the long period when abstract art was ascendant. In spite of the criticism and with resolute dedication to his own ideals, he continued to paint the subjects he preferred in his own style. However, it was not until the early 1960s, when the Pop Art movement embraced the imagery of commercial art and reintroduced into American painting the figurative and objective elements that had been put aside by the abstractionists, that Parrish's work could be seen again in its own terms. Parrish did not often speak publicly of his feelings about abstract art, but in 1936 he confided that he thought "Modernistic-Abstractionist-Art . . . consists of 75% explanation and 25% God knows what!"[4] It was an immediate visual response, not necessarily an intellectual one, that he expected his own paintings to evoke.

In the 1970s further areas of appreciation for Parrish's art have been opened by the New Realists and Photo Realists, many of whom employ the same technique that Parrish used in transferring direct photographic images onto their canvases. Like hundreds of other painters, Maxfield Parrish regularly painted from photographs which he had made. However, unlike most other painters of his period, when transferring photographed images to his paintings he made few major transformations in them. He confined his editing and composing to the arrangement of the objects before they were photographed, and the photographs (glass plates) were simply projected onto his canvas and copied (Fig. 111). But most of his paintings were a composite of objects from several photographs taken both from nature and in the studio. This technique produced results that reflected a quality of detachment and objec-

tivity, even when the subject was a very personal one. In his review of Parrish's 1936 exhibition at Ferargil Galleries, Royal Cortissoz wrote in the *New York Herald Tribune,* "His art is a curious phenomenon. It stands . . . alone, and has charm. Yet it is as unimpassioned as a photograph."[5] This objectivity, combined with Parrish's high finish, unorthodox use of color and attention to minute detail, has caused, on occasion, his technique to be compared with that of Salvador Dali and other Surrealists. Certain of the Photo Realists have achieved a similar objectivity in paintings made from 35mm color transparencies. It should be pointed out that Parrish did not use color transparencies but 4″ x 5″ black-and-white glass plates to transfer only form and the effects of light and shadow. His color, which had the appearance of a Kodachrome transparency held before a light, was his own invention.

Parrish treated impossibilities as realities, depicting in vivid detail imaginary architecture, dragons (obviously not painted from photographs) and other fanciful phenomena. Conversely, and especially in his later landscapes, he often treated real objects unrealistically, giving them the appearance of reality through accurate form, but imposing his own effects of light and color. When asked if the leaves in *Jack Frost* (Fig. 63) were painted from nature, he replied, "No, that wouldn't do. It is purely imaginative, as Autumn leaves are not colored that way at all. That gets us into botany, and away beyond my depth."[6] The lighting that he frequently chose to use, a kind of theatrical backlighting that is rare though not entirely absent in nature, further emphasized the artist's concepts rather than nature's creations. "Just a faithful 'portrait' of a locality, factual, would never do,"[7] he explained. "My theory is that you should use all the objects in nature . . . just as stage properties on

which to hang your idea, the end in view, the elusive qualities of a day, in fact all the qualities that give a body the delights of the out of doors. . . . 'Realism' of impression, the mood of the moment, yes, but not the realism of things."[8]

Not to be overlooked are his abilities in the areas of design and decoration. The crisp, bold designs achieved through skillful distribution of contrasting forms and colors contributed significantly to the aesthetic appeal of some of his more outstanding posters and magazine covers. Although his own inclinations in composition were for awhile influenced by an adherence to the principles of Dynamic Symmetry, a strong sense of design is a quality that runs throughout most of his work. The artist's flair for decoration manifests itself most evidently in the richly patterned costumes of his figures, in the banderoles and cartouches which embellished the borders of so many of his early illustrations and in his uninhibited delight in the use of color.

It is somewhat of an irony that in the early 1960s, just a few years before Maxfield Parrish's death, a changing attitude in the aesthetics of art criticism began to remove the stigma from representational art. Since then more and more Americans have been discovering Parrish's work not in the print media of calendars, magazines and books through which it originally became known, but rather in museums and galleries. In this new setting his work can be seen in the original, as any artist's work should be seen to be evaluated properly. Audiences are able to study his composition, technique and use of color not only in its own right but in juxtaposition with the original work of other artists. And so it is that with this new accessibility a new evaluation of the paintings of Maxfield Parrish and his place in the history of American art is being discerned.

Notes

Chapter 1

1. Stephen Parrish to Dillwyn and Susanna Maxfield Parrish. July 28, 1870.
2. *National Cyclopedia of American Biography,* XII, p. 486.
3. Ibid.
4. Mary Black and Jean Lipman, *American Folk Painting,* p. 143.
5. MP to Mrs. Edward Bancroft, August, 1884.
6. Parrish's use of the pronoun reflects his Quaker background.
7. MP to Mrs. Edward Bancroft, August 25, 1884.
8. MP to Mrs. Edward Bancroft, 1884.
9. MP to Mrs. Edward Bancroft, January 4, 1885.
10. MP to Henry Bancroft (Winter 1884-1885).
11. Grace Glueck, "Bit of a Comeback Puzzles Parrish,"
 The New York Times (June 3, 1964): Section II, p. 1.
12. Maxfield Parrish, "Inspiration in the Nineties," *The Haverford
 Review,* II, 1 (Autumn, 1942): 14.
13. Christian Brinton subsequently became an art collector, critic
 and author of several books on art.
14. Francis B. Gummere was an authority on popular ballads and
 author of several books on the subject.
15. Parrish, "Inspiration in the Nineties," pp. 14-16.
16. MP to Elizabeth Bancroft Parrish, September 7, 1893.
17. MP to Stephen Parrish, August 8, 1893.
18. MP to Elizabeth Bancroft Parrish, October 6, 1893.
19. Notice from Society of Friends to Maxfield Parrish (n.d.).
20. MP to Lydia Austin Parrish, June 20, 1895.
21. MP to Lydia Austin Parrish, June, 1895.
22. MP to Lydia Austin Parrish, July 1, 1895.
23. MP to Lydia Austin Parrish, July 28, 1895.
24. MP to Charles Ward, January 1, 1951.
25. Ibid.
26. Homer Saint-Gaudens, "Maxfield Parrish," *The Critic,*
 XLVI, 6 (June, 1905): p. 515.
27. The size of the colony was determined more by the number of artists,
 writers, etc., working in the area than by the geographical boundaries
 of the town of Cornish, New Hampshire.
28. MP to Irénée du Pont April 13, 1932.
29. Ruth Boyle, "A House That 'Just Grew,'" *Good Housekeeping,*
 LXXXVIII, 4 (April, 1929): p. 44.
30. "House of Maxfield Parrish," *Architectural Record,*
 XXII, 4 (October, 1907): pp. 272-279.
31. The exact date is not available. In a letter written by Elizabeth
 Bancroft Parrish in October, 1900, she indicates that she has been
 in California for a year.
32. MP to Henry Bancroft, February 6, 1902.
33. Percy MacKaye, "American Pageants and Their Promise,"
 Scribner's Magazine, XLVI, 1 (July, 1909): pp. 31-32.
34. MP to Henry Bancroft, 1906.
35. MP to George Eastman, November 23, 1922.
36. MP to Clair Fry, December 18, 1958.
37. Lydia Parrish's second book, *The Lost Loyalists of the American
 Revolution,* based on the lives of the Loyalists who were banished to
 the Bahamas at the time of the American Revolution, was nearly finished
 at the time of her death. The manuscript is now in the archives of the
 Houghton Library, Harvard University.
38. MP to Reinthal and Newman, January 4, 1932.
39. Susan Lewin Colby also modeled for Parrish for many years and is seen
 in a fair number of his early paintings.
40. MP to Clair Fry, June 5, 1949.
41. MP to S. W. Rindfleisch, August 1, 1950.
42. "Grand-Pop" *Time,* LXXXIII, 24 (June 12, 1964): p. 76.
43. MP to J. H. Chapin, February, 1938.

Chapter 2

1. MP to Russell P. MacFall, February 20, 1958.
2. Charles W. Hackleman, *Commercial Engraving and Printing,* p. 59.
3. MP to Rusling Wood, August 13, 1919.
4. Washington Irving, *Knickerbocker's History of New York,* p. 25.
5. Percival Pollard, "American Poster Lore," *The Poster* II, 9
 (March, 1899): 123.
6. J. H. Irvine, "Professor Von Herkomer on Maxfield Parrish's Book
 Illustrations," *International Studio* XXIX (July, 1906): 35-36.
7. Kenneth Grahame, *The Golden Age,* p. 165.
8. Letter from *Ladies' Home Journal* to MP, July 2, 1902.
9. MP to Clarence Crane, May 25, 1917.
10. Eugene Field, *Poems of Childhood,* p. 120.
11. *Collier's Weekly* to MP, November 14, 1900.
12. Nathaniel Hawthorne, *A Wonder Book and Tanglewood Tales,* p. 331.
13. MP to C. D. Gibson, February 1, 1922.
14. MP to J. H. Chapin, October 24, 1920.
15. MP to J. H. Chapin, February 26, 1921.

Chapter 3

1. Maxfield Parrish's Record Book, entry No. *184.*
2. Ibid., entry No. *191.*
3. Adeline Adams, "The Art of Maxfield Parrish," *American Magazine
 of Art* IX, 3 (January, 1918): 86-87.
4. A. W. Drake to MP, January 24, 1901.
5. Augustus Saint-Gaudens to MP, December 5, 1901.
6. MP to the Century Company, September 24, 1902.
7. Edith Wharton to MP, April 7, 1903.
8. "Pen and Pencil in Italy," *The Critic* XLVI, 2 (February, 1900): 166.
9. Will Bradley to MP, April 1, 1912.
10. *Grimms' Fairy Tales,* ed. by Kaye Webb (Middlesex, England:
 Penguin Books, 1971), p. 84.
11. C. D. Gibson to MP, November 3, 1920.
12. MP to C. D. Gibson, March 17, 1921.
13. *Life* LXXX, 2081 (September 21, 1922): 11.
14. MP to *Life,* February 1, 1923.

Chapter 4

1. MP to Rusling Wood, November 30, 1914.
2. MP to Rusling Wood, January 27, 1922.
3. MP to Rusling Wood, December 27, 1919.
4. MP to Rusling Wood, August 3, 1917.
5. MP to Rusling Wood, February 11, 1918.
6. MP to Stephen Newman, May 19, 1923.
7. MP to Rusling Wood, September 30, 1915.

8. MP to Rusling Wood, February 16, 1921.

9. MP to Rusling Wood, January 27, 1922.

10. MP to Rusling Wood, February 5, 1923.

11. J. L. Conger, "Maxfield Parrish's Calendars Build Sales for Edison Mazda Lamps," *The Artist and Advertiser* (June, 1931): 34.

12. Ibid., pp. 5, 34–35.

13. MP to H. S. Morgan, September 15, 1920.

14. MP to H. S. Morgan, June 25, 1923.

15. MP to H. S. Morgan, January 18, 1924.

16. MP to T. J. McManis, November 21, 1927.

17. MP to T. J. McManis, February 6, 1928.

18. "Maxfield Parrish Will Discard 'Girl-on-Rock' Idea in Art," Associated Press, April 27, 1931.

Chapter 5

1. MP to Clarence A. Crane, January 16, 1916.

2. MP to Clarence A. Crane, March 6, 1916.

3. MP to Clarence A. Crane, July 24, 1916.

4. MP to Clarence A. Crane, January 7, 1917.

5. MP to Clarence A. Crane, July 24, 1916.

6. MP to Clarence A. Crane, November 6, 1916.

7. MP to Clarence A. Crane, May 25, 1917.

8. MP to Clarence A. Crane, March 15, 1918.

9. MP to Clarence A. Crane, May 11, 1918.

10. John Unterecker, *Voyager,* pp. 142–144.

11. MP to Stephen Newman, January 24, 1922.

12. MP to Stephen Newman, January 13, 1922.

13. "Caught in Florida," *Literary Digest* LXXVII, 6 (May 12, 1923): 40.

14. MP to Stephen Newman, November 13, 1922.

15. MP to Stephen Newman, April 26, 1923.

16. MP to Stephen Newman, August 30, 1923.

17. MP to Stephen Newman, October 30, 1923.

18. MP to Stephen Newman, June 28, 1924.

19. MP to Stephen Newman, June 3, 1925.

20. Ibid.

21. MP to Stephen Newman, December 11, 1925.

22. MP to Stephen Newman, January 2, 1926.

23. MP to Stephen Newman, April 17, 1926:

24. MP to Stephen Newman, April 12, 1926.

25. MP to A. E. Reinthal, July 1, 1927.

26. When making large mural-sized paintings, Parrish often painted the figures first and then the background.

27. MP to Stephen Newman, August 23, 1926.

28. MP to Celia Mendelsohn, June 4, 1936.

29. MP to Stephen Newman, April 1, 1928.

30. MP to A. E. Reinthal, February 15, 1929.

31. Ibid.

Chapter 6

1. MP to Mr. Street, editor of "Table Topics," May 4, 1946.

2. MP to Nicholas Biddle, September 6, 1905.

3. The amount frequently has been reported erroneously to have been fifty-thousand dollars.

4. MP to Anne Tiffany, July 12, 1936.

5. Gene Fowler, *Good Night, Sweet Prince,* p. 441.

6. Ibid., p. 442.

7. MP to J. H. Chapin, May 12, 1927.

8. MP to Stephen Parrish, April 11, 1894.

9. MP to Stephen Parrish, April 27, 1894.

10. Maxfield Parrish's Record Book, entry No. *17.*

11. MP to Samuel Bancroft, June 1, 1908.

12. MP to Helen Hess, February 8, 1949.

13. MP to Mrs. Frank Seiberling, n.d. (ca. May, 1917).

14. MP to Mrs. Gertrude Vanderbilt Whitney, July 19, 1912.

15. MP to Mrs. Gertrude Vanderbilt Whitney, April 8, 1914.

16. MP to Mrs. Gertrude Vanderbilt Whitney, September 24, 1914.

17. MP to Mrs. Wilber Force, secretary to Mrs. Whitney, October 6, 1926.

18. MP to Edward Bok, July 27, 1910.

19. MP to Edward Bok, July 27, 1911.

20. MP to Edward Bok, January 18, 1912.

21. MP to William Walter, May 2, 1914.

Chapter 7

1. Maxfield Parrish's Record Book, entry No. *10.*

2. MP to Elizabeth Bancroft Parrish, summer, 1892.

3. MP to Jerome Connolly, May 5, 1952.

4. Parrish's use of the pronoun reflects his Quaker background.

5. MP to Elizabeth Bancroft Parrish, September 20, 1893.

6. MP to Spencer Penrose, September 15, 1919.

7. MP to Mr. Goodsill, Northern Pacific Railway Company, October 30, 1934.

8. MP to Brown and Bigelow, January 19, 1949.

9. MP to Brown and Bigelow, January 1, 1935.

10. MP to Brown and Bigelow, April 5, 1935.

11. MP to Brown and Bigelow, April 15, 1936.

12. MP to Roy Hill, December 15, 1959.

13. MP to Brown and Bigelow, September 3, 1939.

14. MP to Brown and Bigelow, June 11, 1940.

15. MP to Brown and Bigelow, January 1, 1940.

16. MP to Brown and Bigelow, November 17, 1947.

17. MP to Brown and Bigelow, July 28, 1943.

18. Clair Fry to MP, January 13, 1955.

19. MP to Clair Fry, December 21, 1950.

20. MP to Clair Fry, January 15, 1951.

21. MP to Jerome Connolly, May 5, 1952.

Chapter 8

1. MP to Elizabeth Bancroft Parrish, September 20, 1893.

2. MP to J. H. Chapin, November 27, 1923.

3. MP to Irénée du Pont, November 24, 1950.

4. MP to Clarence A. Crane, November 6, 1917.

5. MP to the Upson Company, October 20, 1924.

6. MP to the Pantasote Company, July 2, 1924.

7. MP to F. W. Weber, January 7, 1950.

8. Extracted from "Maxfield Parrish's Technique," an unpublished manuscript by Maxfield Parrish, Jr., pp. 1–33.

9. MP to Rhode Island School of Design, January 20, 1953.

10. MP to Irénée du Pont, March 26, 1931.

11. Irénée du Pont to MP, March 28, 1931.

Conclusion

1. F. Scott Fitzgerald, "May Day" (originally published in 1920), *The Stories of F. Scott Fitzgerald,* p. 120.

2. Philip Wylie, "Three Time Winner," *Saturday Evening Post* 214, 44 (May 2, 1942): 52.

3. John La Farge to Charles Scribner's Sons, January 19, 1910.

4. MP to William O. Chessman, March 27, 1936.

5. Royal Cortissoz, "Recent Work by Maxfield Parrish," *New York Herald Tribune* (February 16, 1936): Section V, p. 10.

6. MP to William O. Chessman, March 27, 1936.

7. MP to Brown and Bigelow, January 19, 1949.

8. MP to Jerome Connolly, May 5, 1952.

Catalog of Selected Works

Maxfield Parrish created nearly all of his illustrations, posters, advertisements, landscapes, etc., to be reproduced by commercial publishers. Consequently, many of them were never given titles by the artist, but were captioned by the publishers. Others, such as headings, page decorations and unpublished works, were given no titles at all. Therefore, no attempt has been made to organize the works in this catalog by title. Instead, they have been organized according to the kinds of commissions Parrish accepted and the publications—for example magazines, books and calendars—in which his work appeared. Murals and designs for theatrical scenery, although not necessarily intended for reproduction, also are included in this catalog.

The numbering system used here is an extension of Parrish's own system for identifying his work. He numbered each piece in chronological order as he finished it. He continued this numbering system until January, 1910, when he terminated it with the number *520*. Unfortunately, there are numerous gaps in his records. These gaps leave many works made prior to January, 1910, without numbers and seventy-seven numbers lower than *520* not assigned. In this catalog, those unassigned numbers have been given to works whose dates approximate the dates of works with numerically adjacent numbers assigned by the artist. There were not, however, a sufficient quantity of unassigned numbers under *520* to cover all of the unnumbered works made before January, 1910. Therefore, it was necessary to begin a second sequence with number *521*. The second sequence includes the artist's previously unnumbered early works and continues through the products of his final years in the early nineteen sixties. The numbers in italics are the artist's numbers. The ones not in italics are those numbers newly assigned for this catalog.

It should be understood that a great many of Parrish's works are not dated, and that the apparent chronological sequence in this numbering system is based necessarily upon approximation. Consequently, the numbers are intended only as a means of identifying untitled works, or works with duplicate titles, and in no way suggest dates or an exact chronological order of production.

No painting has been assigned more than one number. The number refers to the work itself, and not to its use. For example, *The Lantern Bearers*—which was reproduced at different times as a magazine illustration, a book illustration, a color reproduction and a calendar—is assigned a single number, No. *485*, not a different number for each use.

Maxfield Parrish occasionally altered his original paintings after they had been published—deleting figures, changing backgrounds, adjusting tonalities, etc. In this catalog these later versions retain the number of the original.

The artist used cut-outs extensively in the preliminary stages of making a painting. Although many of these cut-outs are extant, they are not included in this catalog. However, some of the more complete studies for paintings are included.

The sources for dates and sizes of the individual works were the artist's papers and various exhibition and collection catalogs. In most cases such information has not been verified beyond these documents.

"The Oaks," often indicated as the location at which a painting was made, refers to the name of the artist's home at Plainfield (near Cornish), New Hampshire, on the State border at Windsor, Vermont.

Information (date and volume of publication, size of print, etc.) that precedes the title or description of the work of art refers to the publication in which it appeared. The information (date, size, etc.) that follows the title or description refers to the work itself, unless otherwise specified. Quotation marks around the technical data following a title indicate a direct quotation from the artist's records. The following abbreviations are used throughout the catalog: p. (page); f.p. (facing page); o.p.f. (original painted for); and f.a. (first appearance).

Books Containing Parrish's Illustrations

The Arabian Nights, Their Best-Known Tales, Kate Douglas Wiggin and Nora A. Smith, editors. New York and London: Charles Scribner's Sons, 1909. Size: 9½" x 7⅛". Illustrations in color.

	Number
The Fisherman, cover design. 1909. 9" x 11".	512
Cover linings. 1909. 14" x 10".	513
The Arabian Nights, title page. 1909.	514
The Talking Bird, f.p. 32 (o.p.f. *Collier's*, 12/1/06).	415
The Fisherman and the Genie, f.p. 54 (o.p.f. *Collier's*, 4/7/06).	412
The Young King of the Black Isles, f.p. 74 (o.p.f. *Collier's*, 5/18/07).	421
Gulnare of the Sea, f.p. 86 (o.p.f. *Collier's*, 8/3/07).	418
Aladdin, f.p. 106 (o.p.f. *Collier's*, 6/22/07).	410
Prince Agib, Landing of the Brazen Boatman, f.p. 194 (o.p.f. *Collier's*, 11/9/07).	420
Prince Agib, The Story of the King's Son, f.p. 202 (o.p.f. *Collier's*, 10/13/06).	411
The City of Brass, f.p. 218 (o.p.f. *Collier's*, 3/16/07).	417
The Story of Ali Baba and the Forty Thieves, f.p. 236 (o.p.f. *Collier's* 11/3/06).	413
The History of Codadad and His Brothers, f.p. 276 (o.p.f. *Collier's*, 9/1/06).	419
Second Voyage of Sinbad, f.p. 300 (o.p.f. *Collier's*, 9/7/07).	416
Third Voyage of Sinbad, f.p. 306 (o.p.f. *Collier's*, 2/9/07).	414

Note: Series painted between the fall of 1905 and April, 1906.

Bolanyo, Opie Read. Chicago: Way and Williams, 1897. Cover printed in two colors (front and back covers identical).

Bolanyo, cover design. 1897.	93

The Children's Book, Horace E. Scudder, editor. Boston and New York: Houghton Mifflin Company, 1910. Size: 10" x 8". Cover printed in color.

Toyland, cover (o.p.f. 1908. Madison Square Garden Toy Show poster). 24" x 28".	479

Dream Days, Kenneth Grahame. London and New York: John Lane: The Bodley Head, 1902. Size: 8¼" x 6¼". Cover in color; other illustrations in black and white.

Dream Days, cover design.	542
Its Walls Were as of Jasper, frontispiece. 1900. 14⅝" x 10⅜".	277
Dream Days, title page. 1900. 12" x 8½".	276
The Twenty-First of October, f.p. 3.	543
Tailpiece for "The Twenty-First of October, p.21.	544
Dies Irae, f.p. 25.	545
Tailpiece for "Dies Irae," p. 43.	546
Mutabile Semper, f.p. 47. 1900–1901. 18½" x 14".	297
Tailpiece for "Mutabile Semper," p. 68.	547
The Magic Ring, f.p. 71. 1901.	295
Tailpiece for "The Magic Ring," p. 93. 1901.	299
Its Walls Were as of Jasper, f.p. 97.	548
A Saga of the Seas, f.p. 123. 1901. 12" x 8½".	298
The Reluctant Dragon, f.p. 149.	549
Tailpiece for "The Reluctant Dragon," p. 203.	550
A Departure, f.p. 207.	551
Tailpiece for "A Departure," p. 228. 1900.	300

Free To Serve, Emma Rayner. Boston: Copeland and Day, 1897.

Free to Serve, cover design. 1897. 14" x 9½".	137

The Garden of Years and Other Poems, Guy Wetmore Carryl. New York and London: G. P. Putnam's Sons, 1904. Size: 7⅞" x 5¼". Frontispiece in color.

The Garden of Years, frontispiece. 1904. 18½" x 12".	393

The Golden Age, Kenneth Grahame. London and New York: John Lane: The Bodley Head, 1899. Size: 8¼" x 6¼". Illustrations in black and white.

The Golden Age, cover design, 1899. (Later edition, 1904, used cover design from *Dream Days*.)	211
The Burglers, frontispiece. 1899.	228
The Golden Age, title page. 1899. 14¼" x 9".	214
The Olympians, f.p. 6. 1899.	220
Tailpiece for "The Olympians," p. 9. 1899.	236

The Golden Treasury of Songs and Lyrics. Francis Turner Palgrave, editor. New York: Duffield and Company, 1911. Size 9¾″ x 7¾″. Illustrations in color.

Italian Villas and Their Gardens, Edith Wharton. New York: The Century Company, November 1904. Size: 10¾″ x 7½″. Illustrations in color and black and white.

King Albert's Book. London: The Daily Telegraph, 1914; New York: Hearst's International Library Company, 1914. Size: 11⅛″ x 8¾″. Illustration in color.

The Knave of Hearts, Louise Saunders, New York: Charles Scribner's Sons, 1925. Size: 14⅛″ x 11¾″. Illustrations in color (halftone plates engraved for Scribner's by Beck Company).

Note: All of the paintings for *The Knave of Hearts* were rendered in oil on panels.

The Knave of Hearts, Louise Saunders. Racine, Wisconsin: Artists and Writers Guild, 1925. Size: 12⅝″ x 10⅞″. Illustrations in color. (This is a soft cover, spiral bound edition. Text and illustrations are identical to those in Scribner's deluxe edition, with the exception of the cover lining, *Romance*, which has been deleted.)

The Knave of Hearts, A Fourth of July Comedietta, Albert Lee. New York: R. H. Russell, 1897.

Knickerbocker's History of New York, Washington Irving. New York: R. H. Russell, 1900. Size: 12⅞″ x 9¼″. Illustrations (drawings) in black and white.

Lure of the Garden, Hildegarde Hawthorne. New York: The Century Company, 1911. Size: 10⅝″ x 7⅜″. Illustration in color.

Mother Goose in Prose, L. Frank Baum. Chicago: Way and Williams, December, 1897. Size: 11⅜″ x 9⅜″. Cover printed in six colors; title page and artist's credit page in two; other illustrations (drawings) in black and white.

Current Literature (publication date unknown).

Everybody's Magazine

Harper's Bazar

Harper's Monthly Magazine

Harper's Round Table

Harper's Weekly

Catalog and Program Covers, Playbills, etc. for NonCommercial Institutions

Advertisements and Posters

Maxfield Parrish regarded most of his advertisement designs as posters and referred to them by that term. Many of these posters were used in magazines, on billboards, etc. The classification shown for each of the works below in no way indicates that the work was printed in that form exclusively. (Advertisements designed for a specific location in a specific magazine, for example the back cover of *Scribner's Magazine*, are listed with the magazine illustrations as well as here. Sources listed with the advertisements below are to indicate one publication in which the design may be seen.)

Wanamaker's Goods and Prices. Spring and Summer, No. 42, 1897,
cover. 1897. 15″ x 10½″. Drawn for two paintings.　79
Wanamaker's Goods and Prices. Spring and Summer, No. 42 (1887),
second version of cover. 1897. Drawn for two printings.　83

Way and Williams, Publishers

Bolanyo, poster for book by Opie Read. 1897. (*Artist's note:* This poster
was enlarged from a small sketch, with pathetic results.)　82

Wellsbach Light

The Improved Wellsbach Light, poster. 1896. 30″ x 13¾″.　55

Calendars and Greeting Cards

Brown and Bigelow

Brown and Bigelow reproduced Maxfield Parrish's paintings in both their regular
calendar line and their engraving line of smaller calendars and greeting cards. Some
were in as many as five different sizes, ranging from 4″ x 3¼″ to 22⅜″ x 18″.
Beginning in 1941, Parrish provided a second work each year, a winter subject,
for the Brown and Bigelow engraving line which was reproduced exclusively as
small calendars (along with the regular calendar line) and greeting cards. The
winter subjects, listed here under the years in which they were issued, are desig-
nated by "W", while the regular calendar subjects are designated by "C". (First
title shown for each work is Brown and Bigelow title.)

1936C　*Peaceful Valley* (artist's title: *Elm, Late Afternoon;* other title:
Tranquility). 1934. Oil on panel.　750
1937C　*Twilight* (second version). 1935. Oil on panel. *Ca.* 34″ x 20″.　758
1938C　*The Glen.* 1936. Oil on panel. 27″ x 22″　765
1939C　*Early Autumn* (artist's title: *Autumn Brook;* other title: *The
Covered Bridge*). Oil on panel.　766
1940C　*Evening Shadows* (artist's title: *The Old Birch Tree;* other title:
Old White Birch). Oil on panel. 34″ x 22″.　768
1941C　*The Village Brook.* Ca. 30″ x 20¼″.　770
1941W　*Winter Twilight.* Oil on panel.　812
1942C　*Thy Templed Hills* (artist's title: *New Hampshire;* other title:
New Hampshire: Land of Scenic Splendor). 1936. Oil on panel.　760
1942W　*Silent Night* (other title: *Winter Night*). 1940. Oil on panel.
11″ x 13″.　777
1943C　*A Perfect Day* (artist's title: *June Skies*). 1940. Oil on panel.
22¾″ x 18¼″.　776
1943W　*At Close of Day* (artist's title: *Plainfield New Hampshire
Church at Dusk;* other title: *The Village Street—Winter*). 1941. Oil
on panel. 15″ x 13″.　778
1944C　*Thy Rocks and Rills* (artist's title: *The Old Mill*). Oil on panel.
22¾″ x 18¼″.　782
1944W　*Eventide.* Oil on panel. 13″ x 15″.　783
1945C　*Sunup* (artist's title: *Little Brook Farm*). 1942. Oil on panel.
22¼″ x 18¼″.　791
1945W　*Lights of Home* (re-issued under title: *Silent Night*). 1943. Oil
on panel.　786
1946C　*Valley of Enchantment* (artist's title: *Road to the Valley;* other
title: *Golden Valley*). 1943. Oil on panel. 22¾″ x 18¼″.　785
1946W　*The Path to Home* (artist's title: *Across the Valley*). Oil on
panel.　793
1947C　*Evening.* 1944. Oil on panel. 22½″ x 18¼″.　794
1947W　*Peace At Twilight* (artist's title: *Lull Brook*). Oil on panel.　797
1948C　*The Millpond.* 1945. Oil on panel. 22½″ x 18″.　795
1948W　*Christmas Eve* (artist's title: *Deep Valley*). Oil on panel.
15″ x 13″.　798
1949C　*The Village Church.* Oil on panel. 29″ x 25″.　799
1949W　*Christmas Morning.* Oil on panel. 13″ x 15″.　784
1950C　*Sunlit Valley.* 1947. Oil on panel.　803
1950W　*A New Day* (artist's title: *Afterglow*). 1947. Oil on panel.
13½″ x 15″.　804
1951C　*Daybreak* (artist's title: *Hunt Farm*). 22½″ x
18½″. (Reproduced by Brown and Bigelow on playing cards, 1962.)　807
1951W　*The Twilight Hour* (artist's title: *Hilltop Farm, Winter*). Oil on
panel. 13″ x 15″.　820
1952C　*An Ancient Tree.* Oil on panel. 22″ x 18″.　809
1952W　*Lights of Welcome* (artist's title: *Hilltop Farm, Winter*). Oil on
panel, 13″ x 15″.　810
1953C　*Evening Shadows* (artist's title: *Peace of Evening*). 1950. Oil on
panel. 23″ x 18¾″.　823
1953W　*Peaceful Night* (artist's title: *Church at Norwich, Vermont*).
1950. Oil on panel. 21½″ x 17½″.　824
1954C　*The Old Glen Mill* (artist's title: *Glen Mill*). 1950. Oil on
panel. 23″ x 18½″.　826
1954W　*When Day is Dawning* (artist's title: *Winter Sunrise*). 1949.
Oil on panel. 13″ x 15″.　827
1955C　*Peaceful Valley* (artist's title: *Homestead*). Oil on panel.
23″ x 18½″.　828
1955W　*Sunrise* (artist's title: *White Birches In a Glow*). 1952. Oil on
panel. 13″ x 15″.　829

1956C　*Misty Morn* (artist's title: *Swift-water*). 1953. Oil on panel. 23″
x 18½″.　832
1956W　*Evening.* Oil on panel. 13″ x 15″.　833
1957C　*Morning Light* (artist's title: *The Little Stone House*). 1954.
Oil on panel. 23″ x 18½″.　834
1957W　*At Close of Day* (artist's title: *Norwich, Vermont*). 1954. Oil
on panel. 13¾″ x 15⅝″.　835
1958C　*New Moon.* Oil on panel. (Reproduced by Brown and Bigelow
on playing cards, 1962.)　838
1958W　*Sunlight* (artist's title: *Winter Sunshine*). Oil on panel.　839
1959C　*Under Summer Skies* (artist's title: *Janion's Maple*). 1956. Oil
on panel. 18″ x 16″.　840
1959W　*Peace of Evening* (other title: *Dingleton Farm*). Oil on panel.
13″ x 18″.　842
1960C　*Sheltering Oaks* (artist's title: *A Nice Place to Be;* other title:
River Bank). 1956. Oil on panel. 25″ x 19″.　841
1960W　*Twilight Time* (artist's title: *Freeman Farm*). Oil on panel.
15″ x 20″.　845
1961C　*Twilight* (artist's title: *The White Oak*). Oil on panel. 22½″ x
18″.　844
1961W　*Daybreak.* Oil on panel. 11″ x 15½″.　843
1962C　*Quiet Solitude* (artist's title: *Cascades*). Oil on panel. 22″ x 18″.　847
1962W　*Evening Shadows.* Oil on panel. *Ca.* 11″ x 13″.　848
1963C　*Peaceful Country.* Oil on panel.　849
Note: The Maxfield Parrish landscapes issued by Brown and Bigelow
after 1963 were reprints of previously used subjects to which they as-
signed new titles.

P. F. Collier and Son

Maxfield Parrish Art Calendar for 1907
Spring (o.p.f. *Collier's,* 5/6/05).　402
Summer (o.p.f. *Collier's,* 7/22/05).　404
Harvest (o.p.f. *Collier's,* 9/23/05).　405
Father Time (o.p.f. *Collier's,* 1/7/05).　395

Dodge Publishing Company
(In the late teens and early nineteen twenties, Dodge Publishing re-issued as
calendars a number of Parrish's magazine and book illustrations. The artist made
no original calendar designs for Dodge.)

1917　*Business Man's Calendar* (o.p.f. *Collier's,* 11/20/09).　507
1921　*Calendar of Cheer* (o.p.f. *Collier's,* 12/10/10).　485
1925　*Calendar of Friendship* (*Jason and The Talking Oak,* from *A
Wonder Book and Tanglewood Tales* by Hawthorne).　452
1925　*Contentment Calendar* (o.p.f. *Collier's,* 10/13/06).　411
1925　*Sunlit Road Calendar* (o.p.f. *Scribner's,* Aug. 1912).　562
1925　*Business Man's Calendar* (o.p.f. *Collier's,* 11/9/07).　420
1926　*Business Man's Calendar* (o.p.f. *Collier's,* 10/31/08).　449
1926　*Calendar of Cheer* (o.p.f. *Collier's,* 9/1/06).　419
1926　*Contentment Calendar* (o.p.f. *Collier's,* 7/22/05).　404
1926　*Calendar of Sunshine* (o.p.f. *Collier's,* 9/23/05).　405
1926　*Sunlit Road Calendar* (*Fountain of Pirene,* from *A Wonder Book
and Tanglewood Tales* by Hawthorne).　454
1926　*Calendar of Friendship* (o.p.f. *Collier's,* 1/25/08).　448

General Electric Mazda Lamps
The General Electric Company issued Parrish calendars in several sizes. A large
size (ca. 37″ x 18″) was for intra-organization use, to be displayed by the dealers. A
smaller size (19″ x 8½″), as many as 1,500,000 were printed annually, and cel-
luloid miniatures (3¾″ x 2½″) were made for distribution to the general public.
The dealer paid about $7.00 for each one hundred of the smaller size calendars
with his name imprinted. Many of the designs also were used on decks of playing
cards distributed as promotional items.

1918　*Dawn.* 1917. Oil on panel.　638
1919　*Spirit of the Night.* Oil on panel.　644
1920　*Prometheus.* 1919. Oil on panel.　651
1921　*Primitive Man.* 1920. Oil on panel.　656
1922　*Egypt.* 1920. Oil on panel.　658
1923　*Lamp Seller of Bagdad.* Oil on panel.　689
1924　*Venetian Lamplighter.* 1922. Oil on panel.　683
1925　*Dream Light.* 1924. Oil on panel.　715
1926　*Enchantment.* (Original, entitled *Cinderella,* painted for *Hearst's*
but used as cover for *Harper's Bazar,* Mar. 1914.)　600
1927　*Reverie* (artist's title: *The Fountan*). 1926. Oil on panel. Ca.35″
x 22″.　723
1928　*Contentment.* 1927. Oil on panel. Ca.34″ x 23″.　724
1929　*Golden Hours* (artist's title: *Autumn*). 1927. Oil on panel.　726
1930　*Ecstasy.* 1929. Oil on panel. 36″ x 24″.　728
1931　*Waterfall.* 1930. Oil on panel. 30″ x 22″.　735
1932　*Solitude.* 1931. (Issued in small size only.) Oil on panel.　740
1933　*Sunrise.* 1931. Oil on panel. 31¾″ x 22½″. (Figures painted out
by the artist after use by General Electric.)　742
1934　*Moonlight.* 1932. Oil on panel. *Ca.* 32″ x 23″. (Issued in small
size only: 750,000 printed. Figure painted out by the artist as early as
February, 1935.)　744
G. E. Mazda Lamps, design used for window cards and hanging signs
(o.p.f. *Life,* 11/10/21).　669

Thomas D. Murphy Company
The artist made no original calendar designs for Thomas D. Murphy Company. This company bought through an agent designs already used in magazines, on calendars, etc. Frequently the compositions were slightly changed by the artist after their initial use before a second use was authorized.

1937 *Sunrise* (o.p.f. 1933 G. E. Mazda calendar). 742

1938 *Only God Can Make a Tree* (artist's title: *Autumn*). (o.p.f. 1929 G.E. Mazda calendar). 726

1939 *Rock of Ages* (artist's title: *Arizona*). (f.a. *Ladies' Home Journal*, Oct. 1930). 739

1941 *White Birch* (f.a. *Yankee*, Dec. 1935). 755

1942 *Hilltop* (o.p.f. the House of Art). 722

Color Reproductions

Broadmoor Hotel, Colorado Springs, Colorado
The Broadmoor. Print sizes: 7″ x 8″; 17¼″ x 24″. 667

Brown-Robertson Company (Art Education, Incorporated)
These small prints, primarily for school use, were sold for a very limited time only, due to copyright restrictions.
Tranquility (artist's title: *Elm, Late Afternoon*). (f.a. 1936 Brown and Bigelow calendar entitled *Peaceful Valley*). Print size: 3⅞″ x 3¼″. 750
Twilight (painted as 1937 Brown and Bigelow calendar). Print size: 3⅞″ x 3¼″. 758

Clark Equipment Company, Buchanan, Michigan
The Spirit of Transportation. Issued ca.1923. Print size: 20″ x 16″. 659

Collier's
Jack Frost. Issued 1936 (o.p.f. *Collier's*, 10/24/36). 761

Curtis Publishing Company
The Dream Garden. Issued ca.1915. (Maxfield Parrish painting executed in Favrile glass by Tiffany Studios). Print size: 14″ x 24½″. 617

Detroit Publishing Company
The Garden of Opportunity. Issued ca.1915. This printed triptych includes three of the Curtis Publishing Company murals, *Love's Pilgrimage* (No. 590), *The Garden of Opportunity* (No. 611), and *A Call to Joy* (No. 592). Print size: 24¼″ x 25″. 611

Dodge Publishing Company (Dodge Press, Artex Prints, and The Art Extension Press)
Dodge Publishing Company published as color reproductions suitable for framing numerous illustrations that Maxfield Parrish had made for magazine and book use. Parrish made no original paintings for the Dodge Publishing Company, which made its arrangements for the use of Parrish material with the owner or original publisher, not the artist. Many of Dodge's color reproductions of paintings copyrighted by *Collier's* were also sold through the P. F. Collier and Son Print Department. *Note:* Print sizes are approximate.
Aladdin and the Wonderful Lamp (o.p.f. *Collier's*, 6/22/07). Print size: 11″ x 9″. 410
Atlas Holding Up the Skies (o.p.f. *Collier's* 5/16/08). Print sizes: 3⅜″ x 2⅝″; 11″ x 9″. 450
Autumn (o.p.f. *Collier's*, 10/28/05). Print size: 10″ x 8″. 409
The Book Lover (o.p.f. Collier's, 9/24/10). Print size: 13″ x 10″. 583
The Brazen Boatman (o.p.f. *Collier's*, 11/9/07). Print size: 11″ x 9″. 420
Cadmus Sowing the Dragon's Teeth (o.p.f. *Collier's* 10/31/08). Print size: 11″ x 9″. 449
Cassim in the Cave of the Forty Thieves (o.p.f. *Colliers*, 11/3/06). Print size: 11″ x 9″. 413
The Chimera—Bellerophon Watching by the Fountain (o.p.f. *Collier's*, 5/15/09). Print size: 11″ x 9″. 455
Chiron the Centaur (Jason and His Teacher). (o.p.f. *Collier's*, 7/23/10). Print size: 11″ x 9″. 456
Christmas (o.p.f. *Collier's*, 12/3/04). Print size: 10″ x 8″. 392
Circe's Palace (o.p.f. *Collier's*, 1/25/08). Print size: 11″ x 9″. 448
The City of Brass (o.p.f. *Collier's*, 3/16/07). Print size: 11″ x 9″. 417
Easter (o.p.f. *Collier's*, 4/15/05). Print size: 10″ x 8″. 400
The Fountain of Pirene (f.a. *A Wonder Book and Tanglewood Tales* by Hawthorne). Print size: 11″ x 9″. 454
Harvest (o.p.f. *Collier's*, 9/23/05) Print size: 10″ x 8″. 405
The History of the Fisherman and the Genie (o. p. f. *Collier's*, 4/7/06). Print size: 11″ x 9″. 412
Jason and the Talking Oak (f.a. *A Wonder Book and Tanglewood Tales* by Hawthorne). Size: 11″ x 9″. 452
The King of the Black Isles (o.p.f. *Collier's*, 5/18/07). Print size: 11″ x 9″. 421
The Lantern Bearers (o.p.f. *Collier's*, 12/10/10). Print size: 11½″ x 9½″. 458
The Nature Lover (Man With the Green Apple). (o.p.f. *Collier's*, 4/1/11). Print size: 13″ x 10″. 584
Old King Cole (original painted as a mural decoration for Knickerbocker Hotel). Print size: 6½″ x 25″. 568
Pandora (o.p.f. *Collier's*, 10/16/09). Print size: 11″ x 9″. 459

The Pied Piper (original painted as a mural decoration for Palace Hotel, San Francisco). Photogravure and color print sizes: 6¾″ x 21″. 505
Prince Codadad (o.p.f. *Collier's*, 9/1/06). Print size: 11″ x 9″. 419
Proserpina and the Sea Nymphs (o.p.f. *Collier's*, 4/23/10). Print size: 11″ x 9″. 458
Queen Gulnare Summoning Her Relations (o.p.f. *Collier's* 8/3/07). Print size: 11″ x 9″. 418
The Quest of the Golden Fleece (o.p.f. *Collier's*, 3/5/10). Print size: 11″ x 9″. 457
The Search for the Singing Tree (The Talking Bird). (o.p.f. *Collier's*, 1/1/06). Print size: 11″ x 9″. 415
Sinbad Plots Against the Giant (o.p.f. *Collier's*, 2/9/07). Print size: 11″ x 9″. 414
Sing a Song of Sixpence (study for mural painted for Hotel Sherman, Chicago. Appeared in *Century*, February 1911.) Print size: 8⅞″ x 21″. 586
Spring (o.p.f. *Collier's*, 5/6/05). Print size: 10″ x 8″. 402
The Story of a King's Son (o.p.f. *Collier's*, 10/13/06). Print size: 11″ x 9″. 411
Summer (o.p.f. *Collier's*, 7/22/05). Print size: 10″ x 8″. 404
The Tempest: An Odd Angle of the Isle (original painted in 1909 for Winthrop Ames' production of *The Tempest*). Print size: 7″ x 7″. 504
The Tempest: The Phoenix Throne (original painted in 1909 for Winthrop Ames' production of *The Tempest*). Print size: 7″ x 7″. 501
The Tempest: The Strong-Based Promontory (artist's title: *The Yellow Sands Outside the Cave*). (Original painted in 1909 for Winthrop Ames' production of *The Tempest*.) Print size: 7″ x 7″. 502
The Tempest. Design for scene in which Prospero lifts the spell he previously cast upon the King of Naples. (Original painted in 1909 for Winthrop Ames' production of *The Tempest*.) 7″ x 7″. 503
Thanksgiving (o.p.f. *Collier's*, 11/20/09). Print size: 11″ x 9″. 507
The Valley of the Diamonds (o.p.f. *Collier's*, 9/7/07). Print size: 11″ x 9″. 416

The House of Art (Reinthal and Newman)
In the 1920's The House of Art had an agreement with Maxfield Parrish making that firm the exclusive publishers of all his works designed for the color reproduction or art print market. Of the many Parrish color reproductions issued by other companies, none were designed specifically as art prints but were reproductions of murals, magazine and book illustrations, etc.
The Rubaiyat. Copyrighted 1917. (Original painted to decorate the 1916 gift boxes of Crane's Chocolates.) Print sizes: 2″ x 8½″; 4″ x 14″; 8″ x 30″. 620
Cleopatra. Copyrighted 1917. (Original painted to decorate the 1917 gift boxes of Crane's Chocolates.) Print sizes: 6½″ x 7½″; 15″ x 16″; 24¼″ x 28″. 632
Garden of Allah. Copyrighted 1918. (Original painted to decorate the 1918 gift boxes of Crane's Chocolates.) Print sizes: 4½″ x 8″; 9″ x 18″; 15″ x 30″. 641
Morning (other title: *Spring*). Issued fall, 1922 (o.p.f. *Life*, 4/6/22). Print sizes: 10″ x 6″; 15″ x 12″. 672
Evening. Issued fall, 1922 (o.p.f. *Life*, 10/13/21). Print sizes: 10″ x 6″; 15″ x 12″. 665
Daybreak. Issued late summer or early fall, 1923. Painting finished 1922. Oil on panel. Printed by Brett Lithographing Company, Long Island City, N.Y. Print sizes: 6″ x 10″; 10″ x 18″; 18″ x 30″. 682
The Lute Players. Issued 1924. (Painted in 1922 as a mural for Eastman Theater, Rochester, N.Y.) Vertical print size: 15″ x 12″. Horizontal (cropped) print sizes: 6″ x 10″; 10″ x 18″; 18″ x 30″. 680
Wild Geese. Issued September, 1924. Print size: 15″ x 12″. 717
The Canyon. Issued September, 1924. (Original version painted for *Life*, 3/29/23. Major changes in background made by the artist during summer, 1923.) Print sizes: 10″ x 6″; 15″ x 12″. 685
Romance. Issued December, 1925. (Original painted as cover linings for *The Knave of Hearts* by Louise Saunders. Color reproductions printed by Scribner's Press from the original plates for Reinthal and Newman). Print sizes: 14″ x 12″. 696
The Prince (artist's title: *The Knave*). (Original painted to illustrate *The Knave of Hearts* by Louise Saunders.) Print size: 12″ x 10″. 709
The Page (artist's title: *The Knave Watches Violetta Depart*). (Original painted to illustrate *The Knave of Hearts* by Louise Saunders.) Print size: 12″ x 10″. 713
Stars. Issued December, 1926 or early 1927. Painting finished March, 1926. Oil on panel. 35⅛″ x 21¾″. Print sizes: 10″ x 6″; 20″ x 12″; 30″ x 18″. 720
Hilltop. Issued December, 1926 or early 1927. Painting finished May, 1926. 35⅛″ x 21¾″. Print sizes: 10″ x 6″; 20″ x 12″; 30″ x 18″. 722
Reveries. Issued 1928 (other title: *Reverie*). (o.p.f. 1927 General Electric Calendar.) Slight changes made by the artist before House of Art printing. Print sizes: 10″ x 6″; 15″ x 12″. 723
Dreaming (artists' title: *October*). Issued fall, 1928. Painting finished March, 1928. Oil on panel. 32″ x 50″. (After publication, the artist removed from the original the figure and much of the right half of the picture, intending to strengthen the composition by adding a second tree. The repainting was unfinished at the time of the artist's death.) Print sizes: 6″ x 10″; 10″ x 18″; 18″ x 30″. 727

White Birch. Issued 1931 (f.a. *Ladies' Home Journal*, 1930). Print size: 11" x 9". — 734

Tranquility (artists's title: *Elm, Late Afternoon*). Issued 1936. (1936 Brown and Bigelow calendar entitled *Peaceful Valley.* Color reproductions printed by Brown and Bigelow for The House of Art.) Print sizes: 11½" x 9"; 17" x 13½"; 24" x 29½". — 750

Twilight. Issued September, 1937. (Original painted as 1937 Brown and Bigelow calendar. Color reproductions printed by Brown and Bigelow for The House of Art.) Print size: 22½" x 18". — 758

Ladies' Home Journal

Air Castles. Issued 1904 (o.p.f. *Ladies' Home Journal*, 9/10/04). Print size: 16" x 11¾". — 557

Metropolitan Magazine

Maiden standing between two trees (title not known). Issued December, 1916 (appeared as cover of *Metropolitan Magazine*, January, 1917). Print size: 14" x 10¾". — 602

Charles Scribner's Sons

Note: Print sizes are approximate.

The Dinkey-Bird. Issued *ca.*1905 (original painted to illustrate *Poems of Childhood* by Eugene Field). Print sizes: 7" x 4⅞"; 16" x 11". — 378

The Sugar Plum Tree. Issued *ca.*1905 (o.p.f. *Ladies' Home Journal*, Dec. 1902). Print sizes: 7" x 4⅞"; 16" x 11". — 552

Wyken, Blynken, and Nod. Issued *ca.*1905 (o.p.f. *Ladies' Home Journal*, May 1903). Print sizes: 7" x 4⅞"; 16" x 11". — 342

With Trumpet and Drum. Issued *ca.*1905 (o.p.f. *Ladies' Home Journal*, July 1903). Print sizes: 7" x 4⅞"; 16" x 11". — 343

The Land of Make-Believe. (o.p.f. *Scribner's*, Aug. 1912). Print sizes: 11" x 9"; 20" x 16". — 562

Errant Pan. (o.p.f. *Scribner's*, August 1910). Print size: 11" x 9". — 582

Publishers Unknown

Child Harvester (o.p.f. Heliotype Printing Company in 1896 as poster for a brewery). — 65

Semi-draped woman with right arm outstretched standing in a meadow. Date unknown. Print size: 4⁷⁄₁₆" x 3½". — 119

Portfolios or Collections of Reproductions Which Include Parrish's Work

Brown and Bigelow

Masterpieces, issued as bound calendar for 1956. Six landscapes in color from previous Brown and Bigelow calendars.

Evening (1947C)	794
An Ancient Tree (1952C)	809
Sunup (1945C)	791
Daybreak (1951C)	807
Thy Rocks and Rills (1944C)	782
Evening Shadows (1953C)	823

My Homeland, issued as bound calendar for 1964. Six landscapes in color from previous Brown and Bigelow calendars.

A Perfect Day (1943C)	776
New Moon (1958C)	838
Peaceful Valley (1955C)	828
The Millpond (1948C)	795
Sheltering Oaks (1960C)	841
Sunlight (1958W)	839

Our Beautiful America, ca. early 1940's. Four color reproductions of landscapes previously issued as Brown and Bigelow calendars.

Peaceful Valley (1936C)	750
Twilight (1937C)	758
The Village Brook (1941C)	770
Thy Templed Hills (1942C)	760

P. F. Collier and Son

American Art by American Artists. New York: P. F. Collier and Son, 1914. Includes eleven paintings in color by Parrish for *The Arabian Nights* and *A Wonder Book and Tanglewood Tales.*

The King of the Black Isles	421
Pandora's Box	459
Queen Gulnare	418
Prince Codadad	419
Cassim	413
Bellerophon	455
Sea Nymphs	458
Cadmus	449
Aladdin	410
Atlas	450
Centaur	456

Four Masterpieces in Color: Maxfield Parrish, C. D. Gibson, Frederic Remington, A. B. Frost. New York: P. F. Collier and Son, n.d. Includes one painting in color by Parrish.

Pierrot (o.p.f. *Collier's,* 8/8/08).	461

Maxfield Parrish's Four Best Paintings. New York: P. F. Collier and Son, n.d. Includes four paintings in color by Parrish for *The Arabian Nights.*

The History of the Fisherman and the Genie	412
The King of the Black Isles	421
Prince Codadad, His Brothers, and the Princess of Deryabar	419
Cassim in the Cave of the Forty Thieves	413

Thirty Favorite Paintings by Leading American Artists. New York: P. F. Collier and Son, 1908. Includes one painting in color by Maxfield Parrish.

Pierrot's Serenade (o.p.f. *Collier's,* 8/8/08).	461

Twelve Illustrations From the Arabian Nights. New York: P. F. Collier and Son, 1909.

The Talking Bird	415
The Fisherman and the Genie	412
The Young King of the Black Isles	421
Gulnare of the Sea	418
Aladdin	410
Landing of the Brazen Boatman	420
The Story of the King's Son	411
The City of Brass	417
The Story of Ali Baba and the Forty Thieves	413
The History of Codadad and His Brothers	419
Second Voyage of Sinbad	416
Third Voyage of Sinbad	414

J. H. Jansen, Publishers

A Collection of Colour Prints by Jules Guerin and Maxfield Parrish. Cleveland: J. H. Jansen, Publishers, 1917. Includes seven paintings in color by Maxfield Parrish; all originally drawn for *Century Magazine.*

Villa d'Este Tivoli	365
The Pool, Villa d'Este	362
Isola Bella, Lake Maggiore	377
The Theatre, Villa Gori	356
Villa Gori, Siena	355
The Little Princess	388
Seven Pools of Cintra	518

Charles Scribner's Sons

Maxfield Parrish's Pictures in Colors. New York: Charles Scribner's Sons, 1905. Four illustrations in color from *Poems of Childhood* by Eugene Field.

Sugar Plum Tree	552
Wynken, Blynken, and Nod	342
The Dinkey-Bird	378
With Trumpet and Drum	343

Way and Williams

Proofs of the Illustrations by Maxfield Parrish for "Mother Goose in Prose" by L. Frank Baum. Chicago: Way and Williams, December, 1897.

This special collection of proofs, each of the fourteen proofs in each set being signed in pencil on the bottom margin by the artist, was limited to an edition of twenty-seven portfolios.

Designs for Theatrical Scenery

The Tempest by William Shakespeare. Studies made in 1909 for the scenery for a production by Winthrop Ames and Hamilton Bell at The New Theatre, New York City.

An Odd Angle of the Isle (*The Tempest*, 1-2-23). 1909. 16" x 16". Accidentally destroyed. — 504

The Phoenix Throne (*The Tempest*, III-3-23). 1909. 16" x 16". — 501

A Strong-Based Promontory (*The Tempest*, V-1-46). (Artist's title: *The Yellow Sands Outside the Cave.*) 1909. 16" x 16". — 502

The Tempest, V-1-65. Design for scene in which Prospero lifts a spell he previously cast upon the King of Naples. 1909. 16" x 16". — 503

Once Upon a Time. Unknown production. Inscription on back of painting: "Front Forest Drop for 'Once Upon a Time.'" 1916. 32" x 40". — 631

Town Hall; Plainfield, New Hampshire.

Woodland scenery and backdrop with view of Mt. Ascutney designed by Maxfield Parrish about 1917, and probably enlarged and painted by professional set painters. — 640

Snow White. Proposed production of Walter Wanger.

Parrish designed the scenery and built models of the sets for the Walter Wanger production of *Snow White,* which was canceled during the preparatory stages due to the developments of World War I. These models remained in the attic of the artist's studio at the time of his death. — 623

Bookplates

Murals or Panels Painted for a Specific Architectural Setting

Miscellaneous Commissioned Works (Menus, Labels, Bulletin Boards, Etc.)

Works Commissioned but Not Used

Commissioned Works, Publication Uncertain

Miscellaneous Drawings, Paintings, Designs and Sculpture, Mostly Unpublished

Bibliography

Adams, Adeline. "The Art of Maxfield Parrish." *American Magazine of Art* IX, 3 (January, 1918): 84–101.

Alloway, Lawrence. "The Return of Maxfield Parrish." *Show* IV, 5 (May, 1964): 62–67.

Black, Mary, and Lipman, Jean. *American Folk Painting.* New York: Clarkson N. Potter, Inc., 1966.

Bok, Edward. *The Americanization of Edward Bok.* New York: Charles Scribner's Sons, 1922.

Boyle, Ruth. "A House That 'Just Grew.'" *Good Housekeeping* LXXXVIII, 4 (April, 1929): 44–45.

Brinton, Christian. "A Master of Make-Believe." *Century Magazine* LXXXIV, 4 (July, 1912): 340–352.

Carrington, James B. "The Work of Maxfield Parrish." *The Book Buyer* XVI, 3 (April, 1898): 220–224.

"Caught in Florida." *Literary Digest* LXXVII, 6 (May 12, 1923): 40.

Coke, Van Deren. *The Painter and the Photograph.* Albuquerque: University of New Mexico Press, 1972.

Conger, J. L. "Maxfield Parrish's Calendars Build Sales for Edison Mazda Lamps." *The Artist and Advertiser* (June, 1931): 4–7, 33–35.

Cortissoz, Royal. "Recent Work by Maxfield Parrish." *New York Herald Tribune* (February 16, 1936) Section V: 10.

Faunce, Sarah. "Some Early Posters of Maxfield Parrish." *Columbia Library Columns* XVII, 1 (November, 1967): 27–33.

Field, Eugene. *Poems of Childhood.* New York: Charles Scribner's Sons, 1904.

Fitzgerald, F. Scott. "May Day." *The Stories of F. Scott Fitzgerald.* New York: Charles Scribner's Sons, 1951.

Fowler, Gene. *Good Night, Sweet Prince.* Philadelphia: The Blakiston Company, 1943.

Glueck, Grace. "Bit of a Comeback Puzzles Parrish." *The New York Times,* Section II (June 3, 1964): 1, 70.

Glueck, Grace. "Maxfield Parrish." *American Heritage* XXII, 1 (December, 1970): 16–27, 96.

Grahame, Kenneth. *The Golden Age.* London and New York: John Lane: The Bodley Head, 1899.

"Grand-Pop." *Time* LXXXIII, 24 (June 12, 1964): 76.

Hackleman, Charles W. *Commercial Engraving and Printing.* Indianapolis, Indiana: Commercial Engraving Publishing Company, 1921.

Hambidge, Jay. *Dynamic Symmetry of the Greek Vase.* New Haven: Yale University Press, 1920.

Hamerton, Philip Gilbert. *The Graphic Arts, A Treatise on the Varieties of Drawing, Painting, and Engraving in Comparison with Each Other and with Nature.* Boston: Roberts Brothers, 1889.

Hastings, Thomas. "The Architectural League of New York Exhibition." *Harper's Weekly* XXXIX, 1993 (March 2, 1895): 197–198.

Hawthorne, Nathaniel. *A Wonder Book and Tanglewood Tales.* New York: Duffield and Company, 1910.

Henderson, Helen. "The Artistic Home of the Mask and Wig Club." *House and Garden* V, 4 (April, 1904): 168–174.

Holman, George E. "Maxfield Parrish Looks at Vermont." *Vermont Life,* VI, 4 (Summer, 1952): 12–15.

"House of Maxfield Parrish." *Architectural Record* XXII, 4 (October, 1907): 272–279.

Irvine, J. H. "Professor Von Herkomer on Maxfield Parrish's Book Illustrations." *International Studio* XXIX, 113 (July, 1906): 35–43.

Irving, Washington. *Knickerbocker's History of New York.* New York: R. H. Russell, 1900.

Jullian, Philippe. *Dreamers of Decadence.* New York: Praeger Publishers, 1971.

Life Contest Winners. *Life* LXXX, 2081 (September 21, 1922): 11.

Lynes, Russell. *The Taste-Makers.* New York: Harper and Brothers, 1949.

MacKaye, Percy. "American Pageants and Their Promise." *Scribner's Magazine,* XLVI, 1 (July, 1909): 31–32.

"Maxfield Parrish." *Bradley His Book* II, 1 (November, 1896): 13–15.

"Maxfield Parrish as a Mechanic." *Literary Digest* LXXVII, 6 (May 12, 1923): 40–44.

"Maxfield Parrish Will Discard 'Girl-on-Rock' Idea in Art." The Associated Press, April 27, 1931.

Moffat, William D. "Maxfield Parrish and His Work." *The Outlook* LXXVIII (December 3, 1904): 838–841.

National Cyclopedia of American Biography XII. New York: James T. White and Company, 1904.

Norell, Irene P. *Maxfield Parrish, New Hampshire Artist, 1870–1966.* San Jose, California: The Author: 1971.

Parrish, Lydia. *Slave Songs of the Georgia Sea Islands.* New York: Creative Age Press, 1942.

Parrish, Maxfield. "Inspiration in the Nineties." *The Haverford Review,* II, 1 (Autumn, 1942): 14–16.

Parrish, Maxfield, Jr. "Maxfield Parrish's Technique." Unpublished manuscript, 1972.

"Pen and Pencil in Italy." *The Critic* XLVI, 2 (February, 1905): 167–168.

Pollard, Percival. "American Poster Lore." *The Poster* II, 9 (March, 1899): 123–127.

Saint-Gaudens, Homer. "Maxfield Parrish." *The Critic* XLVI, 6 (June, 1905): 512–521.

Unterecker, John. *Voyager.* New York: Farrar, Straus and Giroux, 1969.

Webb, Kaye, ed. *Grimms' Fairy Tales.* Middlesex, England: Penguin Books, 1971.

Wisehart, M. K. "Maxfield Parrish Tells Why the First Forty Years Are the Hardest." *American Magazine* CIV, 5 (May, 1930): 28–31.

Wylie, Philip. "Three Time Winner." *Saturday Evening Post* 214, 44 (May 2, 1942): 20–21, 50, 52, 54.

Studies and Preliminary Drawings

Miscellaneous Three-Dimensional Objects

Index

Page numbers that appear in italic refer to illustrations.

Edited by Diane Casella Hines
Designed by Robert Fillie and James Craig
Set in 11 point Garamond by University Graphics, Inc.
Printed and bound in Hong Kong by Toppan Printing Company, Ltd.

DATE DUE

NO 29'89			
JAN 2 9 1992			
NOV 2 7 1992			